George Bellows and Urban America

Marianne Doezema

Yale University Press

New Haven and London

George Bellows and Urban America

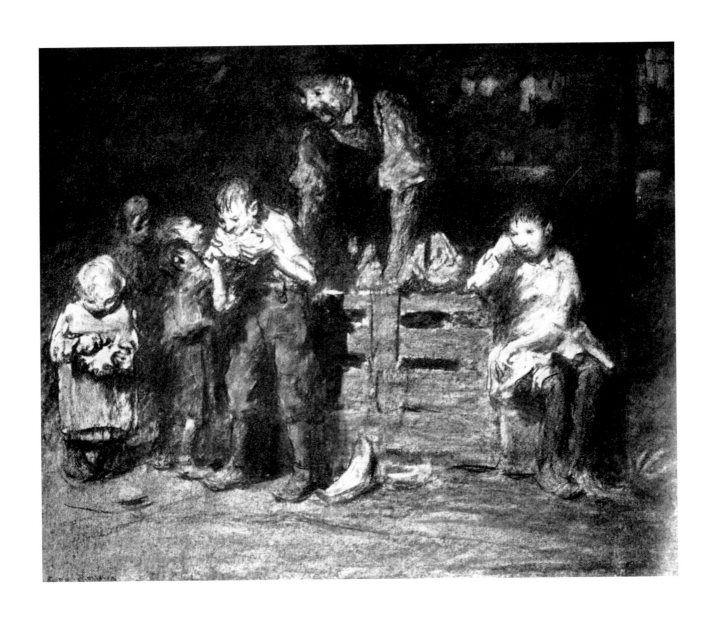

Set in Century types by
The Composing Room of Michigan, Inc.
Printed in the United States of America by
Arcata Graphics–Halliday, West Hanover, Massachusetts.

Library of Congress Cataloging-in-Publication Data
Doezema, Marianne, 1950–
George Bellows and urban America / Marianne Doezema.
p. cm.
Includes bibliographical references and index.
ISBN 0-300-05043-7
1. Bellows, George, 1882–1925—Criticism and
interpretation. 2. United States in art. 3. Cities and
towns in art. I. Title.
ND237.B45D6 1991
759.13—dc20 91-19375 CIP

The paper in this book meets the guidelines for
permanence and durability of the Committee on
Production Guidelines for Book Longevity of the Council
on Library Resources.

10 9 8 7 6 5 4 3 2 1

Frontispiece: George Bellows, *Watermelon Man*, 1906.
Reproduced in *Craftsman*, February 1910. Present
location unknown.

Page 7: George Bellows in his studio, ca. 1907–9. Amherst
College Library. Photograph by permission of the
Trustees of Amherst College.

Page 200: *Ho Bellows, Shortstop, 1902–04, Double "O"
Man, V.O.A.*, photograph from *Makio* (Ohio State
University), 1904.

Contents

Acknowledgments

This analysis of George Bellows's urban themes has depended on a sizable body of previous scholarship on the artist. I gratefully acknowledge my debt to Charles Morgan, Frank Seiberling, Linda Ayres, and others whose work is cited in the notes. Prior to consulting any of the many books and articles on Bellows, however, the original conception of this project derived from my admiration for Elizabeth Johns's superb *Thomas Eakins: The Heroism of Modern Life*, after which this study is modeled in part.

I would like to extend special thanks to Patricia Hills for directing this project while I was a doctoral candidate, for carefully reading each section of the manuscript, and above all for offering criticism and encouragement. David Hall has coaxed me toward sharpening my ideas while at the same time thinking more broadly. I hope I have done justice to his incisive suggestions. David Lubin, Elizabeth Milroy, Frances Pohl, Kim Sichel, and William Vance were kind enough to read parts or all of the manuscript; the effectiveness of my arguments and the precision of my prose have improved considerably as a result of their comments.

Two and a half years of research and writing were made possible by Boston University Graduate School Scholarships, a Henry Luce Foundation Research Fellowship, and a Smithsonian Predoctoral Fellowship. During my stay at the National Museum of American Art, funded by the Smithsonian Fellowship, my work benefited from discussion with many people. Among them I would like to single out Lois Fink, Jonathan Katz, Michel Oren, Beth Roark, Tara Tappert, and Judith Zilczer. And I owe a large debt of gratitude to staff members of the National Museum of American Art library as well as the Archives of American Art and the Inventory of American Painting.

Individuals in many museums, libraries, and archives assisted me at various times during my research. I would like to mention in particular the curators, librarians, and archivists at Special Collections and Archives, the Amherst College Library; Print Department, the Boston Public Library; University Archives, Ohio

State University; Prints and Photographs, the Library of Congress; Local History and Genealogy Division, the New York Public Library; and the New-York Historical Society. I am grateful to Glenn Peck and Franklin Riehlman at the H. V. Allison Galleries for invaluable assistance and cooperation. At Yale University Press, I had the pleasure of working with Judy Metro and Richard Miller, and I thank them for their support during the editing and production of this book. Above all, I want to express my appreciation to George Bellows's daughter, Jean Bellows Booth, for her interest in this project and for her willingness to respond to countless queries. She has also generously granted permission for me to quote from documents in the George Bellows Papers at the Amherst College Library.

I can only inadequately express my thanks to my husband, Michael Marlais, for his patience, his criticism, and his steady support. This book would never have happened without him.

My greatest debt is to my parents, Geraldine and Charles W. Doezema. I dedicate this book to them.

George Bellows and Urban America

Introduction

Less than a year after George Bellows's death in January 1925, the Metropolitan Museum organized a major retrospective exhibition of his work. The museum itself considered such a show "the highest honor which can be accorded an American painter."[1] Only nine artists before Bellows have been similarly recognized. Frank Crowninshield devoted much of his introduction for the exhibition catalogue to marveling at Bellows's accomplishment, as if it were unexpected or illogical. After all, Bellows had "paid no heed to what . . . was lucrative or fashionable; sought no distinguished patrons; adopted no clichés; and flew, with singular persistency, in the face of public taste." It was especially remarkable, in Crowninshield's view, that the museum would pay its highest tribute to an artist who had "made anarchy so much of an avocation."[2]

As had often been the case during his lifetime, Bellows continued after his death to be linked with artistic radicalism and, especially, with the anti-academic posture of "the Eight." At the peak of their notoriety during the years around 1908, these artists led a highly publicized campaign against the exclusionary practices of the National Academy of Design, the seat of authority in art. They made pronouncements about refusing to sentimentalize the tenement district subjects for which they were known. They reveled in portraying unsanitized scenes of quotidian labor at the city wharves. For such transgressions they were labeled "art anarchists" and "rebels."[3] Although never a bona fide member of the Eight—Bellows was not among the original eight artists who showed their work in the famous exhibition at the Macbeth Gallery—he shared the group's reputation for insurrection. Thomas Beer, on the occasion of a lavish publication of the artist's lithographs in 1927, went so far as to contend that Bellows was more of a rebel than his cohorts:

> Bellows had excited much furious discussion. He had, in fact, increased all the offenses of John Sloan, Robert Henri and George Luks. The mention of his name seemed to throw conservatives into a

frothing epilepsy of denunciation. . . . Even a symbolist, such as Arthur Davies, was not so rasping to conservatism as this positive satirist with his bravura, his cold versatility and untamed assertiveness.[4]

A sensational story, and one that was not a little overblown. In reality, the vituperative condemnation of Bellows's subject matter and technique, so often lamented by his supporters during his life and after his death, never really happened. To be sure, Bellows associated with Robert Henri and his circle, a group that identified itself in terms of opposition to the cultural establishment and the stylistic vocabulary it favored, academic idealism; but Henri and his protégés attracted at least as much praise as criticism for their stance. And Bellows garnered more accolades more quickly than any of his colleagues: after only four years of serious study, one of his paintings was purchased by the Pennsylvania Academy of the Fine Arts for its permanent collection, and the following year, 1909, at the age of twenty-six, Bellows was elected an associate member of the National Academy of Design.[5]

The basic facts of Bellows's biography relate the story of a man who achieved remarkable success with spectacular speed. This book traces George Bellows's rapid rise to prominence in the art world, focusing on the early years of his professional career, from 1905 to 1913. During his first years in New York City, Bellows was not only honing his extraordinary technical skills but also practicing rudimentary techniques of career management. From the start he was an eager and adept student, and he had a great teacher. Robert Henri made deliberate efforts to construct a persona, to fashion the public's perception of his activities, and to nurture the notion that those activities constituted a crusade. One of the most essential concepts Bellows assimilated while following in Henri's footsteps had to do with developing a sense of self—especially of his own manhood—and establishing a professional identity.

A heightened consciousness about identity and self-image is a particularly modern phenomenon. Historian Warren Susman has pointed to a new interest in the public presentation of self, in personality as a manifestation of the emerging consumer society at the turn of the century.[6] The work ethic ceased to constitute the primary basis for one's vision of self-development as the nineteenth-century culture of character was gradually supplanted by the culture of personality. In fact, the term *personality* came to be prominent in the American vocabulary during the first decade after 1900. At the same time, a spate of advice literature reflected the emerging social order by prescribing imperatives appropriate to it. Readers of a typical volume learned, for example, that "to be a personality is to be one who is distinguished and recognized among a crowd, . . . to strengthen yourself, increase your connections. It is through them that one's personality makes an impression."[7]

If the culture of personality was indeed a distinguishing characteristic of the new society and the new century, a remark by Sadakichi Hartmann in 1906

seems almost prescient: "It is Henri's personality first of all that has made a mark in our American art life."[8] In a short "studio-talk" note for *Studio International*, Hartmann described Henri as the "patriarch" of a group of young painters "who consider him as a sort of leader." The article also mentioned the kind of banal subject matter Henri promoted as "poetical," but clearly the artist's magnetic personality was deemed to be as noteworthy—as newsworthy—as his theories. None of this was lost on Bellows. The facts of his career serve to demonstrate that Bellows was at least as influenced by the role model Henri provided as he was by Henri's art instruction.

During subsequent decades, many of Henri's students and associates have offered testimony to the powerful impact of his charismatic presence. But Henri's natural leadership qualities comprised only part of his "image." His anti-establishment crusade was also a critical component of his identity—an identity Henri himself helped create through his connections with the press.

Henri was probably quite aware that the title of a 1908 article in the *Independent* magazine would brand him as a revolutionary. The author, Charles Wisner Barrell, mimicked Henri's own works when he described the artist-teacher as a "painter of personality" who promoted "individuality" rather than "facile mediocrity." In the classroom, Barrell continued, Henri endeavored not to teach painting at all, but rather "to help the student develop his own personality by inspiring him to think and work for himself."[9] These were unconventional notions, it would seem. Certainly they were presented as such in the *Independent*, by a writer who well knew that the readers of this progressive magazine were prone to consider unconventionality a virtue. Barrell knew, too, that Henri's ideas might appear as an affront to traditional art pedagogy and practice, but that the affront would be relatively limited—in fact, Henri's basic doctrines were not very far from an influential strain of popular thought. Advice manuals and nonfiction literature reflected a widespread and growing preoccupation with personal fulfillment among the educated bourgeoisie.[10] The idea of developing and expressing one's individuality was undoubtedly familiar to the readership of the *Independent*. Surely Barrell's article was intended to present its "revolutionary" subject as an exemplar of certain advanced cultural trends, as an advocate of appealing, if provocative, ideas about art.

This counterpoint between the revolutionary and the familiar is a leitmotif of Bellows's career. Using his mentor as a model and touchstone, Bellows, too, developed a public persona. His personal and professional associations, his demeanor and behavior, and, most important, his paintings all contributed to the image he presented, an image that incorporated a complex relationship to recognized cultural authority. In his life and in his work, Bellows managed to chart a delicate course between resistance and accommodation. The critic Forbes Watson, looking back on his own personal observation of the artist's career, offered a cogent assessment when he remarked that although Bellows "outraged the more staid conservatives at first, . . . the time was ready and waiting for the outrage."[11]

In the following chapters, I consider how Bellows maintained the delicate balance to which Watson referred, how his bold new artistic statement provoked attention but seldom outright opposition, and how he fashioned a professional identity just outrageous enough to be acceptable, even welcome. Bellows's flamboyant style, his coarse technique, and his frank, sometimes gritty urban subjects all bore the trappings of artistic rebellion; and in many circles, that perceived rebelliousness carried larger cultural and even political connotations. At the same time, however, Bellows's paintings won him critical acclaim and were embraced by many in the arts audience, in large part because their implicit meaning was distinctly unrevolutionary. That subtle mixture of seemingly contradictory elements accounts for an almost protean quality in Bellows's art and, probably, also for his quickly gained popularity. Despite the "storm clouds [that] always hovered over [his] head,"[12] early twentieth-century gallery-goers recognized in the presence of Bellows's paintings that "his ideals, his humor and his activities were those of a healthy American."[13]

Bellows selected the three principal urban themes that are examined in this book—the excavation for Pennsylvania Station, prize fights, and tenement district life on the Lower East Side of New York City—for personal as well as professional reasons. Although paintings of similar motifs by predecessors and colleagues surely informed Bellows's choice and treatment of these subjects, related artworks are cited only occasionally and selectively. The primary focus here is less on sources and influences than on cultural forms that reveal the orientation of society's common values and the operation of political, economic, or social forces. Each chapter offers a "reading" of a discrete group of Bellows's urban subject pictures. The interpretation is premised on the notion that artistic production is a social practice—that a painting represents the ordering of visual data into meaning, which is in turn embedded in the artist's engagement with society. Clearly, a realist painting represents a complex mix. In Bellows's case that mixture includes, among other elements, an acute visual memory of the external world, selection from the facts of a scene, and marshaling those facts into a pictorial construction. All phases of that process—the seeing, the remembering, the selecting, and the painting—were directed by a system of values and assumptions particular to a time, place, and social group.

Bellows tended to choose prominent, often newsworthy motifs, and as a result the images he produced often evoked particular associations and meanings for his contemporaries. To regain a sense of the connotations surrounding these pictures, I analyze Bellows's handling of urban subjects in terms of culturally resonant images, issues, and metaphors current during the first decades of the twentieth century.

Contemporary journals and periodicals serve as a primary body of documentation for this analysis. Not only are they readily accessible, but also the mass media can be said to contribute to as well as reflect the visual and verbal

vocabulary of their readership. George Bellows, for example, learned to draw by copying illustrations from the pages of *Life* magazine, and he followed an increasingly common custom among middle-class Americans when he continued to buy and read a variety of magazines throughout his lifetime. While topics current in the pages of *Harper's Weekly* and *McClure's* are relevant to a consideration of issues that may have attracted Bellows's attention, the visual images reproduced in these magazines are at least as significant. Bellows was by nature attuned to the visual aspect and apparently possessed a special gift for retaining visual information in detail. He read newspapers as well as a selection of magazines, an occasional volume of fiction, and a number of art books; by doing so he absorbed an incalculable number of visual images. In other words, he learned a great deal of what he knew of the world around him from the printed page. While he was taking part in a new, stimulating aspect of the communications revolution, he may not have realized the extent to which a veritable barrage of written and visual texts would have had an impact on his perceptions. When he arrived in New York City in 1904, he was undoubtedly convinced that he was seeing and perhaps sketching his acquired environment from firsthand observation. But in fact those observations and especially the manner in which he recorded them in pencil or paint were interpreted, to some extent, according to the way the city had been presented to him by the press.

The media likewise provide a basis for determining what issues and events may have occupied the minds of Bellows's contemporaries and how they may have responded to the subjects he painted. His immediate audience, it is assumed, was literate and more or less familiar with local newspapers as well as a range of weekly and monthly magazines. This contention gains some support from documented interactions among writers, artist groups, and patrons. The patterns of thinking established in those circles may be extended to broader segments of the public.

Many of the artists in the Henri circle themselves worked as illustrators, and their drawings appeared in the mass-circulation press—especially in *McClure's, Munsey's, Everybody's,* and other popular magazines. These were also the periodicals that featured human interest stories, reports on current events, and the highly popular urban exposé articles by muckraker journalists like Lincoln Steffens and Ray Stannard Baker. The older, more elite literary journals also maintained a loyal readership into the first decade of the twentieth century, but, to speak in very general terms, that loyal readership might also be expected to have demonstrated allegiance to traditional, conservative ideas about art and art making. Robert Henri and his band, which included George Bellows, openly opposed many of those ideas. A groundswell of approval rose up in support of their challenge to cultural authority, a tendency broadly associated with the progressive press. Artists like Kenyon Cox, on the other hand, promulgated the lofty ideals of the classical tradition (not unexpectedly) in *Century* and *Scribner's.* Distinguishing between conservative and progressive temperaments in the press and, by extension, corresponding com-

ponents of the contemporary audience, helps to account for Bellows's appeal across social and political lines.

Art commentators used political and ideological allusions with a relatively free hand during this period. Terms like radical, anarchic, or revolutionary were frequently bandied about. For the most part, critics applied these terms with primary reference to artistic matters, as Arthur Hoeber did, for example, in his review of the 1906 Winter Exhibition at the National Academy of Design: "The revolutionists of yesterday have, generally speaking, settled down to be law-abiding citizens of the republic of art. Maybe it is that our eyes have been accustomed to their various manners and they no longer strike us as being radical." However, terminology of this kind frequently evoked wider resonances, which at times became explicit. Such was the case when a *New York Times* editor, writing about the 1913 Armory Show, characterized the cubists and futurists as "cousins to anarchists in politics" and warned: "The movement is surely a part of the general movement, discernible all over the world, to disrupt and degrade, if not to destroy, not only art but literature and society, too."[14]

Critics of various persuasions adulated Bellows's realism. The arch-conservative Royal Cortissoz, for example, talked of his "delightfully candid vision," his loyalty "to the raw phenomena of the visible world," and the "blunt truth which Bellows drew from the soil." In describing the artist's approach to subject matter, Cortissoz said Bellows painted things he saw and that moved him, with no "*arrière pensée* about it at all." And he went on to describe a phenomenon that many of his contemporaries had similarly perceived: an exquisitely harmonious relationship between Bellows's "art and the world in which he lived." Cortissoz might have admitted that he recognized in Bellows's paintings the world in which he himself lived. Instead, he suggested that Bellows was one of the "people" because he painted what they knew, the way they knew it. He painted "something which they can understand, something keyed to the rhythm of American life."[15]

Bellows certainly was a realist in that he derived his primary inspiration from fresh, visual perception of his world. But in addition to recording episodes from New York City life, he created paintings that held a special significance—a special meaning, one might suggest—for early twentieth-century urban Americans. In selecting his subjects, Bellows instinctively touched foci of energy in the modern environment. Because his paintings related, sometimes in uncanny ways, to contemporary events and topical issues facing urban Americans, they participated in a dialogue about the forces of movement and change in the burgeoning city, the threatening crowds massing at its base, and the search for verities amid the uncertainties of urban life. Bellows's paintings reveal their messages at the point where one can ask why he approached his urban subjects the way he did and why his portrayals of those subjects were so often perceived as truth—by critics and patrons, and by conservatives, progressives, and radicals alike.

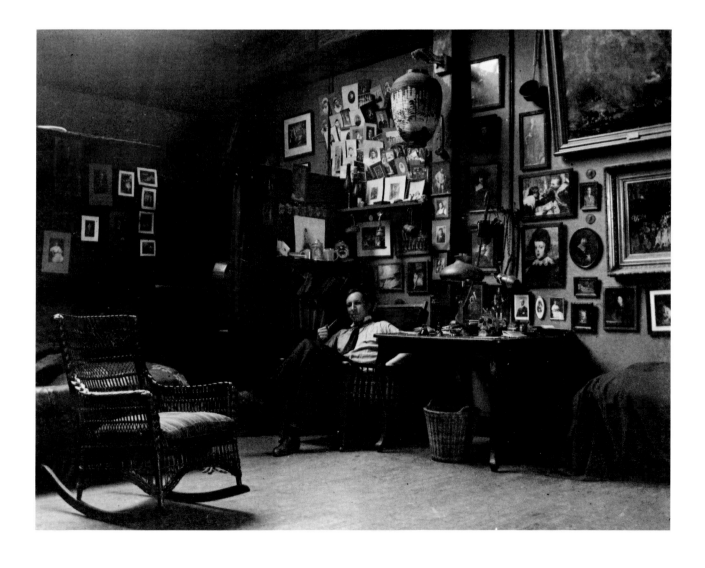

1. George Bellows, *Pennsylvania Excavation*, 1907. Private collection. Photograph courtesy the H. V. Allison Galleries, New York.

The Excavation Chapter 1

Pennsylvania Excavation brought George Bellows important early critical atten-
tion (figure 1). Such epithets as "stark, harsh, ugly and powerfully felt" helped to
establish his reputation as a prominent young newcomer who produced big, brash
paintings.[1] Not surprisingly, he returned to the site, the excavation for Pennsylvania
Station, and in three subsequent paintings he continued to seek striking visual
effects through various and increasingly sophisticated means.

The critical discussion of the Pennsylvania Station excavation paint-
ings centered on Bellows's style as much as it did on his choice of subject matter. It
was clear, furthermore, that his use of a consciously unrefined, bravura painting
technique and his decision to paint a scene drawn from contemporary urban life
reflected the influence of his teacher, Robert Henri. Bellows may have recognized
the advantages of associating himself with the much-discussed and controversial
Henri, for such an association all but guaranteed a degree of notoriety. By the spring
1908 exhibition at the National Academy, when his paintings were hung on a wall
reserved for work by Henri and other members of his circle, Bellows found himself
on center stage. The wall was called "anarchical" by one critic: "It will shock. It will
scandalize. But no one will pass it indifferently. To our surprise we found it to be the
magnet of the galleries."[2]

Bellows cultivated a relatively specific artistic identity with paintings
that bore the hallmarks of Henri's "revolutionary creed."[3] At the same time he
nurtured a rapid rise to professional success with an implicit affirmation of the
status quo. He managed to enjoy the cachet that came from connections with what
many considered a resistance movement—in artistic terms and, at least by implica-
tion, political terms as well—while his paintings were embraced by much of the
urban public. The way for Bellows's early success was paved by members of an
educated, largely middle-class and upper middle-class audience who were looking
for a new spirit in the nation's art, one that challenged the staid fare of academic
painting but stopped short of threatening the underlying tenets of the existing

cultural, social, and economic structure. His genius lay not only in his prodigious natural talent with a paintbrush but also in his ability to combine a "revolutionary" style with an ingratiating message.

New York Observed

During the first decade of his career, George Bellows found the vast majority of his subjects in New York City. Nonetheless, he was and always remained in some sense a visitor to New York, despite his having moved there at age twenty-two to study art and having never left for more than a few months at a time. His paintings show him to be dazzled by his adopted city in a way natives seldom were.[4] His position as a resident outsider may account at least partially for a quality of aloofness in his work: his vision was that of a spectator rather than a participant. New York attracted legions of spectators during this period, but Bellows's impressions of the city might fruitfully be compared with those of two in particular—two other outsiders. Henry James and H. G. Wells made much-noticed visits to New York soon after Bellows arrived; both authors wrote eloquently about their perceptions, and their essays first appeared, very prominently, in the mass media. The way they saw and understood the city was a matter of concern for many reading Americans.

During the fall of 1904, when Bellows was busy acquainting himself with his new surroundings, Henry James was also exploring New York, after a twenty-five-year absence. His ruminations on the experience were recorded in an essay he called "New York Revisited," published in *Harper's Magazine*. He marveled at the "appeal of a particular type of dauntless power" that seemed to pervade every moving thing in the city, from the laboring vessels in its harbor to the wind and the lights. But as he viewed the skyline from a barge circling Manhattan, his initial exhilaration before the "commanding and thrilling" scene gave way to foreboding as he took in one feature after another of the "monstrous organism":

> One has the sense that the monster grows and grows, flinging abroad its loose limbs even as some unmannered young giant at his "larks," and that the binding stitches must forever fly further and faster and draw harder; the future complexity of the web, all under the sky and over the sea, becoming thus that of some colossal set of clockworks, some steel-souled machine-room of brandished arms and hammering fists and opening and closing jaws.[5]

Such bestial imagery was commonly applied to machinery in the nineteenth century, but now the entire urban scene represented to some observers overwhelming forces operating beyond human control. Writing several months later, H. G. Wells also noted "the sense of soulless gigantic forces, that took no heed of men." (His articles were first serialized in *Harper's Weekly* and then published in a single volume, *The Future in America.*) Far less daunted than James, Wells had arrived in New York with the expectation of finding the new world of his visions—a welcome improvement over

decadent England. He saw the city spread out before him, the physical manifestation of a "blindly furious energy of growth." The irregular outlines of its famed skyscrapers appeared to him a strange crown, conveying "an effect of immense incompleteness," as if, like volcanoes still erupting, irrepressible forces were playing themselves out. The very lack of definition he perceived, the frantic movement toward a yet unspecified goal, was for Wells New York's achievement: "a threatening promise, growth going on under a pressure that increases, and amidst a hungry uproar of effort."[6]

Wells was especially struck, as James had also been, by the sight of the city's great bridges—the Brooklyn Bridge in particular, which inspired a bit of monster imagery in his own description. But unlike James, Wells was not repelled. He found the cyclopean visage of the Brooklyn Bridge "impressive": "its greatness is not in its design, but in the quality of necessity one perceives in its inanimate immensity."[7] American readers, accustomed to more condescending accounts of their country by Continental visitors, embraced such open-minded approbation.

In a letter to Wells, Henry James said that he had found *The Future in America* a bit too "loud" but admitted that his correspondent's portrait was probably more suited to the subject than his own: "It's a yelling country, and the voice must pierce or dominate; and *my* semitones, in your splendid clashing of cymbals (and *theirs*), will never be heard."[8]

Like James and Wells and many other city watchers, Bellows singled out features that particularly attracted his attention. He seldom wrote about the subjects he painted and in fact left a relatively meager legacy in the written word. He expressed himself most eloquently through visual images, selecting his vocabulary from the contemporary world around him. The meaning or significance of these images must therefore be garnered from the paintings themselves and from their context, the cultural and historical milieu in which they were produced. Fortunately, Bellows tended to select topical subjects—places or events that attracted local and even national attention. Bellows's interest in such prominent subjects not only sheds light on his artistic nature but also provides a source of contemporary documentation of the paintings themselves.

Of course, the expressive qualities of his paintings convey the nature of his response to those subjects, at least in the broadest sense. The overtly emotional overtones of many of Bellows's paintings were regularly noticed by critics, who frequently offered interpretations based on a perceived mood. In fact, Bellows's contemporaries seem to have regarded him as being temperamentally in tune with their own attitudes and priorities. They recognized in Bellows, as they had in Wells, a sense of vitality and optimism, and they responded to an emotional and physical energy in his work. They could appreciate his apparently positive view of urban America even when they criticized his coarse technique. Henry James would surely have considered the Pennsylvania excavation unsightly, monstrous, and merely one more manifestation of America's indifference to its own history as well as its un-

bounded materialism. The "great gaping wound in the dirty earth," as the *Sun*'s critic referred to the excavation, was far from picturesque in the traditional sense; and Bellows's portrayal of it could, in the words of that same critic, make "rosewater idealism shiver and evaporate." But by 1907 rosewater idealism was commonly in disrepute, and the brazen frankness of Bellows's approach could be a positive attribute. Ultimately, his painting received mild praise in the *Sun* for being "real" and "truthfully painted."[9] *Pennsylvania Excavation* celebrated not a finished monument but the raucous process of New York's commercial growth. It was a portrait of open-ended potential—hideous but dynamic, crude but sublime.

The New York School of Art

Bellows was alerted to the appeal of the city's unvarnished side at the New York School of Art. There Robert Henri instructed him to observe life on the streets and to draw on that life for the subjects of his art.[10] Accordingly, he scoured the Lower East Side for paintable types and executed dark, Henri-inspired portraits such as that of Thomas McGlannigan (*Cross-Eyed Boy*, 1906; private collection) and *Frankie, the Organ Boy* (1906; see figure 56). But when he decided to portray the excavation for the Pennsylvania Railroad's New York City station he was stepping out to a larger measure on his own. Undoubtedly he knew examples of Henri's urban landscapes, such as *Cumulus Clouds, East River* (1901–2; private collection), but the excavation site presented different compositional problems from those of the commercial waterfront of Henri's more conventional landscape painting. In fact, the huge, rude hole being dug for Penn Station was an ungainly scene even by Henri's standards. By early 1907, Bellows seemed to have taken his teacher's ideas to heart and was following those dictates more rigorously even than Henri himself, and certainly with more bravado than his eager classmates. *Pennsylvania Excavation* (figure 1), an early tour de force in his career, demonstrated that by 1907 Bellows had completely assimilated Henri's theories about painting, a feat that required a radical change in his own drawing style. The painting also provided an indication of Bellows's talent as well as his enormous competitive drive, which together would ultimately enable him to outstrip the achievements of his teacher.

The extent to which Robert Henri shaped Bellows's artistic development can only be appreciated by comparing a series of early efforts. Bellows was a facile draftsman by the time he entered Ohio State University, working in a technique honed by copying illustrations out of magazines. He particularly admired Charles Dana Gibson and Howard Chandler Christy, and Bellows's drawings for the Ohio State yearbook, the *Makio*, demonstrate how artfully he mimicked their stylish illustrations.[11] For the 1903 yearbook, Bellows portrayed the heroine of a prize-winning short story (figure 2). The confident but demure young woman clearly represents Bellows's version of the popular Gibson Girl. His methodical cross-hatching, more determined by surface design than by the requirements of contour and shading, is likewise derivative of Gibson's illustrations, then regularly featured

2. George Bellows, untitled illustration for "Burton's Boomerang," *Makio* (Ohio State University), 1903.

in such periodicals as *Life* magazine. In the case of at least one drawing from his university days, called *The Beta Grip* with reference to his fraternity, Bellows was literally copying from a ten-year-old issue of *Life* (figures 3 and 4). Apparently he collected these magazines and culled from them later as needed.

Considering this early grounding in the style and vocabulary of the genteel tradition (reinterpreted and commercialized, to be sure), Bellows's choice of Robert Henri as a mentor seems at first surprising. In an autobiographical statement written almost two decades after the fact, Bellows recorded that he found himself in Henri's class "by sheer luck."[12] Armed with a portfolio of his drawings and an allowance from his father, Bellows had traveled to New York in the fall of 1904 and moved into the safe and respectable YMCA on West Fifty-seventh Street.[13] Located three blocks from the Y, the New York School of Art featured three principal instructors: William Merritt Chase, Robert Henri, and Kenneth Hayes Miller. One might have assumed that Bellows would have devoted his primary efforts to the classes led by the first of these very different men. Chase enjoyed the most conspicuous and distinguished national reputation, and his style of portraiture should have appealed to a young student enamored of C. D. Gibson and H. C. Christy.[14]

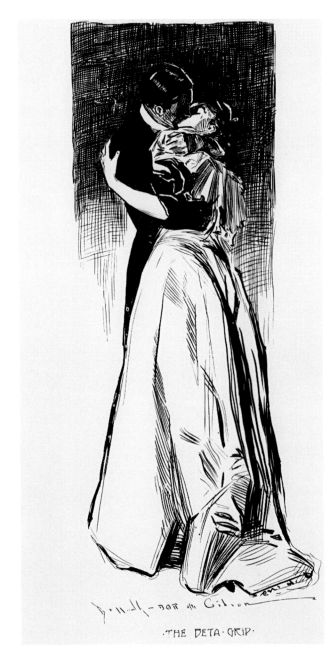

3. George Bellows, *The Beta Grip,* ca. 1903. Ohio State University Archives, Columbus.

4. Charles Dana Gibson, untitled illustration for "An Aristocratic Prodigy," *Life,* 16 November 1893.

In spite of the gruff retort that his portfolio of Gibson-style illustrations elicited from Henri, Bellows remained in Henri's class.[15] Although he received criticism from all three instructors, Bellows repeatedly acknowledged the overriding importance in his life of a single mentor, Robert Henri. Apparently he came under Henri's influence soon after his arrival at the school. His early inclination toward Henri, by his own account, was not the result of a careful analysis of alternative teaching methods or conflicting attitudes toward art. A number of Bellows's fellow students have left reports of the sharp contrast between the famous William Merritt Chase and the younger man who would become his rival. Rockwell Kent, for example, described the master's appearance at his famous Saturday morning criticism:

> Chase was a little man, dapper in dress to the point of foppishness, spatted, bat-wing-collared, his cravat drawn through a priceless jewelled ring. He invariably wore a carnation in his button-hole. Gray haired, gray bearded and moustachioed he was a handsome and distinguished-looking man. Black ribboned *pince-nez* completed—shall we say his make-up? No, it all was natural to him.

The tall, lanky Henri could hardly have presented a more different physical aspect. He was described, again by Kent, as "striking," but in an "utterly unorthodox" way. His smallish head emphasized narrow, penetrating eyes. He moved about a room with authority, won not by flamboyance but by virtue of the "aura" about his person.[16] Guy Pène du Bois remembers seeing Henri enter the classroom for the first time, like "a rock dashed, ripping and tearing through bolts of patiently prepared lace."[17]

Like his classmates, Bellows seems to have instinctively gravitated toward the vital, decidedly masculine Robert Henri. The image of professional artist presented by the dandyish William Merritt Chase held considerably less appeal.

Henri's classroom offered Bellows the opportunity to become part of an aggressively masculine community. He was not alone in responding to the emphasis on manliness. Pène du Bois recalled the atmosphere with obvious relish:

> Henri himself believed that he was creating a class of men. The student of art must be a man first, with a good strong conscience and the courage to live up to it. Art could come later. . . . The first prerequisite of the student, then, was that he be a man and by that was meant that he have guts. Without the attributes of a fighter, he could expect little or no success with an uninterested American public. . . .
>
> Henri did not expect the artist to be a normal man, of which there are always too many. He expected him to be a real man, of which there are always too few. Art and manhood was thus compounded into one—an incredibly healthy unity for that time.[18]

The first paintings that Bellows chose to exhibit publicly in New York City plainly identified him as one of Robert Henri's he-men. They also demonstrated Bellows's distinct break from the stylish mannerisms of his illustration work for the *Makio*. In the spring of his third year as a student at the New York School of Art, he submitted his roughly scumbled *River Rats* to the jury of the prestigious National Academy of Design (figure 5). An academician like Kenyon Cox must have considered the surface of *River Rats* to be as gritty and unfinished as the subject was unideal. Along the lower edge of the muddy-colored canvas a gangling group of scantily clad boys is depicted cavorting at the edge of the East River, while the center of the painting is given over to the graceless, rocky cliff descending from the city streets to the water. *River Rats* was accepted by a relatively liberal jury for the Academy's Eighty-second Annual Exhibition, but it was largely overlooked in the press.[19]

The following April, students at the New York School of Art mounted an exhibition of their work in the school's gallery. There Bellows was noticed, and the issue of masculinity was in fact raised in the reviews. A critic for the *Telegraph* recognized in the students' work generally "the influence of the virile personality of Robert Henri" and proclaimed Bellows "the strongest of the lot." The *New York Sun* singled out his painting of the excavation for special comment: "Here is a slice of New York keenly observed, keenly transcribed. It is not pretty. Nor is the tunnel at full blast very alluring. When you paint a crab apple don't give us a luscious peach (but the idealists always clamor for the pretty peach)."[20]

Underlying the obvious display of so-called manly strength, the work of Bellows and his colleagues was allied, on broader, cultural terms, with the sphere of masculine aggressiveness. Philosopher George Santayana defined this aspect of a bifurcated American culture in 1911 when he identified what he perceived as its two separate and distinct "mentalities." For Santayana, one part of the American mentality looked to the past in an effort to perpetuate traditional spiritual values, whereas the other dealt with the material concerns of real, everyday life:

> The truth is that one-half of the American mind, that not occupied intensely in practical affairs, has remained, I will not say high-and-dry, but slightly becalmed; it has floated gently in the backwater, while, alongside, in invention and industry and social organization the other half of the mind was leaping down a sort of Niagara Rapids. . . . The one is the sphere of the American man; the other, at least predominantly, of the American woman. The one is all aggressive enterprise; the other is all genteel tradition.[21]

Such artists as Benson and Tarbell—as well as, of course, Kenyon Cox himself—epitomized Santayana's genteel tradition. Their paintings celebrated ideals, moral values, good manners, the contemplative life, and beauty, often using female figures to function as repositories of the qualities cherished by genteel society. Henri, on the other hand, encouraged involvement with one's own time and nation; by implication,

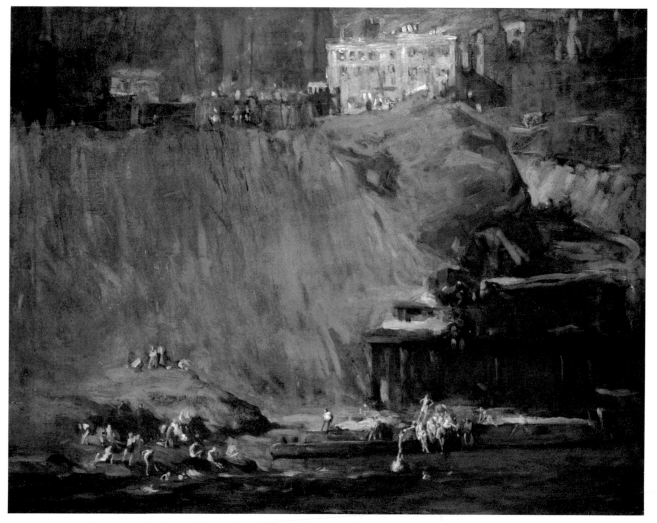

5. George Bellows, *River Rats,* 1906. Private Collection, Washington, D. C.

one's life and art should be in contact with contemporary political, economic, and social concerns. Bellows's excavation painting did just that. Bellows established his early reputation by focusing on tangible aspects of urban life, by *not* reflecting on transcendent values of the inner realm. His first publicly exhibited works were, indeed, "all aggressive enterprise."[22]

Early Recognition

Undoubtedly, Bellows was pleased by his reception in the press. Critics praised him for the very qualities he had so doggedly tried to emulate. His 34-by-44-inch, gray and black *Pennsylvania Excavation* had helped him to achieve exactly what he had yearned for—affirmation of his strength as an artist and, by implication, of his strength as a man.

Bellows exhibited the painting repeatedly. Along with boxing, the excavation became a kind of signature subject during the critical, early period of his professional career. In fact, when the New York art public was first learning about George Bellows, his name was often associated with a pair of big, aggressively painted canvases depicting big, powerful subjects. In December 1907 Bellows again won the approval of the National Academy's jury. *Pennsylvania Excavation* and his first boxing painting, *A Stag At Sharkey's*, were accepted for the Winter Exhibition. A critic for the *International Studio* described the two works together, noting that in both the artist had "presented passing phases of the town in a manly, uncompromising manner."[23] The pair of paintings then went on to the Pennsylvania Academy where they again attracted critical attention.[24]

Bellows was not included in the famous Macbeth Gallery exhibition in February 1908, but in the following month he did participate in a like-spirited effort to sidestep the "blank stone wall" presented by the National Academy. A group of Henri's ex-pupils rented a loft on West Forty-second Street for a show they called simply an "Exhibition of Paintings and Drawings by Contemporary Americans."[25] The *New York Evening Mail* dubbed it "'The Eight' Out-Eighted," and the *Sun* declared, "Luks, Henri, Glackens are simply outdone and parodied." Bellows must have selected his entries carefully. Once again he decided to exhibit the work he now realized was his strongest painting to date, his *Pennsylvania Excavation*, and once again it was acclaimed by the press. He also showed a boxing picture, this time a drawing, *The Knock Out* (1906; see figure 38). Bellows was called the "headliner" of the fifteen young artists. In its review, the *Craftsman* predicted that Bellows would "undoubtedly be well known to the art public of some years hence."[26]

During this period, his connection with the Henri circle conferred on Bellows more than a ready-made artistic identity. He also shared some of the criticism that was leveled at Henri's students. For one reviewer, their work lacked sanity as well as beauty, and "such little details as drawing, construction, and modelling" were all but dismissed under Henri's tutelage. But in the *Times* a reviewer was unquestionably referring to Henri's circle when he described "one of the most

interesting groups of painters in this country to-day . . . who use the material that lies ready close at hand, who concern themselves most largely with depicting the life about us." He saw in the work of this group the promise of a "renaissance of modern art" in America that would be based on a "wholesome disregard" of "old, musty conventions." Bellows enjoyed the distinction of serving as the prime example of "both the power and the shortcomings of this new school."[27] Bellows's association with Henri, then, was anything but detrimental to the young artist's career. Henri brought him to the forefront of one of the most advanced art movements in New York. From that prominent, though controversial, position, Bellows made vaulting leaps toward early success—success that was to a large extent earned on the basis of his early masterpiece, *Pennsylvania Excavation.*

The painting spent little time in his studio during 1908. Soon after the exhibition on Forty-second Street closed, Bellows shipped *Pennsylvania Excavation* to Pittsburgh for the Carnegie Institute's Twelfth Annual Exhibition and, later, on to the Art Institute of Chicago for the Twenty-First Annual Exhibition of Oil Paintings and Sculpture by American Artists. By the time Bellows returned to paint the excavation site again in December, the subject had become closely associated with his identity as a professional artist. And this second painting, too—*Excavation at Night*—was frequently selected as an entry to important annual shows of contemporary art. Clearly, Bellows realized that the excavation had been a particularly potent inspiration. He must also have been aware that each of these two early paintings functioned well, in terms of size, style, and subject matter, as statements of his newly won professional status and identity.

The Pennsylvania Station Excavation

Before focusing specifically on each of the excavation paintings, it is appropriate to consider briefly the historical event that inspired them. The excavation for Penn Station was part of a staggeringly ambitious project destined to have a major impact on regional and even national transport and commerce. Before the first tunnels under the Hudson River, all railroad lines approaching New York City from the west terminated at the New Jersey waterfront. An array of freight- and passenger-handling facilities attempted to negotiate all persons and goods back and forth to ferry terminals on both sides of the river. The increasingly overburdened system was ungainly, time-consuming, dangerous, and ugly. Officials of the Pennsylvania Railroad realized the imperative of "establishing a terminus in the mercantile and monetary center of the country." In 1901 President Alexander Cassatt (brother of artist Mary Cassatt) dispatched a deputy to study the Gare d'Orsay in Paris and soon thereafter initiated plans for construction of a new line and terminal modeled after the Paris station. But the railroad was quick to claim that their American version was "the most colossal and comprehensive project for the improvement of railroad terminal facilities" ever undertaken.[28]

Like the Gare d'Orsay, the location of the Pennsylvania Station in the heart of a congested urban center necessitated a system of underground terminal tracks, which in turn demanded electrification. The project included electrified rail lines from the new Manhattan Transfer Station east of Newark to Sunnyside in Queens, land tunnels under a section of the Palisades and across Manhattan Island, river tunnels under the Hudson River and the East River, and the terminal station between Seventh and Eighth avenues in midtown Manhattan.[29] It was an undertaking auspicious enough to symbolize the best of American ingenuity as well as America's brute physical strength. To an age that, in large measure, defined itself in terms of machine technology, the technical accomplishments inherent in the project evoked promises of an improved and more civilized future, while the physical fact of the work being done inspired pride in American prowess. An editor of *World's Work*, rhapsodizing about modern transportation and communication in the magazine's special issue for January 1907, reflected a mood of confidence typical of the Roosevelt years: "It is a day of marvels, of novel adventures, of triumphs, of the harnessing of new forces such as never came before."[30]

The site of the excavation, along with the terminal building designed by McKim, Mead, and White, became the leading symbol of the entire system planned by the Pennsylvania Railroad. Millions of Americans followed its progress in the press. Beginning in mid-1903 photographs of deserted buildings on the site were juxtaposed with architectural plans for the new station. By 1 July 1904 the entire ground area—bordered on the south and north by Thirty-first and Thirty-third streets and on the east and west by Seventh and Ninth avenues—was cleared, and the New York Contracting Company began the actual excavation (figure 6). Every facet of its work was photographed and reported—the drilling and blasting, the construction of a massive concrete retaining wall around the perimeter, and the removal of debris. It was, indeed, a spectacular demolition and construction project, if only by virtue of its sheer size. The Pennsylvania Railroad Company was, first of all, the second largest rail line in the country. Its new terminal station was to be of such a scale that four hundred houses and stores had been demolished to make way for it. And then the hole—reporters never tired of discovering novel ways of expressing the sense of its vast proportions: "Even the [archaeologists'] unearthing of Herculaneum will be simple child's play beside the Herculean task now being accomplished by an army of Italian earth-diggers and rock-blasters in the American metropolis."[31]

The only thing larger than the Penn Station excavation, it seemed, was the Panama Canal, itself touted as the greatest engineering feat in recent history. For New Yorkers, the comparison was obvious, and they made it often. A drawing featured in the 20 October 1906 issue of *Harper's Weekly* referred to the excavation as the "Culebra Cut" (figure 7), bringing to mind images of the largest and most difficult cut in Panama. This conjunction of the Penn Station excavation and the Panama Canal in late October was no accident. The canal would be a leading news

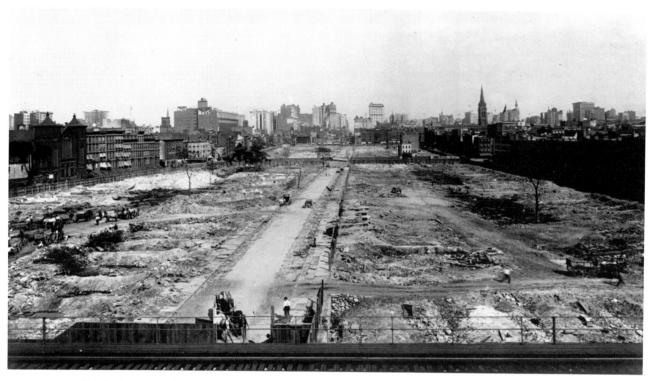

6. Photograph of excavation site from Ninth Avenue, ca. 1905. Courtesy of The New-York Historical Society, New York City.

7. Vernon Howe Bailey, *The Immense "Culebra Cut" in the Heart of New York City,* from *Harper's Weekly,* 20 October 1906.

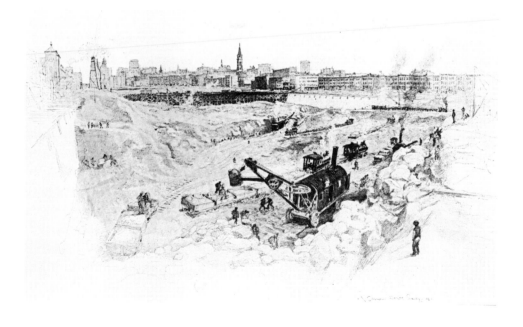

story in November. Teddy Roosevelt became the first president to leave American soil during his term of office, and he did so to visit the Panama Canal. Pictures and feature stories flooded the nation's newspapers and magazines. The famous photograph of Roosevelt posing at the controls of one of the steam shovels was countlessly reproduced (figure 8). The brashness and boldness of what was considered to be the collective American personality was personified in Roosevelt and reflected in the building of the Panama Canal.

The president's trip stimulated a rash of magazine articles about American construction and engineering projects. Most easily accessible to New York writers and publishers were the fourteen tunnels and bridges, newly built or under construction, connecting Manhattan with its surrounding boroughs and the rest of the country. Several of these articles directly or implicitly suggested that projects in and around New York, especially those planned by the railroads, were as impressive as the Panama Canal.[32]

For many of these very topical stories there was a silently acknowledged underside. The very acquisition of the Canal Zone by the United States was controversial, and the project had been plagued with problems almost from the beginning. But Panama was a distant and relatively unknown country, and American actions were easily justified. Closer to home, domestic railroads were more certain to conjure up associations of graft and corruption. By the last quarter of the nineteenth century, railroad companies had come to epitomize not only corporate enterprise but also the ruthless and irresponsible aggregation of business power. Their rapid growth and great economic influence aroused hostility and fear among broad segments of the public. Beginning with the Supreme Court's 1877 decision in *Munn* v. *Illinois*, the government made a series of attempts at regulating railroads and controlling their discriminatory practices. Most recently, in June 1906, Congress had passed the Hepburn Act, giving the Interstate Commerce Commission power to establish new rates. Meanwhile the press was virtually unanimous in hailing the construction in New York City of monumental palaces for the two largest consolidated railroad companies, the New York Central and the Pennsylvania.

Although the unscrupulous practices of Cornelius Vanderbilt and his successors at New York Central were well known, the leaders of the Pennsylvania Railroad Company had maintained a relatively unsullied reputation.[33] That changed in mid-1906, when stories broke about graft in the company. The Interstate Commerce Commission disclosed its inquiry into large gifts of stock and cash paid to company officials by favored shippers, specifically coal companies dependent on the service of the railroad.[34] But in the heady optimism of the Progressive Era, the sense of outrage was quickly drowned by proclamations about how wrongs were being righted. An editorial in the *Independent* expressed confidence in the rapid development of public opinion, which now demanded the abolition of privilege for the rich and powerful. The American people, in the opinion of this writer, had

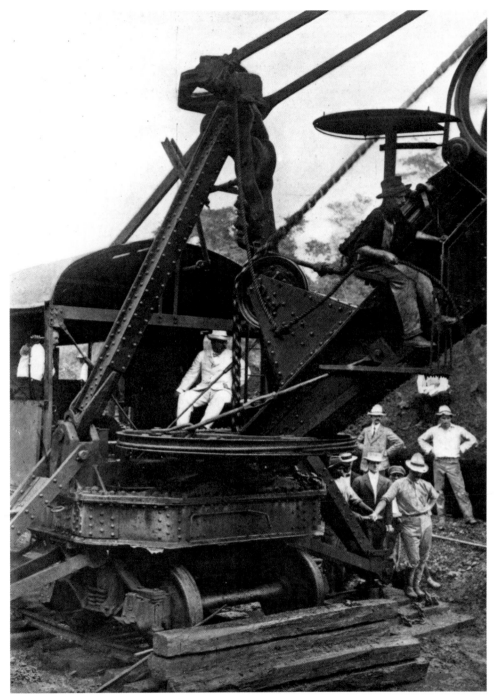

8. Underwood and Underwood, *An Example of President Roosevelt's Method of Getting in Touch with the Work*, from *Harper's Weekly*, 1 December 1906.

"evolved" beyond emotionalism or sentimentality in regard to such issues as railway control and had reached a consensus of opinion informed by "knowledge, discrimination and judgment." An ameliorative process of investigation, exposure, and legislation was being applied to the evils of corporate excess, and a just world was all but at hand.[35] This progressive-minded editor articulated a tacit assumption made by many urban Americans that the consolidation of industry was here to stay and that the practical path was to settle for an unspecified system of controls to guard the public welfare.

By January 1907 a writer for *World's Work* was able to extol the Pennsylvania as "the greatest railroad in the world" and enumerate its munificent contributions to commerce and American society. In passing, the writer did admit that "many smaller matters can be brought up on the other side," alluding to a few of the railroad's corporate sins, but he concluded: "These are but incidents—large, maybe, to the individual, but small in relation to the general public."[36]

By February, stories of scandal at the Pennsylvania Railroad were all but forgotten. Popular magazines were still enjoying the presidential escapades in Panama, and the spurt of national enthusiasm for engineering projects had focused attention on some of the spectacular building sites in and around New York City. The most dramatic from a spectator's point of view was the excavation for Penn Station. Bellows must have walked to see it often from his new studio and living quarters on the top floor of the Lincoln Arcade Building at 1947 Broadway.

Bellows's decision to paint such a prominent and topical subject was a demonstration of self-confidence. His fellow students at the New York School remembered him as being sure of his superior ability, to the point of describing him as "insufferably cocky." Similar remarks have been made by Bellows's college classmates, several of whom recalled his self-assured and overbearing manner years afterward.[37] Such persistent testimonials about Bellows's "absolute belief in himself" invite speculation that he was compensating for deeply seated uncertainties and self-doubt. Whatever the case—and such speculation remains impossible to prove—his display of confidence became a practiced performance. Bellows walked and talked big; he painted on big canvases; and he took on big subjects.

In addition to its prominence and the challenge it presented as a subject for painting, there may have been personal reasons for Bellows's interest in the excavation. First, the New York Contracting Company began operations on the site only weeks before his arrival in the city. So Bellows had the opportunity to observe the project essentially from the start. In fact, the entire six-year undertaking roughly coincided with the first phase of Bellows's new life in his newly adopted city, the period of his "apprenticeship" for becoming an artist. Further, Bellows's father had been an architect and builder in Columbus, Ohio, and Bellows must have accompanied him to construction sites as a boy. His memories of those experiences were part of his fascination with the building of Penn Station.

The vast excavation may have conjured up memories, but it was also strikingly different from anything in Bellows's earlier experience. His father had contracted for local jobs with the leaders of his community. He built the Deaf School in Columbus and the county courthouse as well as a number of substantial private homes. He became a prominent citizen and an influential member of his church in a midsize Midwestern town. He had achieved "success" according to the traditional, American yeoman's dream. But a fifty-five-year age gap between George Bellows, Sr., and his son exacerbated the usual generational differences; and for the young artist, his father's way of life belonged to a remote past.[38]

Painting the Pennsylvania excavation epitomized Bellows's transplantation from Columbus to New York City, from the nineteenth-century world of his father to the twentieth-century world of his painting career. The scale of the Pennsylvania Station project was appropriate to a national metropolis. In contrast to Mr. Bellows's employees in Columbus, the Penn Station excavation was accomplished by armies of anonymous workers who labored to make fortunes for company heads they would never see. The Pennsylvania's new terminal was also up-to-the-minute news. It involved the most advanced technological innovations; it symbolized streamlined, efficient movement of goods and people; and it celebrated economic incorporation on an enormous scale. Whether or not Bellows was aware of the far-reaching ramifications of the entire project, he surely recognized that it was far removed indeed from the local and regional orientation of the work of small-scale entrepreneurs like his father.

There is little concrete evidence to substantiate speculation about personal associations the excavation site may have evoked for Bellows or what, if anything, he wanted to express in his paintings. Yet if he was taking Henri's teachings seriously, he must have been concerned on some level with his emotional response to his subjects. Many of Henri's students have emphasized that a primary theme in Henri's classroom was the importance of painting what you felt about something rather than merely transcribing what you saw.[39] In the published compilation of his lectures about art, *The Art Spirit*, Henri repeated it again and again:

> What you must express in your drawing is not "what model you had," but "what were your sensations," and you select from what is visual of the model the traits that best express you. . . . The great artist has not reproduced nature, but has expressed by his extract the most choice sensation it has made upon him. . . . Art after all is but an extension of language to the expression of sensations too subtle for words.[40]

And feelings and sensations, for Henri, were closely associated with thoughts and ideas:

> Landscape is a medium for ideas. . . . And so the various details in a landscape painting mean nothing to us if they do not express some mood of nature as felt by the artist. . . .

The artist must have the emotional side first, the primal cause of his being an artist, but he must also have an excellent mind, which he must command and use as a tool for the expression of his emotions.[41]

On the few occasions when Bellows's own words have been recorded for posterity, his statements seem to reverberate with the teachings of Robert Henri. In a 1912 interview, for example, Bellows said that works of art were "expressions of powerful ideas." He frequently made the point that paintings should be human documents. By this he meant that art should be an expression of its own time and also that, at its best, a picture should record "the mind and heart of the man who made it." Bellows's most extensive interview was published in the July 1917 issue of *Touchstone,* and on this occasion he again discussed the central importance of a psychic involvement with subject matter: "As a student I was always eager to do the tremendous, vital things that pressed all about me. It seems to me that an artist must be a spectator of life; a reverential, enthusiastic, emotional spectator, and then the great dramas of human nature will surge through his mind."[42]

The Pennsylvania Station excavation afforded Bellows his first opportunity to create a great drama. The massive project represented not just an event, or a scene, or a place. It was truly one of the "tremendous, vital things" of his time, and he knew it. His paintings of the excavation—the very fact that he painted it so often—demonstrate that the subject held special significance and meaning for Bellows the artist and for Bellows the man.

The Excavation: A Vital Thing

For his first painting of the excavation, Bellows chose a fairly popular vantage point, looking east from Ninth Avenue across the site and toward the skyscrapers of New **Plate 1** York's commercial center (see figure 1). Several illustrators for magazines and newspapers had used a similar scheme. Although Bellows certainly relied on his own visual observations, according to the emphatic dictates of Robert Henri, he could not have avoided seeing many other representations of his subject. Images from the media were part of his visual environment. His uncanny memory, which retained even detailed features of places he had seen, likewise recorded images from the popular press.

An illustrated story in the *New York Herald* for Sunday, 29 October 1905, compared the site not only to sections of the Panama Canal but also to the open expanses of the "Western frontier," the ultimate American symbol of vastness. The brief article, however, was merely incidental to a dramatic, half-page drawing of the excavation (figure 9). The artist, L. A. Haplir, attempted to encompass the breadth of the excavation and by doing so reinterpreted its actual, physical configuration. A photograph taken only a few months later, probably from an upper floor of nearby Macy's Department Store, recorded the long, relatively narrow proportions of the

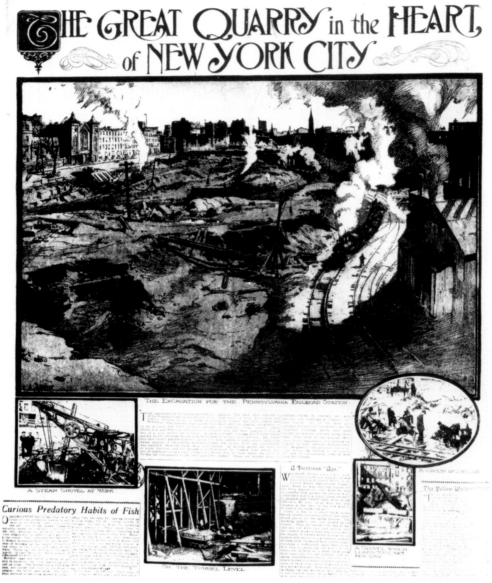

9. L. A. Haplir, *The Great Quarry in the Heart of New York City,* **from** *New York Herald,* **29 October 1905.**

excavation (cover, *Scientific American*, 2 June 1906; figure 10). The *New York Herald* artist had viewed the scene from the opposite end (from the west), but the overall shape of the excavation would, obviously, have appeared much the same. Instead of transcribing the actual contours of the "great quarry," the illustrator has stretched out the foreground and softened the regular, rectilinear shape of the excavation. More picturesque, curvilinear motifs predominate instead. He also emphasized the various craters in the floor of the hole, which had all but disappeared in *Scientific American*'s relatively flat photoreproduction. Human beings, again barely visible in the photograph among the rocks and debris, are introduced in the foreground of the illustration on an exaggerated scale. Puffs of steam rising from the machinery have been transformed into ascending and expanding clouds, conspicuously defined against the intense grays and blacks of the drawing. In sum, the artist's rendering has exploited qualities of the scene that provide its visual drama.

A drawing reproduced on the cover of the 18 August 1906 issue of the *Scientific American Supplement* provides a similar example of an illustrator's portrayal of the site (figure 11). Charles Figaro chose the same vantage point, but the format of the magazine called for a vertical composition. Here the hole takes on an appearance not unlike a river or other body of water in a landscape composition by Turner, William Gilpin, or Claude Lorrain. Yet the basic elements from the *Herald* illustration are repeated—the same train tracks snake along the right side of the picture and the same train is steaming toward the foreground with its load of excavated rock and dirt. The line of buildings and skyscrapers in the distance includes such recognizable landmarks as the Collegiate Baptist Church on Thirty-third Street, on the left, and the steeple of the Church of Saint John the Baptist, in the middle of the upper right quadrant.

These familiar landmarks reappear in the 20 October *Harper's Weekly* illustration, *The Immense "Culebra Cut" in the Heart of New York City* (figure 7). In addition to the two ecclesiastical structures, the artist, Vernon Howe Bailey, has more specifically articulated the trestle that carried the traffic of Eighth Avenue across the excavation. That roadway establishes a kind of horizon line in Bailey's drawing, which is somewhat more sophisticated in conception than that of Charles Figaro.[43] The compositional scheme of Bailey's drawing, in fact, suggests familiarity with etchings by Joseph Pennell or Whistler. The high horizon line, the organization of landscape elements into registers, and the elimination of detail toward the edges could have been derived from any number of etchings by Pennell.[44] The excavation occupies the lower two-thirds of Bailey's composition, and the surrounding buildings spring up in a horizontal band along the level of Eighth Avenue. The foreground of the drawing features a number of anecdotal details—two steam shovels in operation and various clusters of figures at work or observing work.

The combination of observed, anecdotal detail and elements from traditional landscape compositions in each of these three examples is fairly typical of the kind of feature drawings common in the popular press of the period. Although

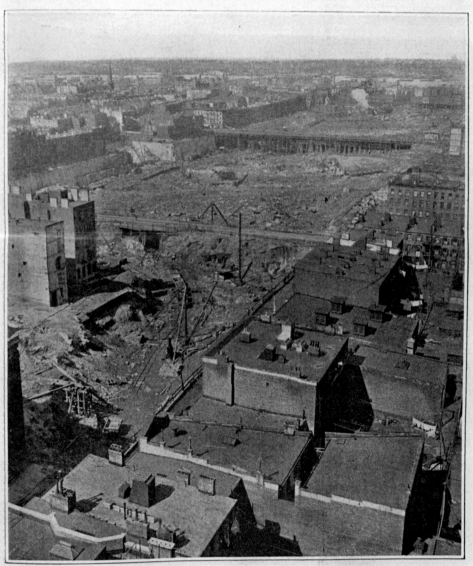

10. Photographer unknown, *Acres of Valuable Land in the Heart of New York City Laid Waste for the New Pennsylvania Railroad Station,* from *Scientific American,* 2 June 1906.

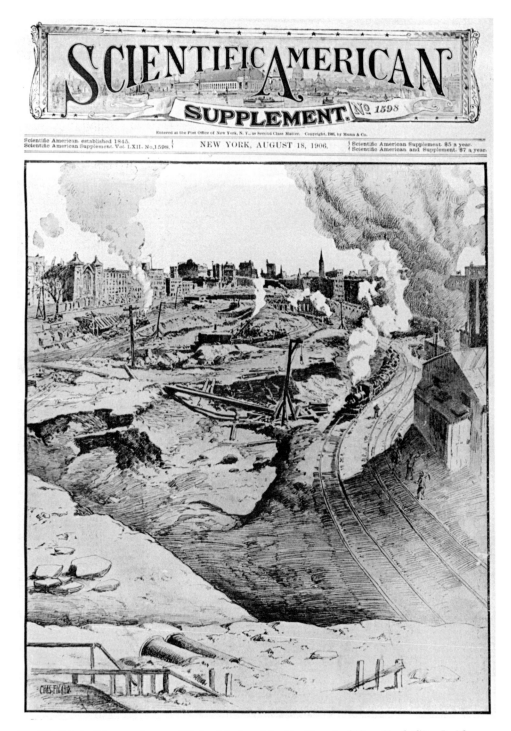

11. Cha[rle]s Figaro, *Acres of Valuable Land in the Heart of New York City Laid Waste for the New Pennsylvania Railroad Station,* from *Scientific American Supplement,* 18 August 1906.

photographs increasingly took the place of reportorial drawings by artist-il-
lustrators, original graphic works continued to appear in many magazines and in
some newspapers, especially in their magazine sections. So, news and feature items
about the Penn Station excavation were illustrated by both photographs and artists'
renderings. The latter were often more visually effective because the mechanical
reproduction process, using the halftone screen, often made photographs dull and
minimized contrasts of light and dark. And although neither photographs nor draw-
ings objectively duplicate fact, the graphic artist has more obvious opportunities to
edit or adjust nature in the process of creating a pictorial composition, either for
purely artistic ends or to suit a particular editorial viewpoint. In all three of the
illustrations cited above, for example, the gritty, visual confusion of the debris-
strewn floor of the excavation has been simplified to some extent and made to
assume a degree of visual harmony. The scale of various elements was altered, the
depth of the hole exaggerated, and the columns of steam embellished.

Published illustrations of the excavation participated in what could be
described as an iconography of technology, which had developed in magazine il-
lustration by the latter half of the nineteenth century. Artist-illustrators tended to
present the machine as a symbol of progress and to interpret industrialization
generally as a vehicle for the advancement of civilization. By manipulating visual
elements and utilizing subtle design strategies, illustrators projected an image of
technology as a powerful but beneficent servant of mankind.[45]

Bellows's *Pennsylvania Excavation* shares several salient charac-
teristics with the work of magazine and newspaper illustrators, most obviously the
combination of specific detail with elements of "fine-art" landscape painting. The
rocky ledges at the southwest corner of the hole, now snow-covered, occupy the
foreground. One worker leans momentarily on his shovel while another bends to
grapple with the object of their efforts: although neither ponders the view, they do
participate in a traditional framing device, initiating movement into the depth of the
composition. Prominent American prototypes for the picturesque landscape for-
mula might have been provided by artists of the Hudson River school, several of
whom had also assimilated the railroad into their compositions. Bellows similarly
integrates the visual realities of industrialized urban America into a traditional
landscape scheme—traditional at least in terms of its essential components. By
harking back to a venerable formula of landscape composition, Bellows conveyed a
resonance of cultural authority for his picture. But, as in the contemporary illustra-
tions, Bellows's repoussoir figures are not pastoral fishermen or aristocratic tourists
or even American pioneers. They are actual workers, striking convincing if ungainly
poses of men familiar with heavy labor. A steam shovel occupies roughly the same
position it did in Bailey's drawing for *Harper's*. The clouds of steam play active,
pictorial roles, as in Figaro's drawing. It is the specificity of the painting's subject,
however, that most tellingly connotes its relation to journalistic illustration. The
major part of the canvas is devoted to the area of the excavation between Eighth and

Ninth avenues. The deepest section of digging cuts through the center, where the underground tracks will eventually run under the post office building. The station itself will be constructed on the far side of Eighth Avenue. The ledges of rock still uncut along the north side of the hole indicate the progress of work at the site during the winter of 1907. Although no specific architectural landmarks are visible in Bellows's painting, the vantage point and the eastward view are easily identifiable. The loosely painted buildings in the distance, generic skyscrapers, clearly represent the commercial center of the city—an appropriate backdrop for Bellows's celebration of urban growth.

The critics' initial response to the excavation painting was to call it "real" and "keenly observed." They recognized not only the familiar scene but also a quality of veracity, of reportorial realism, usually associated with the mass media. Given the involvement of Henri circle members with newspaper and magazine illustration and Henri's emphasis on finding subjects from everyday life, a relationship between illustration and Bellows's art is hardly surprising. His subjects are distinguished from those of John Sloan or William Glackens, however, by their topicality. When Sloan and Glackens began to translate the themes and even the style of their illustration work to paintings, their scenes of city life tended toward the incidental, even the anecdotal at times—vignettes of spielers dancing, picnickers in Central Park, or patrons and prostitutes approaching the Haymarket. The excavation was not merely a subject drawn from "modern life," a concept to which many artists responded since Baudelaire's plea for contemporaneity in art in 1863.[46] The Pennsylvania Station project was a time-specific event and a news story.

But although *Pennsylvania Excavation* was related to the mass media in style and content, it was at the same time emphatically a painting. Bellows clearly reveled in applying the loaded brush to the canvas, with the intention of making a bravura display. The painting process was a key issue in Henri's classroom. He advocated a rapid technique and immediate response to sensation. His students emulated the animated brushstroke of Hals, Velazquez, and Manet. The dark, almost monochrome palette of *Pennsylvania Excavation* also reflects the somber tonalities of Henri's own painting during this period, as well as Bellows's and Henri's mutual esteem for selected Dutch and Spanish artists.[47]

Bellows usually began his paintings of this early period by blocking out the composition quickly with a thin sepia wash.[48] The surface of *Pennsylvania Excavation* indicates that he then developed large areas in deep, rich blacks and browns. The lighter grays and whites of the snow and clouds of steam were laid in thickly, over still-wet darker pigment underneath. A raw, scumbled surface was thus built up of thick, heavy strokes of paint, the brush often dragging darker pigment up, "dirtying" the lighter grays and whites. Finally fluid touches were added with a smaller, more delicate brush. Two thin, skipping lines of brown-black in the lower right quadrant describe the train tracks. With a broader and more loaded brush Bellows recorded some last signature strokes, reminding the viewer once again of

his own presence. A thick, fresh, diagonal streak of blue-black just to the left of the two workers in the foreground is laid in with the same pigment similarly applied in the center of the upper left quadrant, marking out the level of the Eighth Avenue trestle. Thus a point in the deep background is brought up to the surface, denying, at least momentarily, the recession into depth and reinforcing the materiality of manipulated paint.

Bellows's gritty *Pennsylvania Excavation* introduced a new aspect of the city to the National Academy at its 1907 Winter Exhibition. This painting was quite unlike the delicately shimmering canvases of Childe Hassam, for example (figure 12). His impressionist-inspired broken brushstroke provided ingratiating atmospheric effects for scenes of New York parks and streets at various times of the day and of the year. More typical, too, were Birge Harrison's heavily romanticized views, with mood-evoking veils of wet mist or snow (figure 13). The prominent characteristics of cityscapes by Hassam and Harrison were shared by countless images of New York during the first decade of the century. The impressionists and the tonalists were not by any means the only artists who habitually softened outlines, eliminated disagreeable details, and enforced picturesque qualities of city scenes. The pictorial photographers of this period created similar scenographic and tonal effects by a variety of means.[49] The pervasiveness of the aesthetic is also obvious on the pages of popular magazines, where illustrations exploited seasonal conditions of weather and atmosphere to bathe the city in a harmonizing wash (figure 14).

Underlying the stylistic similarities noted in these various images of New York City was a predominating aesthetic of visual ordering. Not only did soft-focus effects blur indecorous sharp edges or unharmonious details but, at the same time, city scenes tended to feature lone or coherently massed buildings. Trees, figures, and street traffic were carefully arranged across the ground plane.[50]

Such images of orderliness might have appeared to fly in the face of observations by Americans and foreign visitors who had increasingly perceived a sense of formlessness in New York. The city seemed illegible, incomprehensible. Speaking through his own veil—of symbolism and metaphor—Henry Adams described his impressions on landing there in the year 1904:

> The outline of the city became frantic in its effort to explain something that defied meaning. Power seemed to have outgrown its servitude and to have asserted its freedom. The cylinder had exploded, and thrown great masses of stone and steam against the sky. The city had the air and movement of hysteria, and the citizens were crying, in every accent of anger and alarm, that the new forces must at any cost be brought under control. . . . A traveller in the highways of history looked out of the club window on the turmoil of Fifth Avenue, and felt himself in Rome, under Diocletian, witnessing the anarchy, conscious

12. Childe Hassam, *Late Afternoon, New York: Winter,* 1900. The Brooklyn Museum, New York, Dick S. Ramsay Fund, 62.68.

13. Birge Harrison, *Fifth Avenue at Twilight*. The Detroit Institute of Arts. City of
Detroit Purchase.

14. John Edwin Jackson, *The Matterhorn of Manhattan*, from *Harper's Weekly*,
13 February 1909.

of the compulsion, eager for the solution, but unable to conceive whence the next impulse was to come or how it was to act.[51]

Speaking from a less cosmic perspective and more straightforwardly, Englishman George W. Steevens delivered a mixed review. To him, New York was at once both "hideous" and "splendid": "Uncouth, formless, piebald, chaotic, it yet stamps itself upon you as the most magnificent embodiment of titanic energy and force."[52] Everyone seemed to agree that the city was big and powerful but also overwhelming and beyond one's control. Even the boosterism of native New Yorker John C. Van Dyke allowed for a sense of disunity in the city's streets: "Jostling details, harsh realities, are flung at you too violently to be merged into an *ensemble*."[53]

In *Pennsylvania Excavation* Bellows came a good deal closer than the impressionists or the tonalists did to conveying a sense of the qualities that these and other writers had perceived and noted about New York. Here was a painted scene that was indeed "uncouth" and "chaotic" while also embodying the city's "titanic energy and force." Bellows's painting is certainly not devoid of pictorial unity. The composition possesses an underlying structure, and the vigorous painterly brushwork reinforces the integrity of the work as a cohesive expression that functions not only in its various sections but also as a whole. Despite its compositional unity, however, *Pennsylvania Excavation* did not present New York City with the veneer of harmony and gentility often associated with artists' views. Bellows endeavored to paint the excavation as he saw it in the bald, cold light of a February day. As a faithful student of Henri, he refused to allow his vision to be chastened by idealizing conventions. In his quest for direct, immediate experience, he came closer to emulating the style of journalistic illustration in his portrayal of a scene that was also a news event. By doing so, he created a visual image of New York that its inhabitants recognized as the truth.

Writers had clamored for artists to portray the real New York. In a 1903 article for *Scribner's*, John Corbin admitted that American city life seemed "grotesque" and "formless," but for that reason he thought that the subject would challenge "an artist bent on divining new forms of beauty." While pleading for new forms, he remained tied to an older aesthetic, never envisioning the audacious forthrightness of Bellows. Corbin wanted an artist to "body forth" the pleasing aspects of the city as Alfred Stieglitz had done in the photographs selected to illustrate his article.[54] Sadakichi Hartmann was more explicit when he called for "new laws of beauty" more appropriate to modern American cities. And he stressed the overriding importance of conveying the character of the age: "To give to art the complexion of our time, boldly to express the actual, is the thing infinitely desirable." Addressing himself specifically to photographers, he posed several suggestions for subject matter: "Wherever some large building is being constructed, the photographer should appear. It would be so easy to procure an interesting picture, and yet I have never had the pleasure to see a good picture of an excavation or an iron skeleton framework."[55]

Bellows may not have intended his *Pennsylvania Excavation* to be seen as responding to so specific a challenge. His mandate had been Henri's more general one: to paint everyday life as he saw it and as he felt about it. The achievement of Bellows's greatest early painting rested in his instinctual ability to respond to that mandate. As a newcomer and resident outsider in New York, he was sensitive to the city's distinguishing characteristics. Furthermore, in his first excavation picture he succeeded in conveying his emotional response to an aspect of the city that had gripped him. *Pennsylvania Excavation* presents more than the skin of the city. Rather, it captures qualities perceived not only visually but also viscerally, qualities that had been noted by natives but emphasized especially by visitors. A traveler from Ireland wrote, "My first impression, then, of New York is of immensity. . . . It is all on a scale gigantic, daring, almost appalling."[56] Like this writer who felt "almost" appalled, Bellows, in *Pennsylvania Excavation*, also communicated a felt response—one that resonated with a sense of fresh visual apprehension, as if he had come upon the scene for the first time. He recorded not a static image of civilized urban life but a dynamic vision of thrilling power and energy played out on a vast scale.

Returning to the Scene

Pennsylvania Excavation arrived back in New York shortly after the Chicago Art Institute's Annual Exhibition closed on 29 November 1908. Perhaps seeing the picture in his studio again after so many months inspired Bellows to paint the subject a second time. In any case, he did so in December; but the picture he produced then,
Plate 2 *Excavation at Night* (figure 15), was a striking departure from his earlier work. By the time Bellows began his second painting of the excavation, he had almost certainly seen another depiction of the subject. Ernest Lawson's *Excavation—Penn Station* (figure 16) had been in the collection of James B. Moore, owner of the Café Francis. The café was a popular meeting place for Robert Henri and his friends and colleagues before Moore was forced to close it in April 1908 to settle his debts. Sloan's friend Frank Crane bought Lawson's painting from the auction of Moore's collection.[57] Bellows was not yet a member of the inner circle in 1908, but he had probably attended the Café Francis gatherings at least from time to time, listening in from the fringes. And Bellows certainly knew of Moore's collection and of its sale.

It was probably also at Moore's that Columbia University English professor Bayard Boyesen saw Lawson's painting. The Henri circle, too, surely took note of Boyesen's article next month in *Putnam's*, "The National Note in American Art." Winslow Homer was singled out for praise, and then Ernest Lawson, beginning with his excavation picture. Boyesen's somewhat idiosyncratic analysis of Lawson's Americanism centered on his "passionate impartiality," his "ability to see and to render pictorially the idea in the shabby details of American life."[58] Art cognoscenti might have disagreed with the way Millet, Meunier, and Raffaëlli suffered in Boyesen's comparison of them with Lawson, but the article contributed to the ever-widening recognition for artists who depicted American life, including

Henri, Myers, and Sloan. And it was not lost on Bellows that a painting of the excavation again received praise for demonstrating how "beauty lives most vigorously in those manifestations of human energy which are stripped of the accident of the picturesque." As one of the artists who participated in the February exhibition of the Eight at Macbeth's and as someone who enjoyed at least limited success with the National Academy jury, he may well have figured as a painter whom Bellows admired.

In *Excavation—Penn Station* Lawson's intense colors, reminiscent of "crushed jewels," were somewhat subdued, but his impressionist- and postimpressionist-inspired texture and light ideas are still visible.[59] Even in this fairly sober picture, the color harmonies include delicate light blues, salmon, and ochre. Lawson's New York City scenes often incorporated inelegant aspects of the landscape, yet he emphasized the beauty he perceived. Bellows's dark, brutal *Pennsylvania Excavation* demonstrated little affinity with Lawson's lighter, more lyrical work. For his second painting of the subject, however, Bellows chose a vantage point closer to the center of activity. By shunning the intervening framing device used in his first excavation painting, the composition of *Excavation at Night* moves more quickly to the floor of the hole, not unlike Lawson's *Excavation—Penn Station.* The overall configuration of the picture is also closer to Lawson's. Movement into the depth of the composition in *Excavation at Night* takes place along a succession of planes roughly parallel to the picture plane. Additionally, the scope of *Excavation at Night* takes in only a fraction of the entire area of the site. Like Lawson, Bellows has focused on a selected section of the landscape; thus, the sense of vast space that characterized his earlier *Pennsylvania Excavation* has been somewhat mitigated.

At the same time, although Bellows certainly saw Lawson's excavation and may have been impressed by it, *Excavation at Night* is more different from than it is similar to the earlier work. As a student of John Twachtman's, Lawson was devoted to the study of nature under different lights. His depiction of the excavation reflects his interest in the place, especially in terms of its visual aspect—the raw earth colors of the rocky dirt freshly exposed, the play of shapes in the urban skyline beyond, and the entire view irradiated by sunlight. Bellows's moodier, nighttime painting reflects Henri's concern for expressive rather than naturalistic effects. In contrast to Lawson's deliberately nurtured surface of textured impasto, Bellows used a wetter pigment, more vigorously applied to convey a personal and emotional response to his subject, a response communicated by the very act of painting. As Henri explained, "the brush stroke at the moment of contact carries inevitably the exact state of being of the artist at that exact moment into the work."[60]

To gain the perspective recorded in *Excavation at Night,* Bellows walked along the northeastern edge of the site, that is along Thirty-third Street near the intersection of Ninth Avenue (figure 17). From there he looked across the excavation toward a row of four-story brick tenement buildings. At the right of his picture Bellows included a specifically identifiable landmark—a five-story school

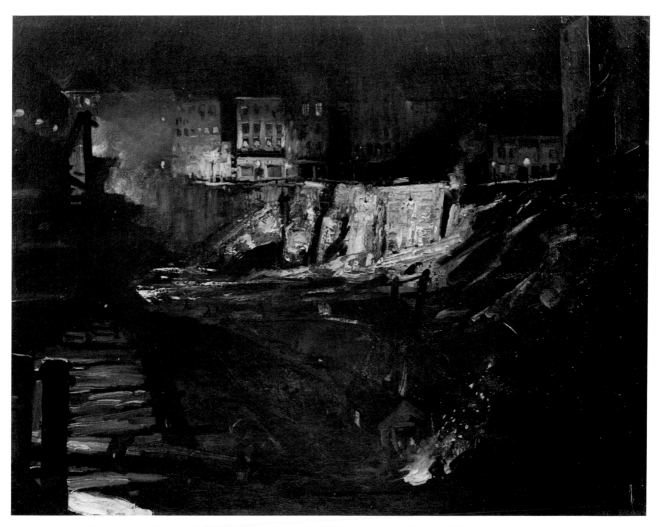

15. George Bellows, *Excavation at Night,* 1908. Courtesy Berry-Hill Galleries, New York.

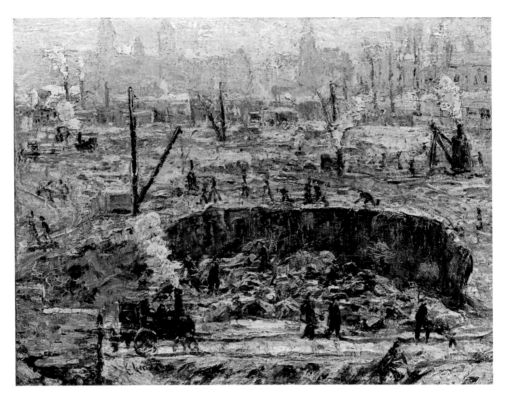

16. Ernest Lawson, *Excavation—Penn Station,* ca. 1906. University Art Museum, University of Minnesota, Minneapolis. Bequest of Hudson Walker from the Ione and Hudson Walker Collection, 78.21.845.

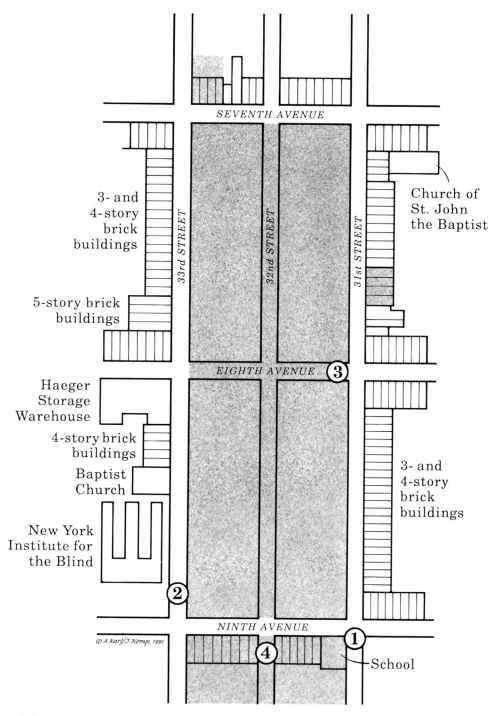

17. Diagram of sites from which the excavation is represented in Bellows's paintings: (1) *Pennsylvania Excavation,* (2) *Excavation at Night,* (3) *Pennsylvania Station Excavation,* (4) *Blue Morning. Shading indicates areas of demolition and excavation. The construction site for the Pennsylvania Station is between Seventh and Eighth avenues, for the Post Office between Eighth and Ninth avenues.*

building that presented two windowless brick faces on its Ninth Avenue facade. The name of a dry goods company, HEARN, was painted in bold letters on both faces. A photograph taken at the time of the painting but from the opposite end of the excavation demonstrates how conspicuous these huge vertical signs were, even from a considerable distance (figure 18). Other features of that section of the excavation, the eastern end of the future site for the post office building, were also picked up by Bellows. One of the huge pipelines running across the floor of the excavation, for example, is prominent in the lower foreground of his painting.

In spite of the site-specific nature of the painting and the accuracy of many observed details, however, *Excavation at Night* was not actually painted at the scene. And if the testimony of Bellows's contemporaries can be trusted, he did not rely on sketches. [61] Rather, he worked from memory. Bellows's paintings from this period record an interaction between perception and recollection, between fresh visual apprehension and the translation of that visual experience through memory.

Henri emphasized the development of visual memory. In his life classes he posed the model for as long as thirty minutes, during which the students were instructed to look but not sketch. Then in the model's absence they created a drawing based on their recollections.[62] By these techniques Henri encouraged his students to bring their experiences of a subject into their drawings, their sensations into their art:

> The most vital things in the look of a face or of a landscape endure for only a moment. Work should be done from memory. The memory is of that vital movement. During that moment there is a correlation of the factors of that look. This correlation does not continue. New arrangements, greater or less, replace them as mood changes. The special order has to be retained in memory—that special look, and that order which was its expression. Memory must hold it. All work done from the subject thereafter must be no more than data-gathering.[63]

Bellows apparently took these lessons to heart. Charles Grant, Bellows's childhood friend, visited him in New York during this period and expressed surprise at the fact that he never painted landscapes on the scene: "He would go out and look at what he wanted to paint and then return to the studio and start work. I questioned the practicability and accuracy of this method and he told me that his theory was that things happened only for an instant and that if you did not get the scene at that instant you would never recapture it."[64] Bellows had undoubtedly assembled innumerable visual impressions of the excavation from his wanderings around the site, but one particular nighttime experience provided the impetus for *Excavation at Night.* Yet the painting is surely a composite of remembered images. It also combines elements of immediacy and distancing. Bellows projected into his painting a convincing sense of his personal and immediate response to the subject,

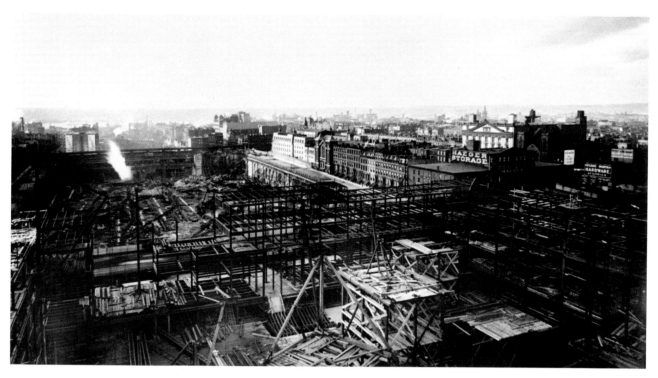

18. L. H. Dreyer, *N[ew] Y[ork] Terminal of P[ennsylvania] T[unnel] & T[erminal] R[ailroad Co.] from Main Scaffold Looking West,* 12 December 1908. McKim, Mead, and White Papers, Avery Architectural and Fine Arts Library, Columbia University in the City of New York.

but still the excavation is seen through the veil of time, memory, and artistic temperament.[65] The effect of these distancing structures enhanced the inherent romanticism of the nighttime setting.

In his response to Grant, Bellows not only mimics Henri concerning technique but also, in the phrase "things happened only for an instant," suggests that he looks for events in nature rather than a static scene. Henri had discussed with his students the variety of impressions that an open, active mind might derive from such phenomena as a tree moving in the wind or simply growing.[66] Following such admonitions Bellows was attuned to searching out features of nature or a moment in time, to which he responded on an emotional level. These moments were etched in his memory. Later, in his studio, those remembered sensations were translated into paintings.

Grant goes on to describe Bellows's method of working "with terrific speed." During one of Grant's visits, Bellows finished a painting in six hours. Working quickly was another part of Henri's formula for cultivating self-expression:

> Work with great speed. Have your energies alert, up and active. Finish as quickly as you can. There is no virtue in delaying. Get the greatest possibility of expression in the larger masses first. Then

the features in their greatest simplicity in concordance with and dependent on the mass. Do it all in one sitting if you can. In one minute if you can. There is no virtue in delaying.[67]

Excavation at Night was largely the result of such an intensive session of rapid and vigorous painting. Although close examination of his canvases indicates that Bellows often returned to them more than once to make additions and changes, a composition was essentially completed on the first effort. One of his roommates in the Lincoln Arcade studio reported that Bellows's working method involved studying the canvas from a distance of about ten feet and then rushing forward with a loaded brush. While in the midst of this totally consuming activity, he was too impatient to reach for a rag and often wiped off brushes under the arm of his smock.[68]

The lashing surface of *Excavation at Night*, like his earlier portrayal of the scene, records Bellows's physical and emotional involvement with the process of painting. At the same time, of course, he was concerned with formal elements of composition. In fact, when Bellows was asked specifically about *Excavation at Night*, in an interview for the Ohio State University *Lantern*, his first remark was addressed to its composition—how he had focused the center of interest by strong light. But his next comment revealed something more: "Those tenement houses behind the excavation always give me the creeps. They're just ordinary houses—but there is something about them that gets me."[69]

The buildings in the vicinity of the proposed station were indeed dilapidated. The area had long been bypassed by developments in more desirable areas of the city. The excavation site was located on the western edge of the disreputable Tenderloin district. A feature writer for the *New York Herald* rejoiced at the expected passing of the "famous landmark of vice and blackmail": "Killed by a railroad," he suggested as an appropriate epitaph. The writer went on to describe the general exodus from the area—"the rats began to scatter," in his words—when purchases of property by the railroad were announced.[70] In fact, land values began to escalate rapidly soon after plans for the new station were revealed, and many buildings adjoining the four square blocks designated for demolition were, by 1908, waiting their turn.

Bellows, like many New Yorkers, felt little nostalgia for the relics of old New York. He enlisted the line of partially lighted tenement facades across from the excavation on Thirty-first Street to become protagonists in an enigmatic drama, creating in *Excavation at Night* his most highly romantic portrayal of the subject. Like a row of speechless sentinels with blinking lights for eyes, the tenements seem to glare day and night at the heavy excavation work. The workmen's fires cast eerie splashes of light against the rock and snow. Human figures are dwarfed by the overwhelming scale of it all. Ghostly silhouettes struggle beneath powerful pieces of digging equipment, while at street level neighborhood residents and passersby, tiny abbreviated forms, scuttle along the sidewalk.

Again, it was Henri who admonished his students: "The various details in a landscape painting mean nothing to us if they do not express some mood of nature as felt by the artist. It isn't sufficient that the spacing and arrangement of the composition be correct in formula. The true artist, in viewing the landscape, renders it upon his canvas as a living thing."[71] Certainly, the critic for the *Nation*, in December 1909, perceived *Excavation at Night* as a living thing when he described its "extraordinary force," its "element of repose," and its "demonic energy."[72]

Bellows's biographer, Charles Morgan, asserts that the artist produced two paintings of the excavation in March 1909. Surviving evidence, however, confirms the date of only one of the paintings to which Morgan refers, *Blue Morning* (figure 19), which presents the gleaming white station building in construction, rising up out of the great hole.[73] As in the previous depictions of the excavation, the painting itself indicates Bellows's exact vantage point: the Eighth Avenue facade of the new terminal is seen from Ninth Avenue, across the future site of the post office. Parts of the superstructure for the Ninth Avenue elevated train track—one supporting I beam and the overhead girder trellis—dominate the foreground. A photograph, taken in March, records the appearance of the west side of the terminal when Bellows was painting *Blue Morning* (figure 20). The structural membranes of the central section, the main waiting room, whose groin vaults would soar above the level of the nearer concourse section, were still unsheathed. The granite facing was also not yet in place above the first floor on the northern half of this facade of the building. In his painting, Bellows sketched in the northern, right-hand section of the facade, without indicating window placement or other articulations; in other words, he avoided "constructing" something that did not yet exist.

The remaining excavation picture is the only one of the series Bellows never entered in his record book.[74] That book, however, was begun in 1910, with earlier work listed in retrospect; and Bellows himself made clear that the record was incomplete: "This catalogue includes only works preserved for interest or merit. I think it includes everything of any value."[75] The painting now known as

Plate 3 *Pennsylvania Station Excavation* was given to his friend, Ed Keefe, and never publicly exhibited during Bellows's lifetime (figure 21).

That Bellows thus consigned the work to private status does not necessarily indicate that he considered it a failure. Keefe had been a fellow Henri student and a studio mate in the Lincoln Arcade for four years. Bellows may have regarded the gift, probably made on the occasion of Keefe's departure in June 1909, as a meaningful token of a valued friendship. On the other hand, his self-conscious concern for nurturing his career would probably have militated against any temptation to make a gift of what he considered to be one of his best paintings.

A photograph of the excavation site taken in February 1909 suggests that Bellows began *Pennsylvania Station Excavation* considerably earlier than

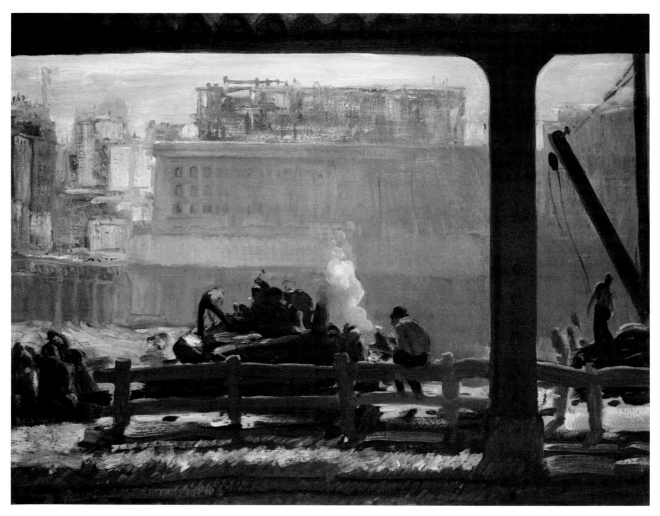

19. George Bellows, *Blue Morning,* 1909. National Gallery, Washington, D. C. Chester Dale Collection.

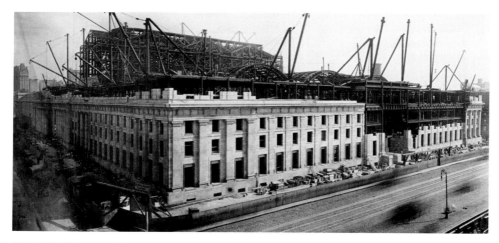

20. L. H. Dreyer, *N[ew] Y[ork] Terminal of P[ennsylvania] T[unnel] & T[erminal] R[ailroad Co.] from Main Scaffold Looking West,* 22 March 1909. McKim, Mead, and White Papers, Avery Architectural and Fine Arts Library, Columbia University in the City of New York.

March of that year (figure 22). The photograph makes clear that although construction had not yet begun on the post office side of the excavation, the retaining wall around the perimeter was being put in place. Bare rocky ledges, however, are still visible in the right foreground of *Pennsylvania Station Excavation.* As Bellows's paintings of the excavation site reflect his interest in its visual details, it seems unlikely that he might have inserted such an anachronism purely for pictorial effect.

The February photograph also shows that a large area across from the excavation along Ninth Avenue had been leveled. Much of the demolition between Ninth and Tenth avenues occurred after early 1907, perhaps after Bellows began *Pennsylvania Station Excavation.* The painting almost certainly depicts the future site of the post office, probably viewed from somewhere on the Eighth Avenue trestle. If Bellows did return to the work sometime before he presented it to his departing roommate, the effects of demolition visible on the far side of Ninth Avenue may have inspired him to slightly alter his composition. On the right half of the picture, just above the horizon line one band of slate blue and one of muddy rose correspond to no similar color bands to the left of the large building that dominates the upper portion of the composition. In fact, at the left and along the top of the canvas the cloud-streaked sky is brilliantly blue and luminous. This apparent discrepancy may either be due to some reworking in this area or to an actual visual phenomenon—a particularly dramatic late-afternoon sky in which murky bands of color were hovering along the southwestern horizon.

Whatever the case, the final version of *Pennsylvania Station Excavation* features a large, imposing building (or perhaps a massing of buildings) in the upper left quadrant, conspicuous for its irregular shape and distinct isolation. But in spite of extensive demolition in the area that Bellows favored in his search for favorable vantage points, nothing around the excavation ever looked quite like this

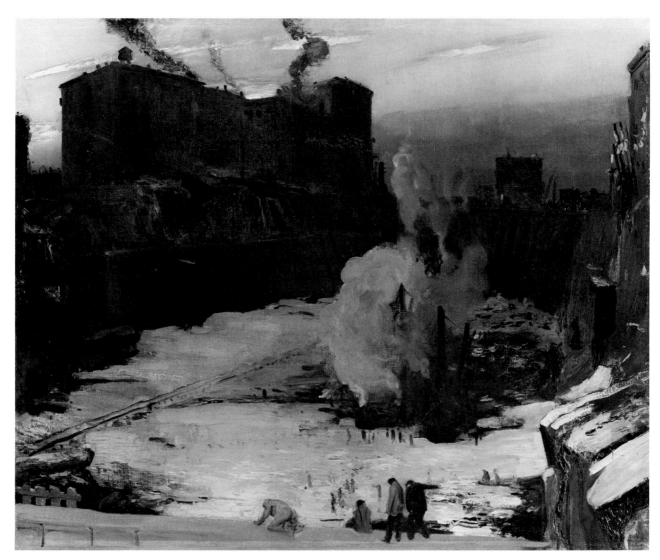

21. George Bellows, *Pennsylvania Station Excavation,* ca. 1907–9. The Brooklyn
Museum, New York. A. Augustus Healy Fund, 67.205.

22. L. H. Dreyer, *N[ew] Y[ork] Terminal of P[ennsylvania] T[unnel] & T[erminal] R[ailroad Co.] from Main Scaffold Looking West,* 17 February 1909. McKim, Mead, and White Papers, Avery Architectural and Fine Arts Library, Columbia University in the City of New York.

lone structure. The painting, then, is unique in the excavation series. Instead of recording his impressions of a specific scene from an identifiable perspective, Bellows has brought together in this work a composite of views, perhaps gathered from disparate time periods. In so doing, he has created a highly evocative image of a looming building, which assumes an almost organic quality as it appears to crouch near the rim of the great hole.[76]

 Pennsylvania Station Excavation is also distinguished from the other paintings in the series by its dimensions. *Pennsylvania Excavation* and *Excavation at Night* both measure 34 by 44 inches. *Pennsylvania Station Excavation* is now 31⅛ by 38½ inches, having been expanded slightly at the top and bottom by a previous stretching.[77] Certainly it never matched the other two excavation paintings. Significantly, when Bellows returned to this subject for the last time, in March 1909, he chose to begin work on a canvas stretched to 34 by 44 inches. Clearly

Plate 4 he considered this painting, *Blue Morning,* to be specifically related to his earlier, highly acclaimed excavation pictures. There are no other paintings corresponding to those measurements listed in his record book before 1910.[78]

 Bellows's final tribute to the spectacular Penn Station project conveys a more emphatically celebratory tone, in comparison with his earlier statements on the theme, by means of a brighter palette and a more delicate though still sensuous paint surface. The composition of *Blue Morning* is also more distinctly modern in its references to impressionism, and especially to Manet.

Henri had long since abandoned his light-filled impressionist-inspired painting style of the early 1890s, but he retained a strong interest in the notion of painting modern life in terms of a fresh, unhackneyed vision.[79] In his classroom, Manet figured as a prime exemplar of taking inspiration from one's own time. Manet and the impressionists had in many respects been looking at a new Paris, its physiognomy transformed by Baron Haussmann. They focused especially on the modern city, with its new boulevards, parks, and railroad stations.[80] Henri covered the walls of his classroom with reproductions of works by artists he admired, and he shared his notebooks of mounted photographs with his students. The focus on the new terminal in Bellows's last painting of the excavation may have prompted him to look again at the French modernists, who approached similar subjects with a similar vision.

The Gare Saint-Lazare in particular had attracted a series of artists in the latter nineteenth century. Both Monet and Manet had painted this most modern of urban subjects, combining faithfulness to naturalism with an allegiance to their own inner experience.[81] Bellows surely had access to reproductions of Manet's *Gare Saint-Lazare* (1872–73; figure 23), then in the Havemeyer collection. Although he would probably not have seen the picture personally, its presence in New York City may have drawn the attention of Henri's associates. Gustave Caillebotte followed the example of Monet and Manet. He painted the Gare Saint-Lazare from the nearby Pont de l'Europe, itself an engineering marvel. And Henri could have seen the largest version of that subject, *Le Pont de l'Europe* (1876; Musée du Petit-Palais, Geneva), in the June 1894 retrospective exhibition of Caillebotte's work.[82] That painting and a later, even more remarkable version (figure 24), suggest themselves as prototypes for Bellows's incorporation of the elevated into the foreground of *Blue Morning*. In Caillebotte's 1876–77 *Le Pont de l'Europe*, the strong geometry of the crossing girders and guardrail of the bridge establishes a structural grid parallel to the picture plane. Bellows makes more tentative use of a similar scheme in his painting. But Caillebotte was little known outside the impressionists' circle. His work remained largely in the hands of private collectors well into the twentieth century and was rarely reproduced. A direct influence from Caillebotte thus appears improbable, although Henri may have remembered and described his work. On the other hand, *Blue Morning*—in its relatively high-key palette and its minimizing of deep space in favor of surface design—almost certainly reflects Bellows's general admiration for the Parisian modernists and for their view of modern Paris.

Like Paris thirty-five years earlier, New York City was undergoing immense changes. Massive immigration was swelling its population; new construction, ever taller and bigger, was transforming its skyline; and burgeoning commercial activity was solidifying its position as the nation's financial center. New York epitomized the expansive vision, the domineering will, and the modernity of the country as a whole. The Pennsylvania Railroad terminal building promised to be a monumental gateway, a fitting entrance to the city that Americans were coming to see as

23. Edouard Manet, *Gare Saint-Lazare,* 1873. National Gallery of Art, Washington, D. C. Gift of Horace Havemeyer in memory of his mother, Louisine W. Havemeyer.

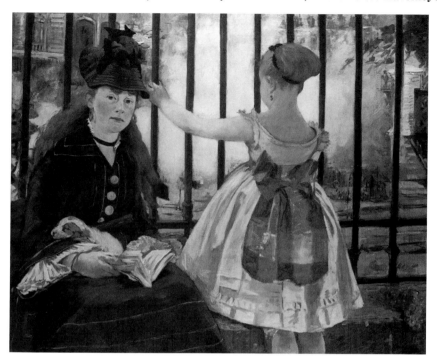

24. Gustave Caillebotte, *Le Pont de l'Europe,* 1876–77. Kimbell Art Museum, Fort Worth, Tex.

one of the world's great metropolitan centers. Like Monet, Manet, and Caillebotte, Bellows recognized the significance of the modern railway station as a symbol of the dynamic and progressive aspects of the city. But he may also have been consciously attempting to express a dynamism and progressivism that was distinctively American. Henri had just published his now-famous plea for a national art with "deep roots" in the "soil of the nation."[83] The New York that Bellows celebrates in *Blue Morning* is a center of ceaseless motion and change, of constant building and growth. *Blue Morning* functions well as the culminating statement for a series of paintings devoted to expressing the qualities of New York as he perceived them: this final painting is at once cooler and more rigorously composed, while its vision of the thriving present is more radiant than in any of the artist's previous work.

Blue Morning can be seen as a painting of Penn Station framed by an architectural structure closely allied to the surface plane. This foreground is firmly and concretely delineated in dark tonalities—a range of brown pigments enriched by strokes of vivid cobalt blue, aqua, and green. A dark, almost-black green describes the metallic parts of the elevated track and supporting beam. The emphatic geometry of its framework echoes the visual themes of construction—weight and mass, resistance and structural support. The strong grid of horizontals and verticals in the immediate foreground also announces the prominence of measure, control, and proportion throughout the composition.

Foreground elements additionally divide the painting into three sections. The central group of laboring figures is articulated by brilliant passages of brushwork. The seated figure perched on the fence rail inclines toward this central group and participates with it compositionally. The central section and the right-hand section are partitioned by the I beam; but less obviously, an irregularity in the fence also separates the right from the center: in its far right span the bottom rail is missing. Within the right section, a crane and a standing figure occupy much of the vertical expanse and block off recession into the distance. The absence of the fence marks the corresponding section on the left side of the painting, occupied by another group of workers in the lower register.

All the physical activity in the painting is confined to this foreground plane. A puff of steam announces the separation of this realm of the concrete and palpable from the relatively visionary realm beyond. Steam is one kind of matter being transformed into another, more ephemeral material. Likewise, the painted scene dissolves into vapor at this point. The distant, visionary realm is defined in colors of lighter values, all harmonized by a pervading blue tonality.

The two realms are distinguished, then, spatially and materially. Yet they are interwoven in terms of Bellows's compositional scheme. For example, the horizontal shape defined by the fence in the foreground extends across the central and right-hand sections of the painting. A similar and corresponding shape—but extending across the center and left sections—has been delineated in the register just above by the dark area of the terminal building, below ground level, together

with the retaining wall scaffolding to the left. The retaining wall on the opposite side of the excavation is not visible; rather, a thin wash of light lavender pigment prevents reading the background beyond the standing figure at the right. Again, movement into depth in this area is resisted by the surface articulation.

The painting is thus delicately balanced, with the closure of the right section compensated by a greater openness to the left. And virtually all aspects of the scheme combine to set off and frame its central element. The placement of the gleaming white palace at the focal point of this composition is not only carefully orchestrated but also highly contrived. In fact, it was physically impossible to gain the view of the terminal building which Bellows used as the basis of his hieratic composition in *Blue Morning*. As a photograph taken in February 1909 indicates (see figure 22), both the Ninth Avenue roadbed and the elevated track were suspended over and between excavated areas. A drawing published in *Harper's Weekly* (figure 25) more dramatically illustrates the manner in which Ninth Avenue was hung by temporary falsework over a deep chasm. Bellows fabricated an ideal vantage point on the far side of Ninth Avenue at the center of the excavation. The scene depicted in *Blue Morning* would have been viewed from a point in midair.

Essentially, Bellows invented a vantage point from which to view the station straight-on and framed by the Ninth Avenue roadbed and the elevated track. Thus the structure of the el is integrated into the formal design of the painting while it also participates in its theme. Electric streetcars played a leading role in the process of urbanizing New York, beginning with their first appearance in the fall of 1899. By the time Penn Station opened in September 1910, they were moving five hundred million people around the city each year.[84]

In *Blue Morning*, though, the el is merely a foil to set off the station itself. Descriptions of this building, which seemed "beyond physical powers to complete," had been tantalizing New Yorkers since 1903.[85] Both in scale and conception McKim, Mead & White's design was intended to recall the magnificent baths of Caracalla. As the architects explained, "The conditions of modern American life, in which undertakings of great magnitude and scale are carried through, involving interests in all parts of the world, are more nearly akin to the life of the Roman Empire than that of any other known civilization."[86] The sheer bulk of the building far exceeded realistically anticipated physical demands; instead, its opulent proportions reflected the tendency of American capitalism in this era to express power and prestige in quantifiable terms. The grandeur and cultural weightiness of its architecture—classical associations and use of design principles upheld at the Ecole des Beaux Arts—allied material progress with more elevated aspirations of the human spirit and of society as a whole. The station was meant to evoke images of a new civic order, which was in turn seen in the context of an advancing American civilization. As Herbert Croly understood, "a city cannot be the metropolis of art, unless it is also a metropolis of industry, commerce and of social and intellectual activity.[87]

In *Blue Morning* Bellows envisions the metropolis of the future, New York City, being crowned by a specific, contemporary building that was highly

25. G. W. Peters, *Moles of Manhattan,* from *Harper's Weekly,* 7 March 1908.

charged with social, cultural, and ultimately political overtones. In his search for the real, essential life of New York, Bellows had seized on a subject of considerable current interest. The three excavation paintings exhibited from 1907 to 1910 were clearly interpreted as celebrations of American industrialism and urban growth. The culminating statement of that series, *Blue Morning*, evoked order, coherence, and monumentality—qualities implicitly conferred on a railroad system that had established itself as a formative example of economic coordination on the corporate scale. The star of Henri's "band of malcontents,"[88] the exemplar of novelty and modernity in painting style and subject matter, offered up in this work an explicit celebration of the new social, economic, and cultural order. If his manner and his professional associations suggested rebellion, his message did not.

Blue Morning was exhibited in the Independent Artists Exhibition that opened in New York on 1 April 1910. Throughout the month of the exhibition, local papers were stepping up their coverage of the soon-to-open terminal, running headlines like "Possibilities to Come." But accommodation to the status quo—economic, social, or artistic—was not the press-release theme of the Independents' show, and Bellows's "remarkable architectural composition" was acknowledged only in passing. Instead, his "gory prize fights" grabbed the headlines.[89]

Technology in the Landscape

While Bellows was showing his excavation paintings in New York and elsewhere, he at the same time solidified his acceptability to even the most conservative of academicians with a series of more ingratiating landscapes. In 1908, *North River* (figure 26) won Bellows his first prize at the National Academy. In this painting Bellows focused on the edges of the urban environment, the view from Riverside Park toward the Hudson (the Hudson River along the length of Manhattan was also called the North River) and across to the Palisades. The park itself, originally designed by Frederick Law Olmsted, represented a fringe of pastoral retreat already marked by the processes of urbanization and industrialization. In Bellows's first painting of the site, he created a composition animated by the effect of strong wind and the activity of working piers along the near bank of the river. Each spatial area of the painting displays a slightly different brushwork technique: bold, broad strokes deftly block out the hillside in the foreground as it slopes down and away from the observer; the area of the Hudson is thickly brushed but with generally horizontal strokes; roughly scumbled vertical streaks of tan and brown articulate the rocky cliffs of the Palisades. The jury for the Academy's Eighty-third Spring Annual honored this vigorous canvas with the Second Hallgarten Prize.[90]

Plate 6 Bellows returned to Riverside Park to produce a series of paintings closely related to his prize winner. In fact, he painted *Up the Hudson* (figure 27) in April, only one month after his Hallgarten Prize was announced, and then showed it at the Academy's Winter Exhibition the following December. At least one progressive critic was unimpressed. Mary Fanton Roberts went so far as to place *Up the*

26. George Bellows, *North River,* 1908. Courtesy the Pennsylvania Academy of the
Fine Arts, Philadelphia. Joseph E. Temple Fund.

27. George Bellows, *Up the Hudson,* 1908. The Metropolitan Museum of Art, New York. Gift of Hugo Reisinger, 1911.

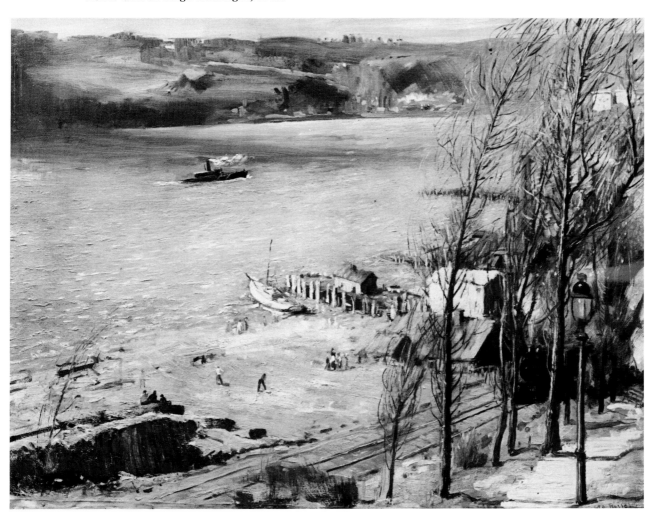

Hudson in the category of "cold-served repetition," in a review that distinguished between the Academy's attitude toward work of "established popularity" and paintings by promising and original newcomers. At the other end of the spectrum, conservative Arthur Hoeber could recognize even in this lively but certainly not indecorous spring scene Bellows's "frank, almost brutal manner."[91]

The majority of critics, however, lavished kudos, and not surprisingly.[92] *Up the Hudson* presents a pretty picture. In reality, the brushstroke evident in the painting is hardly more "brutal" than that of Sisley or Manet—or even Edward Redfield, to cite an American example. In any case, the bravura brushwork associated with Sargent or the "'broad handling' school" was very much in vogue in America.[93] In fact, the painstaking finish of paintings by Cox, Blashfield, or Brush was increasingly the manner of the old guard, still revered in hidebound circles but no longer favored by many new patrons who preferred a flashier technique.[94] Conservative and progressive critics alike, however, conceded that Bellows had injected an "intense feeling" into his picture, that *Up the Hudson* reflected a true sense of the artist's real pleasure and enthusiasm. The tone or projected mood of the painting was seen to be overwhelmingly positive.

There is evidence to suggest that Bellows noticed, and may have been directly influenced by, critical reviews during this period. He made significant changes in *Up the Hudson*, possibly in response to comments in a *New York Times* review about the composition being crowded and not well integrated. Mary Fanton Roberts was more severe: "The landscape seems to be slipping up the river, and the river quite uncertain whether to continue its peaceful painted course or flow inconsequentially out of the frame."[95] Bellows may have attempted to compensate for what these critics perceived as compositional weaknesses. Apparently, sometime after the show closed he restretched the canvas, shifting it slightly in a clockwise direction, bringing the far bank of the river closer to horizontal and in the process creating a less dynamic, somewhat more classical composition. This shift of the painting's axis necessitated other adjustments along the edges of the canvas.[96]

Plate 5 In December Bellows executed a third landscape painting of the Hudson from Riverside Park, this time looking south. The third painting continues his experimentation with axial directions. In *Rain on the River* (figure 28) the Hudson is placed on a more emphatic diagonal, thus activating the composition while avoiding the sense of instability that his detractors noted in *Up the Hudson*. The new arrangement alters the relative emphasis placed on elements within the picture. The railroad tracks, for example, are more prominent in *Rain on the River* than in either of the two earlier paintings in this series, and they play a more salient role in the composition. Here the railroad, along with the near edge of the river, actually divides the composition into virtually equal triangular sections.

The presence of the steaming engines and the train tracks in these landscapes relates, at least tangentially, to Bellows's ebullient portraits of the Penn Station excavation. In both subjects Bellows confronted aspects of urbanization and

28. George Bellows, *Rain on the River,* 1908. Museum of Art, Rhode Island School of Design, Providence. Jesse Metcalf Fund.

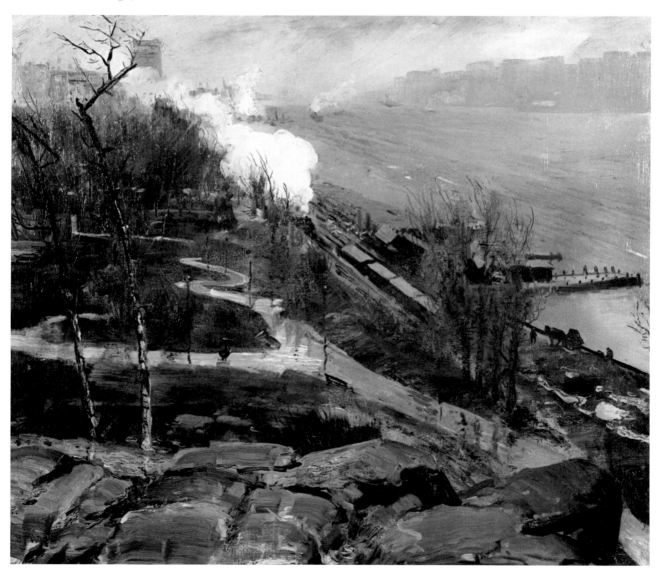

industrialization. Leo Marx has discussed the artistic depiction of the railroad, especially *in* the landscape, in terms of intrinsic meanings—the ways in which portrayals of the railroad convey social and ideological significance.[97] As a primary component in the development of the American industrial economy, the railroad had by the turn of the century come to symbolize the perceived progress of civilization. But, alternatively, the railroad could also have been associated with corruption, the violent suppression of the Pullman strike, or the choking filth of the industrial environment. Virtually all Americans came into contact with some manifestation of the railroad in their daily lives and adopted a position, whether consciously articulated or not, in regard to its ubiquitous and influential presence. Likewise, Bellows's decision to paint Riverside Park cannot have been made without taking some account of the railroad streaking through it. Furthermore, the manner in which he integrated the train into his compositions may reflect at least a generally positive attitude toward the railroad in the landscape, particularly when considered in terms of "tacit presuppositions governing" a society or regional group.[98]

That the tracks imposed themselves on an otherwise "noble park" was noticed by Hildegarde Hawthorne, an English traveler who added her memoirs in 1911 to a growing list of published impressions of New York City. Along Riverside Drive she enjoyed the slopes and bluffs, the winding paths and the stone steps, but, "unfortunately, the tracks of a railroad intervene between park and stream, although they are not very visible, owing to the sharpness of the slope and the many trees."[99] Stereoscopic views of Riverside Park, popular during this period as collectibles and souvenirs, frequently reflected a similar attitude. That is, photographed from the proper angle, the railroad did not intrude on the preferred postcard view of the park and the river beyond (figures 29 and 30).

Bellows, on the other hand, seemed to embrace the railroad, conferring on it a salient compositional role in each of his paintings from Riverside Park. In *North River* the locomotive is a strong black accent moving in from the right. The rising cloud of steam from its engine forms an arching contour at the right of the painting which balances a similar shape on the left, composed of the dock and chunks of ice accumulated against its northern side. In terms of texture, too, the cloud produced by the steam engine has been described with brushstrokes very like those found in the mounds of snow, especially at middle distance. The white pigments used for the steam and the snow are indistinguishable. In other words, the train, though not inconspicuous, has been harmoniously integrated into its setting.

The pair of tracks in *Up the Hudson* likewise merges with the surrounding environment and participates in the compositional structure of the painting. On a diagonal parallel to the river's edge and the pathway at the right, the tracks help initiate movement into depth, signaling along with the tree branches overhead the direction of the brisk spring breeze. The railroad in *Rain on the River* plays an even more dominant role, dividing the land from the water and separating the richly variegated brushwork and value contrasts on the left from the more

29. Stereograph, Stereo-Travel Co., *Hudson and Palisades from Riverside Drive*, 1909. Library of Congress, Washington, D.C.

30. Stereograph, Stereo-Travel Co., *The Hudson River from Riverside Drive*, 1909. Library of Congress, Washington, D.C.

homogeneously painted slate-gray passages to the right of the picture. Juxtaposed to the meandering footpath, the railway also asserts itself as a mechanized, efficient, and rapid means of transport. The tracks, in fact, mark out a direct line to the city beyond, an alternative to the languid pastoralism implied by the serpentine path.

Sadakichi Hartmann, like Bellows, saw the railroad as an integral part of Riverside Park and not at all an unsightly intrusion. The features and "effects" of New York City that he considered ripe for artistic interpretation were "infused with the spirit of to-day" and the "complexion of our time":

> A picture genuinely American in spirit is afforded by Riverside Park. Old towering trees stretch their branches towards the Hudson. Almost touching their trunks the trains on the railroad rush by. On the water, heavily loaded canal boats pass on slowly, and now and then a white river steamboat glides by majestically, while the clouds change the chiaroscuro effects at every gust of wind.[100]

Hartmann's "Plea for the Picturesqueness of New York" came considerably closer to predicting Bellows's Riverside Park paintings than it did to anticipating his first two depictions of the excavation. The Hudson River views present a more congenial subject while they display a brighter palette and a less coarse, though still vigorous, paint surface.

At the same time, like other subjects in Hartmann's catalog of suggestions for pictures, including New York's elevated stations, the aqueducts over the Harlem River, or tall buildings under construction, Riverside Park exemplified the modern aspects of life in this twentieth-century city. The park was new and a particular object of civic pride. But it was more than just new: it was distinctly marked by the modern age, in the form of the railroad. Furthermore, the park itself was a slice of land strategically situated at the junction not only of the city and the Hudson, a major commercial thoroughfare, but also of Manhattan and suburban regions to the north. The city side of the park, along the east edge of Riverside Drive, was a site of rapid change and development. Such an area would naturally have attracted the attention of seekers after the new, the dynamic, the pulse points of urban energy.

Riverside Park figured as a news story repeatedly during the period when Bellows was searching its length for subject matter. In fact, when Bellows was painting *North River,* in February 1908, a much-publicized four-year project to improve and extend the parkway northward neared completion.[101] The plan provided $3 million for the drive itself, two promenades, a bridle path, and terraces planted with grass, trees, and shrubs. Soon thereafter sponsors of a new expansion wanted to push the development further north, to just beyond Spuyten Duyvil Creek, but this proposal met with a series of delays.

In September 1909 Riverside Park made the headlines again, not because of further construction but because it afforded ideal vantage points from

which to view and photograph the Hudson-Fulton Celebration Parade. Bellows had by then based several paintings on visual impressions collected from his wanderings through the park. He returned there on 29 September to witness the three-hundredth-anniversary commemoration of the discovery of the Hudson River, the largest and most spectacular naval display the United States had ever seen.[102] His *The Warships* (figure 31) celebrates that very contemporary event. Bellows experienced the subject—both before and during the parade—in the company of crowds, and the painting reflects the aura of public spectacle. But *The Warships* also expresses his personal involvement with a place and an event that assumed significance on an individual as well as a collective level.

The year 1909 had brought Bellows a series of professional achievements. He sold his first two paintings; he won election as an associate to the National Academy of Design; and he continued to attract favorable attention from art commentators. In August one critic reflected the view of many of his progressive colleagues when he called Bellows "the infant terrible [*sic*] of painting."[103] Indeed, the artist was widely regarded as an exciting and talented new upstart who followed Henri's example in challenging outworn conventions. For several years Bellows continued reaping benefits from his reputation as "contemporary," "uncompromising," and opposed to established creeds.

Particularly after his election to the Academy, many considered Bellows the premier rising star. The opinion of the respected critic Arthur Hoeber, writing for the *Globe and Commercial Advertiser*, was typical and, in fact, was probably influential. Reviewing a February 1910 exhibition at the National Arts Club, for example, Hoeber first described two landscapes by Alfred Maurer as presenting "forms quite impossible of any sane analysis . . . and a general aspect as of the view of some disordered mind." He likewise found works by Steichen and Hartley incomprehensible. By contrast, a Riverside Park landscape by Bellows (figure 32) inspired superlative praise:

> We cannot close this . . . review without directing the attention of these ambitious artistic socialists to the work of Mr. Bellows that hangs on another wall, a large picture which he calls "Morning Snow," and which is quite as original as any they have produced, but with the difference that this astonishingly young painter is entirely himself, and with alluring disregard for all precedents, blazes a path quite his own. . . . Mr. Bellows's performance in this "Morning Snow" is altogether delightful, spontaneous, fresh, and personal, a canvas that easily dominates the wall and stands out from all its surroundings.[104]

Calling attention to Bellows's meteoric rise became a commonplace before 1913. The history-making Armory Show, of course, introduced a flood of new images and painting styles—new at least to many observers in this country—which

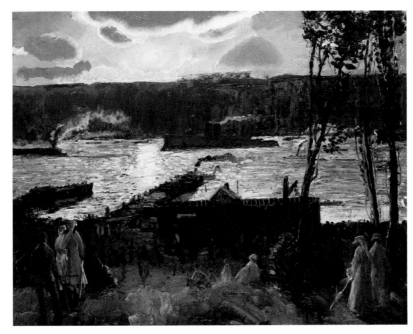

31. George Bellows, *The Warships (Warships on the Hudson),* 1909; repainted 1918. Hirshhorn Museum and Sculpture Garden, Smithsonian Institution, Washington, D.C. The Joseph H. Hirshhorn Bequest, 1981.

32. George Bellows, *A Morning Snow—Hudson River,* 1910. The Brooklyn Museum, New York. Gift of Mrs. Daniel Catlin, 51.96.

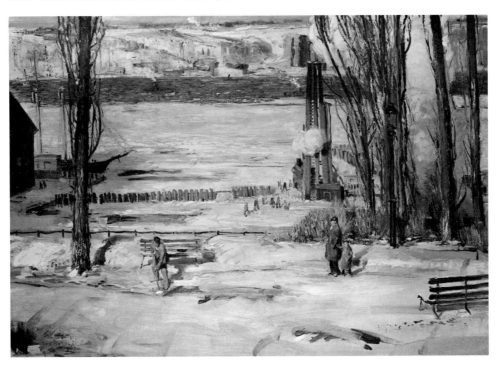

both disrupted and invigorated the development of American art. In spite of his allegiance to a premodernist idiom, Bellows managed to preserve a strong following during and after the advent of cubism, fauvism, and futurism. One of the critics who remained faithful, Forbes Watson, wrote a stunning tribute to the artist's remarkable success in November 1913, calling attention, perhaps for the first time, to Bellows's "rather curious" appeal to "the conservative and radical alike." Though never defining his use of the terms *conservative* and *radical*, Watson did specify that Bellows's constituency included "the artist, dealer, curator, and collector, as well as a wide general public" and that "people of the most divergent viewpoints respond to the dynamic force of his personality."[105] Since the mass-circulation press often aligned advanced artistic ideas with radical political thinking (as in Hoeber's review, for example), presumably Watson meant to imply not only that Bellows's work appealed to a wide range of artistic tastes but also that his audience crossed political lines. He seemed a bit at pains to explain the artist's broad popularity—among cognoscenti as well as the lay public and among progressives as well as conservatives.

Although success is finally as difficult to assess as it is to predict, some measure of Bellows's popularity is obvious from contemporary reviews and related commentary. The nation's leading critics developed a profound respect for Bellows early in his professional career; and if their testimony can be relied on for a reading of broader opinion, Bellows was also widely appreciated among the urban art audience. A close review of the history of Bellows's early cityscapes and their critical reception suggests that a range of ingredients may have accounted for their immediate and broad appeal. Paintings of the Pennsylvania Station excavation evoked a series of issues and ideas engaging early-twentieth-century Americans, issues as specific as the local significance of the excavation itself and as general as progress, economic expansion, and nationalism. In addition, audiences took note of Bellows's brilliant brushwork as well as his fresh approach to his subjects. His canvases exuded a sense of healthy exuberance and masculine vigor, qualities for which Americans had a particular appetite at the turn of the century. Beyond his appealing contemporaneity and his dashing technique, however, another factor seems to have been critical to the response to Bellows's paintings: as Forbes Watson noted in 1913, his pictures could be extolled by radicals as well as conservatives. Bellows succeeded in playing to two different audiences, or perhaps to seemingly opposed sides of the same audience. This duality, implicit in Bellows's art, was basic to the way his paintings were perceived by their first public and points to a key aspect of their subtlety and complexity of meaning as well as their accessibility and ultimately their significance. When Bellows's excavation paintings were exhibited between 1907 and 1910, they seemed boldly defiant but somehow reassuringly familiar. By melding the trappings of artistic radicalism with an approach to his subject that reaffirmed traditional values and priorities, Bellows created a remarkable series of early paintings exquisitely attuned to their time and to the often conflicting attitudes and "tacit presuppositions" of many urban Americans.

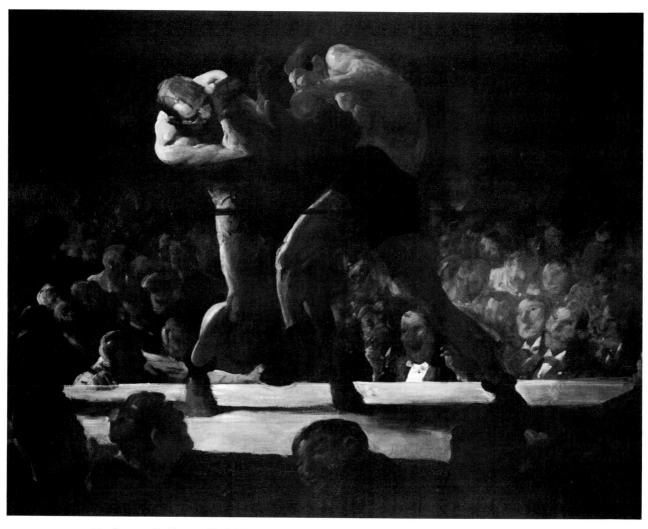

33. George Bellows, *Club Night* (originally *A Stag at Sharkey's*), 1907. National Gallery of Art, Washington, D.C. John Hay Whitney Collection.

At Sharkey's: Boxing Chapter 2

Bellows's first boxing painting was consigned to an inauspicious location, above a doorway, at the National Academy of Design's Winter Exhibition in December 1907. *A Stag At Sharkey's* (figure 33), as the painting was then titled, caught the attention of critics nevertheless. Readers of the exhibition review in the *Sun* were treated to a vivid account of the particulars:

> It is a brutal boxing match (surely four ounce gloves) about to degenerate into a clinch and a mixup. One pugilist is lunging in the act of delivering a "soaker" to his adversary. You hear, you feel the dull impact of the blow. A sodden set of brute "mugs" ring the circle—upon the platform the light is concentrated. It is not pleasing this, or edifying, but for the artists and the amateur the play of muscles and the various attitudes and gestures are absolutely exciting.[1]

The critic, James G. Huneker, might have been writing for the sports page. He seems to have been as much involved with the subject and the "play of muscles" as he was with the way they were painted. Was it the bloody sport that he considered not "edifying," or Bellows's picture? For some of his contemporaries it might have been either one. Through much of the decade, in fact, either prizefighting or George Bellows's art could have been described as topical, as more or less controversial, as brutal, and even as "absolutely exciting."

Boxing, certainly, received much discussion. A writer for *American Magazine* opened an August 1909 article, "In Defense of Pugilism," by declaring the sport impossible to defend, "like war, early marriages and rapid eating." But all these phenomena had proven irrepressible, of course, because "the old Adam in all of us" is just barely hidden beneath the surface.[2] The argument that fighting is ingrained in man's nature had often been made before. An 1887 apologist for *Cosmopolitan* suggested that responding to threats or insults with fisticuffs is "as natural as eating apples; and the effect upon the digestion, circulation, and higher moral qualities generally, is vastly better."[3]

The extensive rhetoric on both sides of the boxing question at the turn of the century grew, in part, out of the nationwide surge of interest in sports of all kinds; but boxing represented a special case. Pugilism was at once "a noble art" and "a brutal spectacle," but above all it was the *manly* art, and masculinity was a prized commodity. A tacit assumption underlay articles about boxing: prowess with one's fists provided a prime measure of manliness, and the lack of fighting instinct must then reflect, for any man alive, a most basic failure. As the author in *Cosmopolitan* exclaimed, "I admit that there may be boys and boys: but the boy who is a boy, in any decent and tolerable sense of the word, that boy" never flees from a fight.[4] Duffield Osborne had probably hoped to subdue objections once and for all when he ended his defense of the sport, published in *North American Review*, with this impassioned plea:

> Come then! let thinking men who value their manhood set themselves in array, both against the army of those who, unmanly themselves, wish to see all others reduced to their own level, and against the vast following who, caught by such specious watchwords as "progress," "civilization," and "refinement," have unthinkingly thrown their weight into the falling scale. Has mawkish sentimentality become the shibboleth of the progress, civilization and refinement of this vaunted age? If so, then in Heaven's name leave us a saving touch of honest, old-fashioned barbarism! that when we come to die, we shall die, leaving men behind us, and not a race of eminently respectable female saints.[5]

The emotional tenor of Osborne's outburst must be understood in terms of the social and cultural tensions that permeated a broad spectrum of middle-class and upper middle-class Americans during this period. Concerns about the impact of industrialization and urbanization—the lack of autonomy in the workplace, the spread of individualistic materialism, and the artificiality of modern existence—were expressed as fear of overcivilization and degeneracy, but fundamentally as anxiety about virility in American life.[6]

By 1900 only a fraction of urban Americans had a considered opinion on the boxing issue, but most were touched in some way by the rise of athletics and sports, which in turn was related to the much-discussed cult of the "strenuous life" as well as to the exaggerated concern with manliness. Boxing continued to receive expansive coverage in the press; only baseball garnered more column space. And President Roosevelt boxed. He seldom shied from championing the sport, and pugilism became one of the many motifs associated with his multifaceted persona (see Figure 34). Then, at the end of the first decade of the century, nearly every urban American did take at least passing notice of boxing as the entire nation awaited the outcome of the most sensational sporting event of the era, the title fight between Jim Jeffries and Jack Johnson.

34. Vernon H. Walker, *A Cabinet Meeting: "The Influence of a Strenuous Life,"* from *Life,* 24 April 1902.

The early history of Bellows's first four boxing pictures is intertwined with the nation's "athletic craze," with changing conceptions of masculinity at the turn of the century, with the mood (or moods) of progressivism, and with the mass-media coverage of and public interest in the Jeffries-Johnson fight. Boxing was a current issue and a prominent news story, but more important, Bellows's treatment of the subject touched a responsive chord. His boxing paintings were sensational: they flaunted the prim codes of effete society and brandished one of the most primal manifestations of masculine hardiness.

Masculinity: A Personal Concern and a Public Campaign

Many urban American men felt their manhood in peril both at work and at home.[7] The close of the frontier, announced as official by the Census Bureau in 1890, signaled the loss of a major arena in which men traditionally tested their mettle. The corporate office, to say nothing of the assembly line, seemed to offer little opportunity in its place for developing masculine superiority or the will to dominance. The women's movement further threatened to encroach on male supremacy, at the same time as new educational opportunities for women were raising their expectations of the opposite sex, so that "it is hard for them to find men to look up to."[8] In the bedroom, signals were confused. Victorian admonitions of restraint and self-control persisted into the twentieth century. But although mastery over passion was a highly touted gentlemanly virtue, sexual activity was an important means of establishing one's masculine identity.[9]

In fact, standards of behavior were changing for men and women. The pressures for redefinition of both gender roles were in some ways reflexive: as women made advances outside their traditional domestic sphere, bourgeois men often responded by attempting to reaffirm the supposed normative feminine identity.[10] Male physicians, publishers, educators, and religious leaders joined to impose a conservative social and sexual role on women.[11] These efforts, however, might be interpreted as desperate attempts on the part of the men themselves to counter rising fears. One author's warning expressed an anxiety widely felt: "Do not entertain the idea that anybody wearing trousers will answer the purpose of a man."[12]

An outpouring of scholarly and popular literature during the decades surrounding the turn of the century indicates that forces of feminization were perceived on several fronts. G. Stanley Hall warned against "the undue influence of women teachers," and S. Weir Mitchell complained that "the monthly [magazines] are getting so lady-like that naturally they will soon menstruate."[13] Not only was there considerable discussion of manliness in articles and books, but in addition, the terms of that discussion reflect changes in the perception of the masculine ideal. Anxieties about masculine validation found expression in an accentuation of the physical and aggressive aspects of the male gender role. In his analysis of "manhood in America," Anthony Rotundo has shown that although the central themes remained relatively consistent—hard work, diligence, and material success were admired throughout the nineteenth and early twentieth centuries—the emphasis shifted subtly. In the late eighteenth century, letters and diaries of fathers and sons reflected admiration for elusive intellectual and spiritual qualities; a century later, men more often spoke of concrete, and presumably more easily achieved, physical traits. Advice articles and other prescriptive literature also reflected this shift. In a similar vein, there was an increasing concern for the growing bodies of young boys, the future generation of American men. Recurring references to physical attributes is also evident in descriptions of male heroes in turn-of-the-century popular fiction and biographies.[14]

Critics called openly for a new muscularity in American literature. Kentucky author James Lane Allen, for example, applauded the recent appearance of the "Masculine Principle" in American writing, which he said was characterized by virility, strength, and massiveness. These were welcome antidotes to the preponderance of the feminine influence. In fact, American novelists and short-story writers were being castigated, he said, for producing a literature "of effeminacy, of decadence . . . a literature of the over-civilized, the ultra-refined, the hyper-fastidious; of the fragile, the trivial, the rarefied, the bloodless."[15] Such assaults on the feminization of American literature reflect the anxieties of male readers. Fictional celebrations of knightly chivalry, played out in medieval England or the American West, provided needed reminders of the dangers of becoming overcivilized. And, in either setting, men sought vicariously to reclaim, through a mythic past, their own identity as vital, virile men.[16]

Jackson Lears has made a connection between these highly popular historical romances and the naturalism of Jack London and Frank Norris, which had a smaller but still sizable following. Both developments contributed to a literature of action and participated in a deliberate move away from effete passivity and introspection. As one of Norris's characters exclaimed, "The world wants men, great, strong, harsh, brutal men—men with purposes, who let nothing, nothing, nothing stand in their way."[17]

For many Americans in the first years of the twentieth century, Theodore Roosevelt was such a man. He personified male potency and aggressiveness when the national tendency seemed to be toward increasing complacency and even weakness in American men. Roosevelt managed to persuade a generation (at least among the middle class) that there were still opportunities for making one's mark in the world. The public was awed not only by his enormous physical energy but also by his tireless enthusiasm. The physical and mental dimensions were closely tied in the description of one contemporary, for whom it seemed that Roosevelt's blood was "beating so hot and fast through brain and sinew that he was never bored in his life. He never felt the ennui or the horrid languor of men like Hay and Henry Adams. He had such excess of animal spirits that, as everyone knows, he was accustomed, after battling with assemblymen or senators, to have in a prizefighter to knock him down."[18]

In his early years Roosevelt figured as an unlikely candidate for such a hearty tribute. To start with, he was frail and timid as a youth; raised in luxury, he seemed destined for privilege. Not surprisingly, when he first entered public life, Roosevelt was considered foppish. He pronounced his *r*s and *either*s in a manner one Chicago reporter said reflected his "insufferable dudism." Another compared him to Oscar Wilde.[19] Roosevelt always retained some qualities that the era otherwise would have regarded as dangerously effeminate. He was a gentleman and an aristocrat, and he socialized with poets and artists; but by way of compensation he was also a soldier and a cowboy and a big-game hunter. Many saw him as a symbol of regeneration in American culture and responded to his call for "the strenuous life."[20] As Lawrence Abbott remembered, "They felt, somehow or other, that he was a symbol of what young America could do if it tried."[21]

One of Roosevelt's most ardent supporters, newspaper editor William Allen White, recalled in 1928 that "he vitalized everything he touched."[22] For White, personally, this was certainly the case. Subject to fears that he himself was a "sissy," White found in Roosevelt an ideal role model.[23] Joe L. Dubbert interprets White's attraction to Roosevelt as a representative example of the president's "profound psychological appeal to middle-aged men anxious about their status and their masculinity."[24] Progressives were by no means immune to the pressures of reconciling their own lives with a narrowly defined and at times conflicted ideal of masculinity. And, as White himself theorized, the spirit of progressivism was by nature partly feminine.[25] The effectiveness of Roosevelt as a role model for these apprehensive

reformers rested precisely in his perceived ability to meld masculine and feminine qualities. Middle age, however, was not a prerequisite for anxieties about being a man, and men of all ages emulated Teddy Roosevelt. In a note to his parents from college, George Bellows wrote, "The Freshmen beat the Sophmores [*sic*] in the Class 'Rush' this year, last Friday. About 500 students try to push a can into the other fellows goal. It's a great sight and I was in the middle, right where Theodore Roosevelt would have me."[26]

That Bellows yearned to get involved with and even stand out among his male college peers would have only been expected. He had experienced rejection in high school, having been excluded from a popular Greek letter fraternity to which every other member of a group of his friends belonged. To the extent that he was a participant in school activities, a classmate observed, "he never got there by popular vote."[27] Surely, Bellows entered Ohio State determined to compensate for previous social failures. Nothing in this behavior points to obvious or inordinate anxiety about affirming his masculine identity. Yet a pattern does seem to emerge from what facts are known about Bellows's early life, especially when considered in the context of the first years of this century, when remaining oblivious to the issue of manliness was all but impossible.

Bellows and Victorian America

Although Bellows was reared in a staunchly conservative, Methodist household, religious conviction was not his primary reason for joining the YMCA. A relative recalled that Bellows's father was "constantly preaching the importance of good health."[28] The value of exercise was indeed a prominent theme in the later nineteenth century, not only on an individual level—proper physical conditioning was "the rough material of success in life"—but also for the sake of the race: "If our best citizens are dyspeptics, our worst citizens will rule the republic. Hence it is the dictate of patriotism that we should encourage such popular games as tend to develop a vigorous *physique*."[29] The spread of urban agencies concerned with nurturing male character and physical hardiness, such as the YMCA and the Boy Scouts, was yet another reflection of anxiety over the loss of masculine vigor.[30] As a youngster enrolled at the Columbus Y, Bellows learned not only to play basketball but also to see good physical conditioning as a quality of manhood.

The most specific evidence of concern on Bellows's part about gender identification comes from his brief but revealing autobiographic statement, in which he reminisces about his youth.[31] By his own account he was considered an "artist" by the time he entered kindergarten. The distinction earned him a degree of "deference," which he enjoyed, although he quickly went on to explain that only his teachers bestowed "kindly interest": "In fact I was faced with a continual need for self defence, and in those young days either the street was too dangerous or my face and fists were wounded with the penalties of adventure." Thus, he took pains to

point out that even in his childhood he had to prove that he was masculine as well as "special."

The trend seems to have continued in high school and college. Boyhood friends report that young Bellows was not physically strong and not a natural athlete; rather, he struggled to participate in sports and excelled only as a result of sheer willpower.[32] An outsider in some respects in high school, he continually sought identification with such groups as sporting teams as well as fraternities. Success was more quickly won in sports. He became a prominent basketball and baseball player in high school and at Ohio State University, but he remained unpopular among his teammates. He was relentlessly determined to gain recognition as a virile athlete and a forceful leader. A classmate recalled that he walked with a "swashbuckling air." His awkward efforts won him a widespread reputation as conceited, cocky, and a "swell head."[33] But the mask unanimously interpreted as self-assurance may have instead been a natural defense against a hostile environment. It is likely that Bellows's artistic gifts were viewed with suspicion at Ohio State. James Thurber attended the same school a decade later and found that his literary inclinations were mostly unwelcome on a campus devoting "millions for manure, but not one cent for literature."[34] Whereas Thurber was reacting to Midwestern attitudes that he considered essentially philistine, Bellows never registered a complaint about Ohio State's intellectual or cultural sterility. His own difficult social adjustment there had more to do with latent uncertainties about his professional and sexual identity, uncertainties aggravated by an environment where artistic matters were regarded with indifference and often, perhaps, associated with a lack of hardiness.

In keeping with the traditional Victorian worldview and value system of his upbringing, Bellows was encouraged to pursue a career in the ministry or else to aspire toward a position of prominence in the community—to become a man of substance—by becoming a banker.[35] When it became clear that young Bellows inclined toward a career in the arts, Bellows, Sr., offered no encouragement; in fact, his strong opposition to his son's ambition was well known among relatives and friends of the family. The elder Bellows may have been conscious that leaders of his church were fearful of artistic inclinations. An author in the *Methodist Review,* for example, had warned, "The aesthetic cravings . . . may and often do lead to effeminacy and voluptuousness."[36]

Concern about the potential implications of an interest in art or literature was not limited to the clergy or to the religious press. David Graham Phillips exhorted readers in no uncertain terms, "If any symptoms of the artistic temperament appear, fight them to the death."[37] William Dean Howells, in *Criticism and Fiction*, distinguished between two images of the writer, between "men whose lives have been passed in activities" and the artist who is essentially unmanned by "a literary consciousness."[38] As Michael Davitt Bell has interpreted this essay, "The

problem, for Howells as for many of his contemporaries and successors, was that the 'artist' was by accepted definition *not* a 'real' man."[39]

Clearly, not all male artists and writers in the late-nineteenth and early-twentieth centuries were deeply preoccupied with gender identification. But Bellows's college career does suggest anxiety about his social identity and ambivalence about his artistic aspirations. He conformed to the pressure of activist ideals. He filled his waking hours with aggressive activity; on the Ohio State campus he was swaggering, loud, and bossy; he tried desperately to excel in team sports.[40] In spite of his intrepid demeanor, however, his biographer describes him as a "lonely and dejected" freshman: he was unable to get into a fraternity or onto the football team.[41] He found solace, instead, in the classroom of his English professor, Joseph Russell Taylor, who offered him personal encouragement and support. Another one of Taylor's students recalled how this remarkable teacher brought into his classroom "the light of the enchanted artistic world he lived in."[42] This was Bellows's other world, the one he remembered from Sunday afternoons during his childhood when he wiled away long hours by drawing. Years later he found enchantment again, in discussions of Walt Whitman and other writers still considered radical, discussions that continued after English class and often moved to the more congenial atmosphere of Taylor's living room. The friendship formed there lasted throughout Bellows's lifetime.

Although Bellows was bid by a fraternity in his sophomore year and did eventually play baseball and basketball, a classmate recalled that he always stood apart from his peers. At a time when college men seemed to be "molded in a cast," Bellows never fit the form:

> He was, in all that I knew him, the direct opposite of all that is conventional or restrained. Do not misunderstand, in his personal life and ideals he subscribed to those things that all of us regard as worth while. He was rigid in his adherence to the teachings of his parents. But, in the things that are of the mind, he stepped out for himself.[43]

This carefully ambiguous statement, written at the time of the artist's death in 1925, ostensibly makes a virtue of Bellows's "freedom from convention," but specific phrases throughout the eulogy—"unusual among the students," "a little different than the rest of us"—suggest that twenty years earlier Bellows's position of separateness may not have been an enviable one.[44]

Bellows avoided an overt break from parental authority and never ventured far from the traditional, middle-class values of his upbringing. With the help of a family friend, he managed to win his father's tacit approval for pursuing a career in art. While still in Columbus, he chafed at obligatory church attendance but submitted to the ritual nevertheless. Even after moving to New York, he often went to services (although he told his colleagues that he only wished to hear the music). His life-style did assume some of the trappings of rebellion against bourgeois social

mores: he moved out of the YMCA and established himself, with two roommates, in a studio apartment on the top floor of the Lincoln Arcade building on Broadway. Van Wyck Brooks described the building as a "Latin Quarter in itself," a "rookery of half-fed students, astrologers, prostitutes, actors, models, prize-fighters, quacks, and dancers."[45] Not only, then, did he acquire a bohemian address, but he also took up some new habits he considered requisite. According to Charles Grant, Bellows had stayed away from smoking and had never tasted alcohol until the Lincoln Arcade days: "If he hadn't indulged in some such manner he would have been conspicuous in the mob he was working and playing with." A number of Bellows's contemporaries have asserted that such behavior was a relatively superficial gesture on his part, that "he was still governed by the moral restrictions which had influenced his youth."[46]

Once again, Bellows struggled to win acceptance within a group, in part by trying to conform to an unwritten but clearly defined gender role ideal. This time the group was relatively homogeneous: it was made up primarily of male art students, and in Henri's class there was a definite and reassuring emphasis placed on their maleness. Although several women were enrolled at the New York School of Art, the men formed closely knit enclaves and felt Henri was addressing them in particular when he said, "Be a man first, be an artist later."[47] And the "Café Francis crowd," as Sadakichi Hartmann referred to the Henri followers who congregated at that restaurant, was apparently all male.[48]

It was in the male-oriented atmosphere of the New York School, and with the support of Robert Henri, that Bellows found a way to reconcile the two seemingly disconnected worlds of his life, the world of artistic sensibility and the world of hard-driving, aggressive action. Not unlike William Allen White, who had found a role model in Theodore Roosevelt, Bellows saw in Henri a commanding, dynamic personality and a man who loved literature and art. He even hailed from the wild West, where he had indeed played the part of a man's man.[49] Henri enjoyed telling of his cowboy past, but he also talked about art and about finding one's individual nature and learning to express it frankly. There was at times a high level of excitement and tension created among Henri's students, pumped up by exhortations to communicate that excitement onto their canvases with bold, painterly effects. As a fellow classmate described it, Bellows's enormous personal vitality served him well in this "emotional scheme of punch and jump." It fit him "like a boxer's glove."[50] In Henri's classroom Bellows learned not only to translate his extraverted manner into a free-wheeling, bravura painting technique but also that "the world of painting . . . was definitely a man's world."[51]

Bellows's attraction to boxing as a subject—one that proved to be the most significant for his early career—was undoubtedly related to his quest for self-definition and manhood. The trail that led him from the Columbus YMCA to the Ohio State University baseball team and to the New York School of Art eventually brought him to Sharkey's Athletic Club. In some respects, following that trail became a quest, one he relived in his favorite novels.

Reading Stephen Crane's *Red Badge of Courage*, for example, re-affirmed for Bellows what the majority of his male contemporaries already believed, that manhood was not a state one simply grew into, as a girl matured naturally into womanhood. Manhood had to be earned. Bellows's boxing pictures were his proof and record of his own descent into the brutal underworld of urban life.

The Red Badge of Courage, along with *Moby-Dick* and *Huckleberry Finn*, dominated Bellows's personal catalog of great American literature.[52] On one level, all three novels are about quests for manhood. In two of them the central character leaves a meaningless or alienated existence in society to pursue a life removed from the "real world." And in all of Bellows's favorite novels, the central action—the quest—takes place in an all-male microcosm, either in the battlefield, aboard a whaling ship, or on a river raft.[53]

Any publicly proclaimed roster of favorites should be viewed with some skepticism. Bellows was fairly self-conscious about his image, and one's reading becomes part of one's history. Bellows would naturally have been inclined to demonstrate that he read intelligently and perhaps, too, that he read like a man. His daughter testified on one occasion that her father always wanted to read "the best," just as he wanted to see the best plays and hear the best music. This explained, in her view, why he avoided contemporary popular novels. Yet it is well known that he often indulged in stories by O. Henry. That his list of favored titles is probably a selected one, however, does not detract from its significance and may even enhance it. Bellows's statements about literature and what he read, especially about his devotion to *Moby-Dick*, are revealing. Whatever his motivations for trumpeting his reading that particular book (*Moby-Dick* is certainly a "muscular" book in terms of its size as well as its symbolic and philosophical complexity), Bellows was knowledgeable about it and probably read it more than once.

The masculine subculture described in *Moby-Dick* seems to seethe with anxiety over gender role. Ishmael is repeatedly engaged in episodes involving sexual innuendo—his parody of a wedding night with Queequeg, for example. The exhilaration of male bonding resonates from at least two intense and highly evocative scenes—the crew on the quarterdeck reacting to Ahab's challenge and the famous sperm-squeezing ritual. And Ahab's maniacal pursuit of the whale is directly related to his own manhood: the creature has "dismasted" him. By joining with Ahab's quest to avenge the loss of his leg—his castration—the crew puts its collective masculinity on the line.

Bellows seems to have responded on a personal level to the novel *Moby-Dick*. He once said that the great white whale symbolized the "unconquerable ideal" pursued by artists.[54] Undoubtedly, he also knew the passage where Melville speaks about painting the whale, or rather, warns about the impossibility of doing so:

> The great Leviathan is that one creature in the world which must remain unpainted to the last. True, one portrait may hit the mark much nearer than another, but none can hit it with any very considerable

degree of exactness. So there is no earthly way of finding out precisely what the whale really looks like. And the only mode in which you can derive even a tolerable idea of his living contour, is by going whaling yourself; but by doing so you run no small risk of being eternally stove and sunk by him.[55]

Bellows may have recognized something of himself in Ishmael, the American version of the outcast in Genesis. In *Moby-Dick*, Ishmael aborts his unmanly teaching career and, instead, journeys to Nantucket, whence he braves the "unshored, harborless immensities" of the sea,[56] pursues a horrible monster, and survives to tell about his adventures. The journey of the *Pequod* is an archetypal descent to the netherworld. In his own life Bellows experienced such a psychic journey and, by means of a painful ordeal, achieved new perceptions of the world.

Bellows, the innocent, proceeded by stages in his pursuit of dark knowledge. The New York School was hardly a menacing environment, but Bellows's attendance there was an important initiation. Classes were stimulating and provocative: Bellows was continually exposed to new ideas, not only in terms of art specifically but also in terms of entirely new ways of thinking—through Henri's discussions of Tolstoy or Bakunin, for example. But Bellows was disinclined to be deeply moved by abstractions: his appetite was piqued to taste more of the world, especially as Henri had urged his students to go out into it and make paintings or drawings of subjects from such "real-life" environs as the Bowery, Childs' Restaurant, and the Matteawan Asylum, as well as from sporting events of all kinds, including boxing.[57]

Prize fights comprised part of the tantalizing landscape of urban nightlife available literally across the street when Bellows moved to the Lincoln Arcade.[58] New York State outlawed public prizefights in 1900. For a nominal membership fee, however, one could gain admittance to the backroom of a club-saloon like Sharkey's. Bellows's painted memories of his experiences there tell a dramatic story. The place was seedy, garishly lit, and—the central attraction—startlingly brutal. Bellows found the atmosphere exhilarating.

The Sporting Underworld

At the turn of the century, prizefighting shared in the burgeoning popularity of urban spectator sports but not in their recently gained respectability.[59] The career of John L. Sullivan did boost interest in the sport among the middle and upper classes. Sullivan's defeat of Jake Kilrain in 1889 made him a national hero; his career earnings totaled more than a million dollars; and he even garnered an invitation to the White House. But "The Great John L." was a drunk, a philanderer, and a brawler; once, he was indicted for assault and battery.[60] The widely publicized excesses of his life evoked the stench of the urban underworld—sleazy saloons, gambling halls, and crowded, backroom sporting arenas.

The prize ring and its attendant rituals—the laying of bets, the display of excitement, and the fighters' stripping down to their trunks as if peeling off the accoutrements of civilized life—symbolized a realm outside the rigid rules of middle-class social decorum. Elliott Gorn, in his superb history of bare-knuckle prizefighting in America, has demonstrated that the adulation of antibourgeois values was part of the conflicted sentiments surrounding the sport already by the mid-nineteenth century. A loosening of conventional morality was sanctioned in the magic ring. In spite of Victorian reticence about the human body, newspaper coverage of fights indulged in explicit language in their graphic and at times lurid accounts. Prudishness in regard to sexuality was forgotten in fervent, implicitly homoerotic descriptions of fit contenders.[61] Clearly, the boxing ring was both disreputable and tantalizing, repulsive and alluring.

For much of the nineteenth century, prizefighting connoted the breakdown of traditional social convention. But after 1880 the rise of immigration, particularly into urban centers like Boston and New York, fostered a subtle change in perspective and conferred on boxing an added load of disapprobation. The middle class now saw blood sports, gambling, and drinking as existing at the center of a matrix of vices that hampered the assimilation of the underclasses and non-Anglo-Saxon ethnic groups into the social order. The saloon, and prizefighting in particular, came to represent an immigrant, working-class life-style alien to the predominant ethic based on self-discipline, productivity, and moral earnestness—an ethic being imposed with increasing vigor by bourgeois urban reformers. Backroom boxing signaled an alternative to that ethic by reinforcing uninhibited self-expression, the absence of responsibility, and the enjoyment of nonproductive leisure time.[62] Defiance of restrictive social norms, however, conveyed one set of oppositional values to working-class males; but at the same time, challenging the limits of genteel propriety held other meanings for those viewing the underworld from a position of privilege. Attention focused by urban reformers on the "social problem" of the poor stirred new interest in their colorful and forbidden recreations.

Gamblers and longshoremen were increasingly joined at ringside by middle- and upper-class gentlemen, who were indulging their taste for raucous amusements and their curiosity about urban lowlife. Although prizefighting continued to be associated with the working classes, sporting news appeared in a growing number of newspapers. The *New York Times* and the *New York Tribune* joined the ranks of workingmen's dailies that covered fights. In spite of this increased patronage and the gradual, inevitable commercialization of the prizefight during the late nineteenth and early twentieth centuries, boxing remained primarily under the control of a loosely knit network of saloonkeepers and promoters. In fact, associations with the "real life" of the streets and the urban underworld were essential to boxing's appeal to social elites. G. Stanley Hall, for example, confessed in his autobiography to have "never missed an opportunity to attend a prize fight if I

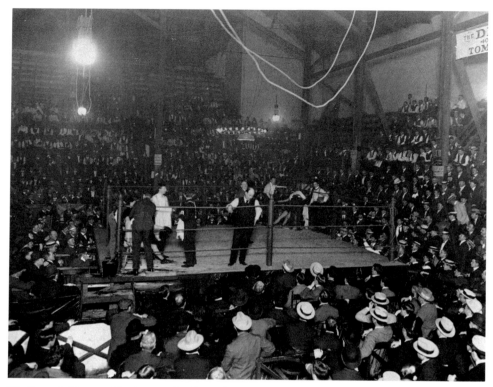

35. Joseph Byron, *Boxing at the Broadway Athletic Club,* 1900. Museum of the City of New York. The Byron Collection, 9048.

could do so unknown and away from home, so that I have seen most of the noted pugilists of my generation in action and felt the unique thrill at these encounters."[63]

Some of these privileged supporters of pugilism, to be sure, promoted efforts to clean up the sport. Hailing its benefits to physical and mental health, Boston poet, editor, and civic leader John Boyle O'Reilly queried, "Where else in one compressed hour can be witnessed the supreme test and tension of such precious living qualities as courage, temper, endurance, bodily strength, clear-mindedness in excited action, and above all, that heroic spirit that puts aside the cloak of defeat though it fall anew a hundred and a thousand times, and in the end reaches out and grasps the silvered mantle of success?"[64] Such men as Roosevelt and O'Reilly considered boxing a genteel—indeed, noble—pursuit and, as a "strenuous" sport, an ideal antidote for the spreading symptoms of flaccidity and overcivilization in society. But these lofty visions of pugilism were set in the context of amateur sportsmanship and the spacious respectability of arenas like the Broadway Athletic Club, where Roosevelt had frequently attended bouts (figure 35).[65] Meanwhile, one of the main sites for professional matches was the more demotic Coney Island, and after public contests were outlawed on 1 September 1900, fights took place in "private" clubs, in secret, on floating barges, and in the backrooms of saloons.[66] Clubs that tried to continue operating openly were plagued by controversies about the legality

of bouts. As the *New York Times* editorialized, "The trumpery device of 'sparring exhibitions' given under the 'auspices' of an 'athletic club' cannot be allowed to protect exhibitions that are not only a violation of the law, but are revolting to all civilized persons."[67] It was commonly understood that even major, established clubs needed "political backing" to avoid raids.[68] And when a fight was canceled, "members" often wanted their "membership fees" refunded.

Even amid this atmosphere of marginal legitimacy, some establishments guarded a better reputation than others. Tom Sharkey, however, never promoted respectability as a feature of his club-saloon. Sharkey's nurtured a reputation for being meaner than most and thereby attracted a considerable audience, one that crossed class lines. But the gentry who frequented Sharkey's Athletic Club left noble notions of sportsmanship behind.

To be sure, the audience for boxing was widening by the turn of the century, along with that for dance halls and the new moving picture shows; and all these phenomena expressed changes in American urban life that tested older value systems and behavior patterns.[69] But professional fights, in particular, bore the added onus of illegality, or at least questionable legality. Throughout the first decade of the twentieth century, boxing resisted the pressure toward organization and modernization associated with other urban spectator sports, such as baseball.[70] It was continuing to thrive in the sporting underworld, still not far removed from dogfights and rat-baiting contests, when feature writer and dialect comedian Joe Welch wrote a column for the 3 April 1910 issue of the *New York American* about his recent one-night adventure at Sharkey's Athletic Club: "I was never in a place like that before in my life." Assuming the pose of a naive, he feigned wonderment at being "identificationed" to gain entry, at the appearance of the participants only in "little under-drawers," and, after the bout commenced, at seeing "red water" running from a fighter's nose and mouth "all over his body." In addition to its humor, the piece appealed because of the sensationalism of its subject.

The mass media frequently exploited the tawdriness of boxing, both as sport and as entertainment. A mawkish tale in the May 1905 issue of *Cosmopolitan*, "A Sucker," by H. R. Durant, typified the way the prize ring lent itself to a mixture of titillation and sentimentality. The editors, well aware that illustrations helped the sales of their magazine, hired the seasoned illustrator William Glackens to produce authentic-looking and dramatic drawings (figures 36 and 37). The story itself pandered to many current notions about the menace of the ring. The characters were all drawn from the working classes or represented that network of gamblers and crooked managers known to control prizefighting.[71] The Irish names reflect Irish-Americans' domination not only in the ranks of the fighters but also as sponsors of professional billiards, bowling, and wrestling as well as boxing. The reputation of Irish Catholics for lacking inhibitions against gambling, drinking, prizefighting, and other forms of dissipation contributed to the aura of the sporting underworld.[72] The loathsome con man in the story, John O'Rourke, was charac-

36. William Glackens, *O'Rourke Started to Climb Through the Ropes,* illustration for "A Sucker," *Cosmopolitan,* May 1905.

37. William Glackens, *A Right-hand Hook,* illustration for "A Sucker," *Cosmopolitan,* May 1905.

terized with transparent euphemisms: "For years he had been the owner of notorious gambling-establishments, and his reputation for honesty, truth and veracity was still to be fully proved."[73]

The Knock Out

Plate 7

A comparison of Glackens's illustrations for "A Sucker" and Bellows's first boxing drawing, *The Knock Out* (figure 38), reveals the combination of elements and influences that manifested themselves in the younger artist's work during this early period. Direct observation was always the basis of Bellows's art, but primary visual experience was conditioned by his intimate knowledge of mass-media illustration. Bellows produced *The Knock Out* during July 1907, in his studio, as an immediate response to a specific event—perhaps his initial exposure to Sharkey's backroom. The claustrophobic space, the surging mass of eager spectators, the eerie light, and the lean, vulnerable body of a wounded fighter were all fresh memories. The intensity of those memories, the jarring mixture of repulsion and attraction, are, however, somewhat submerged beneath the glossy surface of an artfully composed, superbly finished drawing. The theatrical poses and exaggerated facial expressions strongly suggest familiarity with the general conventions of illustration but also, possibly, with Glackens's recently published drawings. As Glackens was a well-known artist and an associate of Henri, it is likely that students of the New York School knew his *Cosmopolitan* illustrations. It may not have been coincidence, then, that Bellows chose in his own drawing to make the fallen fighter's trunks white and the victor's dark. He may have noticed that in Glackens's *A Right-Hand Hook* the use of white trunks had helped to unify visually the prone figure with the floor of the ring while greater value contrasts focused attention on the still-standing hero.

In addition to the anecdotal, illustrational qualities of *The Knock Out*, other elements also distance the viewer from the subject and subdue its brutality.[74] The pastel medium was often associated with genteel subjects and an aesthetic sensibility.[75] The inherent "softness" of the drawn and smeared pastel line, even in Bellows's hand, served to blunt the biting edges of tough, angular shapes. The drawing is thus not only painterly but also quite elegant, especially in passages that describe the referee's striped trousers and rumpled shirt. Furthermore, the composition is essentially adapted from the traditional, shallow stage-set format. There are three basic spatial areas: the one established by the foreground figures, the one occupied by the boxers themselves as well as a conspicuous cluster of fans who intrude into the stage space, and the space for the crowd beyond the ring. But only the white floor of the fighting arena marks out any real, substantial depth.[76] The row of spectators along the lower edge of the picture exists as little more than a line of silhouettes. (One of these figures recalls another convention by mimicking the role of translator or intercessor, beckoning and gesturing toward the viewer.) The audience, packed between the ropes and the back wall of the room and treated as stacked rows of heads, functions as a stage drop. The conceit of removing a section

of the ropes, which would otherwise have crossed the composition in front of the fighters, reinforces the stage-like setting. Although a physical barrier has been taken away, its removal serves as much to distance the action from a sense of real, observed life as it does to permit visual access.

The configuration of *The Knock Out* resembles that of several theater pictures by Everett Shinn, which were well known during this period and certainly would have been available to Bellows. The majority of these were pastels, but works in oil as well as pastel were publicly exhibited and favorably reviewed.[77] One painting in particular, *A French Music Hall* (1906; figure 39), invites comparison with Bellows's drawing.[78] Although Bellows seems to have rendered the grappling referee and standing fighter from a straight-on perspective, the tilt of the floor plane suggests that he intended to position the viewer at a slight elevation, looking down on the action. The angle is, in fact, close to that seen in Shinn's painting. In both compositions the viewer gazes down toward the backs of spectators in the foreground, and in both works a figure (or figures) responds to the viewer's gaze. The setting of a French music hall could hardly have evoked an atmosphere more different from that of Sharkey's backroom, but the texture and coloration of Bellows's pastel are actually closer to the Shinn than to much of his own work of the period. The play of lights and darks over the entire surface of *The Knock Out*, although certainly owing to Henri's stress on value contrasts, also relates to Shinn's style, especially in its relative overall brightness. The affinities between the two works intimate that Bellows was casting in various directions for solutions to new compositional problems posed by his subjects.

Thus, conscious or unconscious borrowing from various sources influenced the development of Bellows's first boxing picture.[79] His subsequent treatment of the subject, undertaken only one month later, further demonstrates how the combination of stylistic and compositional conventions apparent in *The Knock Out* served to mute the intensity of the experience that inspired it.

The Early Boxing Paintings and Bellows's Quest for Manhood

Plate 8

In *Club Night* (see figure 33), the painting originally called *A Stag at Sharkey's*, Bellows created the autobiographical statement that *The Knock Out* could not have been. Pencil and pastel were media still connected with his illustrational mannerisms, but the brush was less encumbered. In oil, it seemed, he was freer not only to exert his newfound self-confidence but also to connect the process of painting with his emotions and in so doing to create a kind of cathartic exposé of his journey to the enticing urban underworld.

When Bellows started his first boxing painting, in August 1907, he reused an old canvas on which he had earlier begun a half-length portrait of a boy. Since the figure was thickly painted, any work done over its surface would have required a heavy impasto to obscure several areas of prominent brush strokes. The fact that the head and body of the boy still reveal themselves quite plainly on any

38. George Bellows, *The Knock Out,* 1907. Pastel and India ink on paper. Rita and Daniel Fraad Collection.

39. Everett Shinn, *A French Music Hall,* 1906. Rita and Daniel Fraad Collection.

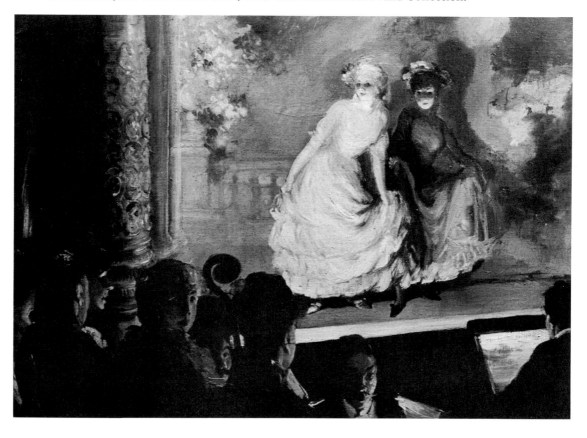

close inspection of the picture indicates that Bellows must have paid little attention to the underpainting as a potential interference. He turned the canvas on its side, so the new image would assume a different orientation, and applied a dark, blue-black pigment to conceal the old design.[80] Reusing an old canvas was an obvious response to economic considerations, but a used canvas might also have seemed a less inhibiting surface upon which to begin a new painting. Perhaps using a "recycled" canvas diminished Bellows's expectations for his boxing picture; or more to the point, the old canvas may have served as another disencumbering factor. Whatever the case, when Bellows returned, equipped with oil paints and brushes, to the subject he had so recently essayed in pastel, he produced a very different result.

First, in *Club Night* the deep, dark pigments familiar from such works as *Frankie, the Organ Boy* and *Pennsylvania Excavation*, have reappeared. The relatively pastel tones used in *The Knock Out* have now retreated, along with the genteel sensibility associated with them, a sensibility that continued to reemerge despite Bellows's efforts during this period to resist it. In *Club Night* effete gentility is expressly and self-consciously obliterated by a gritty, aggressive, masculine statement. The stage-set format, too, has been virtually eliminated, or at least reinterpreted. The jeering audience at the far side of the ring exists more convincingly in space, each row becoming increasingly obscured by darkness. The room is still airless and claustrophobic, but Bellows has evoked those conditions with subtler means. The rear wall, distinctly marked in *The Knock Out* by two paned windows, is now invisible in the murky blackness of Sharkey's backroom. The light, which dramatically cuts through that darkness to highlight garishly the boxers' muscled bodies, also hovers, especially at the left midsection of the picture, as if caught in the blue-green thickness of smoke-filled air. *Club Night*, then, reflects a series of conscious choices. Bellows has avoided a clear definition of the physical space but has cultivated instead an almost palpable atmosphere, one filled not only with sights and sounds but also with ambiguity, mystery, and menace.

Bellows has also adjusted the vantage point from which the action is seen. In *Club Night* the viewer is positioned among the spectators rather than slightly above them, as in *The Knock Out*. It is as if the artist, and thus the viewer, has moved down from the highest row at the back of the room, down into the madding crowd. From there the action presents itself much more directly, more forcibly, and at closer range. The boxers are centered in the composition, placed above the viewer's head, and so close to the foreground plane that the ropes offer little in the way of separation. In contrast with the earlier pastel, this new configuration clearly implies a more immediate engagement on the part of the viewer both with the action in the ring as well as with the audience portrayed around it. The mediating conventions have been, at least partially, stripped away. No longer permitting a comfortable distance from the spectacle-subject, *Club Night* implicitly assigns the viewer a position virtually at the edge of the ring. From there the towering images of the brutish fighters must be confronted at the level of their kneecaps.

The audience is very much a part of the spectacle in Bellows's conception of his early boxing pictures. He once wrote to a Columbus acquaintance that he was not personally interested in the morality of prizefighting, and then he continued: "But let me say that the atmosphere around the fighters is a lot more immoral than the fighters themselves."[81] It is significant, in the light of this statement, that in his first boxing subject the artist-viewer occupied a position at the periphery, still partially removed from the feverish excitement surrounding the ring. The changed vantage point in the second work suggests itself as a metaphor for Bellows's own progress in pursuit of real life, of dark knowledge. He places himself not at the edge looking on but in the midst of the clamoring crowd. He has ventured unequivocally into a place that proper society considered a den of depravity. At the base of his own feelings, Bellows essentially agreed with that judgment. In Sharkey's backroom he felt surrounded by immorality and sin.

Club Night presents a hellish place, illuminated by an unidentified and somehow unearthly light from the left. All the light pigments, moreover, are applied over the dark background tone. Although the blue-black ground seems to have been dry prior to the addition of surface layers, the underpainting does darken the entire picture and contributes to the eerie, gaseous quality of the whites and yellows.[82] The bluish hue, most saturated in the left fighter's trunks but used throughout the composition, conveys the sense of ambient conditions rather than actual local color. The combined effect of the undefined space, the impenetrable darkness, and the ghostly light is sinister.

The occupants of this unsavory backroom seem to warm to the spectral light. Though less exaggerated and caricatured than in the drawing, the audience is largely a disreputable company. Bellows has taken care to represent a mix of social classes: hard-drinking workers, gamblers, and generic lowlifes comprise most of the faceless mob, but a group of men sporting collars and ties is conspicuous at the right. In fact, the white of the shirtfront worn by the rotund gentleman framed between the legs of the right-hand fighter is among the lightest values on the painting's entire surface. Crisply defined triangles of his companions' shirts also provide a sharp contrast with their black ties and jackets and further emphasize the presence of this group. Evening dress does not indicate respectability here, however. The bright shirtfront of the clapping fat man calls attention to the wearer's ghoulish laugh. His nearest counterpart on the opposite side of the ring turns away from the action to display a similarly lascivious grin. The juxtaposition of these two figures from different social registers seems to imply that they are related by more than their proximity to the ring.

Bellows's depiction of the majority of Sharkey's patrons as rapacious knaves conformed to a stereotype. Scandalous as the painting's subject might have been in the view of the urban middle class, *Club Night* also projected the requisite condemnation of a vulgar and violent sport and the depraved character of many of its supporters. But disapproval is by no means the single or even the primary spirit of

this powerfully evocative painting. The psychic tensions implicit in the treatment of the subject are complex and conflicted. To begin with, the audience is mixed not only in terms of class but also in terms of responses to the main event. Individual spectators exhibit attitudes that range from bloodthirsty anticipation to cool appreciation. Thus, Bellows opens up the painting to equivocal interpretations, at least to a greater extent than he did in *The Knock Out*, where the audience behaved in a more uniform manner, like participants in a chorus. Moreover, as compared with *The Knock Out*, the boxers in *Club Night* have been aggrandized, even heroicized: condemnation and adulation coexist.

The fighters themselves are more isolated by the composition of *Club Night* than they were in *The Knock Out*. They rise well above the crowd, which is circled around them, evoking more distinctly the ritualism of the fight. The glowing bodies of the pugilists stand out against the darkness of the upper half of the painting. The onlookers are adoring as they clamor for more. The dramatic spotlighting of the boxers and the painterly articulation of the play of light and shadow on their skin introduces a new, sensual element into Bellows's portrayal. The central attraction, the grappling of bodies, can be seen as a surrogate for sexual activity.[83] Although the boxers are ostensibly locked in desperate combat, erotic innuendo is implicit in the display of near nudity and the manner in which their limbs are intertwined.[84] Together the fighters form a single visual unit, a tensely compressed coil. A sinuous curving line begins at the left fighter's right foot and moves diagonally up through his knee and along the foreleg of his opponent. The spiraling movement then travels up that fighter's arched back, over to and down across the brightly lit shoulders of the fighter at the left. Finally, the line encircles them both in a taut ring completed by their outstretched arms.

Bellows's original title for the painting, *A Stag at Sharkey's*, makes reference to the camaraderie specifically based on maleness that was so much a part of his adventure into the sporting underworld. The all-male company at Sharkey's represented not merely the absence of women but everything associated with the feminine—social constraints, marriage, responsibility, civilization. For Bellows to venture there might be interpreted as a flight as well as a quest. Sharkey's Athletic Club functioned as a refuge from the smothering influences of effete society, but escaping to its enticements did entail personal risk. It was that perception of danger in a tantalizingly sordid place that turned Bellows's adventure into a quest, a rite of passage, and a test of manhood.

The emotional pitch of his experience, the psychic stress involved in his descent into the depths of the urban underworld, is conveyed in *Club Night*. The formal and emotive changes evident in the comparison of his two earliest boxing pictures, separated by only weeks, demonstrate Bellows's rapidly maturing artistic powers. But, more significantly, the manner in which he moved away from the formulaic conventions of *The Knock Out* to an individual expressive voice in *Club Night* also speaks of the powerful emotional resonance that the subject aroused

within him. Whereas the Penn Station excavation had tapped a reservoir of aggressive energy and personal association, the prize ring moved him even more profoundly. The rough and brooding *Club Night* conjures the haunting memories from Sharkey's. The artist had been shocked, thrilled, perhaps aroused, and probably frightened, as much by what he saw and heard as by his own reactions.

The world of Sharkey's backroom was, in a sense, Bellows's wild West, a place where he was emotionally and spiritually challenged and in which he felt compelled to fight for his own survival. Bellows later came to regard the incredible painting that resulted from this experience as "not much good."[85] Only two years after *Club Night* he would produce *Stag at Sharkey's* and *Both Members of This Club*, two canvases that surpassed the earlier work in terms of fluid, bravura paint handling and coherent compositional arrangement. This first oil painting, however, remains the primary, raw document of a vivid, personal memory.

In the Public Arena

The critical commentary stimulated by the public appearance of *Club Night* indicates that masculinity was prized in the art world much as it was in other areas of American culture. A writer for the *New York Herald* said that the Winter Exhibition revealed the "purity and vigor of American art," but it seemed from his subsequent remarks that those qualities were manifest in separate parts of the exhibition: "Although it contains pictures which are beautiful and many that are dainty and pretty, the exhibition does not lack in the strong and virile." The writer called on Bellows's *Club Night* as well as E. W. Deming's *Prayer to the Manes of the Dead* to represent the manly component of the show.[86]

Virility was a valued attribute for art throughout the late-nineteenth and early-twentieth centuries. Laurvik used variations on *manly, virile,* and *healthy* five times in his *International Studio* review of the Academy's Winter Exhibition.[87] Such adjectives were used liberally and almost indiscriminately at times, but generally *strong, healthy,* and *potent* were qualities associated with a native, American strain of artistic expression that was fresh and uncontaminated by decadent Europe.[88] The Gilded Age, of course, had expounded the values of a classical tradition handed down from venerable sources of the past. Forms of artistic expression that embodied these values were disseminated throughout the Continent, and especially in Paris. Although by no means totally discredited, academic idealism and other styles allied with the genteel tradition were by the early twentieth century losing their hold.[89]

When the paintings of Henri and his men began appearing in greater numbers in exhibitions of contemporary American art, they looked like something new and refreshingly different. In Laurvik's review of the National Academy, for example, he referred to the generation of younger artists as "the leaven of to-day and the hope of the future," and he lamented the limited opportunities for the public to see the work of men who promised to be "the masters of to-morrow."[90] Shortly after

that writing, the annual show at the Pennsylvania Academy of the Fine Arts provoked Laurvik to make further specific comparisons between several established artists and what he identified as a "new school." As might be expected from the tight scheduling of the two exhibitions (the National Academy's closed just nine days before the opening of the Pennsylvania Academy's on 20 January 1908), many of the same works were on view in both places; and Laurvik often found himself discussing the same paintings a second time in a new context. He took the opportunity to assume a broader critical stance in his review of the Philadelphia show and to make a strong point about signs that he perceived of a "renaissance of modern art" in America. Specifically, he saw work "characterized by an exhilarating spirit of manly vigor" and attributed the new spirit to a "separation from European culture and traditions" and to "a wholesome disregard of the old, musty conventions that still fetter foreign art": "This has already begun to make itself felt to the consternation of all that is formal and academic, and one of the most interesting groups of painters in this country to-day is composed of a number of the younger men who use the material that lies ready close at hand, who concern themselves most largely with depicting the life about us."[91]

Laurvik identified Bellows's entries in the show as the most fitting demonstration of "both the power and the shortcomings of this new school." Whereas the shortcomings included excessive exuberance and self-assertiveness, the vigor and promise of the newcomers clearly overshadowed their weaknesses. Bellows's boxing painting convinced Laurvik that the artist had the capacity to intelligently direct and control his artistic energies. He concluded, "This is a straightforward, virile work that looks life unsquintingly in the face and that completely laughs out of countenance such a smug, inane canvas as the "Portrait" by Philip L. Hale, or his sad, silly imitation called 'Glitter.' "[92] In fact, Laurvik went on to catalog a sizable group of figure paintings that exemplified the continuing existence of the genteel tradition in art. Although he termed portraits by Irving R. Wiles and John White Alexander "refined" and "earnest," the overall import of his discussion, which repeatedly compared work by newcomers to that by established artists, left the impression that he considered much of the latter facile but lifeless.

Three paintings, each of which garnered special critical notice when they were shown in 1907–8, may serve to represent still-predominant aspects of academic painting. In addition to Hale's *Portrait* (figure 40), Laurvik selected one other canvas for special abuse. William Paxton's *Glow of Gold, Gleam of Pearl*, like its "pretentious[ly] alliterative" title, he thought was nothing more than "super-refined affectation" (figure 41). In spite of such criticism from progressive critics, however, images of idealized feminine beauty in luxurious interior settings did retain a large following. William Sergeant Kendall's *Interlude* was awarded a prestigious location in the Vanderbilt Gallery in the 1907 Annual Exhibition at the National Academy and was illustrated on the frontispiece of the catalog (figure 42). Not

surprisingly, conservative critics lavished praise for its charm, grace, and sentiment.[93]

These three works, all by celebrated artists, were salient entries in exhibitions where three of Bellows's early pictures were being introduced to the public. Paxton's life-size nude, *Glow of Gold, Gleam of Pearl,* is the most obvious example among them of academic figure painting;[94] but in fact all three artists had been trained in Paris, where they were inculcated with the principles of the academic tradition, principles that were defended and disseminated by the prestigious Ecole des Beaux Arts.[95] They absorbed an approach and an attitude toward art based on sound draftsmanship, a mastery of the human form, and the idealization of nature. They also learned that the artist was invested with a moral responsibility to uplift and inspire. According to the academic formula, the figure was the primary vehicle of meaning, but the display of fine technique also implied a dedication to the loftiest ideals of art. Likewise, the rendering of the figure was informed and disciplined by a thorough knowledge of classical prototypes. Most important, such elevated artistic values connoted the high moral standards of the conservative social establishment.

Hale, Paxton, and Kendall were all members of the conservative social elite in New York City and Boston.[96] They, along with their patrons, had vested interests in maintaining the existing social order and the political and economic systems that it entailed. Such paintings as *An Interlude* not only celebrated woman as the repository of spiritual values and the mother of purity but also paid tribute to the social structure that made such exquisite refinement and indolent sweetness possible. Because these artists and their production of art were involved with society's conservative elite, the social and economic upheavals of the early twentieth century threatened the security of their positions.[97] Similarly, the values implicit in their art rendered it vulnerable to attack by more progressive critics as it had not been vulnerable in previous, less unsettled times.

In addition to these class-based considerations, the paintings by Hale, Paxton, and Kendall could be associated with feminized, sentimentalized aspects of culture—this during a period when effete culture often had negative connotations. Warnings about the dangers of overcivilization had been sounded throughout the fin-de-siècle decade. Sensing signs of decline in certain quarters of the "highly educated, sophisticated class," Henry Childs Merwin wrote in the *Atlantic*:

> There are in all of us certain natural impulses, or instincts, which furnish in large measure the springs of human conduct; and these impulses . . . are apt to be dulled and weakened by civilization. . . . Pursue the process [of developing the intellect] . . . and soon you will have a creature who is what we call over-sophisticated and effete,—a being in whom the springs of action are, in greater or less degree, paralyzed or perverted by the undue predominance of the intellect.[98]

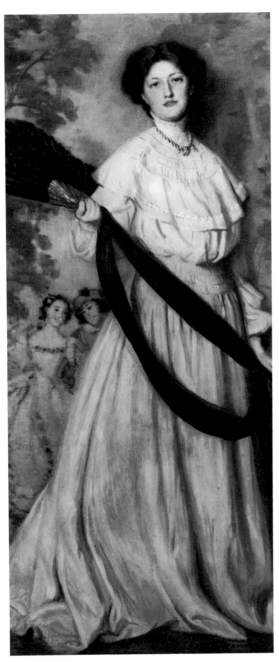

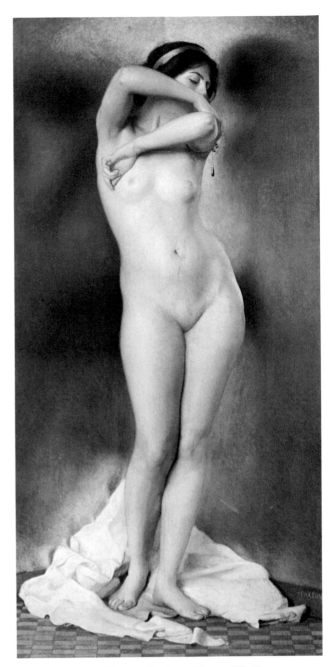

40. Philip Leslie Hale, *Portrait* (now known as *The Black Fan*), ca. 1905–7. Mr. and Mrs. Charles C. Hermanowski Collection.

41. William McGregor Paxton, *Glow of Gold, Gleam of Pearl*, 1906. Indianapolis Museum of Art. Gift of Robert Douglas Hunter.

42. William Sergeant Kendall, *An Interlude,* 1907. National Museum of American Art, Smithsonian Institution, Washington, D.C. Gift of William T. Evans.

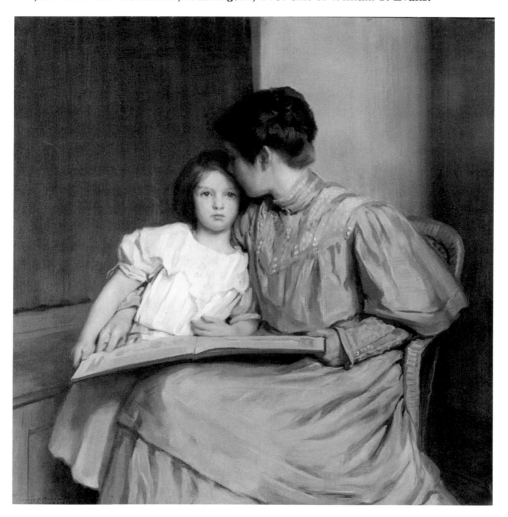

Teddy Roosevelt, of course, brought the issue of overcivilization to national prominence and helped give the cult of masculinity broad popular appeal.[99] Inevitably, the themes of activism as well as nationalism inserted themselves with renewed stridency into commentary on the arts. John Ward Stimson had this to say in *Arena*:

> Art has a great and noble function to perform, but it must itself be genuine, vital, national, constructive, inspired, and universal in application, based on living principles not spuriously mimetic of other times and peoples; . . . American art has too many fads and faddists— little posers who monkey foreign mannerisms and peddle foreign tricks. They start so-called "art schools" which do more to discourage genuine native talent and to pervert American taste than they do liberally to enlighten, enlarge, and empower it.[100]

Art critic Charles Caffin was less fearful of foreign influence than many of his contemporaries but spoke directly to the question of feminization. He charged, in fact, that the excessive demand for portraits of fashionable women was "retarding the lustier growth of our painting":

> For throughout our art from the high-priced easel portrait to the illustrations in the humblest magazine, our artists are encouraged by that strongest of inducements, a fatter pocketbook, to exploit continually the eternal female in all her unearned increment of elegance, until a considerable portion of our art is obsessed with femininity, and many a young artist . . . is seduced from such virility, as he may have had, into a lady-like condition of mind, young ladyish at that.[101]

The art of Hale, Paxton, and Kendall—along with a host of their conservative colleagues—though still popular, no longer held a secure position at the summit of the American art world. Instead, critics and the progressive segment of the art public called for a new, more vital, uniquely national artistic expression. Robert Henri, trumpeting his allegiance to the Emerson-Whitman tradition, entered on the scene at a propitious moment. Sensing the mood of the times, he spoke directly to it and, in so doing, seized the headlines again and again.

An exhibition at the National Arts Club in January 1904 of works by Henri, Davies, Glackens, Luks, Prendergast, and Sloan drew praise for "marked originality" and "freshness of outlook" from a reviewer for the *New York Evening Telegram*. As if surprised to come on something novel and inventive in an art gallery, the critic concluded, "it is perhaps needless to say they are all young men—young men of aspirations and ideals, about whom the prison house of convention has not yet begun to close." Henri, always at the lead, was called "the Manet of Manhattan" and a "revolutionary"; and his art, to be sure, was "virile."[102] Not always content, however, to wait for the press to notice him, Henri sometimes took the initiative. In a dramatic move that attracted considerable publicity, he withdrew two paintings that

had been accepted by the jury for the Academy's 1907 Spring Exhibition. His fellow jurors had rejected work by several of his colleagues and on the first round of voting had given one of his own canvases a number-2 rating. On the final round they delivered what he considered to be the ultimate insult by downgrading another of his paintings from 1 to 2. The entire event was widely covered and provided Henri yet another platform for preaching his philosophy and consolidating his image as a rebel with an honorable cause. "I believe in encouraging every new impulse in art," he told a *Sun* reporter. "I believe in giving every American artist a chance to show what he can do, no matter whether he abides by the conventions or not."[103]

News of Henri's flap with the Academy jury was broadcast nationwide by a feature article in *Harper's Weekly.* Samuel Swift detailed the plight of the "revolutionary figures in American art" and their struggle against the art establishment, seemingly committed to the "penalization of originality." In describing the current state of American art from the progressive point of view, he painted an uncompromising picture of the old guard clinging to their positions in the face of newer, stronger trends:

> Abbott Thayer has done little new work lately, and George de Forest Brush's maximum of power and beauty seems also to have been reached. . . . Twachtman, an isolated and earnest artist, has left many disciples, but no school. Most of his colleagues among the Ten American Painters seem to care more for proficiency than for creative expression. . . . The landscape school . . . has presented little that is new or vital since, let us say, the war with Spain.

By contrast, according to Swift, the "school of Robert Henri" was offering "something affirmative and stimulating":

> These painters convince us of their democratic outlook. They seek what is significant, what is real, no matter whither the quest may lead them. . . . There is virility in what they have done, but virility without loss of tenderness; a manly strength that worships beauty, an art that is conceivably a true echo of the significant American life about them.[104]

Bellows was not mentioned in the *Harper's* article. (He had actually fared rather well at the hands of the jury: his *River Rats* was accepted over work by several of the older artists in Henri's circle.) But his mentor was making the news again, half a year later, only weeks before Bellows's *Club Night* and *Pennsylvania Excavation* were shown at the Academy's 1907 Winter Exhibition. A *New York American* headline put it this way: "Wm. M. Chase Forced Out of New York Art School; Triumph for the 'New Movement' Led by Robert Henri." Differences had led to Chase's withdrawal from the school, to teach instead at the Art Students League. The *American* article, undoubtedly by Guy Pène du Bois, interpreted the move as a takeover by Henri. Chase himself had hired Henri only four years earlier, and according to du Bois, students soon flocked to classes taught by the younger instructor,

attracted by his new philosophy of art.[105] In a follow-up article, which included interviews with both artists, Henri hammered away at his now-familiar theme:

> The Julian and Beaux Arts schools in Paris have been responsible for a good deal of mischief. Their influence on American art has not been of the best. . . . It is my theory that years of precious youth are wasted in learning to draw, and by the time we are finished draftsmen we have lost individuality, our minds are threadbare of ideas. We can draw to perfection, but the results are lifeless, without individuality.[106]

Henri had been excluded from the jury for the Academy's Winter Exhibition, and without his championing efforts, work by his followers was excluded virtually en masse; the exceptions included Bellows's *Club Night* and *Pennsylvania Excavation.*[107] Thus, the contrast between these two aggressively "virile" canvases and the all-too-familiar quality of much that surrounded them must have been especially evident. The benefit was all Bellows's. Even skied above a doorway, his *Club Night* could not be missed.

For gallery-goers sensitized to symptoms of an enfeebled, feminized American culture, Bellows held out the promise of renewed health and vigor. His paintings were about doing rather than being, about action rather than passive repose. *Pennsylvania Excavation* celebrated economically and ecologically significant work. *Club Night* was bold, exciting, and daring—but not too daring.

The seediness of Sharkey's backroom was an affront to genteel sensibility, to say nothing of middle-class morality. But although Bellows's painting was available to varying interpretations, the majority of gallery-goers saw what they expected to see: acknowledgment of the disreputable, brutal nature of the prizefight world. Had the artist offered, instead, a more clearly sympathetic, nonjudgmental view of the sporting bachelor subculture, he might very well have encountered a different reception from his audience. Thus, in spite of evoking the sensationalism associated with its lurid subject and even toying with the limits of social acceptability, Bellows's painting stopped short of outright offense. As a result, critics like Laurvik were able to embrace the brash, young newcomer and endorse his emphatically masculine art as signal of a renaissance of American culture.

Stag at Sharkey's and *Both Members of This Club*

A review of the periodical press and even daily newspapers clearly indicates that the reaction against the genteel tradition was a commonplace in progressive circles well before Santayana defined the term *genteel tradition* in his famous 1911 critique.[108] Broad-based changes in American taste, manners, and ideas were under way throughout the first decade of this century. In spite of strategically placed strongholds of power—in higher education and publishing, for example—the conservative custodians of culture and their idealist creed were under attack. The rise of new values affected many areas of American life, including the professional spe-

cializations. In medical schools, the emphasis was shifting from passive learning in the amphitheater to a new stress on practical experience and clinical research.[109] Likewise, when Robert Henri encouraged his students to see life for themselves rather than train their vision according to classical prototypes and conventional formulas, he was in tune with the times. Bellows benefited from this rise of realism as an accepted aesthetic in American art and literature. His contemporaries interpreted his boxing paintings as eyewitness accounts. The documentary authenticity of these pictures contributed to their artistic merit, but in turn they were criticized for factual flaws.

Bellows painted *Stag at Sharkey's* in August 1909 and then *Both Members of This Club* two months later, in October. He exhibited both works at the Pennsylvania Academy of the Fine Arts in its 105th Annual Exhibition, which opened 23 January 1910. A critic for the *New York Globe* criticized the second painting for its spatial construction, which he said belonged "to Never Neverland, and not to this mundane sphere, where such trifles as perspective have to be settled by scientific rules."[110] Bellows had apparently fielded such objections before. His friend Charles Grant reports that sporting news writers (and Grant's own father, who was also a journalist) had all been quick to point out technical problems in *Club Night.* They said that the ring was too narrow and the lighting was wrong. Bellows defended himself by declaring that his intention had not been to depict a boxing match but "to make a picture of two athletes in intense action." Furthermore, he had purposely narrowed the fighting arena to bring the faces of spectators on the far side of the ring closer to the fore plane.[111] Thus, Bellows had been compelled to explain that he was concerned first of all with picture making and not with documentation.[112]

Plate 9 In spite of Bellows's strong connections with the tradition of the artist-journalist, his three-by-four-foot *Stag at Sharkey's* (figure 43) stands clearly apart from the realm of journalistic illustration. Although inspired by the real, material life of the city, the image portrayed in Bellows's second boxing painting is by no means quotidian documentation. From the start, he intended this picture to be about large, life-encompassing issues. The early months of 1909 had brought Bellows professional recognition with his election as an associate to the National Academy and the tangible rewards of success through his first two sales. By August he felt prepared for even greater achievements. The subject he turned to was one that retained strong personal associations as well as the added benefit of demonstrated public appeal.

The composition of *Stag at Sharkey's* depends on lessons Bellows learned from his earlier boxing subjects, especially *Club Night.* The general distribution of elements is repeated in the later work, but greater assurance is apparent in a bolder, more definitive arrangement. The figures of the boxers appear larger in relation to the entire painting. In fact, this is an illusion; but the aggressively painted and more brightly lit figures in *Stag at Sharkey's* project themselves more forcefully toward the surface plane of the composition, and the strong triangular shape

comprised by the fighters and referee more assertively dominates the picture. The largest and primary triangle begins at the extreme left of the painting with the left-hand boxer's hidden foot, finds its apex in the right-hand boxer's sharp elbow, and is completed by the left arm of the referee. The strong, angular shapes of these figures make the more sinuous forms of the boxers in *Club Night* seem boneless by comparison. The broad, centrally placed triangle of *Stag at Sharkey's* is also locked firmly in place by the grid of ropes, canvas floor, and corner post.

 The composition of Bellows's second boxing painting functions, essentially, as a two-dimensional frieze. In several areas, elements in the middle-ground and background planes are visually linked with elements near the surface. Bellows painted the vertical corner post at the right with scumbled strokes of sienna-ochre pigment. He positioned the post directly above the head of the figure second to the right in the foreground, almost as if it could be planted in his head. Furthermore, the face and bare arm of this figure are described with shades of ochre and sienna closely related to the color of the post. Thus connected, the post and the figure constitute one vertical unit across three-quarters of the height of the painting. Immediately to the left of that post, the referee's outstretched hand has been placed exactly at the level of the middle rope so that he might be grasping it. In fact, his hand must logically be a few feet in front of the rope, but the juxtaposition, again, serves to bring an element from the background plane nearer the surface. In another instance, the cigar-smoking spectator at the left, who looks back over his shoulder, gestures toward the fighters and, in doing so, establishes a visual connection with a second cigar smoker across from him on the far side of the ring. The near figure's stubby-fingered lump of a hand is painted with the same ochres and whites seen in the face only inches above it. Both the hand and the face are squarish, outlined with black, and marked with touches of red. The foreground figure is pointing toward the fighters, but clearly Bellows also intended his hand to participate in a kind of visual dialogue across the ring. The straight diagonal formed by the left-hand fighter's leg seems broken by the foreground rope that intersects it. Again, the rope must actually be separated from the leg by some distance, but Bellows has explicitly brought the two elements together visually with the substance of the paint itself. The black of the rope was applied *through* the thick, still-wet flesh tones of the calf of the leg. Then Bellows returned to the canvas with another loaded brush and laid in a juicy swath of peach-colored pigment at the knee, allowing a thin line to leak onto the area where he had just painted in the rope. A similar play with overlapping occurs at the point where the same rope intersects and seems to sever the right-hand fighter's left leg.

 Such calculated, painterly manipulations seem out of place in the context of Bellows's powerful, even explosive *Stag at Sharkey's*. Although the surface is rapidly and spontaneously brushed, not only is the composition carefully composed but also the application of pigment is explicitly and intentionally controlled. The artist, in fact, interjected numerous reminders of the artfulness of his

Plate 10

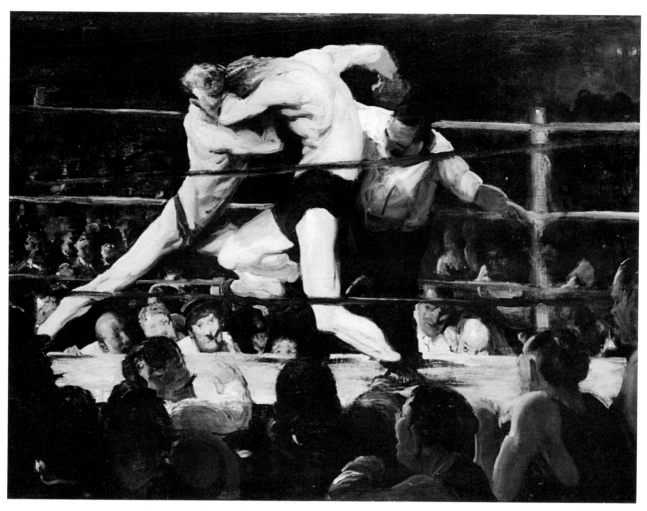

43. George Bellows, *Stag at Sharkey's* (originally *Club Night*), 1909. The Cleveland Museum of Art. Hinman B. Hurlbut Collection, 1133.22.

work, producing a varied display of paint handling. A few areas, such as the front fighter's right glove, are covered with only a thin layer of blue-green, a glaze apparently used to block in shapes at the initial stage of painting. Thus, an exposed section of underpainting creates an area of form. Other passages show built-up layers of impasto, at times wet pigment having been painted into wet and at other times a wet brush having been dragged over dryer paint. The variety of brushwork and paint handling serves the expressive subject at the same time that it enlivens the composition. The lack of definition in the front boxer's right hand, for example, conveys an impression of movement, as if a punch is about to be unleashed. The highly animated paint surface builds progressively to a pitch of suggested action at the focal point of the composition, where all lines of force converge: the meeting of the boxers' heads. Passages of their legs are broadly and richly painted; the torso of the left-hand fighter is more crudely handled, almost hacked in by a broad brush, and areas of the thin blue-green glaze layer remain partially visible; and up toward the heads and the one visible face, brushwork is increasingly spirited, resulting in a dense mass of vigorously applied strokes. The use of blood-red pigment, which is distributed throughout the composition, also builds to a climax in this area; its generous application here serves the moralistic tone of the painting, to highlight the violence of the sport and the characterization of the crowd as bloodthirsty.

Although the composition of *Stag at Sharkey's* functions in the shallow, friezelike plane, there are specific but masterfully understated suggestions of depth. A bit of green at the extreme edge of the painting's upper left quadrant indicates the placement of a doorway at the rear of the room; a standing figure blocks out most of the light from the opening. At the opposite edge, a pair of lights reflects a spot of greenish light against another wall. Between these points in space and the ring, a throng has gathered, a field of barely articulated heads sprinkled with tiny sparks marking lighted cigars.

As in the previous boxing pictures, the crowd plays a secondary but critical role. The faces display a stereotypical range of reactions, from stupefied horror to fascination. This time, however, Bellows may very well have included himself among the spectators, his face half-hidden by the floor of the fighting surface but his balding head still prominent just to the left of the post, at ringside.[113] The eyes and raised brows of this figure are the only expressive features visible, as if he is here only to look. His head is inclined downward, perhaps toward a sketchbook, so he must glance sharply up to catch the action. In other words, he presents himself as a relatively detached observer, the professional artist in the act of gathering visual material for his creative work.

This first example of self-portraiture in a subject picture reflects Bellows's continuing study of the old-master tradition and, at a time when he was gaining recognition as a successful professional artist, perhaps also reflects his perception of himself as assuming a place in that tradition. Thomas Eakins provided an immediate, contemporary prototype for slipping a self-portrait into a composi-

tion—specifically, by painting his own facial features on the head of a subsidiary figure, as he had done in *The Agnew Clinic* (1889, University of Pennsylvania School of Medicine, Philadelphia). Bellows was certainly cognizant of his own relationship to the Eakins-Anshutz tradition of realism via his teacher Robert Henri. Whatever specific references he may have been intending to make, the self-portrait was a self-conscious gesture indicating Bellows's ambition for *Stag at Sharkey's*: he saw it as a major work.

Plate 11

In October he decided to approach the theme again and produced the fourth and last picture in his early boxing series, *Both Members of This Club* (figure 44). In returning to a familiar subject, Bellows chose not to attempt a new compositional scheme as he had done in the last of his excavation paintings but rather to build directly on previous work. The recently completed *Stag at Sharkey's*, safely stored in the studio, may also have stimulated him to approach this new canvas with greater boldness and a willingness to take risks. He chose to reuse the heroic triangular format, which becomes in these paintings the superstructure for a series of related interlocking shapes, but made critical changes. In *Both Members of This Club* the strongest side of the triangle is established by the powerful diagonal of the black fighter's outstretched leg, his back, and his raised left arm. This time, the dominant central shape peaks at a climactic meeting point of opposing forces, the converged gloves at the top of the composition. The completion of the triangle on the left is more ambiguous than in the previous boxing paintings. The powerful forward movement of the black fighter is resisted by the white opponent, whose body constitutes a vertical element. His raised arm begins to form the left half of what might have been an equilateral triangle, but that diagonal line begins to bend downward at the point of the fighter's shoulder—the line collapses, as it were. The central, overarching shape does find a tentative completion in the diagonal shoulders of a spectator at the left edge of the painting. But the ultimate open-endedness of the left side of the triangle introduces a new level of compositional as well as thematic complexity. The imbalance of forces, the unresolved tension in the interplay of dynamic shapes, activates the composition; and it also implies the inevitability of an ultimate conclusion, a resolution to conflicting forces that must play themselves out. Thus, the composition evokes the basic issues involved in the fight itself.

Both Members of This Club is more ambitious than *Stag at Sharkey's* not only in terms of compositional complexity but also in terms of size. Bellows started with a canvas approximately six inches larger in each dimension than the one used for the earlier work; but at some point he switched to a larger stretcher and unfolded six more inches of canvas along each side and the top margins. *Both Members of This Club* hence is the biggest of the early boxing paintings and in some ways the most freely handled.

Bellows articulated the anatomy of each fighter with broad, sweeping gestures. Sometimes the brush followed the contour of the form; at other times

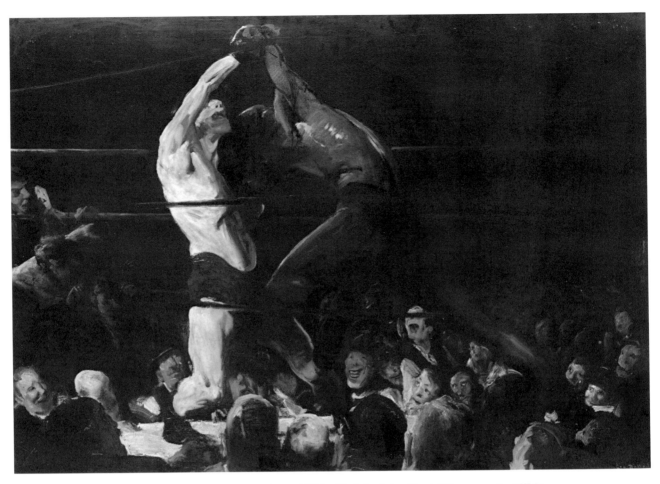

44. George Bellows, *Both Members of This Club* (originally *A Nigger and a White Man*), 1909. National Gallery of Art, Washington, D.C. Chester Dale Collection.

quick, thick parallel strokes were used to fill out and effectively flatten broad areas, as in the black fighter's lower left leg; and often the pattern of brushwork is only loosely related to the part of the body described. The configuration of the human torso provided little more than a starting point—a thin excuse, as it were—for the thick slabs of paint laid in to describe the white fighter's midsection.

To some extent, this painting bears a relationship to *Stag at Sharkey's* similar to that of *Club Night* to *The Knock Out*. While *Stag at Sharkey's* reflects Bellows's struggle to focus on the manipulation of formal elements, to keep his eye and his mind in control (as the little self-portrait might suggest), *Both Members of This Club* is, on some levels, more revealing of Bellows's nightmarish experience in the urban underworld.

The impenetrable blackness of Sharkey's backroom subsumes fully two-thirds of the background of *Both Members of This Club*. The light source is located in the front, upper left, and causes bluish reflections resembling tones used in passages of *Club Night*. Most important, the aura of the unearthly and forbidden, the atmosphere so effectively achieved in *Club Night*, has been conjured up again in *Both Members of This Club*. This painting exudes that same foreboding of being caught, of being inextricably enmeshed with an excited, unruly mob in an unknowable but enclosed space. There is a doorway, indicated by vertical touches of yellow and a spot of red at the extreme right edge of the picture; but this opening seems tiny and remote, providing little hope for escape. In any case, escape is not an issue here. Again, the artist was totally engaged with these Satanic proceedings.

Both Members of This Club is not the depiction of a static scene but an impressionistic record of the artist's visual and psychic experience of an event. Bellows has portrayed the subject much as an emotionally involved spectator might see it, focusing on salient areas and at the same time *not seeing* others. The ropes in the foreground inexplicably disappear to the right and left of the boxers. In fact, to the left of the left-hand fighter Bellows has included a spectator's face, which should logically have been partly obscured by the ropes. But Bellows has dispensed with logic and the rules of a consistently maintained vantage point in order to allow this gray visage to emerge from the darkness behind the ring. And he did the same at the far right. Behind the right-hand fighter's outstretched leg, heads in the crowd are not blocked by the rope, which should span that section of the viewer's field of vision. Such inclusions and elisions based on compositional and formal considerations enhance the quality of active, constantly shifting, seemingly schizophrenic perception which enhances the mood of this painting. Solutions to undesired or confusing juxtapositions seem bold and impulsive, such as blacking out half a face between the legs of the left-hand fighter. *Both Members of This Club* is a kind of collage—pieces of reality and nightmare sifted through time and memory, spliced together and spit out in a frenzied re-creation of a series of powerful and moving experiences.

This fourth boxing picture, then, is the most dynamic of the early series, as well as the most impulsively and intuitively put together. It also represents

the maturation of Bellows's artistic abilities, as if an influx of visual and psychic stimuli had incited the full range of his technical and expressive power. A relatively sheltered Midwesterner, George Bellows had ventured east to make his way in the New York City art world and in so doing encountered much that was new and unexpected—not only visual phenomena but also emotional experiences, some exhilarating, some shocking. Clearly, Sharkey's backroom had a significant impact on the artist. *Both Members of This Club* must be understood as the culmination of a series of direct, personal confrontations with the brutal facts of real life as Bellows was seeing and experiencing them in these early years of his artistic career.

Boxing in the News: Jack Johnson

When Bellows showed *Stag at Sharkey's* and *Both Members of This Club* at the Pennsylvania Academy in January 1910, he was praised in the *Globe and Commercial Advertiser* for his "nerve and daring."[114] Still referred to by the *Globe* critic as a "young painter," Bellows had risen with enviable speed to a position of prominence in the art world. Five of his paintings were accepted for the Philadelphia exhibition, and as in a number of previous instances, Bellows succeeded in eliciting at least as much commentary from the critics as any other artist represented in the show. Bellows was truly an *enfant terrible*, a new talent whose progress was closely watched.[115] Meanwhile his boxing pictures continued to stand out even in comparison with other examples of his own work. Some of this notoriety may have been due to the currency of boxing itself: the sport was, indeed, attracting an unprecedented level of national attention. Throughout the time that Bellows was working on *Stag at Sharkey's* and *Both Members of This Club*, the sporting world was increasingly caught up in the vicissitudes of the "white hopes."

The search for an Anglo-Saxon champion to vindicate the "master race" had begun soon after Jack Johnson handily won the heavyweight title from Tommy Burns on 26 December 1908.[116] That a black fighter could capture the title was at first considered an aberration, but Johnson proved unbeatable. As the months wore on, observers—and eventually, it seemed, the entire white nation—grew increasingly desperate. During the summer and fall of 1909 a series of events stimulated new levels of hostility and even hysteria among ever-widening circles of the American audience. Virtually no segment of the culture was exempt.

The enormity of public passion stimulated by the entire unfortunate episode was apparent from the start. The illustrious Jack London had been dispatched to Sydney, Australia, by the *New York Herald* in December 1908 to cover the much-anticipated interracial bout between Johnson and the reigning champion. In his story, which appeared the day after the fight, London was blunt about his own position: "Personally I was with Burns all the way. He is a white man, and so am I. Naturally I wanted to see the white man win." London's bias went hand in hand with the widespread tendency to see boxing champions as symbols of racial superiority. Post-Darwinian science had supposedly demonstrated the lesser mental capacity of

blacks in comparison with Caucasians; and the United States had institutionalized white supremacy with the Supreme Court's *Plessy* v. *Ferguson* decision of 1896, which guaranteed "separate but equal" status for black citizens. Many felt that the Burns-Johnson match should never have happened. In the first place, such a pairing, on equal terms, came too close to implying equality between the races; but worse, it might call white supremacy into question should the black man actually defy "natural law" and prevail.[117] London and other reporters justified Johnson's victory over Burns by stressing that the contenders were mismatched: "The fight—if fight it can be called—was like unto that between a Colossus and a toy automaton. It had all the seeming of a playful Ethiopian at loggerheads with a small and futile white man." London recognized immediately, though begrudgingly, that Johnson's strength and skill would be hard to defeat. He saw only one hope: "Jeffries must emerge from his alfalfa farm and remove that smile from Johnson's face."[118]

Jim Jeffries, the undefeated heavyweight champion, had retired in 1905. As one white hope after another fell before Johnson, pressure increased for Jeffries to come out of retirement. Cries were heard from all sides. On 4 April 1909 the *Chicago Tribune* printed the picture of a very blond youngster, not yet pubescent but intended to be seen as vulnerable, pointing up at the ex-champion, her would-be avenger, with the caption, "Please, Mr. Jeffries, are you going to fight Mr. Johnson?"[119]

By fall, many of New York City's newspapers were printing at least one item a week concerning the possibility of a Jeffries-Johnson bout. Jim Jeffries had announced his willingness to fight soon after a Johnson victory in midsummer, and Jeffries had even begun to train. But other white hopes came first: Al Kaufman was felled in September, and then Stanley Ketchel in October. Ketchel's defeat left no one other than Jeffries, and terms for the big fight were signed on 30 October 1909.

Sometime that October, in the midst of the growing furor surrounding these events, Bellows decided to create a fourth boxing picture and in it to portray a meeting of a black and a white fighter. He first called the painting *A Nigger and a White Man* but later changed the title to *Both Members of This Club*. Bellows could not have based the picture specifically on either the Ketchel-Johnson fight or the Jeffries-Johnson fight. (The latter did not take place until 4 July 1910. In fact, Johnson never fought in New York during the era of white hopes.) Yet it seems likely that the current national prominence of the racial issue in relation to boxing inspired Bellows to bring the theme directly into his art and make this painting as topical as his paintings of the Penn Station excavation had been—to deal once again with "the tremendous, vital things" of contemporary life.[120]

On the basis of surviving records it may never be known whether Bellows personally witnessed an interracial fight sometime in the fall of 1909 on which he might have based *Both Members of This Club*. Newspapers that regularly announced schedules at the various New York City clubs made no mention of a fight between a black and a white contender at Sharkey's. Bellows might, however, have

seen such a fight elsewhere, although blacks were rarely paired with whites in the ring and, as a rule, only in divisions other than heavyweight.[121] It has been assumed that all the early boxing pictures were based on what Bellows saw at the club-saloon across from his studio, and the close proximity of the spectators to the ring in each of these paintings does call to mind a relatively small-scale operation such as the one managed by Tom Sharkey. (Compare the setting of the Broadway Athletic Club [see figure 35] with that of a smaller, unidentified ring [figure 45] photographed sometime between 1900 and 1909. No photographs of Sharkey's have been located.) The admittedly scant remaining evidence suggests, then, that Bellows may have spliced experiences together. *Both Members of This Club* may represent a bout witnessed at an athletic club in another part of the city, which the artist then set in the environment he knew well from repeated visits to Sharkey's. Whatever the details of this eighty-year-old story, however, the point is that Bellows self-consciously introduced race into his fourth boxing picture, thus intensifying the already volatile nature of the subject.

The final title of the painting, *Both Members of This Club*, not only made reference to the device of charging "memberships" to circumvent the law against public prizefights but also underscored the issue of race. The title becomes a dark satire of the fact that by virtue of transforming sport arenas into "clubs," favored membership status was conferred on a black fighter as well as a white, at the same fraternal society and at the same time. Few contemporary organizations would have condoned or tolerated such an occurrence under ordinary circumstances.[122]

The race issue was often closely associated with boxing during the early decades of this century. That Joe Gans was both black and the greatest lightweight champion of the era, for example, posed a problem for many contemporary white observers of sport. Suggestions were put forward in all seriousness that Gans was not actually black but rather "of Egyptian or Arab blood." A 1907 feature article in the *New York American* considered the "remarkable similarity" between Gans's profile and that of Ramses II and Sethos I, and photographs of sculptured portrait heads of the Egyptian pharaohs were juxtaposed with Gans's to support the line of pseudo-scientific argument. A photograph of Jack Johnson, on the other hand, was used to illustrate the "perfect negro profile."[123]

By late fall of 1909, the tensions surrounding Johnson's continuing claim to the heavyweight championship had reached explosive proportions. The staunchly antiboxing *New York Times* lamented the fact that so much was invested in the forthcoming fight, noting that "it keenly interest[ed] a large majority of the inhabitants of the United States, to say nothing of not a few million people in other countries." The coolly understated editorial hinted at the fears felt nationwide:

> It is really a serious matter that, if the negro wins, thousands and thousands of other negroes will wonder whether, in claiming equality with the whites, they have not been too modest. . . .

45. Waldon Fawcett, *Boxers Shaking Hands in the Ring,* 1900s. Library of Congress, Washington, D.C.

Not a few white pugilists, from an instinctive feeling of ethnic pride founded on a deeper wisdom than they had the intelligence to realize, have refused to meet negroes in the ring. It were desirable, we incline to think, that all of them should do so, for it is not well that the two races should meet in formally arranged and widely advertised competition when the conditions are such that victory and defeat are decided by the possession on one side or the other of a superiority so trivial as that given by weight, strength, and agility.

. . . While the sort of efficiency which avails in pugilism is in itself a valuable asset for the members of a dominant race, it is perilous to risk even nominally the right of that race to exercise dominance in a conflict which brings so few of its higher superiorities into play.[124]

But in spite of serious misgivings in some quarters, the fight was on for the coming summer. By January 1910 the press was covering every preliminary detail on a daily basis. An article in the *Globe* reporting one of the changes of location for the fight, this time to Salt Lake City, provided an opportunity in the lead illustration for a demeaning caricature not only of Johnson but also of the Mormons (figure 46).[125] Wheeler-dealer Tex Rickard won the bid to promote the fight and immediately began to hype it as spectacle at every opportunity. In a media campaign that was massive by the standards of its time, Rickard played up the sensitive theme of black versus white. He exploited already fierce racial hostilities and eventually brought the fight story from the sports page into other sections of the newspaper.

For example, on 3 April the *New York American Magazine* featured a two-page spread under the headline, "Why All Mankind Is Interested in a Great Prize

46. *The Big Fight Situation as Scar Sees It,* cartoon from *New York Globe and Commercial Advertiser,* 24 January 1910.

Fight" (figure 47). Science, once again, provided a ready answer: "People who will spend $100,000 to see the Jeffries-Johnson battle are following perfectly natural and well understood play impulses." The article distinguished between play and the struggle for existence in real life but stressed significant similarities as well. In their scheduled bout, in fact, Jeffries and Johnson would "play at primitive combat," and the victory achieved by one or the other opponent would represent success in the most basic and essential contests of real life: "To-day the victor in a simulated combat feels in his brains and nerves the same pleasure that his ancestors experienced from a victory that meant life and food. The pleasure is shared for similar reasons by the spectator."[126] These words were by no means intended to diffuse the tensions and the antagonisms attending the upcoming fight. Neither was the pairing of a photograph of Johnson with a sketch of a gorilla aping his at-the-ready posture. Photographs of four "fighting heads" comprised the most inflammatory section of the layout. Images of Jeffries, Johnson, "Monkey Man," and a gorilla were arranged in "descending" order. The message was clear. The forthcoming fight was charged with meaning: it was incumbent upon white Americans collectively, as a race, to reaffirm their dominance over all inferiors, before it was too late.

On 4 April 1910, the day following the appearance of this highly provocative feature, the *American* printed Guy Pène du Bois's review of the Exhibition of Independent Artists. The "immense throngs" that had gathered at the opening on 1 April earned the story a bold headline and a third of one page of the paper—considerable space for an art event (figure 48). Photographs of four paintings at the top of the page were headed by one of Bellows's boxing pictures, *Stag at Sharkey's*

(then *Club Night*). The choice of this particular painting was probably not a coincidence. In spite of the lively discussions that his boxing paintings had stimulated during earlier outings, none had ever been reproduced in the media. The topicality of the Jeffries-Johnson fight and the magazine section feature of 3 April undoubtedly focused new attention on Bellows's treatment of the boxing theme.[127]

The editors of the *American*, interestingly, chose to reproduce the painting in which the two contenders were white, and not *Both Members of This Club*. Perhaps that slightly later picture was considered too topical for the arts page, too close to the actual fight, even though in reality it was not a portrayal of either Jeffries or Johnson. In fact, the face of the black contender in Bellows's painting is completely obscured, and neither fighter could have been considered a heavyweight. The connection with the much-discussed contemporary event existed only by inference, but inference sufficed. The artist and critic Helen Appleton Read, for example, years later described the violent reaction at the Exhibition of Independent Artists to Bellows's painting of the "Johnson-Dempsey fight."[128] Read had not been a boxing fan, clearly: she remembered the painting of a black-versus-white prizefight, and she remembered the famous black fighter's name, but not that of his white-hope opponent. She incorrectly paired Johnson with a fighter, Jack Dempsey, who became prominent a decade later. In hindsight, however, when Read recalled Bellows's painting, she made an automatic association with one of the hottest topics of the day. It is fair to assume that during the weeks of the Exhibition of Independent Artists many of her contemporaries registered the same connection.

The association of Bellows's boxing pictures with Jack Johnson also called up a range of allied issues. In addition to the reluctance on the part of American Caucasians to accept any black as the best fighter in the world, Jack Johnson in particular aroused intense emotions, especially in response to his blatant defiance of convention. Rather than accept the "place" society conferred on members of his race, Johnson openly and contemptuously taunted white opponents in the ring. He also paraded his liaisons with numerous white women, and this aspect of his behavior was probably the most threatening of all. The personality of Jack Johnson, himself, was not necessary to evoke the myth of black sexuality. He reinforced it and probably augmented it, but long before Johnson Americans had learned to view immorality as a trait of the black race. Thus, Bellows's inclusion of a black fighter in his picture of the sporting underworld conjured up, besides the usual array of antibourgeois values connected with the ring, the sensitive issue of sex. While segments of the foreign-born and the working classes were widely assumed to be relatively subject to the baser, animalistic, and primitive instincts—all of which seemed at home in the prize ring—a black man in particular personified for many Americans *furor sexualis*.[129]

Such highly charged associations must have made *Both Members of This Club* a sensational painting indeed. Its resonances in the minds of viewers, however, remain hidden for the most part. Although Read said she remembered an

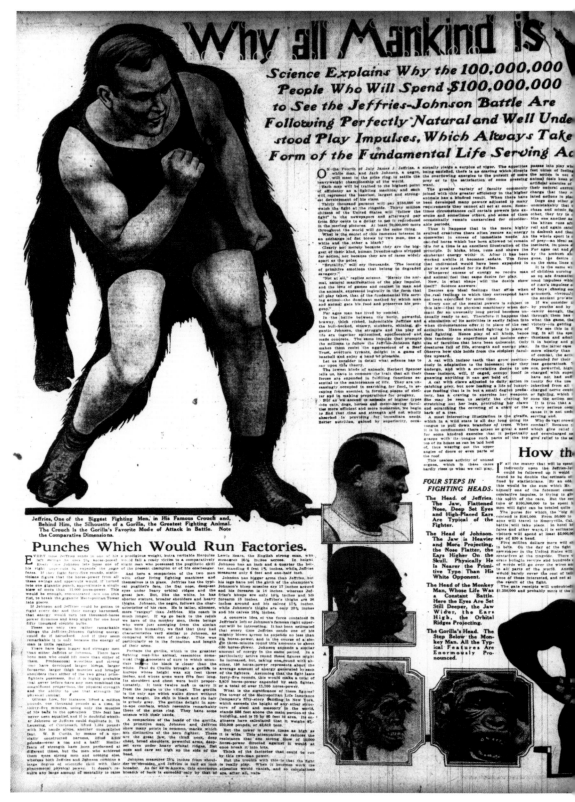

47. "Why All Mankind Is Interested in a Great Prize Fight," *New York American,*
3 April 1910.

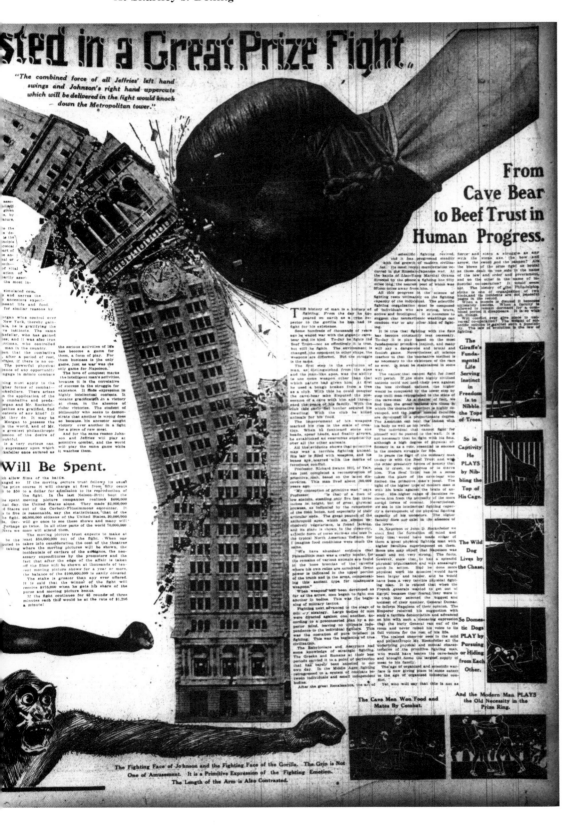

sted in a Great Prize Fight

"The combined force of all Jeffries' left hand swings and Johnson's right hand uppercuts which would be delivered in the fight would knock down the Metropolitan tower."

From Cave Bear to Beef Trust in Human Progress.

The Giraffe's Fundamental Instinct in Serving Life Is to Nibble the Top of Trees.

So in Captivity He PLAYS by Nibbling the Top of His Cage.

The Wild Dog Lives by the Chase.

So Domestic Dogs PLAY by Pursuing or Hiding from Each Other.

The Cave Men Won Food and Mates By Combat.

And the Modern Man PLAYS the Old Necessity in the Prize Ring.

The Fighting Face of Johnson and the Fighting Face of the Gorilla. The Grin is Not One of Amusement. It is a Primitive Expression of the Fighting Emotion. The Length of the Arm is Also Contrasted.

48. "Exhibition by Independent Artists Attracts Immense Throngs," *New York American*, 4 April 1910.

uproar in the press, there was actually little unfavorable commentary about Bellows's paintings in reviews of the Independent Artists' Exhibition. The violent reactions seem to have been confined to discussions Read heard among her critic colleagues, the import of which never reached their printed newspaper columns. Others have testified, too, about the hostile reception that greeted Bellows's boxing pictures.[130] The specifics, again, went unrecorded. But a review of Bellows's early career and a brief reconstruction of the relevant current events of April 1910 suggest that since criticism of Bellows's style was rare and objections to his choice of the prizefight as a subject were hardly overwhelming, the vehement reactions to Bellows's boxing pictures must have been stimulated by other issues. One of these pictures in particular, it seems, reminded many gallery-goers of the controversial and dreaded as much as anticipated bout between Jeffries and Johnson. Probably, too, it called up emotionally charged attitudes about race as well as darker feelings about sexuality. These issues were unspoken and probably unacknowledged, but they were factors that must have influenced the responses of urban contemporaries who saw Bellows's paintings for the first time in April 1910. These attending mental associations may have sparked hostility, but they also served to make the pictures seem remarkably real and contemporary. Both of Bellows's boxing pictures, in fact, were alive with potential allusions, references, and, ultimately, meanings.

The Exhibition of Independent Artists

A brief summary of the salient associations that might have been allied with Bellows's big pictures demonstrates how exquisitely they were suited to symbolize the revolutionary spirit of the Exhibition of Independent Artists in April 1910.[131] These ferociously expressive paintings represented, among other things, the intensity of "real life" and the liberal challenge to middle-class social conventions, as well as heroicized masculine hardiness. What better painting than *Stag at Sharkey's* to illustrate du Bois's assertion (in his review for the *New York American*) that the American artist was no longer typified by the "long-haired, dreamy-eyed, velvet-coated aesthetic." As du Bois continued, the Independent Artist "is a man—a living, breathing, seeing man":

> Blindly, without reference to a handbook of aestheticism, each one of them has put down what he has seen and how it impressed him. They are individuals with personal viewpoints, and their exhibition is a vital, manly—if artistically vulgar—record of a living, seeing, breathing set of human beings whose hands and visions are not warped into inefficiency by the conventional aesthetics.[132]

Other newspapers, too, selected Bellows's *Stag at Sharkey's* to illustrate reviews of the Independent Artists' Exhibition. The Sunday following the opening, the *New York Sun* devoted virtually a full page, illustrated, to somewhat

bemused reflections on what the exhibition was all about. It was thought to be "everything that is not academic," yet work by academicians was hanging, too. And it was noted that artists who exhibited at the Academy were represented "not [by] the pictures they show in Fifty-seventh street." Since this assertion went unexplained in the text, the pictures were left to tell their own story, to illustrate the assumed differences between the Academy and the Independent Artists' Exhibition. Positioned underneath an utterly benign landscape with two nudes, *Stag at Sharkey's* made by far the most aggressive statement of the six paintings reproduced.[133]

One of the most cogent, though simplistic, of the contemporary discussions of the Independent Artists' Exhibition appeared some weeks after it closed, in the *New York World*. By that time Bellows's boxing paintings had come to be closely associated with the Independents' show. The subtitle of Henry Tyrrell's *World* article indicates that for him the prizefight pictures also embodied its spirit: "How the 'Art Rebels' of America Are Shocking the Older Schools by Actually Putting Prize Fights on Canvas and Picturing Up-To-Date Life As It Really Is Here and Now." Not only was Bellows's *Stag at Sharkey's* the largest reproduction on the page, but Luks's *Wrestlers* was also enlisted as an illustration even though that painting was never in the show.[134] The shock value of these raw and seemingly "un-Academic" subjects was meant to demonstrate the novel quality of work by the Independents, although several critics had reported the absence of anything surprising, let alone startling, in their exhibition.

The real story of the Exhibition of Independent Artists, other than the sheer volume and variety of work, consisted in its statement of resistance against the exclusivity of the Academy. Henri explained the concept of the project, in an article for the *Craftsman*, as "an opportunity for individuality" and "freedom to think and to show what you are thinking about." But in practical terms, the opportunities that Henri was really concerned with involved finding a way around the Academy's jury as well as its equally hated hanging committee.[135]

Although few critics detailed specifics about the organizational nuts and bolts of the exhibition or just how the participants were "independent," reviewers consistently emphasized the spirit of revolt that surrounded the enterprise. And the artists' protest garnered considerable sympathy. The story of Henri's ongoing battle with the Academy had become familiar within art circles, but in April 1910 the political climate was particularly receptive to the efforts of a repressed group to make its voice heard and to force change. The *Globe*'s review of the Independent Artists' Exhibition made the connection explicit: "This is unmistakably the day of the Insurgent, the Revolutionist, the Independent, in art as in other directions."[136]

The uprising of the determined young artists around Henri, artists who had a reputation for being "democratic" and concerned with "the people," sounded much like the insurgents' movement in Congress. There, too, young upstarts were waging a revolt against entrenched power, a revolt broadly publicized as pitting

proponents of direct democracy against the Money Trust. A group of insurgent Republican congressmen had begun coordinating opposition to the dictatorial power of Speaker Joseph P. Cannon back in early spring of 1909. The progressive press quickly took up the cause, portraying Cannon and his cronies as thorough-going reactionaries. In connection with the debate over new tariff legislation, which clearly favored the interests of big money, periodicals like the *Outlook* lashed out against the "princes of privilege" and their betrayal of "the people."[137] Sensitized by a decade of muckraking exposés to the arrogance of soulless corporations and the involvement of big business in the political process, angry taxpayers and consumers responded to the press campaign. The four-month battle over the tariff bill ended in defeat for its opponents on 8 August 1909, but public opinion had been rallied to the side of the congressional insurgents. Meanwhile their opposition—Speaker Cannon and Nelson W. Aldrich in the Senate—came to symbolize monopolies, trusts, and high finance.

Insurgency remained in the news throughout the fall. President Taft's administration failed to act on charges brought against the new secretary of the interior, Richard Ballinger. The progressive press again rallied behind the minority position of the insurgents, and *Collier's Weekly* printed a damning article by the Interior Department functionary who initially wrote the report against Ballinger and was subsequently fired.[138]

Skirmishes over the tariff and the Ballinger issue played strategic roles in the larger war on Speaker Cannon. The new session of Congress opened in March 1910 with a challenge against the Speaker. The protest movement reached a climax in a pitched battle on the floor of the House, which kept the insurgents in the headlines across the nation for weeks. Meanwhile, in the Senate, charismatic Robert La Follette of Wisconsin was the press's darling. In a *Harper's Weekly* centerfold cartoon (26 February 1910; figure 49) E. W. Kemble portrayed La Follette as the favored underdog in a boxing match against the formidable "Machine Champion," Nelson Aldrich. Uncle Sam was a booster in the progressives' corner: "Don't let up, Little One, this must be to a finish!" Leaders on both sides of the fray acknowledged the role played by the popular press. Senator Albert J. Beveridge, himself an insurgent, wrote to associates reflecting on the fact that the "cheaper magazines," which he called "the people's literature," had virtually effected "a mental and moral revolution."[139]

Indeed, insurgency was the theme of the times. The *Independent's* last issue for March featured an article titled "Insurgents We Are Watching." La Follette headed the list, and the article opened: "Insurge against something if you would be popular. And this is not such a bad condition, for, politely paraphrased, it simply means that the man of the hour is the man with convictions—and the courage of them."[140] Thus, the political context in which Tyrrell set his *New York World* review of the Independent Artists' Exhibition invoked a familiar theme:

49. Edward W. Kemble, *Uncle Sam: "Don't Let Up, Little One, This Must Be To a Finish!"* cartoon from *Harper's Weekly*, 26 February 1910.

"It is not a revolt, sire, it is a revolution."

These words of the courtier to Louis XVI on the day the Bastile fell may be applied not inappropriately to the recent inaugural exhibition of the Independent Artists, held in improvised galleries on the three vacant floors of a commercial warehouse in New York City.

The spirit manifested by the young men and women who organized it is characteristic of the "insurgent" influence that is in the air in matters artistic as well as in politics, religion and society generally.[141]

Parallels between congressional insurgency and the protest movement of Henri's group were obvious enough. The *Literary Digest* titled its report on the show, simply, "Insurgency in Art."[142] Several critics conferred political ramifications on the spirit of the Independents' show, and sympathies generally ran along partisan lines. James Huneker, a moderate whose support for the Henri group was often qualified by rather large reservations, poked fun: "All the lads and lasses, the insurgents, revolutionists, anarchs [*sic*], socialists, all the opponents to any form of government, to any method of discipline, are to be seen at this vaudeville in color." Meanwhile the socialist *Call* embraced the perceived political content of the artwork, concluding, "Radicalism, artistic and social, was the dominant note."[143]

These alignments between art and politics during April 1910 were described, of course, in broad terms. Critics like Tyrrell made sweeping gestures toward "the influence that is in the air." The "influence" associated with insurgency was, in reality, at least as conflicted as it was coherent. The campaign of the congressional insurgents was no more single-minded or monolithic than the entire history of the progressive movement;[144] in like manner, the actions of Henri's revolutionaries sprang from a range of personal and professional motivations. Henri himself was acting on a longtime commitment to greater freedom of artistic expression and to opposing the exclusionary policies of the Academy. But personally he was also still recoiling from the sting of rejection: his own *Salome* had been thrown out of the Academy's recent Winter Exhibition.

Having acknowledged these complexities, however, a few general observations can be made about the relation between the mood of insurgency and the staging of the Independent Artists' Exhibition. First, the gathering of "throngs" at its opening on 1 April speaks of an active interest in the art event being orchestrated by Henri's "insurgents." Second, the critical commentary concerning the exhibition, on the progressive as well as the conservative side, suggests an appetite for change and innovation in the arts. Third, these phenomena were occurring during a period of wrenching social and economic change in America. At least one historian has described these transformations in terms of a cultural revolution.[145] But in fact the early years of the twentieth century saw great pressures for change along with a compelling and widely felt need for continuity. Peter Conn has painted a convincing

picture of "the divided mind," the ambivalent attitudes that characterized the American psyche during the years 1898 to 1917, and an ongoing "conflict between tradition and innovation."[146]

Competing allegiances to tradition and to innovation can also be identified in the group of artists involved with the Independents' show. Indeed, the exhibition project, which represented their collective effort to resist the art establishment, retained strong conservative elements. The Independents longed for the benefits that membership in the existing establishment conferred, namely, having their work exhibited and therefore available for purchase along with that of certified academicians. Some of the insurgent artists did express the desire to modify the form and structure of the "establishment" in question—again, the National Academy—but only so that it would accommodate outsiders such as themselves.

The modest dimensions of the Independent Artists' "revolution" were aptly noted by perceptive critics. James Huneker, for example, who was himself well informed about art movements internationally, conceived of the Independents' revolution primarily in artistic terms, as a swing away from "the insipidity and conventionality of the Academy to the opposite extreme." But he suggested a telling comparison between the seemingly unselective Independent Artists' Exhibition and a recent show at the Photo-Secession Gallery, where Stieglitz had exhibited "a grouping of the minor spirits of the Matisse movement that were actually new, not mere offshoots of the now moribund impressionists as are the majority of the Independents."[147] Even the arch-conservative Royal Cortissoz found "the air of protest filling the three floors" of the Independents' show relatively unsubstantiated by the artwork itself:

> On the one hand you have entrenched authority, usually committed to academic formulae and usually rich in mediocrity, resenting the rise of anything new. On the other hand, you have youth and originality, sometimes genius, and always a generous ambition. Because your hidebound academician is intrinsically an obnoxious type it is natural to sympathize anyway with the movement he tries to repress. . . . One may reasonably attribute to everybody in this crowded gallery a distaste for conventional methods, and, by the same token, a desire to paint life rather than subjects built up in the studio. The themes drawn from the prize ring by Mr. Bellows or from the movement of our city streets by more than one of the painters represented may be taken as significant of a broadly diffused interest in what is free and contemporaneous. There is, to be sure, nothing very startling about it, but at least it may be given its full value. . . . There are certain men who are clever enough to arrest the observer, interest him and give him some pleasure. . . . But it is curiously mild, it falls curiously short of making one feel that an exhibition of this kind was, after all, worth while. More-

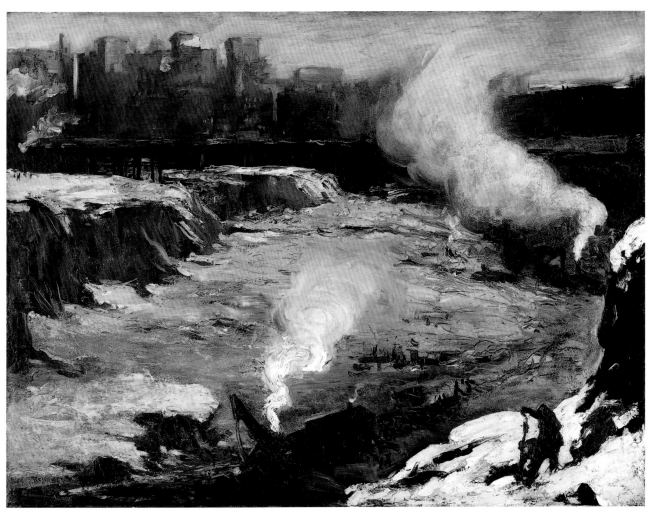

Plate 1. George Bellows, *Pennsylvania Excavation,* 1907. Private collection.
Photograph courtesy the H. V. Allison Galleries, New York.

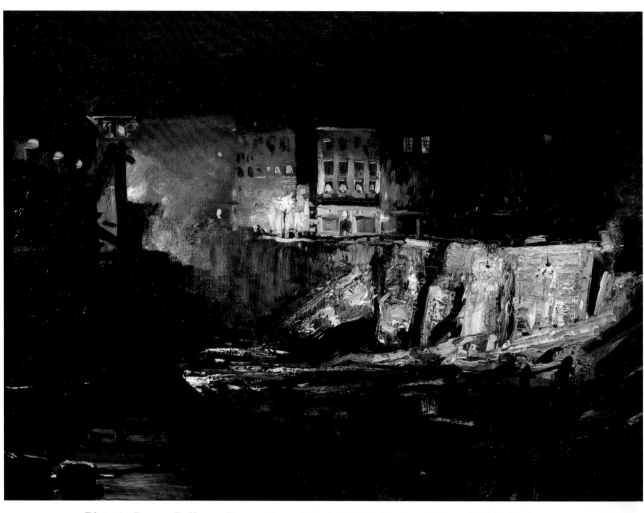

Plate 2. George Bellows, *Excavation at Night,* 1908. Courtesy Berry-Hill Galleries, New York.

Plate 3. George Bellows, *Pennsylvania Station Excavation*, ca. 1907–09. The Brooklyn Museum, New York. A. Augustus Healy Fund, 67.205.

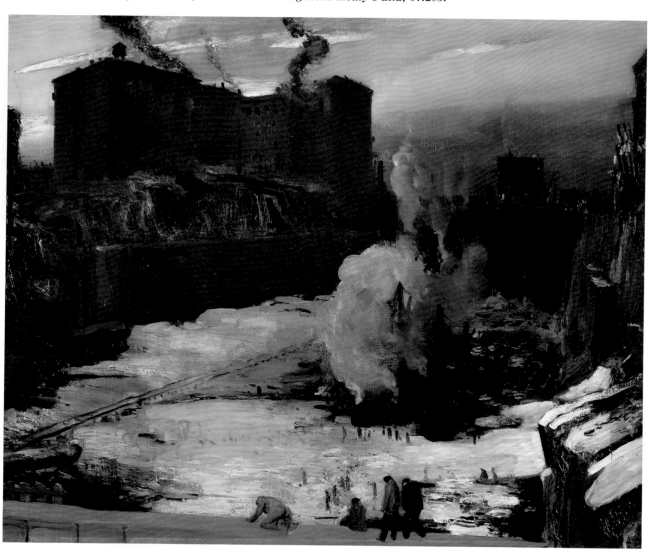

Plate 4. George Bellows, *Blue Morning*, 1909. National Gallery, Washington, D. C.
Chester Dale Collection.

Plate 5. George Bellows, *Rain on the River,* 1908. Museum of Art, Rhode Island School of Design, Providence. Jesse Metcalf Fund.

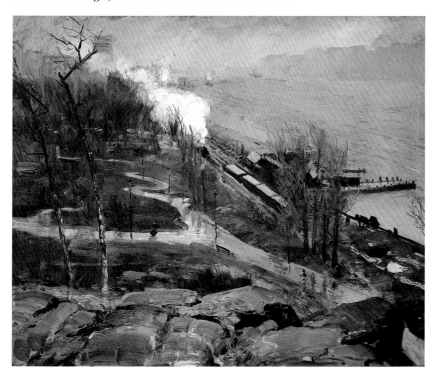

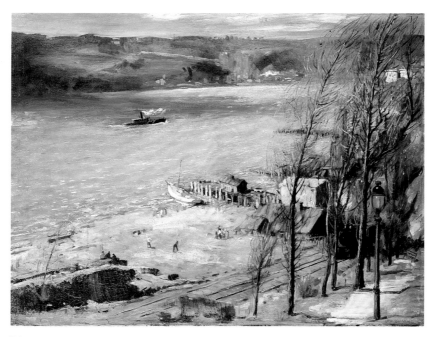

Plate 6. George Bellows, *Up the Hudson,* 1908. The Metropolitan Museum of Art, New York. Gift of Hugo Reisinger, 1911.

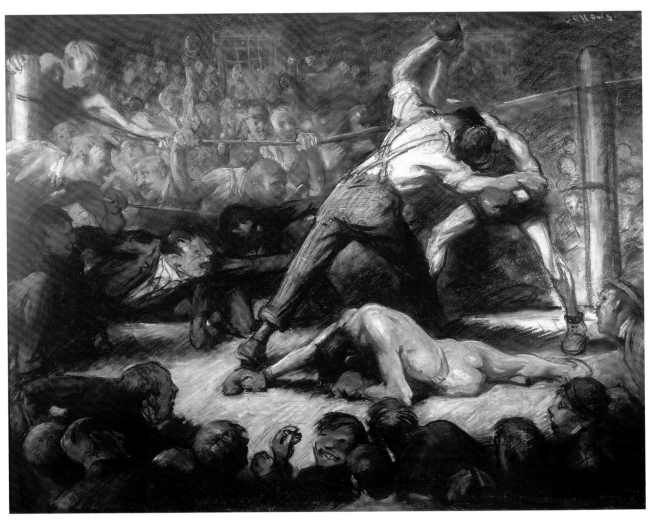

Plate 7. George Bellows, *The Knock Out*, 1907. Pastel and India ink on paper. Rita and Daniel Fraad Collection.

Plate 8. George Bellows, *Club Night* (originally *A Stag at Sharkey's*), 1907. National Gallery of Art, Washington, D.C. John Hay Whitney Collection.

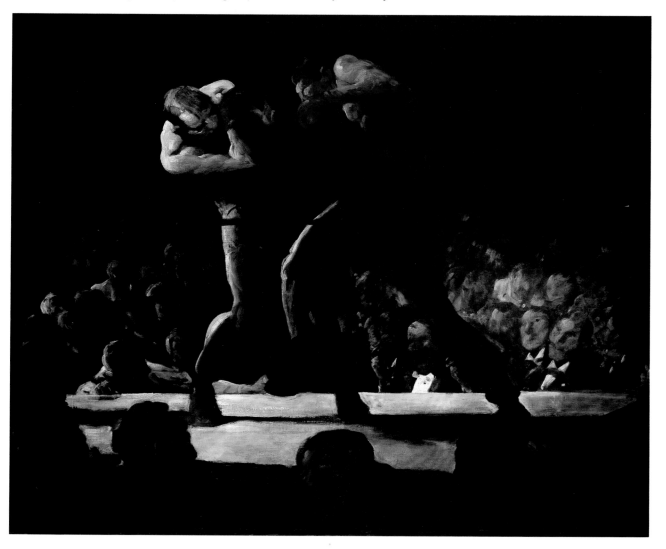

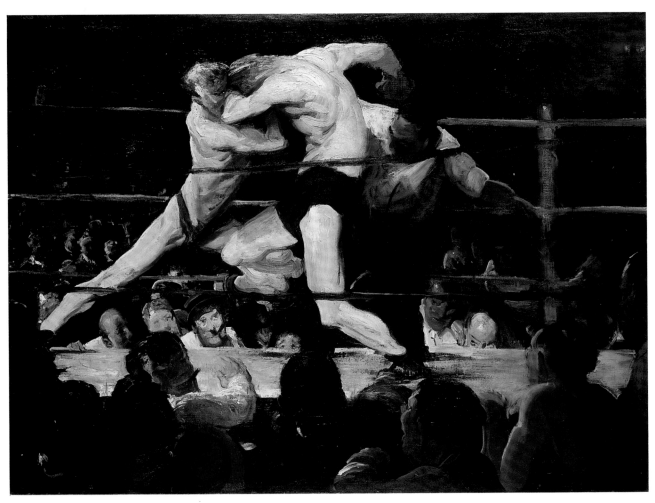

Plate 9. George Bellows, *Stag at Sharkey's* (originally *Club Night*), 1909. The
Cleveland Museum of Art. Hinman B. Hurlbut Collection, 1133.22.

Plate 10. Detail of *Stag at Sharkey's*.

Plate 11. George Bellows, *Both Members of This Club* (originally *A Nigger and a White Man*), 1909. National Gallery of Art, Washington, D.C. Chester Dale Collection.

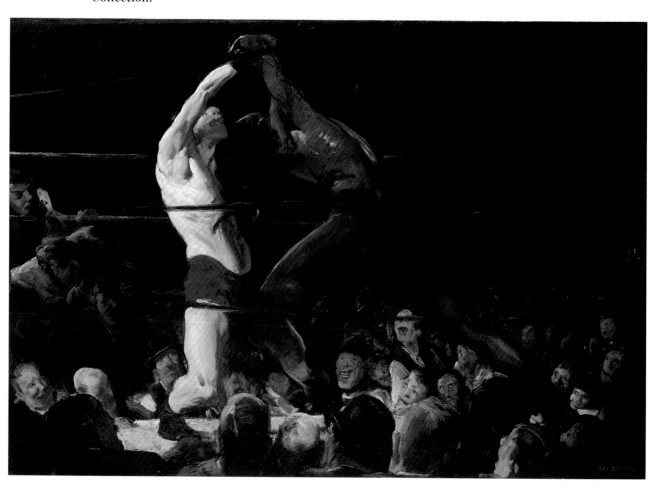

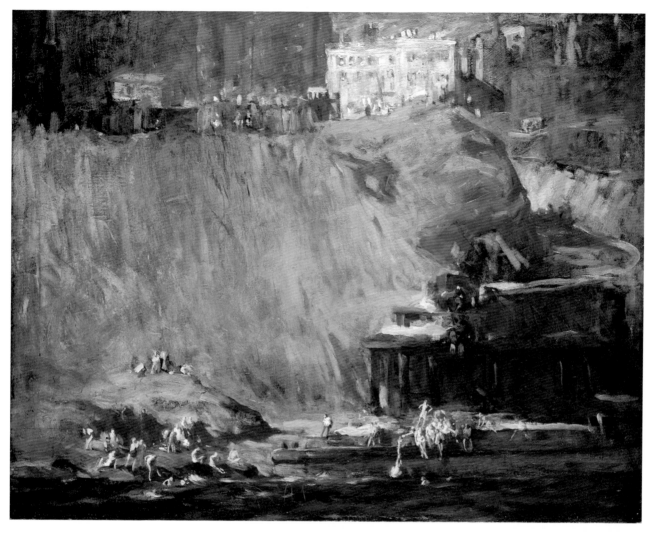

Plate 12. George Bellows, *River Rats,* 1906.
Private Collection, Washington, D.C.

Plate 13. George Bellows, *Kids,* 1906. Rita
and Daniel Fraad Collection.

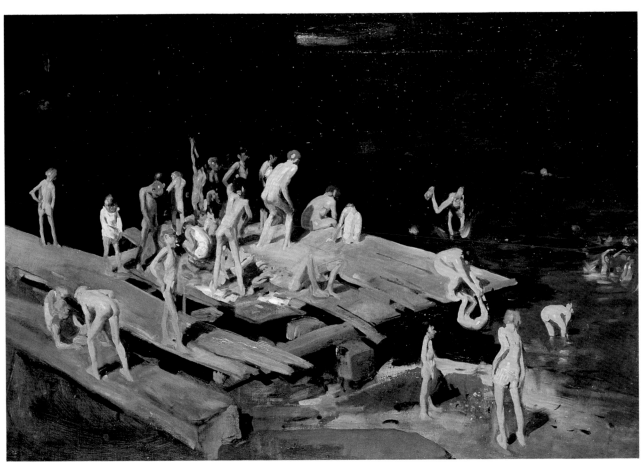

Plate 14. George Bellows, *Forty-two Kids,* 1907. In the collection of the Corcoran Gallery of Art, Washington, D.C. Museum Purchase, William A. Clark Fund.

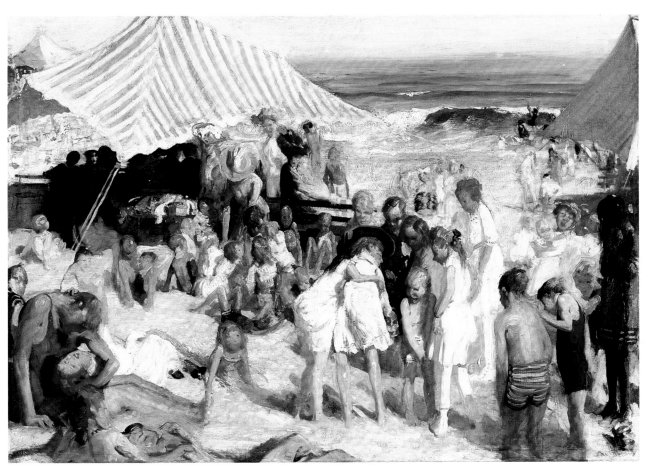

Plate 15. George Bellows, *Beach at Coney Island,* 1908–10. Private Collection.
Photograph courtesy the H. V. Allison Galleries, New York.

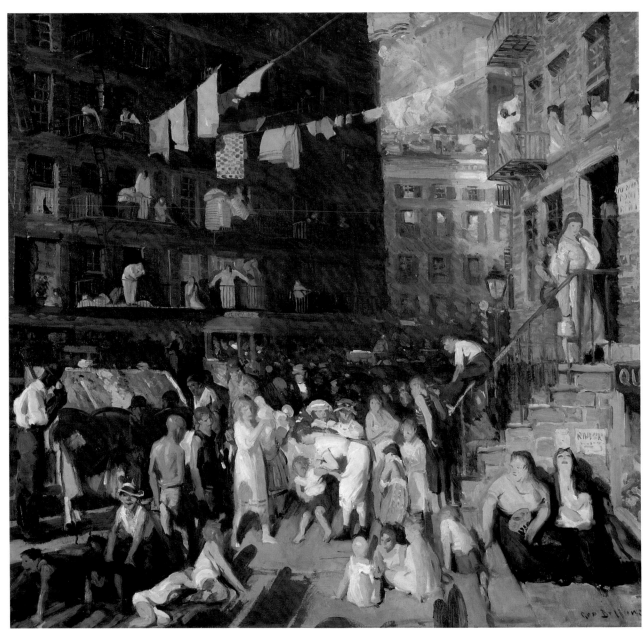

Plate 16. George Bellows, *Cliff Dwellers,* 1913. Los Angeles County Museum of Art. Los Angeles County Funds.

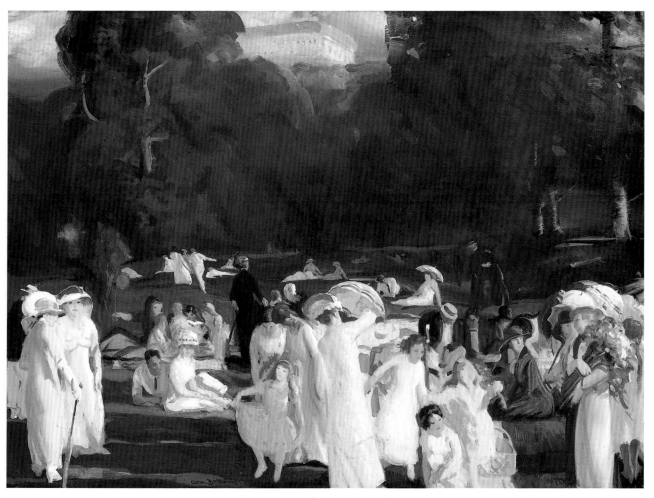

Plate 17. George Bellows, *A Day in June,* 1913. The Detroit Institute of Arts. Detroit Museum of Art Purchase, Lizzie Merrill Palmer Fund.

Plate 18. George Bellows, *Frankie, the Organ Boy,* **1907. Courtesy Berry-Hill Galleries, New York.**

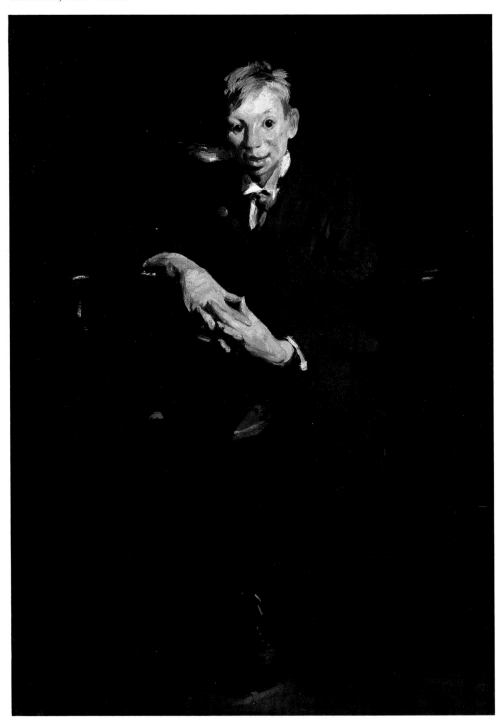

over, not one of these artists, not even the prodigiously clever Mr. Henri, impresses us as an especially new type.[148]

Cortissoz's characterization of the Independents as evincing a "broadly diffused interest in what is free and contemporaneous" was actually not far from the mark. Likewise, his concluding verdict was probably correct: the show would have been more favorably received, especially by the old guard, if it had been limited to a selection of the strongest entries by the most mature artists. Finally, Cortissoz's damning description of the show as "curiously mild" may ultimately hold the key to its broad and popular appeal. In fact, virtually all the New York reviews, written by experts and dilettantes alike, suggested again and again that the exhibition was perceived as a mixture of the refreshingly novel and the comfortably familiar. Billed as New York's Salon des Refusés, the show promised to be everything "conservative conventionalism" was not.[149] But, much like Bellows's first boxing painting as it was seen in the 1907 Winter Exhibition at the National Academy, the Independent Artists' Exhibition offered a modest degree of excitement and stopped short of shock or offense.

Everyone agreed that the exhibition was large—some 260 paintings, 219 drawings, and 20 sculptures.[150] Joseph Edgar Chamberlin, in the *Evening Mail*, called it "one of the biggest exhibitions, in various senses, ever seen in New York."[151] In addition to several members of the original Eight, whose work was not new to gallery-goers but was still considered advanced, if not revolutionary, many of the exhibiting artists were Henri students. It was primarily toward this student work that critics directed such terms as "struggling," "half-realized," and "crude talent . . . without schooling or direction."[152] But mainly because Henri's dominating influence was reflected in such a large proportion of the work, many reviewers did discern a forthrightness, in technique and in approach to contemporary subject matter, throughout the exhibition. In other words, they identified qualities that seemed at least loosely to characterize much of the work on display, qualities often associated with Robert Henri. As the critic for the *Times* reported, "The impression upon entering the galleries is one of vigor and sincerity rather than novelty. . . . And while a good deal of the work . . . is crude, the best of it demonstrates a healthy spirit and honest intention."[153]

Although Henri insisted that the exhibition was not about rejected artists and consistently stressed the positive aspects of the project, one of his own paintings was expressly identified in the press as an Academy reject. Henri had certainly intended to jolt the jury with his *Salome* (figure 50), a highly recognizable reference to the Richard Strauss opera, which had a colorful history in New York City. When it was first performed there in 1907, self-appointed defenders of the public morality succeeded in getting several performances canceled and in the process produced considerable publicity for the opera. When Henri painted Mademoiselle Voclezca in the revealing costume she wore for the famous dance

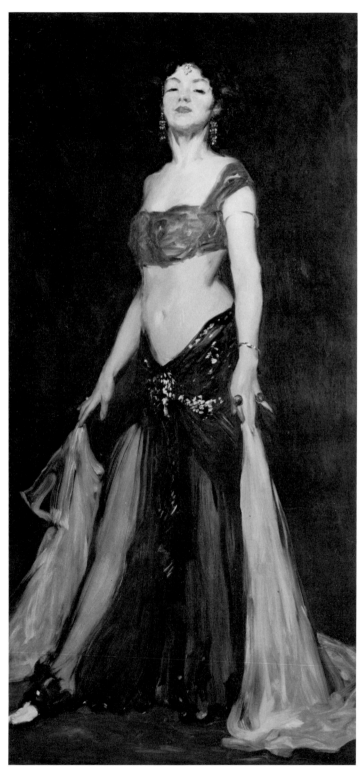

50. Robert Henri, *Salome*, 1909. Mead Art Museum, Amherst College, Amherst, Mass. Museum Purchase.

scene, the focus of the furor, he knowingly toyed with sensationalism. His Salome was "half-nude," a condition usually thought more suggestive than complete un-dress.[154] Firmly grounded in Manet, however, Henri's painting was stylistically repu-table, and on the imposing scale of 77 by 37 inches, *Salome* might have been a gallery centerpiece at the Academy, a *salon machine*. But an overly sensitive, or perhaps vindictive, jury intervened. When it finally did go on display, in the Exhibition of Independent Artists in April, the painting provoked a few raised eyebrows but no scandal.

Bellows's two boxing paintings performed much the same function. They were sensational, probably even more so than the *Salome*, and they stimulated much discussion. If the visibility of *Stag at Sharkey's* in the press serves as any indication, the boxing paintings were crowd gatherers. For all their red blood and brutality, however, they must be characterized as relatively conservative images: they delivered an essentially Victorian statement, disapproving of boxing and of the tawdry milieu associated with it. By contrast, Henri's *Salome* presented a straightfor-ward, apparently nonjudgmental portrait of a notorious actress in an obvious evoca-tion of her most outrageous scene. Because the boxing paintings reflected the conventional, judgmental stance, they seemed more palatable in the eyes of contem-poraries.

Stag at Sharkey's and *Both Members of This Club* had their most illustrious outing at the Independent Artists' Exhibition. Since then both pictures have remained vital, almost sublime works of art; but never again could they serve as the fully potent and expressive vehicles that they did in April 1910. Not only was boxing a current and hotly debated subject but also, in terms of a wider, cultural perspective, these particular paintings were exquisitely attuned to the conflicted attitudes and expectations of the Progressive Era. They succeeded in combining oppositional and traditional values. In terms of their subject, and to some degree their style as well, the boxing paintings implicitly presented a challenge to the social as well as the artistic establishment. Yet these paintings reaffirmed traditional stan-dards of respectability and responsibility. And Bellows's brilliant, slashing technique was fast becoming the vogue.

The boxing pictures were signature paintings for Bellows. They bore the hallmarks of Henri's teachings and therefore confirmed Bellows's association with that still-prominent circle. At the same time they stood out with an individual expressive voice and helped establish Bellows's own identity as an artist. The bold, brash subject fit his self-conception, and the process of creating these pictures was part of Bellows's efforts to construct a sense of his own manhood. The strong personal, emotive resonances in the boxing paintings and their tacit affirmation of heroic individualism seemed to embody something of the essence not only of the Independent Artists' Exhibition but also of the entire first, strenuous decade of the twentieth century.

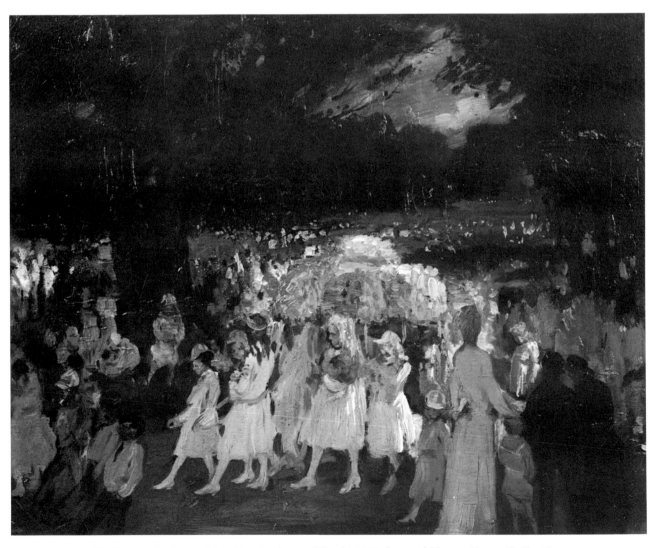

51. George Bellows, *May Day in Central Park*, 1905. Ira and Nancy Koger Collection.

The Other Half Chapter 3

Several of Robert Henri's followers and students have testified to their mentor's place in history, and in so doing, to their own. The most outspoken have generally been loyal to the idea of his, and their, radicalism. Everett Shinn maintained, in 1944, that paintings by the Eight were "the authentic implements of a rebellion" in an age when "an ankle was a rare sight." The honesty of their paintings, their grasp of the real, was startling to "a deceitful age, drugged in the monotony of pretty falsification."[1] Helen Appleton Read, reflecting back on Henri's famous life class, called it "a symbol of the new ferment in the social and cultural life of the nation," and his school, she remembered, had the reputation of "encouraging radical ideas." For many of Henri's associates, his central doctrine, that all of life held potential subject matter for artists, implied the corollary than the life of the poor was somehow more real than the life of the wealthy and thus provided better subjects. This reasoning led in the direction of what Read termed "a species of mild socialism."[2]

More recently scholars have tended to place less emphasis on ties between social protest in the art of Henri's circle and reform movements in politics and society at large. The broad relationships have perhaps seemed too obvious to dwell on and specific connections too insubstantial. Sam Hunter refers briefly in his survey of twentieth-century American art to a national interest in reform that seized the American imagination in Theodore Roosevelt's second term. With what Hunter described as "boyish opportunism," writers and artists alike reveled in the purging, refreshing spirit of the time. He concludes, however, that the commitment to grapple with social subjects, especially among the painters, lacked depth and stopped short of real involvement with radical politics and the problems of the working classes. Their radicalism, in his view, consisted of "their spirit of insurgence and desire to address art to life."[3]

The consensus of art historians probably lies somewhere between two poles: John Baur's claim, on the one hand, that the Eight's revolution in subject matter can be equated with the stylistic revolution brought on by the Armory Show

and, on the other hand, Amy Goldin's contention that Henri's group failed even to make a common thematic statement. In her effort to dismiss the "myth of the radical Eight," Goldin strictly delimits their revolt to a business matter: "The Eight stood for artistic laissez faire in opposition to the patronage monopoly exercised by the Academy."[4]

Henri himself would most certainly have wanted to challenge Goldin's assertion that his ideas "stood in no particular opposition to the values of the Academy."[5] Henri carefully nurtured his reputation as a revolutionary, proselytizing his artistic doctrines with a missionary zeal. Moreover, a substantial segment of the early twentieth-century arts audience accepted as fact the reality and the imperative of his revolt—a revolt not just against the National Academy but also against the academic approach to art. New Yorkers could read about all this in the daily press. As Henri himself made it clear, his method of instruction at the New York School of Art stood in direct opposition to academic idealism and the routinized training associated with it. He favored, instead, a spontaneous response to quotidian reality. It was the nature of that everyday reality that most often earned him the radical label: his followers and students depicted what they supposed to be the real life of New York City, but in the view of many of their contemporaries they were particularly enamored of painting the slums.

New York's Art Anarchists

A series of Bellows's early drawings and paintings clearly indicates that sometime after his arrival in New York City his choice of subject matter changed significantly, as did his technique. Initially he was attracted, as he had been in Ohio, to popular, commodious subjects like the scene depicted in *May Day in Central Park* (figure 51). *Children Playing in a Park* (figure 52), an ink drawing that probably also dates from the spring of his first year at the New York School, reveals quite distinctly the lingering influence of Gibson-style illustration. The familiar mannerisms are especially evident in the abbreviated cross-hatching intended to be read as tree foliage. *Children Playing* presents a collage of vignettes—groups of healthy, active children involved with various outdoor and sporting activities. Bellows has brought these vignettes impossibly close together in his drawing, but in the shorthand of illustration convention they are understood to stand for clusters of representative scenes taking place in the verdant open spaces of Central Park.

By the spring of his second year under Henri's tutelage, Bellows was painting different children, in a very different section of the city, and in a different style. The girls and boys depicted in *Kids* (figure 53) are definitely not upper-class. In fact, the term *kids* was not used during this period to refer to children of the well-to-do; it was generally reserved for streetwise youngsters of the poor and working classes. The "kids" in Bellows's painting pass their time without the benefit of parks or even balls and skates. In front of a simple planked facade they interact, play

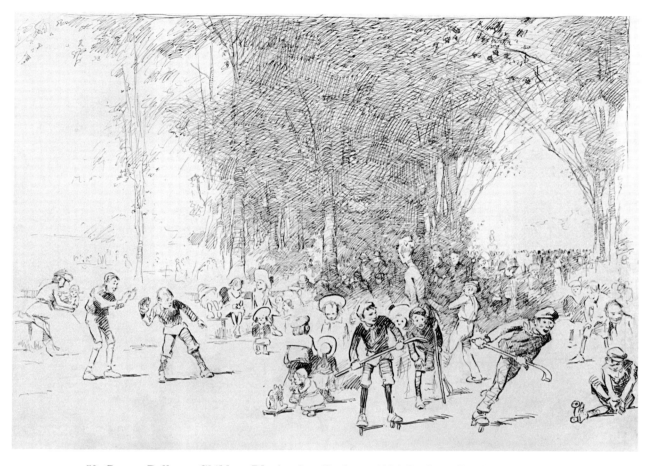

52. George Bellows, *Children Playing in a Park,* ca. 1905. In the collection of the Corcoran Gallery of Art, Washington, D.C. Museum Purchase.

games, slouch, hang around; one sucks her thumb, another smokes. The entire scene constitutes a sharp contrast with the activities and the very postures of the children Bellows depicted playing in Central Park. Little remains in the later work from the modish realm of Charles Dana Gibson or *Life* magazine. Gone, too, is the crisp, two-dimensional drawing style. Bellows's approach to subject matter, indeed his vision of reality, would seem to have been transformed.

Showing *Kids* in the Society of American Artists' Annual Exhibition in 1906—the artist's first entry in what would have been considered a national show—proclaimed Bellows's identification with antigenteel subjects approached without idealization.[6] In 1906, when the arbiters of taste were still promoting depictions of the "more smiling aspects" of American life,[7] paintings like *Kids* could create a definite stir, especially when the painting itself showed strong signs of talent. Thus, Bellows forged his link with the notorious Henri camp, a connection that would help shape the development of his early career.

Later that spring, Bellows's name appeared in an article entitled, "New York's Art Anarchists," one of the earliest substantive efforts to define the radicalism of Henri's doctrine. Ostensibly a review of the 1906 student show at the New York School, the article, by Izola Forrester, was published in the Sunday magazine of one of the city's most popular newspapers, the *New York World*. The richly illustrated feature focused on Henri's composition class, where students portray "Manhattan everyday life . . . not idealized and worked up into unnatural 'effect' but truthfully and powerfully and without flattery." Forrester suggested, with a tone of genuine astonishment, that it took more than a love of art to recognize meaning and even beauty in a crowd of East Side children "hanging over garbage cans." The result of such sympathetic study of neighborhoods on the Lower East and Middle West sides[8] was readily apparent in the exhibition, where student work on display represented "a radical reaching out toward an entirely new line of American art."[9]

Confrontations with the underside of the city were still startling the following spring for a *Globe* reviewer who ventured into the 1907 student show at the New York School (where Bellows's *River Rats* [see figure 5] and *Pennsylvania Excavation* [see figure 1] were on view):

> But above all, it should be instilled in these pupils that God's world is frequently a cheerful place; that there are light, air, and sunshine occasionally; that for the purposes of the decoration of the walls of the drawing room one now and then demands a bit of beauty, of hope, of optimism; that the average human being is a fairly proportioned person, with a bit of color, some life under the flesh, and some animation in the countenance. These characteristics we miss here, and we leave the hall with a sense of oppression, glad to get in the open, where we find normal people, smiling and happy, with background of glorious sky and colorful buildings.[10]

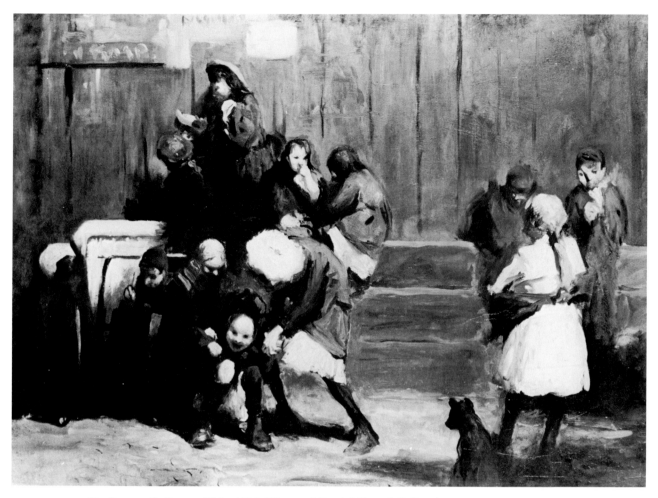

53. George Bellows, *Kids,* 1906. Rita and Daniel Fraad Collection.

One-time Henri student Helen Appleton Read remembered that challenging the canons of academic good taste by painting unsavory subjects entailed political overtones and, furthermore, that George Bellows soon came to be seen as a moving force behind that challenge: "It was the unprecedented realism of these portrayals of tense moments in the prize ring and the early paintings of riverfronts and crowded tenement districts which did more to establish the Henri group's reputation for hard-hitting realism and radicalism than any other single factor."[11]

During the years 1906 to 1910, however, it was most often Henri's name that was paired with terms like *revolutionary* and *radical*—even by such a seasoned critic as James Gibbons Huneker. In January 1907, reviewing a one-person show of Henri's work at the New York School, Huneker admitted that in France Henri would hardly be aligned with the "anarchs who display their violent deeds in paint at the Autumn Salon," but here in America there could be no mistake: "He is a revolutionary and we glory in him."[12]

The following April, Henri waged his fight with fellow members of the National Academy jury. Henri had fought most valiantly, and unsuccessfully, for including a painting by George Luks; and Huneker took the opportunity to feature Luks in a long and extraordinary article. In it he attempted to examine the divergence between the Academy and this talented painter—and, by extension, Henri's group of "younger men." He set himself the task of explaining why Luks's pictures were rejected by the Academy and then went on to assert that they did not "belong in an academic exhibition." Luks was a "revolutionist" whose work was "too big, too virile, too ventral, too Rabelaisian" for polite academic society. Huneker touched on both style and subject matter in his analysis, and clearly they went hand in hand: "The truth is that George Luks has a love of rough paint. He is not refined when he handles unrefined themes. He calls a spade a spade." It was, finally, the totality of his vision that offended: "This violent imagery, this seeing things in the gross, this diabolic representation of an ugly reality fascinates, disturbs, repels."[13]

Such commentary appeared with increasing regularity in all but the most conservative quarters. Paintings by members of Henri's circle were perceived as standing distinctly apart from the kind of art New York audiences were accustomed to seeing—different, indeed, from the pictures Huneker described as "cadavers," which usually hung in the Academy shows. This same critic called the Eight's Macbeth Gallery exhibition "reactionary" in comparison with the Parisian avant-garde, but back in "provincial" New York City their vision of contemporary life was noteworthy:

> They are realists inasmuch as they paint what they see, let it be ugly, sordid or commonplace. Luks, Sloan, Glackens, born illustrators, are realists, as are Gorky, the late Frank Norris in "McTeague" and Theodore Dreiser in "Sister Carrie," though very often in sheer artistry superior. But they are not afraid of coal holes, wharf rats, street brats,

the teeming East Side and the two rivers. They invest the commonest attitudes and gestures of life with the dignity of earnest art.[14]

Even as mainstream art critics were calling Henri's men revolutionaries, on the basis of their unrefined themes and brutally expressive technique, some political radicals were attracted to the cause of new artistic trends that seemed to express social awareness and concern. John Spargo, whose *Bitter Cry of the Children* brought him to national prominence when it was published and reprinted twice in 1906, was among the most popular propagandists for Marxian socialism in America.[15] Spargo happened across some pictures by Eugene Higgins in a French magazine.[16] Deeply touched by what he described as "powerful pictures of outcast, broken and desolate human beings," he located Higgins and wrote a celebratory article about this "Gorky in paint."[17] Spargo's own *The Comrade*, which was devoted to socialist literature and art, folded in 1905, but his strong links to the tradition of art appreciation tracing from John Ruskin through William Morris harmonized perfectly with the utopian outlook of *Craftsman* magazine. He published his tribute to Higgins in the May 1907 issue of *Craftsman* and shortly thereafter contributed to the same magazine a spirited interpretation of the George Luks–versus–National Academy affair. The "natural conservatism" of the Academy was once again blamed for posing "a serious obstacle to big and virile artists who breathe the spirit of revolution and radical change." But for Spargo, radical change entailed more than a liberalized exhibition policy. He called for "freedom from the dry rot of age and tradition, from the conservatism which kills the soul, from the dead past which like a mountain weighs upon the living brain," and he exhorted Americans to despise the "cleverness" and "artificiality" of academic art. He praised Luks, on the other hand, for finding artistic inspiration in the streets of the American city, where "great vibrant passions . . . seethe between mansion and hovel."[18]

Spargo had indeed found a congenial publication vehicle for his articles on socially relevant art. Gustav Stickley, *Craftsman*'s founder and editor, had made the philosophical perspective of his magazine clear in the first issue: he pledged his commitment to the principles established by William Morris, "in both the artistic and the socialistic sense."[19] The first issue also contained an article on "The Economic Foundation of Art," by A. M. Simons, editor of the *International Socialist Review,* which was surely intended as an elaboration of *Craftsman*'s position:

> The words artist and artistic have come to be so much the playthings of certain coteries that it is only when a Ruskin or a Morris uses them, and in some way correlates them with the whole of life that they interest any save the dilettanti. But if it be true that that thing is artistic which gives the greatest pleasure to the minds most fitted to understand it, and if the chief end of life is to seek pleasure, the conclusion follows that the chief aim of social workers should be to make society

artistic. . . . Any movement toward the revival of the beautiful, the pleasant, and the good,—in short of the artistic,—which does not connect itself with the great revolutionary movement of the proletariat, has cut itself off from the only hope of realizing its own ideal.[20]

Stickley not only continued to promote the ideas of the English Arts and Crafts Movement but also increasingly broadened his scope to include various aspects of contemporary art and social reform. Over the years, no group benefited more from Stickley's progressive interests in the arts than Henri and his associates. *Craftsman* stepped forward as the first nationally circulated magazine to publicize the Eight's exhibition at the Macbeth Gallery. Stickley's associate editor, Mary Fanton Roberts, wrote an approbatory article for the February 1908 issue, surely with Henri's full cooperation, which presented the Henri men as innovators of imagination and originality who were creating a vital, new, "home-grown" art.[21]

Henri seldom gave public voice to his own political leanings during this period.[22] It should come as no surprise, however, that the most substantive articles about his artistic philosophy and about some of his protégés were penned by radicals. Socialist Charles Wisner Barrell, for example, contributed a celebratory piece about Henri (see introduction p. 3), to the *Independent* in June 1908 during the same period when Barrell was also forming a friendship with John Sloan. Sloan's growing interest in the Socialist party provided a common ground for conversation. He considered Barrell particularly well informed on the subject and credited him with strengthening his "Socialistic trend."[23] The writer had first met both artists in 1907 and apparently expressed his intention of featuring them in forthcoming articles. Sloan was very much looking forward to the exposure that he would receive from a story about his etchings in the *International Studio:* "It would certainly be useful for me to be represented in this magazine as it has the greatest clientele of all the art periodicals."[24] But *International Studio* rejected the article, and Barrell was unable to place it until early in 1909, when it appeared in *Craftsman.* In "The Real Drama of the Slums" Barrell not only compared Sloan's depiction of the "bald realities" of New York life to stories by American realist writers Jack London and Frank Norris (the former a professed socialist and the latter an occasional social critic and consistent enemy of everything genteel) but also described Sloan's painting *The Coffee Line* as a "biting commentary upon the social system of our big cities."[25]

Sloan himself did not consider his paintings overtly political, seeing magazine illustration as the most appropriate vehicle for expressing his desire for social change.[26] But any work of art that focused on the working classes was subject to a range of interpretations by various contemporary audiences. Radicals could identify the spirit of "mute protest" in a portrait of a humbly clad child by Luks[27] or the indictment of an entire social system in a street scene by Sloan. In the same paintings, others might simply appreciate the spectacle of local color. Whether

interpreted as bland picturesque views or biting social criticism, however, paintings and drawings of life among the urban tenements attracted attention and comment in the first decade of the twentieth century. Clearly, such images elicited an array of charged associations in the minds of their first audiences.

•

A newspaper reporter who paid Bellows a studio visit in 1908 confessed to feeling a mixture of emotions in response to seeing two portraits of "street gamins." He described them as "brimming with humor," but not of the simple, comedic variety. Rather, for this writer, Bellows's paintings of slum children also possessed an emotive spirit, "which brings tears and sends people to rescue work." The specific portraits on view in the studio that day were not identified in the *New York Herald* article, but the reporter may well have been referring to *Little Girl in White* or *Frankie, the Organ Boy* (figures 54 and 55). Both works are virtually monochromatic and present their subjects at full length, against an extremely dark background, much in the manner of Robert Henri. Like Henri, too, Bellows posed his young models in the studio. Partly as a result of that distancing formula, such portraits as *Girl in White* and *Frankie* remain tied to a venerable artistic tradition that inevitably mitigated the sense of intimacy and candor evoked by the figures. It was Bellows's genre scenes, rather than his paintings of single figures, that startled the contemporary art audience by their gritty realism.

Reviewing a Water Color Society exhibition, a critic for the *Times* chided Bellows, along with Glackens, for focusing on the "ugly truths" of the city streets but acknowledged redeeming qualities in their drawings:

> They err, perhaps, on the side of brutal frankness in their description of childlife in our parks and public squares, but it is indubitably life, and that is the main thing. Their screaming, grimacing, contorted youngsters are notes taken on the spot and published without rewriting. Ugliness has a tonic quality in their hands, because it is vigorous, not anaemic or debased.

The critic was relieved to see, in the same exhibition, how Jerome Myers had managed to introduce a little "sunny warmth" into his pastels of East Side life, how he "refine[d] and beautif[ied] his gaunt women and children" with mists of color. Such an optimistic interpretation was only appropriate, in the view of the *Times* critic, because "of course, all the children of the east side are not sophisticated, prematurely aged, or brutalized by rough life."[28]

Thus, time and again observers remarked on the new subjects seen in American paintings, the new view of "so-called ugliness in art."[29] Daumier and Millet were occasionally cited as prototypes, but for most Americans French peasants and Parisian daily life had always seemed far away. Pushcarts and street fights and young girls tending infants on Mulberry Street were a different matter. Depicting New York City street life, especially those aspects considered devoid of charm or apparent

Plate 18

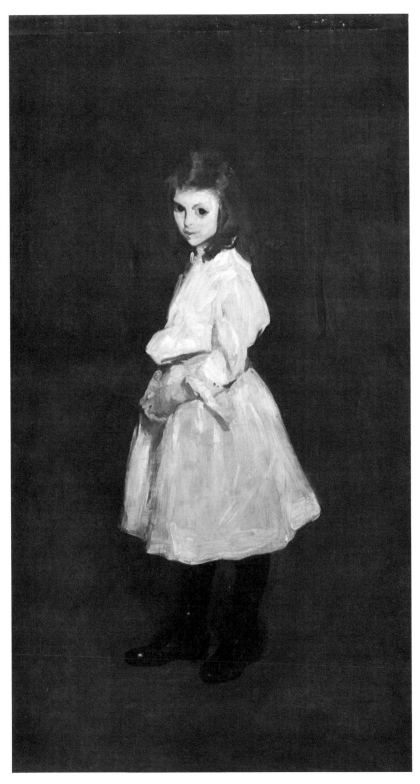

54. George Bellows, *Little Girl in White (Queenie Burnette),* 1907. National Gallery of Art, Washington, D.C. Collection of Mr. and Mrs. Paul Mellon.

55. George Bellows, *Frankie, the Organ Boy,* 1907. Courtesy Berry-Hill Galleries, New York.

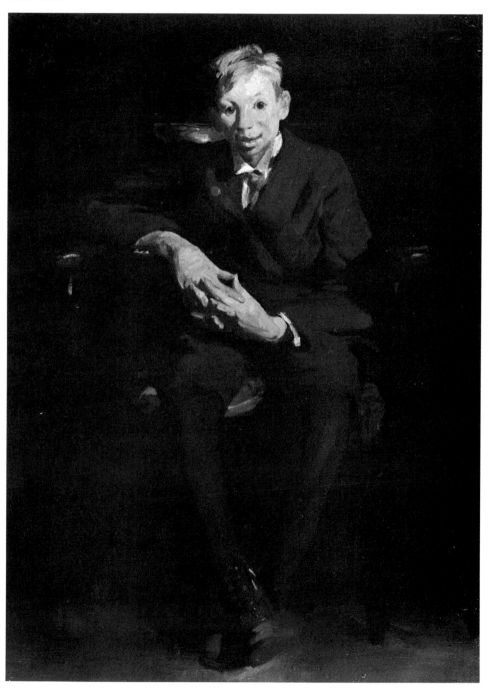

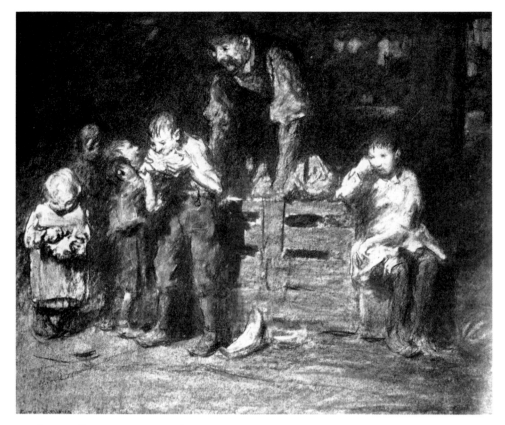

56. George Bellows, *Watermelon Man*, 1906. Reproduced in *Craftsman*, February 1910. Present location unknown.

beauty, constituted a novel artistic trend. Until the Armory Show provided even more challenging grist for the art critics' mill, issues involved with the new realism were debated at length. Subtle nuances were seen to distinguish one realist's vision from that of another. Many works were condemned as "morbid," "grotesque," and "disgusting"; occasionally others were hailed as "original" and "clever."

Bellows made "real life" a strong component of his oeuvre. He delved into Lower East Side neighborhoods in search of subjects, initially because Henri encouraged him to do so. He produced a powerful body of oil paintings as well as drawings, particularly in 1906 and 1907. As his work gained prominence in the New York art world, he continued to show his early Lower East Side subjects. Four of his eight drawings selected for the 1910 Exhibition of Independent Artists, for example, were urban street scenes: *Watermelon Man* (ca. 1906; figure 56), *Hungry Dogs* (1907; figure 57), *Street Fight* (1907; figure 58), and *Tin Can Battle, San Juan Hill* (1907; figure 71). Again, his "slum sketches" attracted special comment for being the most hard-hitting of the genre.[30] At the same time Bellows, more than most of his fellow exhibitors, was nurturing an artistic identity marked by increasingly conservative components. A brief review of the social context in which Bellows's forceful street

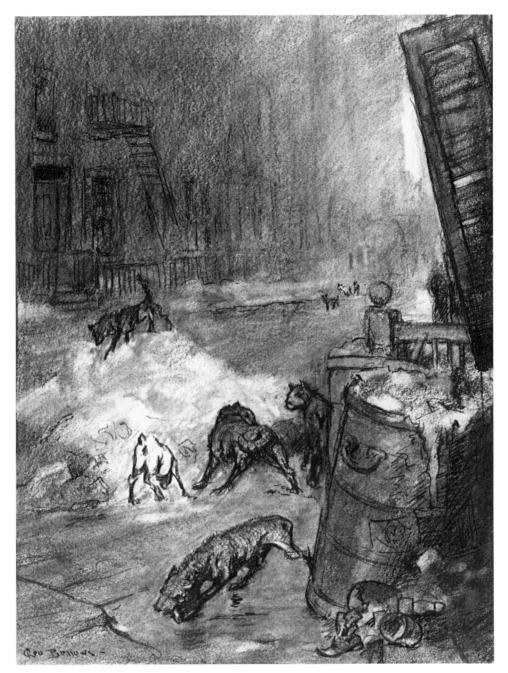

57. George Bellows, *Hungry Dogs*, 1907. Boston Public Library, Print Department.
Gift of Albert Henry Wiggin.

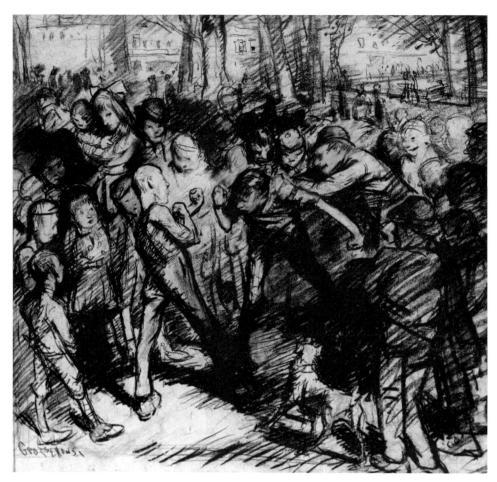

58. George Bellows, *Street Fight,* 1907. Dr. and Mrs. Robert Nowinski Collection, Seattle, Wash.

scenes were first seen will indicate that, like his boxing pictures, these dramatic drawings held interest for reactionaries as well as radicals.

Nether New York

Henri's students were by no means the first to explore the underside of New York City. At the end of the nineteenth century the articles, books, and illustrated lectures of Jacob Riis were providing the most influential source of information on the horrors of tenement life. In many respects, however, Riis's presentations also borrowed from an older and continuing tradition. Sensational exposés such as *The Nether Side of New York* (1872) had long pandered to the public's fascination with the darker elements that festered in the city.[31] The very title of Riis's most famous book, *How the Other Half Lives* (1890), followed the pattern established by this literary genre of urban exposés, veritable guided tours, which typically divided the urban environment into distinct halves. James D. McCabe's *Lights and Shadows of New York Life,* for example, with its "full and graphic accounts," exaggerated the unmediated polarity between New York's two separate segments, its "splendors and wretchedness . . . high and low life . . . marble palaces and dark dens."[32] The Reverend Matthew Hale Smith, whose *Sunshine and Shadow in New York* also capitalized on dualities, probably responded with charitable sentiments to "life among the lowly," but his stronger emotion was abhorrence. And he surely titillated his readers with lurid descriptions of sights and sounds, as well as smells "that would poison cattle."[33]

Riis himself promoted a relatively advanced view of urban poverty and crime. He saw the plight of the underclasses as a product of an unfit and deprived environment rather than the result of moral failure; yet his entire campaign was fueled by revulsion and fear.[34] He perceived the masses of urban poor as a restless rising tide threatening to overflow the boundary between the two "halves" of the city. His portrayal of the tenements and the evils breeding there found its basic prototype in Matthew Hale Smith, who three decades earlier had described the dwellings of the poor as "reeking vice and bestiality."[35] Riis earned a special place in the history of urban reform by instilling his own fears in the susceptible minds of thousands with a provocative combination of irrefutable photographic evidence and impassioned message. He influenced a generation of writers, photographers, and settlement workers with a compelling new version of familiar dualities: vice and virtue, chaos and orderliness, the urban menace and the middle class.

Informed of recent findings from sociology and economics, urban environmental reformers concentrated on ameliorating the living conditions of the poor; but their efforts also centered on moral improvement, which was seen as the inevitable result. Literature produced by some of the most enlightened charitable organizations spoke of overcrowding as a "prolific source of sexual immorality."[36] The University Settlement Society's yearbook of 1900 included a report on the deleterious effects on the young "of the vulgarity and all the unspeakable sights and

sounds of the streets."[37] Such reports, and the work performed by settlement societies generally, were motivated by sincere determination to restore corrupted lives and souls; but in the process—in collecting and publishing data on specific neighborhoods, for example—they often only confirmed inherited biases. Their conservative, moralistic perspective and their tendency to associate the evils of industrial America with the urban poor echoed the thinking of Charles Loring Brace in his *Dangerous Classes of New York* (1872). Brace devoted his Children's Aid Society to the fight against laziness and moral decay, which he saw as the primary cause of poverty. He had raised a solemn warning: "If the opportunity offered, we should see an explosion from this class which might leave this city in ashes and flood."[38] Turn-of-the-century environmental reformers tended toward greater subtlety, but the fear of social upheaval was still implicit in their ubiquitous entreaties for society to "discharge the obligation it owes," especially to the children of the slums, "who will soon play their part in the citizenship of the country."[39]

While the publications of urban reform organizations were aimed at a specialized readership, more popular mass-circulation magazines, such as *McClure's*, *Everybody's*, and *Cosmopolitan*, trumpeted similar themes to broader audiences. Managed in the tradition of newspaper journalism rather than that of the older, more elite literary periodicals like *Atlantic* and *Century*, the cheaper new magazines published investigative feature stories.[40] They participated in the fact-gathering trend of the Progressive Era, along with charity organizations, settlement houses, and government bureaus. The weight of the facts, not unexpectedly, reflected the traditional value system that stimulated the reform movement generally, but as S. S. McClure instructed his writers, the moral element of every good story should express itself only "unconsciously."[41]

These magazines capitalized on the didactic impact as well as the marketability of pictures. In the wake of Jacob Riis's successful campaign, the utilization of photography burgeoned not only to enhance the publications of reform organizations but also to illustrate the more popular muckraker-magazine exposés. As Peter Hales has pointed out, many of these pictures reflected the pervasive influence as well as the conservatism of Riis's formula for photography, which presented the tenement environment as the opposite of everything valued by the middle class. His pictures of tenements spoke eloquently of what was *lacking*, such as cleanliness, order, and appropriate space.[42] As with Riis's lantern-slide lectures, magazine illustrations rarely stood alone. Visual images—photographs as well as artists' renditions—were presented in the context of elucidating, reinforcing, or clarifying text. Thus, a photograph of a crowded Lower East Side street in the January 1907 issue of *McClure's* derived its full meaning only when read together with the caption, which described the people in the photograph as "the poorest class of Russian Jews" who dwelled in "squalid quarters" (figure 59). Likewise, the sometimes ominous titles of so-called muckraking articles, such as "The Menacing Mass"

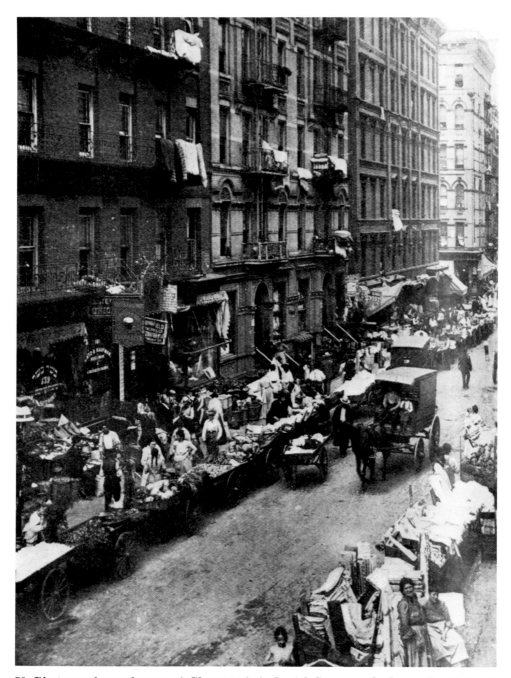

59. Photographer unknown, *A Characteristic Jewish Scene on the Lower East Side of New York,* from *McClure's,* January 1907.

or "The Alien Peril," betrayed the bigotry, hostility, and fear that often hid behind loftier motivations for saving the slums.[43]

In an 1895 *Century* article Mariana Griswold Van Rensselaer had pointed out how topography correlated with the demographic separation between "Upper" and "Nether" New York: outside "that central strip" spanning the length of the island "the majority of the well-to-do never set a foot."[44] Increasingly, however, respectable citizens did descend to those "other" sections of the city—some to perform beneficent services, others for entertainment. But the vast majority remained ensconced in their comfortable homes and read about the slums. By the 1900s the media were printing an enormous number of stories and images to satisfy the public's seemingly insatiable curiosity about the "social problem" of the urban poor. In fact, the burgeoning array of printed drawings and photographs undoubtedly comprised a real part of the visual environment. Thus, when Henri's students went out to study street life on the Lower East Side, they were at the same time exposed to hundreds of pictures of "the other half." For these artists, as much as for the magazine-reading public, perceptions of tenement districts were partly conditioned by the mass-circulation press. Both groups inevitably became conversant with an increasingly familiar set of pictorial codes—visual conventions that developed in the process of documenting and publicizing the filth, disease, indolence, and crime associated with the growing immigrant population of big cities.

Bellows's Kids

In view of the emphasis placed on reform issues after the turn of the century, the literate urban audience likely could not have viewed paintings of the slums as totally benign. Pictures in art exhibitions, of course, were seen without the benefit of didactic labels or explanatory text; but even apart from an explicitly ideological setting, scenes of the Lower East Side resonated with social and cultural overtones. The commentary provided by contemporary reviewers indicates that images of poor, immigrant children reminded some viewers, at least, of the need for "rescue work."

Plate 13 Gallery-goers recognized at once that Bellows's *Kids* were part of "the other half" (see figure 53). The casual grouping of obviously poor children in this painting might have brought to mind any number of similar images. *Darkness and Daylight* (1899), Helen Campbell's popular book-length exposé of slum conditions in New York, for example, featured several illustrations of tenement district children.[45] One of these was staged in an alley not unlike the setting of *Kids* and displayed a selection of the requisite trappings of the slum environment similar to those chosen by Bellows, including one youth smoking a cigarette. In the book, the message was unequivocal. In fact, the entire conception of *Darkness and Daylight* as well as its photograph-derived illustrations found its inspiration in the investigative work of Jacob Riis.[46] Thus, text and pictures were orchestrated to present the dark side of New York as dirty and dangerous. The illustration (figure 60) carried the

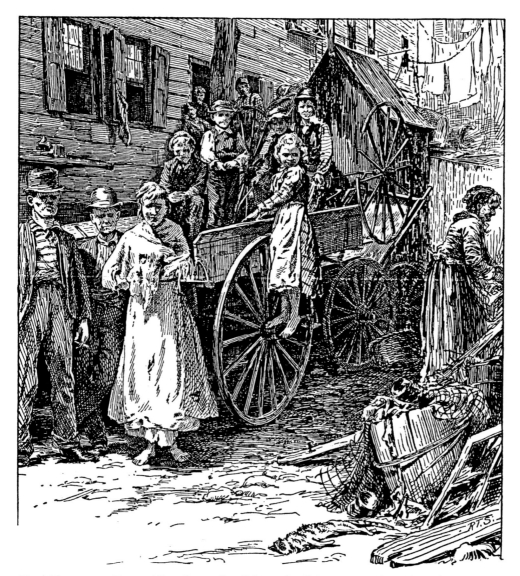

60. *A Tenement-House Alley Gang. Candidates for Crime,* engraving after photograph by O. G. Mason. Reproduced in Helen Campbell, Thomas W. Knox, and Thomas Byrnes, *Darkness and Daylight; or, Lights and Shadows of New York Life* (Hartford, Conn.: Hartford Publishing Co., 1899).

caption "A Tenement-House Gang. Candidates for Crime." The accompanying text explained how these innocent-seeming children actually posed a threat to society:

> Born in poverty and rags, nursed in filth and darkness, reared in ignorance and vice, matured in sin and crime, is the life history of tenement-house creatures, and the end must be either the almshouse or the prison, or possibly the felon's death. . . .
>
> Petty thieving by boys and girls who are not taught to discriminate between right and wrong, who are, in fact, led to believe it a virtue to steal in order to provide themselves and parents with comforts impossible to obtain otherwise, is a matter of course among the poorest classes. . . . The boy who steals coal to provide his mother with a fire, or a shawl to cover her thread-bare dress, becomes a hero, in his own estimation at least, and perseveres in the same direction toward a felon's cell.[47]

Child saving became one of the most popular urban reform crusades. Whereas prostitutes, gamblers, and tramps elicited little sympathy from moralistic reformers and the public at large, everyone wanted to rescue children from a host of social and economic evils. The street environment figured as a prime target for attack. As the chosen playground for tenement district youth, streets were certainly dangerous for the children. But reformers were at least as concerned with the degenerative effect of street life on moral character.[48] The 1899 annual report of the University Settlement described the street as "a free field in which the most evil and corrupting influence may work against the morals of the community."[49] The latest theories of child development, which stressed the importance of play for the moral and cognitive development of young people, only added to the sense of urgency that emanated from reformist rhetoric and spurred child savers to action. As settlement worker Ruth True expressed it, in *Boyhood and Lawlessness*, "Every day the Middle West Side bears witness to the truth of the saying that 'a boy without a playground is the father of a man without a job.' "[50] The imperative of the child-saving crusade was by no means limited to the publications of settlement houses and reform organizations. *Harper's Weekly* reported on the progress being made in regard to "the 'child problem' in New York" in an August 1908 feature article. The collective opinion of several prominent "men and women with . . . facilities for studying the subject at first hand" was that

> any normal child under fourteen years of age, and a great majority of those under sixteen, no matter what conditions of birth or previous surroundings may have been, may be led into useful walks of life; that congenital criminal traits may be eradicated; and that, with so few exceptions as to constitute a negligible quantity, every child in this big town—no matter whether his parents are degenerate victims of Russian oppression, or depraved exiles of the Neapolitan Camorra and the

Sicilian Mafia (although the children of the Russian and Italian immigrants are giving more trouble than those of all the other alien races combined), or criminals, or ignorant laborers of any other country of Europe or Asia, or of American birth—may be made a respectable member of society, given the proper training at the proper age.[51]

Joseph Lee, one of the leading proponents of supervised playgrounds for city children, saw structured play as a primary vehicle for promoting the development of social skills and the moral sense. But as with so many Progressive Era crusades, the benefits of the highly touted playground movement extended not only to the young offspring of "degenerate" and "depraved" immigrants but also to the middle class. Dismayed by the foreign appearance and unfamiliar behavior of new immigrant groups from Eastern Europe, the inhabitants of "Upper" New York looked to such organizations as the Society for Parks and Playgrounds for Children to "Americanize" these immigrants through their children. Removing the still-malleable urchins from the street provided some hope for developing a future generation of hardworking, law-abiding citizens.

The slum children depicted in Bellows's *Kids* exhibit few signs of this Americanization, so vital to maintaining the existing social order. Although at first glance their behavior seems anything but menacing, an alert contemporary observer could have discerned signs of trouble. In the first place, their play is clearly unorganized. Only three of the children, the group of girls in the left foreground, enjoy some kind of energetic, physical activity. None participates in anything approaching a team sport, the ultimate social training for young Americans. Urban reformers and settlement house workers, in fact, were seriously concerned about the kinds of games children played in tenement neighborhoods. A resident of the Maxwell House Settlement conducted a walking tour of the Lower East Side in 1905 and formulated a list of observed games, in descending order of popularity. Playing with fire and playing craps headed the list, followed by marbles, potsy, leapfrog, jumping rope, baseball, cat, buttons, and tops. He was able to conclude on the basis of his study that the gambling instinct was alarmingly strong among these children, and he noted with regret that "running games . . . [were] replaced by cramped games such as leapfrog and hopscotch [*sic*]."[52] His survey received considerable attention in settlement and charity publications as well as the popular press. The ominous effects of such restricted play and of life in overcrowded conditions were publicized by Lilian Brandt, another playground activist. She called attention to such manifestly unhealthy symptoms as "the listless, 'unattached' air of the children who crowd the steps and sidewalks of the tenement streets. For the most part they saunter to and fro or sit idly regarding the panorama before them." Brandt sounded the inevitable warning:

> The result is that the tenement dweller, if left alone, becomes more and more a spectator of life, and less and less personally interested in

it, until there arises an apathy as strangely out of harmony with occidental ethics as with New York life. . . .

This inertia, this "indifferentism," which germinates among the tenements, is a menace to social welfare if allowed to mature.[53]

If Lilian Brandt had seen *Kids* in the 1906 Society of American Artists Exhibition, she would likely have recognized the portentous signs of listlessness. A persistent and critical observer might have noticed yet another indication that Bellows's "kids" were on the road toward stunted adulthood. The baby carriage in the midst of this group of young people was a hallmark of the "little mother problem"—school-age girls caring for infant siblings because their mothers were unable to do so. Idell Zeisloft had catalogued a litany of the little mother's woes in her parlor-table book, *The New Metropolis* (1899):

> Of all the tragedies of child-life in New York City there is none so great as that of the Little Mother. This poor human being, attenuated by improper physical nourishment, passes through her child-life "weary and heavy laden." Herself needing a mother's care, her time is given up to the drudgery of "minding the baby," whose weight is sometimes more than her own. When other children are playing in the street, she stands stolidly by, looking on, but "minding the baby." From early morning until it is time for her to creep into her none-too-pleasant couch she must "mind the baby." Other children may go to school, other children may go off on little jaunts to the parks. . . . She must "mind the baby." Her relief comes when she has become old enough to go to work, and her girlhood is spent in a shop. What sort of womanhood can such a preparation produce?[54]

Groups like the Little Mother's Aid Association and the Little Mothers League were organized to deal with this aberrant social phenomenon. Members "ransack[ed] the tenement-houses for Little Mothers" and endeavored to rescue them along with their young charges, often in spite of objections from parents.[55] The daily press followed and assiduously reported on these philanthropic efforts.

At the right side of Bellows's painting, opposite the carriage, stands a slum child of one further type, a diminutive character who might be seen as the archtypal streetwise "kid." The youngster, holding a cigarette in one hand while the other is thrust in his pocket, assumes a pose beyond his years and a knowing air of experience. The March 1906 issue of *McClure's* featured a short story about just such a boy—Heiny, "child of the Bowery and waif of the world":

> By the time he was ten years old, he was an able practitioner of life, capable of meeting any emergency which might confront him on or about New York's great East Side.

Profession or trade, Heiny had none. Odd jobs of a light and airy nature, such as running errands, he would do at inclination rather than upon the compulsion of necessity. Gambling at craps netted him a wavering income when he chanced to have the capital for an original "fade," without which the crap-shooter finds no game open to him on the sidewalks of New York. He had been known to sell "extrys," and once, at least, had applied for and held a job, until, at the end of four days the pettiness of unchanging to-morrows had so wrought upon his soul, that he forsook the grocery-store regime and was seen in that environment no more.[56]

As the hero of the *McClure's* story, entitled "A Matter of Principle," Heiny lived outside the law and apart from anything resembling a nuclear family; yet he was tenderhearted, fair-minded, and an altogether sympathetic figure. Heiny and his cohorts considered capture by the "kid-grabbers"—generic slang for children's aid societies—the worst of fates. Even heartier ridicule was meted out to the police, depicted in "A Matter of Principle" as typically drunk or corrupt. Life in Heiny's Bowery functioned according to a code of conduct somehow more authentic than the one that governed so-called respectable society. Thus, the story demonstrates one of the alternative "moods" of the Progressive Era—fascination with and even attraction to the colorful life of "the other half." Heiny, like any one of Bellows's "kids," could be viewed with suspicion and fear or, in another context, with sympathy and affection.[57]

Everett Shinn did the illustrations for "A Matter of Principle." It is tempting to speculate that these drawings might actually have attracted Bellows's attention to the story in *McClure's*. The romantic moralism of the tale and the contrived twist of plot at the narrative climax were standard elements of O. Henry tales, Bellows's favorite. Coincidentally, the March issue of the magazine was probably on newsstands at the time Bellows was working on *Kids*.[58] And Shinn's depiction of Heiny in the opening drawing resembles the far right-hand "kid" in Bellows's painting (figure 61). Another illustration, a scene in an alley, makes use of a planked backdrop hung with lettered signs, quite like the setting that appears in *Kids* (figure 62). Such similarities again suggest that Bellows occasionally looked to graphic sources during the period he was retraining his eye and changing his drawing style according to Henri's instructions.

Any possible connections, however, between *Kids* and Shinn's illustrations of the hero kid, Heiny, provide no specific indication of Bellows's own feelings toward the subjects of his painting—whether he viewed them with suspicion or sympathy. And such a likable character as Heiny only complicates the question of how the painting might have been interpreted by art audiences in 1906. Attitudes clearly varied, but at least one thing is certain: as a prominent focus of the news, a favorite cause for urban reformers, and subjects of popular fiction, slum "kids" permeated the media as well as the culture at large.[59] Even such words as *kids*

61. Everett Shinn, *Heiny: "Child of the Bowery and Waif of the World,"* illustration for "A Matter of Principle," *McClure's,* March 1906.

62. Everett Shinn, *In Two Minutes He Was Whining for Mercy,* illustration for "A Matter of Principle," *McClure's,* March 1906.

and *street games* were charged with associations and, at times, with alternating and conflicting meanings.

Photographs of immigrant life and the tenement districts proliferated, too, at an explosive rate. Cheap, photomechanical reproduction processes, although commonly in use by the 1890s, continued to stimulate demand for photographs well into the following decade. Professional photography firms and news picture agencies responded to the growing market by stockpiling negatives and prints of personalities, sporting events, crimes, fires, and strikes, as well as the ubiquitous Lower East Side street scenes. A selection of such photographs not only demonstrates how reform-style photography had a powerful influence on many kinds of picture taking in the slums but also provides some sense of the contemporary nuances associated with another of Bellows's tenement district subjects.

A cameraman for the Bain News Service photographed a group of boys swimming among the docks in New York City (figure 63). The debris-strewn foreground and the boys' lack of fashionable swimming attire clearly mark them as being from working-class families. Separated from any ideologically specific format, however, the picture lends itself to various readings—reformist, exotic, picturesque, or voyeuristic. Thus, the news service could have sold the same photograph to fill a range of buyers' needs. Two photographs of a similar subject by Brown Brothers were used in the 21 July 1906 issue of *Harper's Weekly* (figure 64). In this case, captions about keeping cool during the summer months at public swimming stations suggested a scene of innocuous, passing interest: pictures of boys swimming off docks in the East and North rivers were intended as slice-of-life filler for the magazine.[60] In another context, a photograph of a similar scene, reproduced in Ruth True's study *Boyhood and Lawlessness* and above a different caption, "Wading in Sewage Laden Water," indicated that keeping cool in one of the same rivers constituted a social problem (figure 65).

Bellows depicted the apparently popular subject of street kids bathing along the shore of the East River in two major canvases, *River Rats* (1906; see figure 5) and *Forty-two Kids* (1907; figure 66). Critics referred to the children in these paintings variously as "a bunch of gamins," "street Arabs," "urchins," or "kids,"—all class-based terms that identified the boys as manifestly distanced from the readers of art criticism or the artist's intended audience. Bellows was calling up a specific set of allusions with the title of his 1906 painting: *river rat* was an especially loaded appellation. While "kids" behaved mischievously, they were, according to popular usage of the term, capable of redeeming qualities. River rats or dock rats, on the other hand, were thought of as young criminals.

Helen Campbell provided an account, in her urban exposé *Darkness and Daylight,* of the process whereby a "pertinacious" young bootblack could drift into cheating, fighting, and thieving. At first, errant escapades were limited to the idle hours of his trade, but all too often the lure of an easier livelihood offered by the docks proved irresistible:

Plate 12
Plate 14

63. Bain News Agency, *Bathing in River, New York City*. Library of Congress, Washington, D.C. Bain Collection.

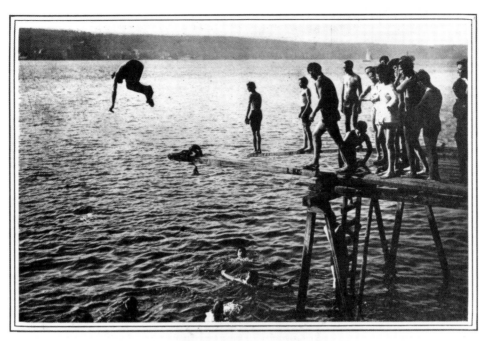

A Public Swimming Station on the North River, where numerous Bathers amuse themselves from Dawn till Dusk throughout the Summer Months

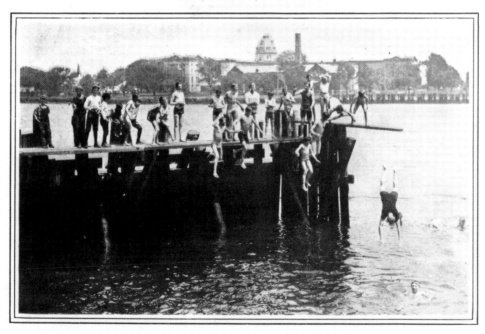

A Bathing-place on the East River opposite Blackwells Island which is largely patronized by Dwellers on the crowded Upper East Side

64. Brown Brothers, *New York City's Rivers As First Aid in Keeping Cool*, from *Harper's Weekly,* 21 July 1906.

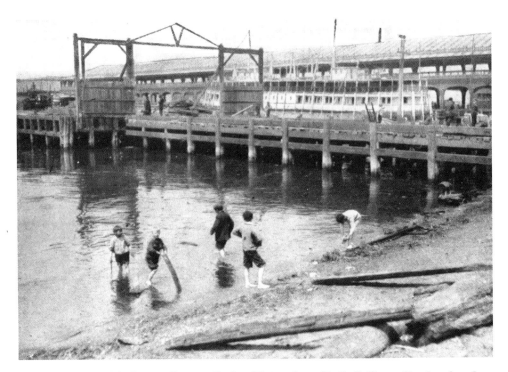

65. Lewis Hine, *Wading in Sewage Laden Water,* from Ruth S. True, *Boyhood and Lawlessness,* vol. 1, *West Side Studies* (New York: Survey Associates, 1914).

66. George Bellows, *Forty-two Kids,* 1907. In the collection of the Corcoran Gallery of Art, Washington, D.C. Museum Purchase, William A. Clark Fund.

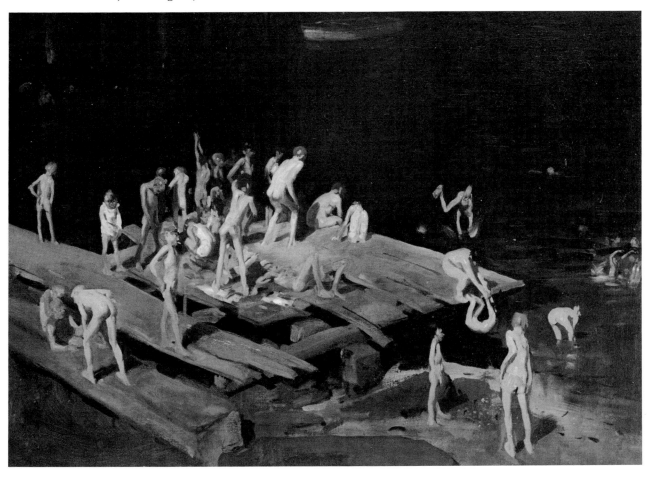

Anywhere along the docks are facilities for petty thieving, and, guard as the policeman may, the swarms of small street rovers can circumvent them. A load of wood left on the dock diminishes under his very eyes. The sticks are passed from one to another, the child nearest the pile being busy apparently playing marbles. If any move of suspicion is made toward them, they all take off like a swarm of cockroaches, and with about as much sense of responsibility. Children of this order hate school with an inextinguishable hatred. They smash windows, pilfer from apple-stands, build fires of any stray bits of wood they can collect, and warm themselves by them, and, after a day of all the destruction they can cram into it has ended, crawl under steps, into boxes or hallways, and sleep till roused by the policeman on his beat, or by a bigger boy who drives them out.[61]

The boys pictured in illustrations accompanying the section of Campbell's text titled "Homeless Street Boys, Gutter-Snipes and Dock Rats" might have appeared innocent to the uninitiated (figure 67). But reform-minded urbanites were well aware of the dangerous elements to which these youngsters were exposed and the future to which most were expected to succumb.

Similarly, no one would suggest that every naked bather in *River Rats* necessarily participated in roving criminal gangs, but when the painting was exhibited in 1907 viewers perceived distinctly unsavory overtones. Frank Fowler considered the theme "so sordid" that the artist's achievement seemed even more remarkable: "It proves afresh that the artist and not the subject makes the work."[62] The following year, Bellows's other treatment of bathing dock rats, *Forty-two Kids*, was denied a prize at the Pennsylvania Academy because of its potentially offensive nature.[63] A newspaper cartoon of the period, in which a nightstick-waving policeman was introduced into a satirical sketch of *Forty-two Kids*, further demonstrates the kind of associations that such a band of bathing urchins elicited in the minds of many early twentieth-century viewers (figure 68). A group of coarse and ill-behaved youngsters (the undisciplined activities of these boys included smoking and urinating in a public place) congregating at the docks meant that some petty crime was in the making.[64]

The visual coding in Bellows's depictions of slum kids included not only the environment in which they were set and recognizable behavior patterns of the children but also figure types. His treatment of the naked boys in *Forty-two Kids* was so extreme, in fact, that critics referred to them as "animalculae" and "maggots."[65] Bellows developed at least two basic models which he utilized in representations of tenement district children. These were based in part on his own observations but also on mass-media imagery, which again must be considered as a component of the artist's visual environment.

Two early drawings, *Children Playing in a Park* (see figure 52) and *Street Fight* (see figure 58) exhibit several stylistic and technical mannerisms that

67. *A Favorite Pastime for Dock Rats,* engraving after photograph by O. G. Mason.
Reproduced in Helen Campbell, Thomas W. Knox, and Thomas Byrnes, *Darkness
and Daylight; or, Lights and Shadows of New York Life* (Hartford, Conn.: Hartford
Publishing Co., 1899).

68. Cartoon satire of *Forty-two Kids.* From a newspaper clipping in
Bellows's scrapbook. Location and date of original publication
unknown.

seem to derive from the mass media. The shorthand cross-hatching in *Children Play-
ing* reappears in the slightly later drawing. Although the neighborhood has changed
and the nature of the crowd is noticeably different, diagonal slashing strokes used to
fill in broad areas in both the foreground and background of *Street Fight* are a
holdover from Bellows's early Gibson-inspired style. Bits of this technique are also
evident in the pastel boxing drawing of the same period, *Knockout*. A close look at
the figures in the foreground of *Children Playing* reveals another, more significant,
aspect of Bellows's style that originated from his illustration-copying days. The thin,
long-limbed, gangling body type, which later would become pronounced in *Forty-
two Kids*, is nascent here in one of Bellows's earliest New York drawings.

One of the most popular illustrators at the turn of the century was
Edward W. Kemble. In fact, his stereotyped and grossly racist cartoons of blacks,
known as "Kemble's coons," were said to be as widely enjoyed as the "Gibson girl."[66]
Bellows surely saw countless drawings by Kemble in *Life* during the period when he
was studying that magazine assiduously. It is likely that he also knew the 1885
edition of his beloved *Adventures of Huckleberry Finn*—the standard edition for
nineteenth-century American readers—and its illustrations by Kemble.[67] Two ex-
amples of Kemble's work, an illustration from *Huck Finn* and a "coon" cartoon
(figures 69 and 70), demonstrate a probable source for the short-waisted, gawky-
legged body type that became a standard in Bellows's repertory. As his style devel-
oped, Bellows adapted that type to suit the needs of his tenement district pictures.
He applied it not only to his depiction of blacks, as in *Tin Can Battle, San Juan Hill*
(figure 71) but also to that of underclass whites, as in *Meeting of the "Daffydil"
Athletic Club* (figure 72).

Bellows need not have been consciously aware of the long-standing
impression made on him by Kemble's style and characteristic figure type. He did
recognize, however, that in the realm of mass-media imagery, slum kids looked
different from children of well-to-do families. Kemble provided a prominent exam-
ple of the way the underclass was often distinguished, in visual terms, from respect-
able society, but many other illustrators as well as photographers followed the type-
casting trend. While ethnic and racial slurs permeated news stories, editorials, and
feature articles, racial stereotyping was also rampant in pictures. One cover cartoon
for *Life* shows two typical stereotypes (figure 73). A black child is portrayed with
thick white lips, a familiar feature from the blackface caricature of the American
minstrel show and burlesque, and one well established by the end of the nineteenth
century as part of a visual code that meant black.[68] A group of Irish youngsters in the
same cartoon displays different features—small eyes, pug noses, and long upper lips
were associated with the Irish nationality in the work of such cartoonists as the well-
known and highly influential Thomas Nast. The overall demeanor of these cartoon
figures, furthermore, conforms to a more generic, recent-immigrant, slum-child
type. Their figures are squat; their broad heads are adorned with tattered hats or a

69. Edward W. Kemble, *Jim and the Snake,*
illustration for Mark Twain, *Adventures
of Huckleberry Finn* (New York: Charles L.
Webster, 1885).

70. Edward W. Kemble, *Sport in Blackville,* from *Cosmopolitan,*
April 1910.

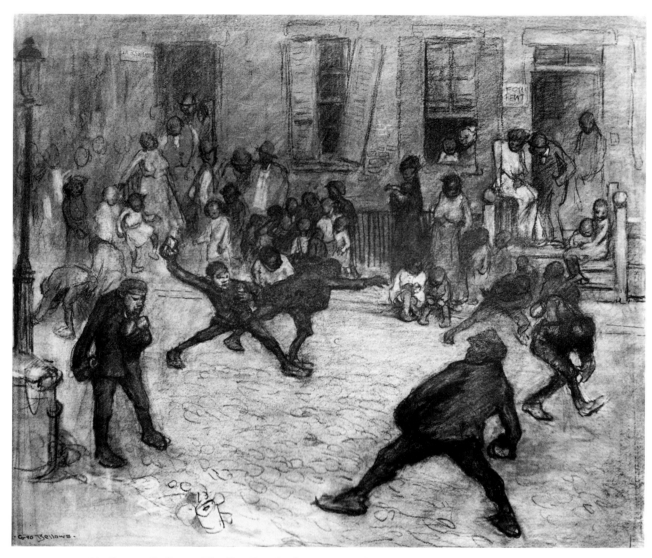

71. George Bellows, *Tin Can Battle, San Juan Hill, New York,* 1907. Sheldon
Memorial Art Gallery, University of Nebraska, Lincoln. F. M. Hall Collection, 1947.

72. George Bellows, *Meeting of the "Daffydil" Athletic Club,* ca. 1906. Private
Collection.

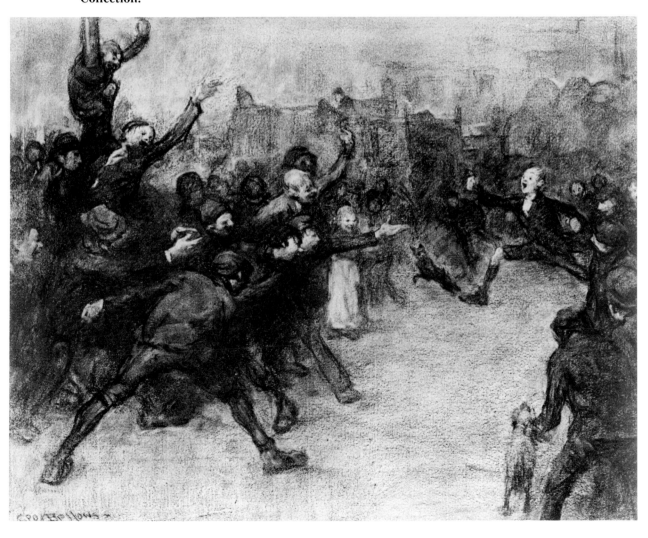

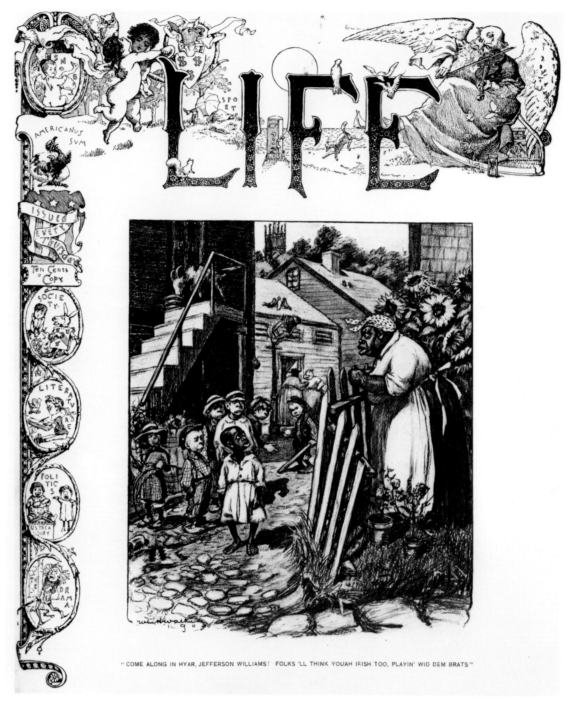

"COME ALONG IN HYAR, JEFFERSON WILLIAMS! FOLKS 'LL THINK YOUAH IRISH TOO, PLAYIN' WID DEM BRATS"

73. William Walker, *Come Along in Hyar, Jefferson Williams! Folks'll Think Youah Irish Too, Playin' Wid Dem Brats,* from *Life,* 11 October 1900.

thin crop of scraggly hair; they stand either slightly hunched over or, in this case, with stomachs protruding; and they appear dull-witted and slow-moving.

Bellows avoided overtly caricatured features in his depictions of blacks, but he did use the generalized slum-child type. In *On the East Side* (figure 74), for example, a cluster of such apparently witless children slouches in the front lines of a gathered crowd, staring dumbly at a lounging drunk. The incident obviously marks the setting as a tenement district—in fact, it would be regarded by reformers as an especially alarming example of the kind of evil influence to which slum children were exposed daily—but Bellows's figure types underscore the "on the East Side" theme. The drawing was intended as a framable glimpse into the life of the "other half," created by a middle-class observer for the delectation of a middle-class audience.

Thus, by subtle references to mass-media imagery and an approach to his subject that emphasized its otherness, Bellows established a critical distance between himself and the slum kids he painted. Besides the subject's remoteness from everything middle-class, however, the images themselves made no explicit ideological statement about immigrants or urban poverty. The children depicted in *River Rats* or *Forty-two Kids*, or even *On the East Side*, display no obviously threatening behavior. Aspects of their situation might have connoted actual or potential social problems according to the perceptions of urban reformers or readers of the progressive press, but those same images were probably regarded as picturesque curiosities by many others.

Robert McIntyre, in a 1912 article in *Art and Progress*, for example, remembered *Forty-two Kids* as the painting that first attracted attention to Bellows's work. But for McIntyre, the "central idea" of the painting had nothing to do with social unrest or any other urban problem; rather, in his view, the artist was celebrating the "very joy of pure existence." Seeing a unique kind of unaffected happiness in *Forty-two Kids* reflected not only the prevalent tendency to cherish the innocence of childhood but also the romanticized conception of poverty as an innocent state. McIntyre's interpretation of *Forty-two Kids* was not unlike the romantic characterization of the kid Heiny in "A Matter of Principle": both depended on the assumption that poverty simplifies life and brings one closer to its basic elements, allowing for the expression of genuine, uncompromised emotions and authentic action. Furthermore, by calling Bellows "a pagan reveling in life, and in the joy of living," McIntyre acknowledged another common supposition, that of the artist's special ability to traffic between the civilized and uncivilized realms of society in order to offer the former an occasional, revivifying taste of real life.[69] Thus, one alternate, contemporary perception of Bellows's kids derived from the cultural phenomenon known as slumming.

The urge to reestablish some connection, if only fleeting, with genuine, meaningful experience expressed itself variously and with increasing frequency in the early years of the twentieth century.[70] The renewed fascination with the

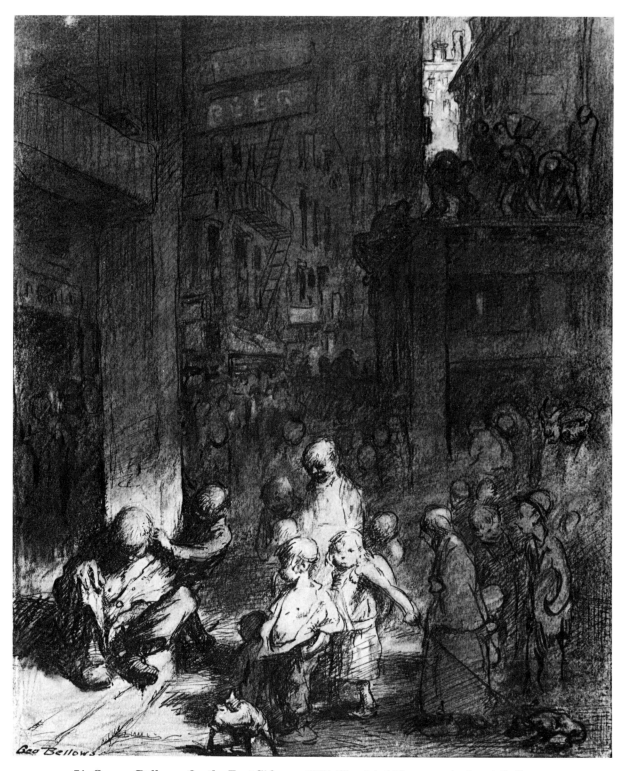

74. George Bellows, *On the East Side, ca. 1907*. Mead Art Museum, Amherst College, Amherst, Mass. Museum Purchase.

Lower East Side was a phase in this quest for the supposedly real. As Hutchins Hapgood, a self-described "intellectual and esthetic adventurer," confessed:

> There is nothing more exhilarating than to turn yourself loose among the people. I know two or three men of education who, whenever they want to have a good "temperamental" time, go out at night, alone, and wander for hours about the lowliest streets in the city. They go in search of anybody whose face shows that he has been subjected good and hard to what Henry James calls the "irregular rhythm of life."

Such "exhilarating" experiences also fortified Hapgood's writing: on the city's "lowliest streets," he was confident of finding "genuine" material. What is more, he could find the means of avoiding entanglements with "inessential, meaningless refinements" that trapped many bourgeois writers.[71]

In fact, pilgrimages to the shrine of real life became so common that for one adventure-seeker, the enchantments of the "fabulous East Side" were loosing their luster. In a satiric piece for the *New York Sun*, this writer waxed nostalgic over the "Arabian Nights entertainment" that could once be had:

> Twenty years ago you could play the role of the disguised Sultan and with a favorite Vizier sally forth at eve from Park row in pursuit of strange adventures. What thrilling encounters! . . . To slink down an ill lighted, sinister alley full of Chinese and American tramps, to hurry by solitary policemen as if you were engaged in some criminal enterprise, to enter the abode of them that never wash . . . ah! what joys for adventurous souls. . . . An East Side there was in those hardy times, and it was still virginal to settlement workers, sociological cranks, impertinent reformers, self-advertising politicians, billionaire socialists, and the ubiquitous newspaper man.[72]

Indeed, the slums attracted, in addition to settlement workers and journalists, out-of-town tourists, who typically hired a detective-guide for their netherworld expeditions. Slumming provided a quick escape from the stifling confinement and respectable mediocrity of middle-class life. Thrill seeking, however, stood opposed to the interests of urban reformers—at least ostensibly, since visiting the slums, either for personal renewal or for entertainment, presumably required the preservation of urban poverty and vice.[73] Nevertheless, adventurers as well as settlement workers apparently could see their own visions, their own assumptions, reflected in pictures of the Lower East Side.

Bellows's tenement district subjects, whether seen as troubling or titillating, rarely went unnoticed. *River Rats* and *Forty-two Kids*, in particular, were assertive, bold canvases that attracted a great deal of attention. One critic ranked *Forty-two Kids* along with Bellows's boxing pictures in the category of his most sensational motifs, which "no other artist would dare think of presenting."[74] Re-

viewers extolled the energy of paint handling and the spirited treatment of figures in an environment. But beneath all their concern with formal qualities, it was clear that the subject had moved them and that the theme was socially and culturally charged.

Painting the Poor

Artists, like critics and the public at large, certainly approached the "other half" with differing preconceptions. One of Bellows's colleagues at the New York School, Bessie Marsh, moved to a studio-apartment in Greenwich Village in order to make a close study of East Side types. She lined her walls with drawings of children playing in gutters and women staggering under loads of sweatshop work. When interviewed for the *New York World* article titled "New York's Art Anarchists," Marsh seemed quite capable of appreciating the visual aspect of her adopted neighborhood as well as the freedom from social convention enjoyed by her immigrant neighbors, with relatively little consciousness either of pressing human need or of impending social upheaval:

> It is a little crowded. . . . But I'm going to put a hammock there [on the fire escape] when the July nights come. It isn't a bit wrong down here, you know, to sleep out of doors. The life class can't compare with my view from here of that court-yard on a warm night. . . .
>
> Some of the girls like the east side best. Of course it is more foreign and picturesque, but over here one gets everything all at once. I found one little youngster down on Sullivan street, and after I had puzzled over him and wondered just what racial type he was, he enlightened me. He was Italian, and Irish, and Negro. You can't beat that on Ellis Island. That's pure Sullivan street.[75]

Another of Henri's protégés, Dorothy Rice, called her subjects "queer people": "Into my studio they troop just as if I were running an employment agency." Rice selected various "wonderful types," invited them into her studio for sittings, and conscripted their gaunt faces into large group portraits like *Bread Line* (figure 75). She said of this work:

> My "Bread Line," I have been told by those who have seen the real bread line, is exactly as if I had walked alongside and made drawings. I never saw a bread line, but I knew when I met this old woman and that queer man on a Madison Square bench or on the street that they had suffered, and they belonged in my "Bread Line." So I got them to come to my studio.[76]

Aside from their youthful enthusiasm and naïveté (which might account for the bloodless tone of certain remarks), both of these young artists appear emotionally detached from the working-class people they painted, at least in the interviews briefly quoted here. Dispassionate descriptions of what they *saw* seem to

75. Dorothy Rice, *Bread Line* (immediately below photograph of the artist) ca. 1909–10. Reproduced in *New York American*, 22 March 1910. Present location unknown.

reflect a carefully maintained distance between themselves and the individuals who served as picturesque or pitiable objects for their artwork. George Luks, on the other hand, displayed a markedly different attitude when he was interviewed for an article on "the appeal of the proletariat" for artists:

> To the average person the slums represent filth, squalour, and uncleanliness; to the philosopher they represent simply a refuge. In the sense which strives to make of them a thing apart—of a different order—there are no such things. Life in the slums is precisely what it is "up-town," save that "up-town" it has the advantage of a protecting mantle of prosperity. . . . Humanity is essentially the same. The same types will be found in every walk of life, only when they are desperately poor they will more explicitly and unmistakably demonstrate their true selves.[77]

Admittedly, Luks was no poet, and the article's author undoubtedly paraphrased his comments; still, an ability to see inhabitants of the tenements as actual people is apparent in the Luks interview. His attitude reflected not only intimate knowledge based on years of living among the residents of the Lower East Side but also a perception of those residents as individuals like himself. Luks was not a spectator of the "other half": as a veteran barroom brawler, he would have found it unnecessary to go slumming.

Bellows sketched and painted the immigrant poor, not at first by his own inclination, but on class assignment. Once he decided to join in with the Henri he-men, he threw himself wholeheartedly into the effort. When Henri instructed his students to find some "real life" to paint, Bellows went out and did so in his typically thoroughgoing and hard-driving manner. When a group of his tenement district drawings were included in the Independent Artists' Exhibition, Frank Mather observed that even in comparison with similar work by Jerome Myers, the "expression" of Bellows's sketches seemed forced "to the danger point." Although he described the pieces as "extraordinary," he accused Bellows of lapsing at times into the grotesque.[78]

Bellows never spoke for the record about these drawings or about his slum kids. In view of the paucity of surviving documentation, scattered shards of evidence must be assembled in an effort to reconstruct what Bellows may have felt about scouring nether New York for subjects and, more broadly, about the entire anti-idealism, anticonvention revolution in which he found himself involved.

Discussions at the New York School of Art ranged across diverse subjects, spearheaded by Robert Henri's advocacy of radical individualism and the social function of art. In addition to Emerson and Whitman, topics included Rousseau, Dostoyevsky, Tolstoy, Zola, and Maupassant. Bellows may have been flaunting his exposure to new ideas when in 1906 he presented Tolstoy's recently published *Twenty-three Tales* to a Columbus friend for Christmas.[79] In the Lincoln Arcade studio, volumes by Oscar Wilde, Ibsen, and Nietzsche were introduced by friends and visitors. His roommate remembered that although Bellows read a great deal, he exhibited little interest in such fashionable writers.[80] On one occasion, a college friend visiting from the Midwest was treated by Bellows to orchestra seats for Ferenc Molnar's *The Devil*. (The play's lively satire of social convention earned considerable success for its first American production in 1908.) Bellows's extravagant gesture paid off. Years after the event his friend still remembered being impressed by the performance—and even more so by a visit to the notorious Haymarket.[81] Such admittedly random anecdotes suggest that Bellows relished exposure to names and ideas, and generally to the trend toward personal and political liberation current among the New York intelligentsia. The majority of his acquaintances, however, have agreed that Bellows's basic outlook and pattern of thinking remained unshaken. Walter Pach was emphatic that during his colleague's tenure at the New York School "his mind underwent no essential change" and that

even Henri's special solicitations "could not bring any real depth to the mind that had expressed its quality from the beginning."[82]

Pach's testimony clearly reflected personal bias, even animosity, toward Bellows. Such an inability to perceive complexity in Bellows's vision was Pach's own failure. But his basic assertion about the consistency of Bellows's mindset has been corroborated by other contemporaries and colleagues. During the years when Bellows was producing some of the era's most wrenching portraits of tenement life, his perspective on what he saw and painted remained grounded in his conservative background and his inherited respect for principles of individualism, traditional morality, and personal responsibility. Therein may lie a key to the sensibilities implicit in Bellows's treatment of urban themes, sensibilities shared by many of his contemporaries.

Most significantly, perhaps, the scenes in *River Rats* or *On the East Side* were familiar. Viewers may have differed in how they perceived the implications of these pictures, but the early twentieth-century urban audience generally could recognize not only the subjects but also Bellows's method of approaching those subjects. It understood the distancing structures through which Bellows viewed the slums: the artist and his audience had each learned the same visual codes from reform-style, urban-exposé, and postcard-view photography and other imagery reproduced endlessly in the media. By 1910, many viewers were so comfortable with these genres of imagery, the basic elements of which were largely interchangeable, that reform activists were warned that "the public soon wearies of pictures of destitute children or desolate tenement interiors."[83] Slum subject matter was still sufficiently novel in art galleries to generate lively discussion and an occasional public flap. But as long as certain ground rules were observed—that is, as long as the "other" was kept at arm's length—paintings by "revolutionaries" like Bellows posed no immediate threat to existing institutions or the leadership of American culture. Indeed, these paintings were included in the art establishment's most exclusive exhibitions and were praised by the most conservative critics.

The artistic revolution associated with Robert Henri involved technique as well as subject matter. In fact, Bellows maintained in an interview for the press that concern about the "naked painting" in *Forty-two Kids*, not the naked children, had provoked museum administrators in Pittsburgh to deny him the Lippincott Prize.[84] Critical response to the painting, however, indicates that Bellows's exuberant technique won accolades in most quarters. Arthur Hoeber called the canvas "frankly brushed" in the *Globe*, and Huneker admired the nudes, especially for the way they were rendered, "with nervous intensity."[85] But in virtually every case these critics devoted more attention to the provocative subject of *Forty-two Kids* than they did to its vivacious surface.

Although in some respects the Henri circle, strongly identified with real-life subjects, was merely falling in line with a larger cultural trend, no member of the group derived greater benefits from the prominence and topicality of the slum

environment and its inhabitants than did George Bellows. The purchase of *Forty-two Kids* in the spring of 1909 marked his second sale, his first to a private collector. This at a time when John Sloan, who had been working as a professional illustrator and artist for several years in Philadelphia and then in New York City, still had not sold a single painting. At least as important for the development of Bellows's career was his managing to engage the attention of critics at virtually every major exhibition he entered. *River Rats* and *Forty-two Kids*, as well as the drawings Frank Jewett Mather referred to as his "slum sketches," figured prominently among the pictures that garnered valuable column space in the daily press and in art magazines. The overwhelmingly positive attitude of the press toward Bellows's "other-half" subjects invites comparison with one of Henri's other protégés, Dorothy Rice.

A relatively inexperienced artist at the time of the Independent Artists' Exhibition, Rice nonetheless generated a surprising amount of critical commentary—in part, no doubt, because she was the daughter of socially prominent parents.[86] Huneker described her as "young, gifted, and not burdened with a spirit of reticence," but he was probably most honest when he called her (not her work) "disquieting." He considered *Head of an Anarchist* her best entry in the show, but one suspects that he also felt at least slightly "disquieted" by seeing such a tribute to anarchism painted by the daughter of the editor of *Forum* magazine. Again, he seemed most interested in the subject matter of her canvases and, when he came to one overtly anticlerical picture, in discrediting the basis of her newly acquired tendency toward freethinking. Her "notion that nuns are sinister hypocrites," he suggested, derived from her knowledge of popular fiction rather than facts.[87] Joseph Edgar Chamberlin described Rice's paintings of gaunt faces, including *Bread Line*, as "overstrained, lacking in variety, wholly imitative and quite unrelated to life," but he hoped she might improve "by and by."[88] Clearly, the reviewers were judging Rice on the basis of her talents, which seemed as yet largely undeveloped, but they also took pains to point out that her hopeless, hungry subjects were fiction—"nightmares" was Mather's term.

From these contemporary reviews, it would seem that Dorothy Rice succeeded in provoking a defensive reaction from at least a few visitors to the Independent Artists' Exhibition. If that was indeed the case, it was not because she failed to maintain the requisite distance between herself and her subject. Her crudely exaggerated portraits explicitly established the otherness of her "queer people." Those rows of "horror-stricken" faces, however, still presented themselves as a departure from the familiar formula for picturing the slums. Rice's unconventional but entirely schematic arrangements showed neither facility nor imagination; but they were unexpected, imposing in scale, and they made a striking impression. Furthermore, Rice used titles to emphasize the specifically ideological intent behind her work. She wanted her imploring heads to be interpreted as a critique of the economic and social system that produced the kind of desperation they embodied (even though Rice admitted she herself had seen relatively little poverty). As a result,

critics moved quickly to dismiss the authenticity of her art and of her espoused radicalism, devoting rather lengthy remarks to a group of paintings that might otherwise have merited little or no attention in the press.

A more pertinent contrast to the favorable reception enjoyed by Bellows is provided by John Sloan. An in-depth comparison of the complex careers of these two major artists would be impossible within the scope of this book, and inappropriate given the focus on tenement district subjects. A few observations, however, are in order concerning the seemingly protean nature of Bellows's art that allowed him to align with radicals as well as conservatives during this period of his career.

The Working-class Subjects of John Sloan

Sloan came to live permanently in New York City in April 1904, only months before Bellows's arrival, and the next several years saw both men struggling to make their mark in the cultural center of the nation. As it turned out, the road to recognition and financial reward proved to be considerably more difficult for the older, more experienced Sloan than it was for the greenhorn from Ohio. A fascinating remark in Sloan's diary suggests that, very early on, he felt some instinctive premonition about Bellows's future. The occasion was a visit, in Henri's company, to the exhibition of student work at the New York School in April 1907. Sloan called it "a great show" and mentioned seeing "fine stuff" by some of Henri's students; but after Bellows's name he made the note, "who may grow academic."[89]

Sloan had by this time enjoyed some successes. His *Dust Storm, Fifth Avenue* won acclaim at the National Academy only the previous December. More recently, however, a painting he called *Gray and Brass* (figure 76) was rejected by the jury, and his single entry in the 1907 spring annual, *The Picnic Grounds* (figure 80), received little attention from critics. Meanwhile, young Bellows must have been the talk of the Henri circle: after only two and a half years of serious study, his extraordinary *River Rats* was hanging in the National Academy of Design, a stunning achievement by any standard. Thus, envy may have played some part in Sloan's thoughts about Bellows. But it seems significant that at this early student show, even before Bellows's excavation painting was highlighted in the *Sun* review,[90] Sloan made a prescient observation about a quality incipient in this young man's work with which he felt unsympathetic.

The following December, Sloan went to see the Academy's Winter Exhibition and afterward wrote in his diary, "Awful show. Bellows has two good things, Prize Fight and P.R.R. Excavation."[91] Sloan's own entries had been rejected.

Two months later, the Eight's landmark show at the Macbeth Gallery brought largely favorable attention to all participants, including Sloan. In March some of Henri's younger followers opened their own anti-Academy exhibition. Sloan made a note on 7 March: "Henri says that some of his men who have been working away from the school have now opened an exhibition on 42nd Street in rooms of an

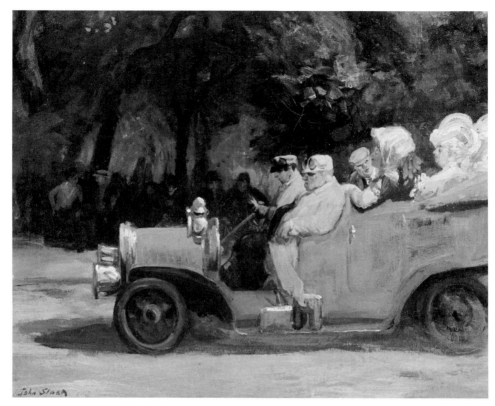

76. John Sloan, *Gray and Brass,* 1907. Private Collection.

auction company. Golz, Bellows, Sprinchorn and others, Coleman, etc." By the time Sloan went to see the show for himself, some reviewers had already suggested that it was more revolutionary than the exhibition at Macbeth's had been, and Bellows had been hailed as the "headliner." Sloan wrote in his diary that he had seen some very good work at the exhibition and even expressed the wish that he could buy "some of these things by Golz, Dresser, Keefe, etc. They would be fine to own, so different from the 'regular picture game.' "[92]

From Forty-second Street Sloan went on that evening to the National Academy, where two of his own paintings were on display. In fact, the Eighty-third Annual Exhibition was somewhat exceptional, and Sloan had to admit that it had "a more interesting look than usual." Academicians were making efforts to answer the challenge raised by all the recent rabble rousing. Although Henri was no longer on the jury, officials still made sure that the 1908 annual had the appearance of openness to new blood. They put together one of the largest shows in years, crowding the walls with a variety of work and clustering paintings by Henri's people together in one area. Of Sloan's two entries, a relatively conventional portrait hung "on the line," but his more provocative *Haymarket* was skied (figure 77). Bellows's *North River,*

on the other hand, had received the Second Hallgarten Prize and was illustrated in the exhibition catalog.

Huneker's review of the Spring Academy came out on 21 March. He pronounced *North River* alone to be "worth the trip to West Fifty-seventh Street" and applauded *Forty-two Kids* as well. He thought Bellows's paint handling showed signs of immaturity; but clearly he had his eye on this emerging talent: "A man who has such power in his elbow ought not to stop at the elbow." A few sentences about Sloan followed the outpouring of praise for Bellows.[93] Although the verdict on Sloan was generally positive, too, it seemed halfhearted when juxtaposed, as it was, to the longer discussion of Bellows. The older artist surely winced at what must have read like an implicit comparison. A few days later Sloan returned to the show of Henri's ex-pupils on Forty-second Street and remarked in his diary, "Bellows is already too much 'arrived'—it seems to me."[94]

In December 1909 Sloan officially joined the Socialist party, thus making a personal commitment to the cause of radical reform. But as Patricia Hills has pointed out, Sloan also remained committed to a traditional conception of art as transcendent, above specific, materialist issues.[95] He determined to keep propaganda out of his paintings, not only because he believed that they would be better for

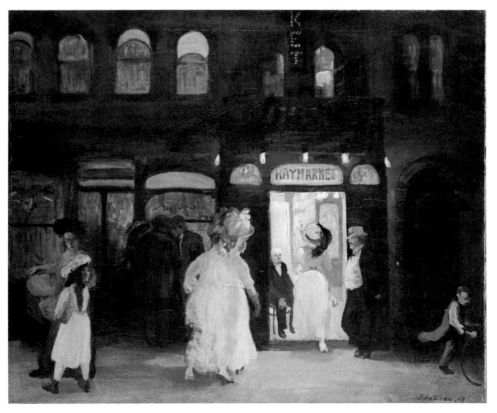

77. John Sloan, *The Haymarket,* 1907. The Brooklyn Museum, New York. Gift of Mrs. Harry Payne Whitney, 23.60.

being nonpolitical but also because he knew that the art establishment would disapprove of overtly anticapitalist pictures. Sloan aspired to a ranking among great artists, and he hoped that his paintings—the enduring component of his oeuvre—would win their place in the canon. Like every other member of the Henri circle, he recognized that only the cultural establishment was empowered to make that kind of success possible.

In this regard, the appearance of the article by Charles Wisner Barrell in the February issue of *Craftsman* represented a landmark for Sloan. It meant exposure for his name and for his etchings of New York City life, five of which were reproduced. A second glance at Barrell's article, however, especially in the light of the paintings that New York gallery-goers were likely to associate with Sloan, suggests that the artist's professional identity was increasingly linked to the working classes in a way that guardians of the status quo may have considered undesirable.

Barrell opened his article, "The Real Drama of the Slums," with a few observations about artists and writers who dealt with the "raw reality" of poverty. The tendency in the face of such subject matter was idealization. Barrell described the "strong, heavy, patient figures of Millet's peasants," for example, as so close "to the great primal things of earth and of life" that they convey "a sense of universality." Sloan, on the other hand, "shows no tendency to grasp human wretchedness in the mass, but rather to show here and there a detached bit of life which has the power of suggesting the whole turbid current."[96] Barrell was referring to Sloan's predilection for isolating comprehensible vignettes from the larger confusion of the city, but he was also talking about the artist's willingness to approach specifics. In Barrell's view, Sloan felt genuine empathy with his subjects, the inhabitants of the slums.

Sloan's empathy with the working class cannot be discussed apart from his habit of people watching. The position of the voyeur implies distance between the watcher and the watched as well as exploitation; but the testimony of Sloan's diary suggests that although he indulged his voyeuristic impulse, observing the private lives of others was not associated for him with a will to subordinate the subjects of his gaze:

> I am in the habit of *watching every bit* of human life I can see about my windows, but I do it so that I am not observed at it. I "peep" through real interest, not being observed myself. I feel that it is no insult to the people you are watching to do so unseen, but that to do it openly and with great expression of amusement is an evidence of *real vulgarity*.[97]

Along with accounts of people watching, Sloan's diary recorded the development of his social consciousness: "I feel that if 5,000 people in this city are wealthy and content and two million are unhappy, something is wrong."[98] Such testimony, taken together with the evidence provided by his paintings and graphics, indicates that Sloan's approach to "real-life" subjects was relatively free of condescension. And his

rate of rejection at the hands of the National Academy jury suggests, further, that class-conscious progressives, not to mention conservatives, may have felt uneasy about his treatment of subjects that were by nature politically and culturally sensitive.

His lighthearted jab at overfed patricians in *Gray and Brass* may or may not have accounted for the Academy jury's rejection of that painting in 1907. But in the context of Barrell's article, the satire of his etching *The Show Case* seems sharper and more serious (figure 78). The setting, in front of Madame Ryanne's corset shop, and the attention of the passersby to a window display of undergarments established the stolen-glimpse quality that characterizes many of Sloan's genre scenes; but the presence of a corset probably offended few New Yorkers. Less appreciated in some circles, perhaps, was the decidedly unflattering portrayal of one of Madame Ryanne's wealthy, amply proportioned clients. On the other hand, Sloan frankly admired the lithe and comely working-class girls in the center of his composition.

Barrell also made references in his article to selected paintings by Sloan and, in at least one instance, conferred more political content than some readers might otherwise have perceived. Devotees of the art scene might have remembered Sloan's *Coffee Line* from the 1905 Carnegie International, where it won an honorable mention (figure 79). The somber scene of undifferentiated male figures standing on line for a handout of coffee could have been associated with the familiar mass-media formula for reform-style slum pictures, and as such it would have been acceptable to virtually any audience. But Barrell called the picture a biting "commentary upon the social system of our big cities."[99] Progressives, of course, generally did not favor the kind of substantive changes in the "social system" advocated by the likes of Charles Wisner Barrell.

In addition to such a specifically political remark, however, Barrell's article characterized Sloan's interest in working-class subjects as something other than mere sight-seeing. He recalled, for example, *The Picnic Grounds* from the 1906 Winter Academy (figure 80). Once again, the picnickers in the painting were manifestly working-class. Barrell described the subject as "a bevy of city hoydens" who are "evidently guests at an 'outing' given by a political association in the vicinity of East Fourteenth Street."[100] The connection between a working-class gathering and politics would not have been uncommon; but *The Picnic Grounds* was probably not considered political by most viewers. Sloan's approach to the subject, however, might have been disturbing in a subtler way. The uninhibited, romping game in the foreground of the picture exemplifies carefree disregard for the strictures of genteel deportment. Additionally, the fun is mixed-sex and seemingly unchaperoned. Sloan adulates this scene, which a moralistic, middle-class audience would have considered indecorous at best, and genuinely appreciates the activity portrayed—much as Frank Benson did in a painting like *Summer* (1909; figure 81), which represented the quintessence of genteel propriety and elegant leisure.

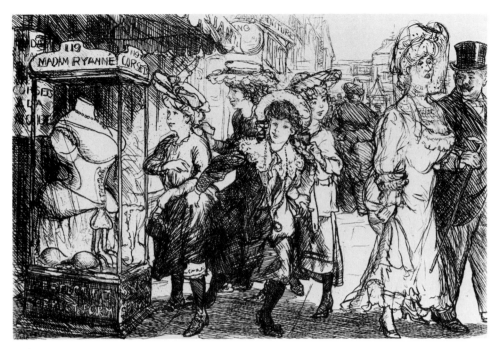

78. John Sloan, *The Show Case,* 1905. Delaware Art Museum, Wilmington. Gift of Helen Farr Sloan.

79. John Sloan, *The Coffee Line,* 1905. The Carnegie Museum of Art, Pittsburgh. Fellows of the Museum of Art Fund, 83.29.

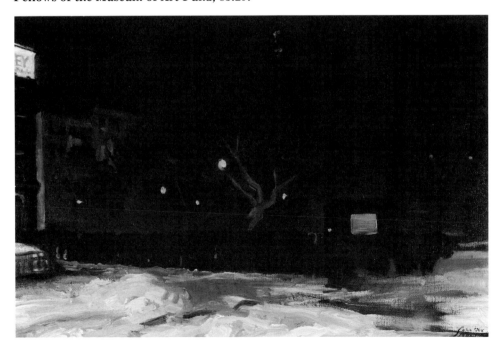

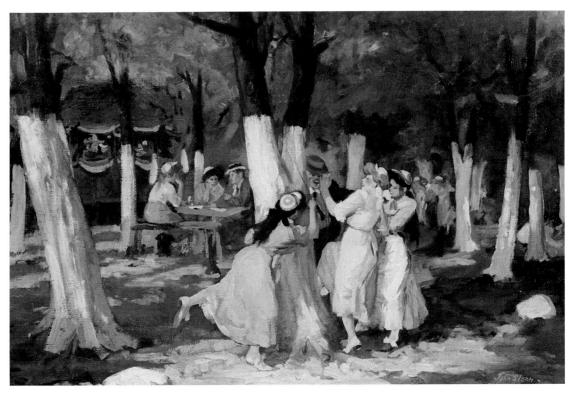

80. John Sloan, *The Picnic Grounds,* 1906–7. Collection of the Whitney Museum of American Art, New York. Purchase 41.34.

In fact, a review of Sloan's urban subjects from 1905 to 1909 would indicate that he depicted the working class and the inhabitants of nether New York without patronizing them, sentimentalizing their situation, or relying on stereotypical figure types. In his stunning *Haymarket* (see figure 77)—the painting that slipped past a particularly liberal academy jury only to be hung well above eye level—Sloan presented three chicly dressed prostitutes stepping into one of the most notorious night-spots in New York City.[101] Far from judging the prostitutes, Sloan seems to poke fun at the dour-faced mother at the left who scolds her daughter for stealing a glance (an impulse with which Sloan surely sympathized).

Contemporary art criticism does not explicitly confirm the foregoing suggestion that a segment of the early twentieth-century audience found Sloan's urban pictures disquieting. In fact, when reviewers did turn their attention to Sloan, remarks were usually positive. Certainly his technical facility was not faulted to a greater extent than other members of Henri's group. By the time of the 1910 Exhibition of Independent Artists, Sloan was always included among "leaders in the movement." The strongest evidence for a particular resistance to his work over against that of other members of the Henri circle is provided by Sloan's exhibition record. And in the present context, Sloan's repeated rejections are in striking contrast to

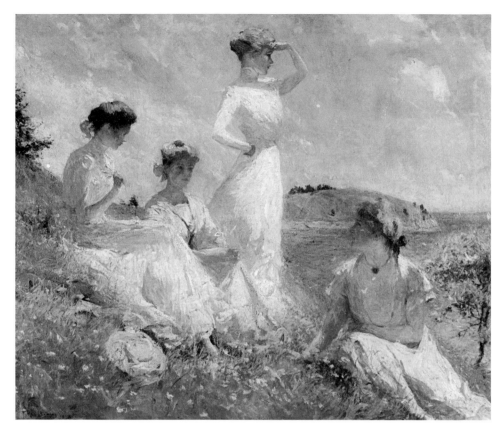

81. Frank Benson, *Summer,* 1909. Museum of Art, Rhode Island School of Design, Providence. Bequest of Isaac C. Bates.

Bellows's consistent success. A side-by-side comparison of related paintings by the two artists reveals possible differences in nuance between their respective approaches to a similar subject. Speculating about viable reasons for antipathy toward some of Sloan's urban pictures in the opening years of this century might shed light on the basis for Bellows's popularity.

The Public Beach and Working-Class Amusement

Sloan began working on *South Beach Bathers* (figure 82) shortly after a visit to the Staten Island resort of South Beach in June 1907. He put the painting aside for several months but completed it the following year. Since he thought enough of the picture to return to it after such an interval, he probably considered submitting it for the National Academy's Winter Exhibition in the fall of 1908. Sloan was in fact excluded from that exhibition; but as records of jury decisions have not been retained, whether *South Beach Bathers* actually appeared on the rejected list is unknown.

Plate 15 Bellows painted a beach resort scene in 1908, submitting the work, entitled *Beach at Coney Island* (figure 83) for the Academy's 1910 Spring Annual. It

was accepted, along with a Riverside Park landscape and a portrait. Once again, Sloan's entries failed to pass the Academy's jury.[102]

Bellows received particularly enthusiastic reviews that spring, but critics lavished most of their attention on the Riverside Park landscape, *Floating Ice*. The portrait typically came in a distant second, and *Beach at Coney Island* was often overlooked entirely in exhibition reviews. Frank Jewett Mather, for example, found *Floating Ice* "at once the most nervous and restful picture of the show." His lengthy description gave clear indication that this critic no longer regarded Bellows as a newcomer or his technique as undisciplined: "Nothing could be more impetuous than the workmanship or more discreetly controlled. Every touch is quite literally an indication; there is no inert passage."[103] In view of such effusive praise, it seems puzzling that Mather had no comment on the equally spectacular *Coney Island*. James Huneker did remark about the painting a year later, in a review of Bellows's first one-person exhibition. He admired the artist's knowledge of the figure and his handling of the composition but described the subject as "a distinctly vulgar scene."[104]

It would seem that even the *enfant terrible* was well advised to take caution when approaching a touchy subject like Coney Island. The resort had a long-standing reputation for low life, but recently constructed amusement parks were attracting new throngs and new controversy.[105] South Beach, the setting for Sloan's picture, was less topical, but similar associations about working-class amusements shrouded that public beach as well.

The suggestion of moral laxity that attended Coney Island, in particular, stemmed from the nineteenth century. Norton's Point at the far western end of the island had long been known as a refuge for criminal gangs, gamblers, and prostitutes. Those activities continued even as respectable hotels and restaurants began to appear, by the 1880s, at the island's opposite end. In 1883 Richard Fox, proprietor of the *Police Gazette* and prizefight promoter, published an illustrated guidebook to Coney Island's enticements, subtitled "How New York's Gay Girls and Jolly Boys Enjoy Themselves by the Sea." The "gay girls" were themselves, of course, prominently featured among the attractions:

> There are a good many ladies who travel to Coney without male escort. . . . You meet them on the boats and trains, the piers, hotel piazzas and the sands. They travel in pairs, make their faces up and dress a couple of notches above the very top of fashion. . . . They never go home alone.[106]

By the 1880s, Manhattan Beach and Brighton Beach were attracting middle-class excursioners to Coney Island. But well into the twentieth century, the island's tawdry past added resonance to its reputation for fantasy and escape; and commercial photographs for use on stereographs or similar formats continued to feature groups

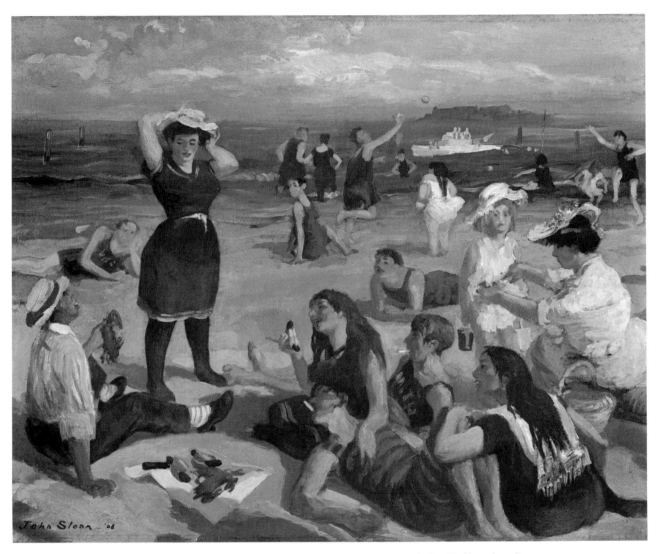

82. John Sloan, *South Beach Bathers,* 1907–8. Collection of the Walker Art Center, Minneapolis. Gift of the T. B. Walker Foundation, Gilbert M. Walker Fund, 1948.

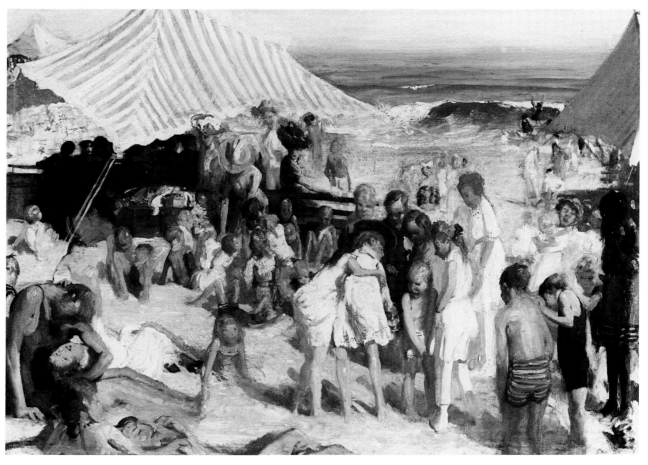

83. George Bellows, *Beach at Coney Island,* 1908–10. Private Collection. Photograph courtesy the H. V. Allison Galleries, New York.

of frolicking young women (figures 84 and 85). In an age when elite and conservative society still clung to an image like Benson's *Summer* as a depiction of ideal maidenhood, the implication behind many of these Coney Island postcards was clear.

Prostitution was only one segment of Coney Island's offerings for men in search of excitement, companionship, or sex. Single, wage-earning women from factories and department stores flocked to all the beaches surrounding Manhattan. Many of these women, it was widely assumed, were free with their sexual favors. As one reformer worried:

> The amusement resources of the working girl run the gamut from innocent and innocuous vacation homes and settlement dancing schools, sparsely furnished for those "well recommended," to the plentiful allurements of the day boat, with its easily rented rooms, the beach, the picnic ground, with its ill-lighted grove and "hotel," to numberless places where one may dance and find partners, with none too scrupulous a supervision.[107]

Thus, the physical circumstances of daily life for the urban working class were seen to virtually foster promiscuity. One settlement house worker did admit that "many of the liberties which are taken by tenement boys and girls with one another, and which seem quite improper to the 'up-towner,' are, in fact, practically harmless."[108] But most moralistic, middle-class observers applied their own standards of respectable behavior to the population as a whole and found part of the working class conspicuously lacking. Young, wage-earning women—who spent their meager salaries on stylish clothing and plumed hats, frequented dance halls and other popular amusements, and interacted freely with the opposite sex—were becoming increasingly visible as part of the social fabric of New York City. For settlement worker Ruth True, the phenomenon inspired a mixture of concern, alarm, patronizing sentiments, and, perhaps, a touch of envy. She described "the West Side girl"—any one of countless young women, fourteen to eighteen years of age, growing up in a Middle West Side tenement district—as an "independent" person:

> She has seen a good deal of the world. She has the early sophistication bred of a crowded, close-pressed life. . . . She is self-assertive, arrogant, "able to take care of herself." She comes, asking nothing, at ease and alert, but ready to give a trial to anything thrown in her way. . . . In all her pleasure-loving, drifting adventures she is hunting steadily for the deeper and stronger forces of life. Into her nature are surging for the first time the insistent needs and desires of her womanhood. But this she does not know. She is the daughter of the people, the child of the masses. Athletics, sports, diversions, the higher education, will not be hers to divert this deep craving. She is not close enough to her church for religion to control it. It will simply stay with

84. Keystone View Company, *A Pretty Good Story—On the Beach at Coney Island,
N.Y.,* 1899. Library of Congress, Washington, D.C. Stereograph Collection.

85. Stereoscopic view published by Strohmeyer and Winn, *Ah There! Coney Island
(Five Bathing Beauties),* 1897. Museum of the City of New York.

her, sweeping her inevitably out of the simplicity of little girlhood into the thousand temptations of her environment, if not, into one of the commonest of neighborhood tragedies.[109]

True might have recognized some of her West Side girls in Sloan's *South Beach Bathers*, but she might also have been startled by the artist's approach. The same young women whom True considered to be unfortunate victims of deprived circumstances Sloan presented as exuberant, fun-loving, and healthy. Even more distressing, Sloan failed to indicate in any way that their behavior, the public display of familiarity with their male companions, was unseemly. In fact, to present the working-class girls on Staten Island's South Beach not as colorful types, but as attractive, spirited young people was to draw attention toward changing value systems and the emergence of a new urban society. Sloan's relatively objective approach to a subject associated with a challenge to cultural authority perhaps showed a greater capacity for reconciliation with that challenge than his audience was willing to condone.[110]

At first glance, Bellows's *Beach at Coney Island* seems to share much in common with Sloan's almost contemporary *South Beach Bathers*. Both artists chose public resorts for their settings and filled them with the frolicking urban masses that customarily congregated there. Bellows even included an openly amorous couple in the left foreground to underline that this beach was distant, indeed, from the eastern, up-towners' end of the island. In terms of technique, Bellows's canvas displayed the more robust, unrefined surface of the two. In sum, both works would clearly have been identified with the "new movement" in American art and its "revolution" against the cultural establishment. A closer examination of *Beach at Coney Island*, however, reveals that although its subject was topical and even controversial, Bellows managed, once again, to approach the boundaries of social respectability without offending his class-conscious, moralistic audience.

First, Bellows established the otherness of his subjects in a way Sloan explicitly did not in *South Beach Bathers*. Sloan endowed his figures with naturalistic proportions and fluid, lifelike movements. By contrast, Bellows applied his demeaning, gangling body type to several youngsters in the fore- and middle ground of his picture. Although he depicted his figures in the midst of familiar, very human gestures and actions, they were often caricatured or slightly exaggerated, just enough to emphasize their ungainliness. Bellows was exploiting body movements to communicate class distinctions, just as the self-conscious, almost mannered grace of the female figures in Benson's *Summer* (see figure 81) bespoke their upper-class background. In the class-sensitive early twentieth century, the language of dress and deportment was more precise than it is today.[111] Thus, when James Huneker wrote about the "masses" and the "classes" at Coney Island, literate New Yorkers knew exactly what he meant. They knew it was the children of the "masses" whom Huneker was referring to when he described them "[sitting] on dirty newspapers

spread on the dirty sand and in the poisonous blaze of the sun."[112] They would have recognized a similar class awareness in Bellows's *Beach at Coney Island.*

By setting his lower middle- and working-class figures on a Coney Island beach, Bellows was conjuring up the special associations that surrounded that resort. Agnes M., a twenty-year-old German immigrant and wage earner, visited South Beach, North Beach, Glen Island, and Rockaway, but considered Coney Island to be "just like what I see when I dream of heaven." Yet she was well aware that "high people" questioned the respectability of her favorite resort.[113] In fact, people from every New York neighborhood indulged in visits to Coney Island, but especially for uptown excursioners the escape was flavored with a subtle sense of the forbidden. It was common knowledge that at Coney Island conventional proprieties were relaxed, if not totally cast aside.

Every year the New York newspapers and even nationally circulated magazines dutifully reported that Coney Island was finally fit for the whole family. In 1905, *Munsey's* pronounced the island's "wonderful regeneration" largely accomplished: "The man who formerly came with a gang of fellows from his office or shop to enjoy a relapse into rowdyism now brought his womenfolk and was decent." But seven years later the West End Improvement League was still promoting efforts to clean up Coney Island "both morally and physically."[114] Even a writer for the *Independent* admitted that the place was "no Sunday school." And Huneker called it an "open-air slumming spot."[115] Thus, while many contemporary gallery-goers remembered, and probably enjoyed, personal experiences at Coney Island's parks and beaches, they no more associated themselves with those environments than they did with the Lower East Side. They felt themselves as distant from the tawdry, commercialized amusements as they did from the people who swarmed in such numbers to enjoy them.

One of the first impressions conveyed by the scene in Bellows's painting is its crowded atmosphere. Not only is the sandy beach virtually hidden by bodies and paraphernalia, but the sky above the horizon line, which contributed to the spaciousness of Sloan's portrayal of South Beach, is partially blocked out by sun tents in Bellows's composition. In fact, the artist created one of his densest compositions to date in *Beach at Coney Island.* The stage-set format, which he had used in the boxing pictures to organize space and the elements positioned in it, has been replaced here by a massing of elements along a diagonal line from the right foreground moving back toward the left. The red-and-white-striped tent arrests that movement in the middle distance. The tent actually provided an opportunity for a magnificent passage of painting: Bellows clearly relished articulating its shape and making it seem almost to hover in space. The striped tent, however, constitutes a distinct and dominant note in the composition and, along with the other tent, just visible at the right, tends to force everything in front of it out toward the picture plane. This concentration of variously contorted figures in the foreground emphasizes the sense of density and crowding in the picture.

Middle- and upper-class Americans were particularly sensitive to the issue of space versus congestion. The effectiveness of reform-style photography depended in large part on well-established expectations for spaciousness in public as well as in the domestic environment. Reformers blamed the overcrowded conditions of the tenements for many social evils, including moral laxity. In view of the lack of privacy at home, young men and women from tenement neighborhoods were "almost obliged," in the words of one settlement worker, to rendezvous beyond the limits of parental supervision, in hallways, at streetcorners, or on public beaches.[116]

The kind of sexual promiscuousness that the middle-class often associated with the underclasses and their public behavior is a major theme of *Beach at Coney Island.* Although the couple in the lower left of the composition have eyes only for each other, several members of the crowd watch them. At the far right, two boys take furtive glances, one hiding behind his friend's shoulder. To their left, a small boy and perhaps his older sister face each other but stare at the kissing couple. Likewise, a woman behind and to the right of the girl cannot avert her glance. The crowd of twisting, turning bodies is peppered with faces directed toward the lower left, including one woman in the center of the composition who turns around, away from the water, to gawk.

The structure of the composition reinforces this visual focus on the increasingly conspicuous couple. Two major diagonals, which intersect the dominant diagonal motion into depth, terminate in the lower left corner. One starts at the front rib of the tent, moves down along a supporting rope, and ends up at the back of the man's head. The other line begins at the extreme upper right corner, moves down along the edge of the right-hand tent, along the back of the bent-over girl in the center foreground, and eventually conjoins with the body of the woman reclining in her companion's arms.

This visual orientation around the incident in the lower left corner of *Beach at Coney Island,* along with a subtle use of caricature, served to convey an implicit message to the first viewers of the painting. As usual, Bellows left the specific nature of his comment ambiguous; he might have been amused or scandalized. But by simply drawing attention to the aspect of his subject as spectacle, whether funny or vulgar, Bellows established distance from the scene. At that comfortable vantage point he found himself to be in closer alignment with the mood of most contemporary gallery-goers than was his more radical colleague, John Sloan.

Academic Accolades and Radical Politics

Sloan ultimately concluded that Bellows "never got away from the Charles Dana Gibson" point of view. Perhaps not surprisingly, he also thought Bellows tailored his art to his audience too much, that he painted "with his eye on the bleachers."[117] At the same time Sloan often admitted, if begrudgingly, that his younger colleague was brilliantly talented. During the period between the Exhibition of Independent Artists

of 1910 and the Armory Show of 1913, Bellows and Sloan continued to cross paths professionally and, from time to time, socially, but they never became friends.

Bellows was elected as an associate member of the National Academy of Design in April 1909 and increasingly moved at will between "revolutionary" and conservative circles. He continued to criticize what the Academy stood for and its exclusionary methods, but he also kept striving for acceptance within its sanctified walls and mixing with its society. He met Cecilia Beaux at a social occasion and afterward wrote to ask for her photograph.[118] During the spring of 1909, Miss Beaux invited him to teas and a performance of *Aida*. Such a connection with a permanent resident of Gramercy Park and the grand dame of the Academy surely did Bellows no harm.

Bellows cemented his uptown social aspirations in the minds of many when he married Emma Story, the daughter of a well-to-do businessman from Upper Montclair, New Jersey. Although Bellows was able to install his new wife in a house on East Nineteenth Street and soon thereafter was able to provide her with a maid, the Storys always harbored the belief that George and his family were basically Midwestern ruffians. Emma routinely reprimanded her husband for ignoring social courtesies, scolding him on one occasion, "Oh, George, how *can* you be so proletarian!" Meanwhile George maintained that social conventions were his "arch enemy." A close friend of Emma's remembered that whenever her husband made some "outrageously radical statement," she would just smile and change the subject.[119]

The Bellows's address on East Nineteenth Street was mere blocks from that of Henri and his new wife. Over the years, the two couples became close. Meanwhile, Sloan was moving gradually away from his intimate relationship with Henri, and Henri began replacing the first-generation "membership" of his circle with a group of younger followers. This change of the guard and Bellows's new position as "beloved disciple" became apparent during a heated squabble over a second Independent Artists' Exhibition, organized primarily by Rockwell Kent. Kent's insistence that participants boycott the Academy for a full year sent Henri into a rage. He accused Kent of using a "labor union method" of coercion and set about galvanizing his followers against the scheme. Sloan sided with Kent at first but started to waver: "Henri is right in saying that we have never put the 'screws on' anyone in our exhibitions. I came away quite undecided with a bias in favor of H.'s position."[120] Kent himself described the final, confrontational meeting over the issue, held in Sloan's studio:

> Beyond Sloan and Henri, no one but eight or ten of the younger artists attended. . . . At one end of the large studio sat Henri; and next to him George Bellows. At the other end sat I. We talked, we aired our views, we argued. . . . And when at last the rival leaders called for enrollment in their respective camps, nearly all moved to my end of the room,

leaving Henri and, of course, Bellows, and possibly one or two others, in inglorious isolation.[121]

A few days later, Sloan reluctantly abandoned the project as well, feeling continuing pressure from Henri.

During the next few years Henri, Sloan, and Bellows shared several interests, including Emma Goldman and radical politics. Henri started attending her lectures in early 1911; by the end of that year, Sloan and Bellows often went with him.[122] But increasingly, Sloan followed his own political inclinations and, with the strong support of his wife, became actively involved in socialism and in the iconoclast magazine *The Masses.* Meanwhile Bellows, up until the outbreak of World War I, when he abandoned radical politics and publicly supported the war effort, alternated between socialist and anarchist flirtations.

Henri continued to figure as a primary influence on his protégé, in what has been described as a father-son relationship, and undoubtedly played a role in Bellows's involvement with an anarchist project.[123] A Gramercy Park neighbor of Henri's and Bellows's, Bayard Boyesen, was censured at Columbia for his involvement with Goldman. He resigned his position in the English department to become the director of the Ferrer School, which opened early in 1911 largely through Goldman's efforts. Henri eagerly accepted Boyesen's invitation to teach art at the school. Bellows followed suit, thus joining his name to the roster of faculty at what was fast becoming a center for radical thought in New York City.[124]

In March, an exhibition of Henri's paintings was put up in the hallways of the school. Boyesen marked the occasion with a lecture on the relationship between artists and philosophical anarchism. He opened by declaring that the artists doing "anything great in this city to-day" did not graduate from the usual schools but had studied with Henri, and he called attention to Rockwell Kent and Bellows in that regard. Robert Henri, he said, "stands for freedom. And because all genuinely inspired artists have stood for absolute freedom of conscience they have necessarily stood exactly where the philosophic anarchists stand."[125]

Meanwhile, Sloan became increasingly involved with political activities and especially graphic work for the socialist cause. By the close of 1912 he was serving as the informal art editor of *The Masses,* working with artist and political cartoonist Art Young and bohemian radical Max Eastman to revive the floundering periodical "as a *popular* Socialist magazine."[126] Sloan was largely responsible for making *The Masses* a vehicle for some of the finest graphics of the period. A sensitive treatment of artwork in layout as well as production drew visual artists with differing attitudes toward socialism. Most shared a commitment to the vital relation between art and politics; surely a few were attracted to the chance to rub elbows with the fascinating counterculture characters associated with the magazine and its enterprise. Without question, a seductively ebullient atmosphere surrounded the *Masses* crowd—a gathering of energetic men and women who were

heady with new ideas and eager optimism. In April 1913, Sloan persuaded Bellows to join.[127]

Once again, Bellows left no record of his personal reasons for his involvement with *The Masses*, or with the Ferrer School for that matter. Certainly he never professed support for socialism, for the Socialist party in America, or for the anarchist movement and its ideas about radical social change. The strongest indication is that Bellows felt a commitment to personal and artistic freedom. Although his own life-style suggests that he resisted, or at least avoided, substantial deviations from relatively traditional, middle-class social mores, in his professional life he stood firmly for unrestricted, individual expression. Art was the primary focus of Bellows's life, and he carefully considered not only the subject matter of his pictures but also where and how his work would be seen. A letter that Bellows addressed to *The Masses* during its final months of publication indicates that his vested interests in regard to the magazine had more to do with his work than with issues of cultural change or political reform:

> [*The Masses*] offers the opportunity which artists and writers of young enthusiastic and revolutionary spirit have always wished for in this country, and this opportunity is sliding away. . . .
>
> You can not have today a magazine of the wide appeal which The Masses should hope to have, without a greatly increased preponderance of interesting and vital pictures over what The Masses has recently presented. . . .
>
> Now, whether you like it or not, or whether you think it "practical" or "right" or not, you will get very few good artists to give their time or their best work freely and without pay or compensation [*sic*] of any kind, no matter what their feelings about social revolution, for work to be done in this spirit, men who have had the experience of cartoonists, may do so; the others will not.
>
> You have got to create the atmosphere of an exhibition in which great artists are having a great time. This will attract the best of them. You have got to get rid of obvious, heavy propaganda.—The public will not read it—and make what propaganda there may be, subtle, interesting, full of wit and art, or not at all. The social cartoon is an obvious and tiresome affair. There are other magazines and papers where it may be used to advantage, but not here.[128]

Elsewhere in this same statement, Bellows mentioned "the defeat of the old 'art' element," a reference to the controversy over editorial control and the relationship of art to the magazine's political focus, which led to the resignation of Sloan and five other artists from the board. As the dispute involved artistic freedom and the right of the artists to publish drawings without propagandistic captions attached without their consent, it seems puzzling that Bellows decided against

supporting Sloan and the "'art' element."[129] It appears that he tried to keep all his options open. In fact, Bellows never resigned from *The Masses*, even after Eastman asked him, along with the other board members, to sign a manifesto against America's entrance into the war. Bellows returned the statement unsigned with a strong letter of explanation, which included the following:

> *The Masses* has no business with a "policy." It is not a political paper and will do better without any platforms. Its "policy" is the expression of all its contributors. They have the right to change their minds continually, looking at things from all angles.
>
> In the presence of great, ultimate, and universal questions like these, it is impossible, at least for me, to know quite where I stand.[130]

Wartime censorship closed *The Masses* before Bellows reached a firm decision. It is likely, however, that he would have continued to resist pressure to declare a position for the sake of a *Masses* policy statement—but not because he was unable to make a commitment. Bellows did come out publicly in support of the war effort after the United States officially joined the conflict. But in his letter to Eastman he wanted to make a point about freedom of expression, the principle he still associated with *The Masses*—somewhat stubbornly, in view of how substantially circumstances had changed during the four years since he had joined its board. He also requested that if the antiwar statement was published, the views of nonsigners should be published as well.

This evidence would suggest that, far from making a commitment to political activism, Bellows was seldom primarily concerned with politics per se. Instead, he followed the example of Robert Henri in opposing dogma or any other instrument of domination by the ruling class. Bellows rarely addressed these issues in political terms, but in a September 1912 interview he said, "As a painter I am not a preacher; I am not trying to uplift or teach. I am merely trying to do the best work of which I am capable. The mind can do its best work only in absolute freedom, freedom from conventionality and freedom from the desire for money and fame."[131]

Bellows considered *The Masses*, dedicated as it was to oppose "rigidity and dogma wherever it is found,"[132] as an appropriate enterprise to become involved with. He devoted much of April and early May 1913 to a series of ambitious drawings, remarkable for their technical experimentation and expressive richness. April was an eventful month in other respects. That spring tested the limits of Bellows's ability to present different personas to different audiences. His 1907 portrait of Queenie Burnette (see figure 54), the girl who brought his laundry when he was living in the Lincoln Arcade, had been awarded the First Hallgarten Prize in the Academy's Eighty-eighth Annual Exhibition, which remained on view through the twentieth. Significantly, *Little Girl in White* combined a working-class subject with a salon-style tradition of portraiture that owed a large debt to Manet. The award

stirred up accusations of favoritism and even collusion,[133] a bitter but relatively minor bluster against the background of the larger controversies still raging over the just-closed Armory Show. In the midst of all this, Bellows was notified of his election as a full member of the National Academy.

Bellows seems to have welcomed a directed outlet for his energies that April. Earlier, preparations for the Armory Show had kept him busy but had distracted him from his studio. The show was forcing him into a reevaluation of his own work in relation to fauvism and postimpressionism. Making drawings for *The Masses* enabled him to postpone temporarily such a troubling reassessment, and furthermore, the project seemed meaningful and substantive. The full implications of the Armory Show were not yet apparent that first spring, but during succeeding years the Henri circle never reclaimed their place in the headlines. In some respects the remainder of Bellows's career might be seen as a succession of attempts to come to terms with his displacement from center stage in the art scene and to reassert the relevance and validity of his work in the face of the avant-garde. The pictures that he completed during April and May 1913 still belong, thematically and stylistically, to his pre–Armory Show career. As such, they represent the culmination of the first mature phase of Bellows's oeuvre.

Drawings for *The Masses* and a Major Canvas

In one burst of activity, Bellows produced five drawings that would appear in *The Masses* during the spring and summer of 1913. They were all assiduously worked in a variety of media.[134] His *Business Men's Class* (figure 86; *The Masses*, April 1913), for example, is a monotype and a collage with ink, crayon, and graphite. A wonderfully humorous satire on an aspect of upper-class urban life, the image not only reflects the influence of Daumier's graphic style but also exemplifies Bellows's own creative conflation of stereotype and individual characterization. Paunchy patricians and affected fops present an array of "distinctive" poses and facial expressions. The first work Bellows created specifically for *The Masses*, *Business Men's Class* probably represents the brand of humor he considered particularly suited to the magazine's readership.[135]

Bellows also returned to some of his earlier urban themes in the series. The drawing Sloan used for the June issue harks back to *May Day in Central Park* and *Children Playing in a Park* (see figures 51 and 52), but the composition of the later drawing (figure 87) shows greater complexity as well as a more successful integration of elements than did previous treatments of the theme. Bellows, first of all, chose a relatively unusual and sometimes difficult compositional format: whereas he used the more traditional horizontal orientation for his earlier park scenes, the *Masses* drawing is square. Within that shape he marked out distinct horizontal registers, a device he commonly used. But rather than distribute the figures fairly randomly across the lower half of the picture, as he did in *May Day*, he grouped

86. George Bellows, *"Superior Brains": The Business Men's Class,* 1913. Boston
Public Library, Print Department. Gift of Albert Henry Wiggin.

figures in three separate areas, indicating three stages in depth. Thus, the bottom
register combines two spatial zones: the boys on the rock at the left occupy the
foreground, and the larger group of children to their right begins the movement back
into space. A third group of figures, above and behind the children, is considerably
farther away. The entire scheme is both lucid and cohesive. Bellows's handling of
light-dark contrasts in this picture demonstrates a similar, though increased, sophis-
tication. Dense areas given over to the trees and foliage provide textural variation
while virtually blacking out the background, against which spots of lighter value
seem to flicker across the surface, animating the figures of frolicking children.

Bellows reapproached the theme of *Forty-two Kids* in his drawing for
the July issue (figure 88), and again the later composition is considerably denser and
more complicated than that of the 1907 painting. The most ambitious drawing of all,
however, appeared in the August issue of *The Masses* (figure 89), although it was
actually produced immediately after *Business Men's Class.* Bellows was gratified
enough by his achievement in this second drawing in the *Masses* series to use it as
the basis for a major painting, *Cliff Dwellers* (figure 90).

The drawing, which appeared with the title *Why Don't They Go to the
Country for a Vacation?* incorporated many aspects of tenement district life that
had appeared in Bellows's earlier work. A frail-looking "little mother" in the fore-
ground seems just able to keep her infant charge aloft. At the extreme lower left,
boys play the "cramped game" of leap frog. Climbing the steps into a tenement at the
right is a young woman carrying home a bucket of beer, a practice known as "rushing

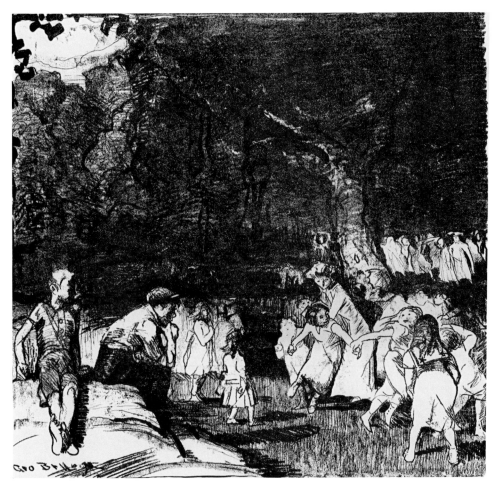

87. George Bellows, *Philosopher-on-the-Rock: "Gosh, But Little Kids is Happy When They's Young!"* 1913. Reproduced in *The Masses,* June 1913. Courtesy Evette Eastman.

the growler." The fact that she allowed her dress to slip tauntingly off her shoulder as she exchanged a few words with an unidentified man went along with what, in the view of respectable society, the beer bucket had implied—that she had entered the predominantly male domain of the local saloon alone.[136]

All of these incidents, however, are subsumed within the overall packed-in congestion of the slum neighborhood depicted in *Why Don't They Go to the Country for a Vacation?* This seemingly unbearable overcrowding was the supreme sensation registered by middle- and upper-class observers of New York's tenement districts. As one English visitor observed after "doing" the East Side with a detective-guide, "The architecture seemed to sweat humanity at every window and door."[137] The conditions fostered by this unrelenting press of humanity continued to be a source of worry and wonder for reformers like Lilian Brandt: "It might be thought that the care of four or five children, and the maintenance of a home in three

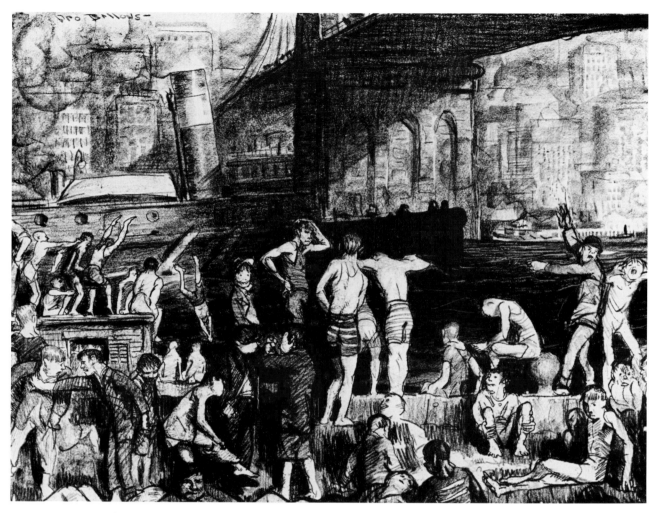

88. George Bellows, *Splinter Beach,* 1913. Mr. and Mrs. Harold Rifkin Collection,
New York.

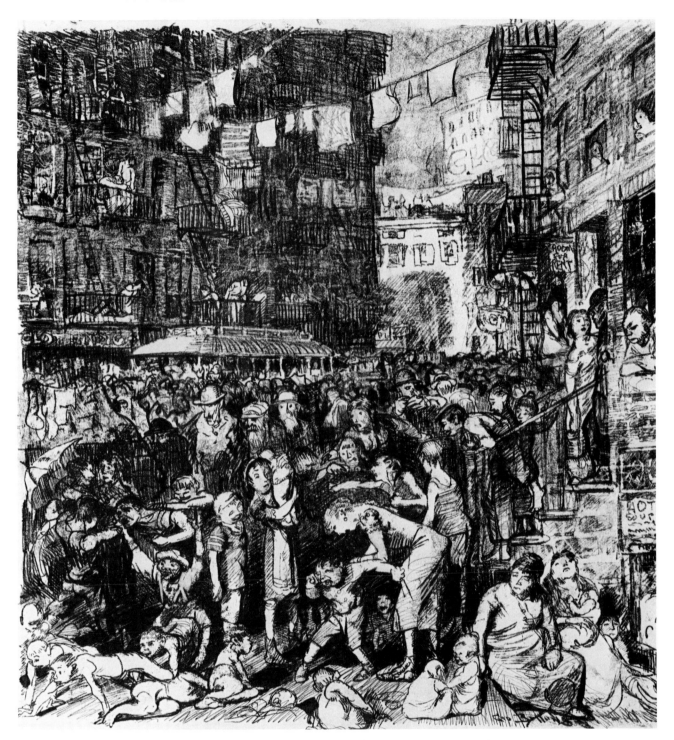

89. George Bellows, *Why Don't They Go to the Country for a Vacation?* 1913. Los
Angeles County Museum of Art. Los Angeles County Funds.

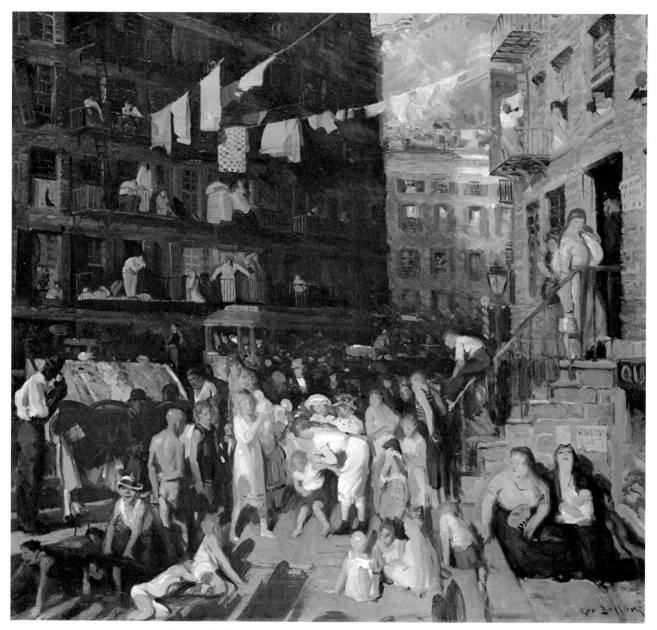

90. George Bellows, *Cliff Dwellers*, 1913. Los Angeles County Museum of Art. Los Angeles County Funds.

rooms, would furnish an average woman with occupation for most of her hours. But there are always women to be seen gazing out of the windows, sitting on the steps, and standing on the sidewalks, engaged in no more fruitful activity than an interchange of ideas."[138] Two such phlegmatic women lounge conspicuously in the right foreground of Bellows's drawing, and the windows and doors do indeed seem to be sweating humanity.

In his *Masses* drawing Bellows has marshaled his skills as if with the intention of outdoing reform-style photography, of compressing within the frame of his composition the visual information from an entire collection of documentary images. In addition to filling the foreground with recognizable slum scene vignettes, Bellows has manipulated the standard format for Lower East Side street views. The orientation of *Why Don't They Go to the Country?* is slightly vertical. One side of a virtually contemporary stereograph, also slightly off square, with the vertical dimension greater than the horizontal, provides an appropriate image for comparison (figure 91). This stereograph view from the corner of Prince and Elizabeth streets contains the typical triangle of light sky above and reciprocal triangle of street below, standard elements of the camera lens view of a city street. A line of receding tenement facades creates similar triangular shapes at both sides. The apexes of all these triangles converge at a vanishing point in the distance. A view of a busy, narrow street such as the one photographed for this stereograph served the purpose of conveying the sense of congestion and chaos that was understood, and often expected, by culturally programmed middle-class observers. The usual accoutrements—laundry and clutter on the balconies, push carts along the street— distanced the scene from established notions of proper environment. Bellows exaggerated the sense of visual overload by packing into his composition more figures and incidents than a photographer could ordinarily incorporate within the physical limits of a camera lens. He also blocked out the sky with the unyielding faces of tenement buildings that expand from the left across more than half the picture space. One rectangle of health-bestowing sunlight remains visible at the upper right, but even that small area is partially cut off by lines of laundry and the top corner of a distant building. Bellows has restricted recession into depth to a considerably greater extent than he did in *Beach at Coney Island.* Here the design exists within a relatively shallow shelf of space, and on that shelf the artist has jammed literally hundreds of figures and a streetcar.

Without the satirical title that appeared with it in *The Masses*, Bellows's drawing presented a relatively typical middle-class vision of the slums— an informed vision, to be sure, based on personal experience as well as awareness of the contemporary emphasis on tenement district evils as portrayed by the progressive press, but not shocking or overly provocative. Bellows's vision also conformed to a middle-class notion of appropriate power relations: he viewed the world of the lower classes as subject to the will of those who observed it, investigated it, and

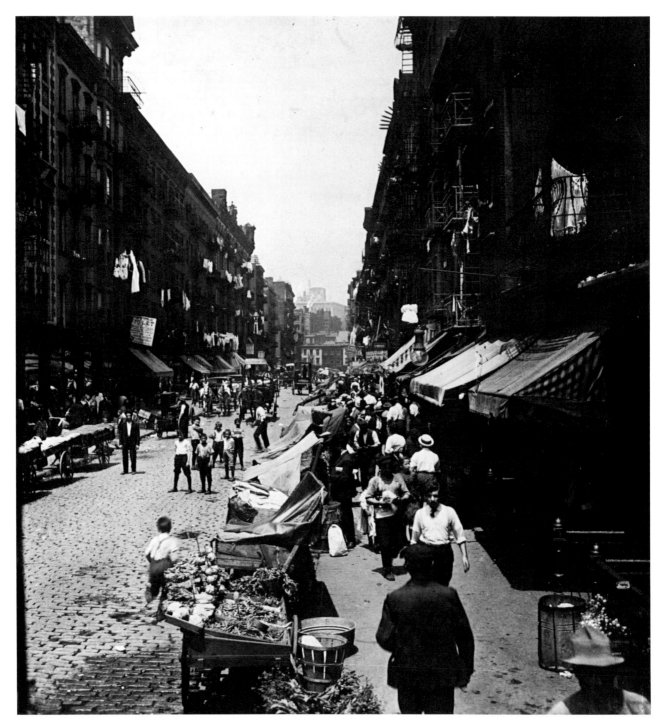

91. Stereoscopic view, *Corner Prince and Elizabeth Sts., NYC,* ca. 1911. Library of Congress, Washington, D.C.

ultimately controlled it. The caption conferred additional layers of meaning to the image, without essentially altering the vision it presented or the power relations it implied. In the context of the counterculture stance of *The Masses*, the image together with its caption pointed a finger at society's indifference to the side effects of capitalism and, secondarily, satirized the conventionalism of bourgeois leisure.

Plate 16 As Bellows reinterpreted his drawing for the painting *Cliff Dwellers*, he toned down some of the grimmer details. The haggard expression on the "little mother's" face is brightened considerably in the painting, and the infant in her arms is smaller in proportion to herself and, therefore, seems less of a physical burden. The young woman entering her building at the right still holds the noxious beer bucket; but she exposes no bare shoulder, she seems older and more matronly, and she carries a child. The combination of the baby and the beer conjured up another set of problems, of course, but at least the blatant "loose-woman" type has been eliminated. All the foreground figures are positioned slightly further back, away from the front plane, mitigating to some extent the claustrophobic closeness of the drawing. In fact, the figures are proportionately smaller in relation to the buildings and the composition as a whole. The woman rushing the growler rises up and away from the congested mass behind her as she approaches the door of her building. In the drawing, she seems to be still part of that swarming mass which occupies the entire lower half of the composition. Spots of vivid orange enliven the painting's subtle but rich mauve-green color scheme, and sunlight streaming in from the foreground plane serves to lighten the more open space and even purify the air.

 In spite of these changes, Guy Pène du Bois recognized the dehumanizing effect of Bellows's exaggerated figure types when *Cliff Dwellers* was exhibited at the Montross Gallery late in 1913. He praised Bellows for a strong composition and for bold, even "joyous" workmanship, but he criticized the artist's tendency to generalize and, by implication, to dismiss the crowd:

> He has built a crowd of people in which not one single person exists; a crowd that loses its reality the moment that it is dissected. Searching through it for a friendly face one finds a young girl who bends stiffly, at right angles like a jack-knife, a brute boy whose bare back does not suggest flesh, a horrible bit of blown-up surface feeding an infant. . . . But we must not dissect this picture, for if we find no people in it we do find in its entirety the turmoil, sway, riotous rhythm and character of a crowd.[139]

Du Bois was not the only contemporary critic to take note of Bellows's fierce exaggerations. Charles Buchanan called *Cliff Dwellers* a "semi-fantastic, semi-reportorial" statement, in which "the congestion of the city streets becomes a shrill pitched cacophony of warring sounds."[140]

Plate 17 Bellows's stereotyping of the upper classes was not unlike his handling of slum dwellers. He painted *A Day in June* (figure 92) later that same spring of

1913, after a scene in Central Park. The figures are as elegant as those in *Cliff Dwellers* were ungainly; the picnickers in Central Park are as tall and noble, according to Bellows's vision, as the inhabitants of the tenements were bent and brutalized. The scene presented in *Day in June* was relatively conventional, even according to the Academy's standards. Though not, strictly speaking, idealized in the manner of Cox or Paxton, for example, Bellows's painting adulates the same middle-class, Victorian ideals of womanhood, family, cleanliness, space, and order that the more hidebound academicians celebrated in their paintings. He could, as Sloan once suggested, come close to looking academic, but his reputation, even among academicians, depended in part on how he was different. Bellows's artistic language was more direct, his style was bolder, and he approached a much wider range of subjects than did the patriarchs who dominated the Academy.

It was his tenement district subjects, especially the sordid scenes he presented in some of his early drawings, that reminded conservatives of his radical heritage and his ties with Robert Henri. But academicians could tolerate the brashness of this youngster from Henri's fold: in fact, they needed him. While the paintings by the likes of Sergeant Kendall, Frank Benson, and Childe Hassam still represented the mainstream of American taste, the signs of sterility were all about. For years James Huneker had been calling the Academy "the morgue" and their paintings "cadavers." The sudden appearance of George Bellows on the scene presented a kind of temporary antidote for the degenerative tendencies that seemed to threaten American art and culture. Of course, Bellows represented what the critics were referring to as the new movement in American art—though not the cutting edge of that movement, perhaps, as the initial battles had been waged by others before him. But Bellows brought the best of what that movement had to offer: revitalization of worn-out artistic formulas, youthful exuberance, and masculinity. Furthermore, Bellows presented the possibility that the renewal process could be carried out without completely disregarding the old, familiar forms and established priorities—that is, without abandoning the system.

•

Bellows's essentially middle-class conception of poverty corresponds to issues discussed in chapters 1 and 2. His vision of the sporting subculture, for example, was likewise conservative, and his celebration of industrialization and urbanization conformed to established American values. That he and his colleagues treated these subjects at all and did so straightforwardly, that they made pictures that were judged ugly by the standards of the time, startled many art lovers. But even in the revolutionary aspects of their art, Henri and his colleagues laid claim to a venerable artistic tradition in the examples of Hals, Velazquez, and Goya as well as to more recent but already established figures such as Daumier and Manet. Their revolution, in other words, was limited in scope and was waged within prescribed boundaries that were seldom violated. Bellows knew better than most how to show respect for the rules

92. George Bellows, *A Day in June,* 1913. The Detroit Institute of Arts. Detroit
Museum of Art Purchase, Lizzie Merrill Palmer Fund.

while addressing his art to them. As a result, his style and his subject matter kept him at the center of most of the debates that occupied the New York art world for more than a decade.

After 1913, Bellows no longer figured in those pivotal debates. Conservatives never abandoned Bellows, however, and the art establishment continued to bestow prizes on him. Late portraits like *Elinor, Jean, and Anna* (1920; Albright-Knox Art Gallery) and *Emma and Her Children* (1923; Museum of Fine Arts, Boston) must be considered among the artist's best work. But even as Bellows painted them, he was working away from and behind the forefront of stylistic innovation in American art.

His early death in 1925 brought an outpouring of eulogies and reassessments of his career. Naturally, they were still colored by memories and impressions of Bellows the man. His all-American-boy persona had its beginnings in the first decade of his career in New York City, but a half-truth developed into a full-blown and widely believed myth by the time of his death. In addition to his Americanness, however, observers expressed frank appreciation for his middle-of-the-road vision of American life. Rollo Walter Brown reiterated the familiar comparisons of Bellows with Jack London and Walt Whitman. Brown felt compelled to redefine the bases of these comparisons: for example, Bellows was "more comprehensive in his sympathies, more healthy in his vigor" than London. Brown agreed with the assumed consensus that Whitman came closest to prefiguring Bellows's contribution to the American tradition. Both artists were "impatient" with outmoded forms and subjects; both expressed the energy of American life; and both respected the individual while celebrating all of life. But Brown appreciated Bellows for being closer to the center: "Bellows was a more complete person than Whitman, a more representative person. Whitman was, with all of his democracy, an exotic democrat. He was an exotic American. He was not himself representative; he only wrote about representative things. He was, moreover, in his sympathies a remote pagan, and George Bellows was close and warm and reverential."[141]

By 1966, first-hand memories of Bellows were becoming increasingly rare and in any case irrelevant to serious analysis of his art. Yet when John Canaday, critic for the *New York Times*, entered a large-scale exhibition of Bellows's work, he was struck by recognizing in what he saw "an art that was essentially provincial in its optimism and in its sturdy faith in such values as the warmth of home and family, the honest picturesqueness of the common man, and the beauty of the visual world . . .—values that seem so destroyed that it is almost embarrassing to list them."[142]

It seems obvious now: of course, the values implicit in Bellows's paintings are conservative, even trite. The point is that Bellows's first admirers were so involved with either clinging to or shedding their innocence that they failed to appreciate that the appeal of Bellows's paintings rested partially in the way they

incorporated the essence of that innocence. Conservatives were in battle to defend it, whereas radicals were already nostalgic about it. Although Bellows's rapid rise to success was fueled, certainly, by his ability to paint—by his facility not only with the materials of his craft but also with the structure and arrangement of pictorial space—technical proficiency alone cannot account for the artist's almost immediate popularity. The real significance of Bellows's art to his contemporaries derived from the content of his pictures and how that content was understood. I have argued that Bellows's treatment of urban subjects addressed the concerns of many middle-class Americans during the opening years of the twentieth century. His depictions of the slum poor, for example, approached issues of changing moral and social values in a way that seemed not only relevant and congenial to much of the gallery-going audience but also reassuring to their attitudes and preconceptions about urban life in America. Furthermore, in addition to keenly observing the contemporary world around him, Bellows appraised and possibly tailored his position in the art community, with astonishing acuity.

Forbes Watson remembered Bellows as being particularly determined to achieve success.[143] In reality, Bellows's ambition was probably not unlike that of his colleagues; but he admitted his goals candidly and often achieved them. He not only established a considerable reputation in the space of less than ten years, but he also succeeded in forging something of a double-edged identity. He was known for his "frank" and "uncompromising" paintings of "brutal crudity." He was associated with a rebel group whose work was said to pose a threat to the nervous systems of Kenyon Cox and "his Fifty-seventh Street flock"[144]—and, by extension, the certainty of moral values. But, as is clear from the nuance of remarks about the vulgarity of Bellows's paintings, an excess of "guts" was preferred to an excess of gentility.

In 1911 an art journalist for the *Telegraph* called Bellows "the most successful young painter in New York" and asked him how he accounted for his "immediate" recognition. Bellows's response was uncharacteristically humble as well as acutely perceptive: "Others paved the way, and I came at the psychological moment."[145]

In many respects, Bellows's way was indeed paved. By the 1900s a vocal segment of the art public was weary of the "rosewater idealism" regularly served up by Academy painters and sculptors. Henri, along with a handful of progressive commentators and critics, repeatedly reminded New York gallery-goers that they were looking for a new sensation—and an authentic, American art. Bellows arrived on the scene making exuberantly spirited pictures of the bigness and boldness of New York, of topical events, and of current history. His paintings responded to the current appetite for insurgence while paying implicit homage to the "smiling aspects" of American life. Indeed, for a few short years George Bellows was the new sensation everyone was waiting for.

Notes

Introduction

1. Frank Crowninshield, introduction to *Memorial Exhibition of the Work of George Bellows*, exhibition catalog (New York: Metropolitan Museum of Art, 1925), p. 11.

2. Ibid.

3. See, for example, Izola Forrester, "New York's Art Anarchists: Here Is the Revolutionary Creed of Robert Henri and His Followers," *New York World*, 10 June 1906, magazine section, p. 6; "New York's Art War and the Eight 'Rebels,'" *New York World*, magazine section, p. 1.

4. Thomas Beer, introduction to *George W. Bellows: His Lithographs* (New York: Knopf, 1927), p. 17.

5. Crowninshield repeated what was already a long-standing inaccuracy in his 1925 catalog introduction when he said of Bellows: "At the age of twenty-seven he was elected an Associate of the National Academy of Design, the youngest painter ever to be so recognized." In fact, Bellows would not have been twenty-seven until the following August. In any case, as Franklin Kelly has recently pointed-ed out, Frederic Church was even younger when he became an associate academician in 1848. See Kelly, "George Bellows' *Shore House*," in *American Art around 1900*, ed. Doreen Bolger and Nicolai Cikovsky, Jr., Studies in the History of Art, no. 37 (Washington, D.C.: National Gallery of Art, 1990), pp. 134–35, n. 7.

6. Warren I. Susman, "'Personality' and the Making of Twentieth-Century Culture," in *Culture as History: The Transformation of American Society in the Twentieth Century* (New York: Pantheon Books, 1983), pp. 271–85. Amy Kaplan discusses the modern art of personality as a subject of realist fiction in *The Social Construction of American Realism* (Chicago: University of Chicago Press, 1988), esp. pp. 24–25, 35–38, 129–30.

7. Henry Laurent, *Personality: How to Build It* (New York: Funk and Wagnalls, 1915), pp. 11, 100. Some art critics noted the ascendency of personality as early as the 1890s. See Sarah Burns, "Old Maverick to Old Master: Whistler in the Public Eye in Turn-of-the-Century America," *American Art Journal* 22, no. 1 (1990), pp. 38–39.

8. S. H. [Sadakichi Hartmann], "Studio-Talk," *International Studio* 30 (December 1906), p. 183.

9. Charles Wisner Barrell, "Robert Henri—'Revolutionary,'" *Independent* 64 (25 June 1908), pp. 1428, 1432.

10. Susman, "Personality," pp. 277–78. See also T. J. Jackson Lears, "From Salvation to Self-Realization: Advertising and the Therapeutic Roots of the Consumer Culture, 1880–1930," in *The Culture of Consumption: Critical Essays in American History, 1880–1980*, ed. Richard Wightman Fox and T. J. Jackson Lears (New York: Pantheon Books, 1983), pp. 1–38. Henri's ideas were also related to broader intellectual and philosophical concerns of the period. Rebecca Zurier has noted, for example, that central tenets of his teaching—the individuality of expression, the organic development of art, and the artist's role in society—were also debated by such writers and critics as John Dewey, Louis Sullivan, Frank Lloyd Wright, Montgomery Schuyler, and Theodore Roosevelt. See Zurier, "Picturing the City: New York in the Press and the Art of the Ashcan School, 1890–1917" (Ph.D. diss., Yale University, 1988), pp. 41–58.

11. Forbes Watson, notes for a lecture, "George Bellows—The Boy Wonder of American Painting," delivered at the National Gallery, Washington, D.C., 27 May 1945 (Forbes Watson Papers, Archives of American Art, Smithsonian Institution, Washington, D.C.).

12. Henry McBride, "Bellow's [*sic*] Death Is Great Blow," *New York Sun*, 10 January 1925, p. 7

13. Forbes Watson, "George Bellows," *New York World*, 11 January 1925, p. 10-E. In her essay, "A Critical History of Bellows' Lithographs," Linda Ayres has summarized the critical reception of the artist's prints, on the basis of reviews by Forbes Watson as well as by Royal Cortissoz, Henry McBride, Elizabeth Luther Cary, and Helen Appleton Read. See Jane Myres and Linda Ayres, *George Bellows: The Artist and His Lithographs, 1916–1924* (Fort Worth, Tex.: Amon Carter Museum, 1988), pp. 129–54. Although the majority of these reviews postdates the period during which Bellows produced the urban paintings of concern here, Ayres's discussion of the conservative-radical dichotomy, which was noted during Bellows's lifetime, is relevant.

14. Arthur Hoeber, "The Winter Exhibition of the National Academy of Design," *International Studio* 30 (February 1907), p. xcvi; "Cubists of All Sorts," *New York Times*, 16 March 1913, editorial section, p. 6, cited in Milton W. Brown, *The Story of the Armory Show*, 2d ed. (New York: Abbeville Press, 1988), p. 167. Just as the meaning of terms with political ramifications became fluid if not blurred, newspapers and journals did not line up rigidly along radical or conservative lines with respect to art commentary. The *New York Times*, for example, cultivated an elite, conservative readership by stressing propriety and accuracy in its presentation of the news; but critics who wrote for the paper were not necessarily opposed to advanced art. Likewise, newspapers associated with liberal political and social positions, such as the *World* or the *Globe* were not always consistent in their support for progressive artists and art movements.

15. Royal Cortissoz, "The Field of Art," *Scribner's* 78 (October 1925), pp. 41–42.

Chapter 1, *The Excavation*

1. "Academy Exhibition," *New York Sun*, 23 December 1907, p. 4.

2. "Spring Academy," *New York Sun*, 21 March 1908, p. 6. Of the artists whose work was hung near Bellows's two entries, Robert Henri and John Sloan had participated in the recent and infamous exhibition of the Eight at Macbeth's gallery. Other artists of the Henri circle also represented were Jerome Meyers, May Wilson Preston, and Rockwell Kent. A painting by Ernest Lawson was hung in another gallery.

3. See "New York's Art Anarchists: Here Is the Revolutionary Creed of Robert Henri and His Followers," *New York World*, 10 June 1906, magazine section, p. 6.

4. Donald Kuspit has observed that members of the Eight "retained the immigrant's sense of naive wonder at the city, which went hand in hand with their sense of its uniqueness." See "Individual and Mass Identity in Urban Art: The New York Case," *Art in America* 65 (September–October 1977), p. 70. Although Bellows was not a member of the original Eight, Kuspit's description applies to him even more aptly. The older artists were seasoned, professional illustrators by the time they arrived in New York, whereas Bellows was a wide-eyed university dropout. He avoided final examinations at the end of his junior year at Ohio State, precluding the possibility of enrolling for his senior year. Instead he came east, with the benefit of an allowance from his father.

5. Henry James, *The American Scene* (New York and London: Harper and Brothers, 1907), pp. 71, 73. The essay was first published in *Harper's Monthly* 112 (February, March, and May, 1906), pp. 400–406, 603–8, 900–907. Alan Trachtenberg discusses the shift of imagery in James's essay in "The American Scene: Versions of the City," *Massachusetts Review* 8 (Spring 1967), pp. 281–95.

6. H. G. Wells, *The Future in America* (New York: Harper and Brothers, 1906; reprint, New York: Arno Press, 1974), pp. 35–36.

7. Ibid., p. 38.

8. James to Wells, 8 November 1906, quoted in Lovat Dickson, *H. G. Wells: His Turbulent Life and Times* (New York: Atheneum, 1969), p. 154.

9. "Academy Exhibition," *New York Sun*, 23 December 1907, p. 4.

10. Bellows enrolled at the school in the fall of 1904 and probably attended full-time for approximately two years. He then gradually began working on a more independent basis, especially after he moved into a studio in 1906 with sufficient room to paint. He continued taking occasional classes with Henri, however, at least through 1909.

11. Charles Grant, a boyhood friend of Bellows in Columbus, records that George's room was lined with his pencil drawings already in high school and that most were copies of works by current illustrators, including his favorite, C. D. Gibson. The typed manuscript of Grant's account, written in 1936 and entitled "Stag at Sharkey's," is in the library of the National Gallery of Art, Washington, D.C. Portions of the account were published in *Beta Theta Pi Magazine*, May 1947, pp. 674–79.

12. The statement is a three-page typed manuscript in the George Bellows Papers (box 4, folder 5), the primary source of original materials on the artist, which were donated by his daughters to the Special Collections Department, Amherst College Library, Amherst, Mass.

13. For the facts of Bellows's life, I have relied on Charles Morgan's biography, *George Bellows: Painter of America* (New York: Reynal, 1965; reprint, Millwood, N.Y.: Kraus Reprint Co., 1979). An additional source, which includes valuable interviews with Bellows's wife as well as friends and colleagues, is Frank Seiberling, Jr., "George Bellows, 1882–1925: His Life and Development as an Artist" (Ph.D. diss., University of Chicago, 1948).

14. Howard Chandler Christy, formerly a student of Chase's, had been an instructor at the New York School of Art during the 1903–4 academic year. (Instructors are listed in "The New York School of Art," *Sketch Book* 3 [April 1904], p. 220.) Although no recorded list of instructors has been found for the fall of 1904, it is likely that Christy was still on staff, and Bellows may have enrolled at the school for that reason. A faculty member in the Department of Architecture at Ohio State University told Frank Seiberling that Bellows went to New York with the intention of becoming a professional illustrator. See Seiberling, "George Bellows," p. 183.

15. According to Morgan's record of the incident, Henri remarked about the drawings, "Haven't I seen these before?" See Morgan, *George Bellows*, p. 40. Walter Pach comments on Bellows's naiveté in regard to this incident, in his account, *Queer Thing, Painting: Forty Years in the World of Art* (New York and London: Harper and Brothers, 1938), p. 48.

16. Rockwell Kent, *It's Me, O Lord: The Autobiography of Rockwell Kent* (New York: Dodd, Mead, 1955), pp. 76–77, 81.

17. Guy Pène du Bois, *Artists Say the Silliest Things* (New York: American Artists Group, 1940), p. 86.

18. Ibid., p. 88.

19. The single mention of *River Rats* in the 1907 Academy exhibition was a very favorable one by Frank Fowler: "Impressions at the Spring Academy," *Nation* 84 (28 March 1907), p. 298. Bellows continued to exhibit the painting between 1907 and 1911, and it was often noted by critics, especially after the artist's own reputation became established.

20. "Art Students Exhibition," *New York Telegraph*, April 1907, undated clipping in Bellows's scrapbook, Bellows Papers; James G. Huneker, "Around the Galleries," *New York Sun*, 25 April 1907, p. 8.

21. George Sanatayana, *Winds of Doctrine* (New York: Scribner's, 1913), p. 185.

22. For an extended discussion of virility in American art and Bellows's art in particular, see chapter 2.

23. J. Nilsen Laurvik, "The Winter Exhibition at the National Academy of Design," *International Studio* 33 (February 1908), p. cxlii. *A Stag at Sharkey's* is now known as *Club Night* (1907; National Gallery of Art). Bellows switched the titles of two of his boxing pictures, probably at the time of or shortly before the Cleveland Museum acquired the canvas now titled *Stag at Sharkey's*. For a more detailed history of the switch, see E. A. Carmean, Jr., "Bellows: The Boxing Paintings," in *Bellows: The Boxing Pictures*, exh. cat. (Washington, D.C.: National Gallery of Art, 1982), pp. 28–29. The painting will also be discussed further in chapter 2.

24. See, for example, "Significance of the Exhibition of the Pennsylvania Academy," *New York Times*, 26 January 1908, sec. 10, p. 8.

25. Fifteen artists participated: George Bellows, Glenn O. Coleman, Harry Daugherty, Laurence T. Dresser, Guy Pène du Bois, Arnold Friedman, Julius Golz, Jr., Edward Hopper, Rockwell Kent, Edward R. Keefe, George McKay, Howard McLean, Carl Sprinchorn, Stuart Tyson, and LeRoy William. For a full account of the exhibition, see the manuscript by Arnold Friedman, "The Original Independent Show, 1908," now in the collections of the Library of the Museum of Modern Art, New York. The quotation is from Friedman.

26. Joseph Edgar Chamberlin, "'The Eight' Out-Eighted," *New York Evening Mail*, 2 March 1908; James Huneker, "Around the Galleries," *New York Sun*, 12 March 1908, p. 6; "Notes and Reviews," *Craftsman* 14 (April 1908), p. 345.

27. "Pictures at the Gallery of the New York School of Art," *New York Globe and Commercial Advertiser*, 24 April 1907, p. 8; "Significance of the Exhibition of the Pennsylvania Academy," *New York Times*, 26 January 1908, sec. 10, p. 8.

28. William Couper, ed., *History of the Engineering, Construction, and Equipment of the Pennsylvania Railroad Company's New York Terminal and Approaches* (New York: Isaac H. Blanchard, 1912), p. 7.

29. See ibid., pp. 8–16 and Carl W. Condit, *The Port of New York: A History of the Railroad and Terminal System from the Beginnings to Pennsylvania Station* (Chicago: University of Chicago Press, 1980).

30. Introduction to "The Communication Number," *World's Work* 8 (January 1907), p. 8365. The euphoric tone of this statement was fairly typical of *World's Work*, which generally emphasized the positive aspects of American industrialism. See Frank Luther Mott's sketch of the magazine during the editorship of Walter Hines Page, in *A History of American Magazines*, 5 vols. (Cambridge, Mass.: Harvard University Press, 1957), vol. 4, pp. 773–83.

31. Gilson Willets, "Digging a $60,000,000 Hole in New York," *Leslie's Weekly* 100 (30 March 1905), p. 29.

32. Representative articles include "The Romance of Tunnel Building," *World's Work* 13 (January 1907), pp. 8301–6; "The $200,000,000 Tunnels of New York City," *Review of Reviews* 35 (February 1907), pp. 227–29. Then, *Engineering Magazine* opened its April issue with "New York and Panama: A Contrast in Engineering Achievement," by Ernest John Munby, who argued, "At a time when the construction of the Isthmian Canal is engaging so much public interest, the magnitude of the undertaking is apt to overshadow in the popular mind—Nationally, if not indeed locally—the importance of improvements in transportation facilities almost as great in conception and certainly more difficult in execution, which are now proceeding with very little in proportion of advance advertisement and ostentation" (p. 1).

33. The Pennsylvania Railroad Company was established in 1852 as a connection between Philadelphia and Pittsburgh. By the turn of the century it had acquired more than two hundred other companies and owned rail lines between Chicago and the Atlantic coast. See Emory R. Johnson, *American Railway Transportation*, 2d, rev. ed. (New York: Appleton, 1909); Thomas C. Cochran and William Miller, *The Age of Enterprise: A Social History of Industrial America*, rev. ed. (New York: Harper and Row, 1961), chap. 7.

34. See "Graft in a Great Railroad," *Current Literature* 41 (July 1906), pp. 17–20; "Railway Graft," *Outlook* 83 (26 May 1906), pp. 142–43.

35. "Editorials: The Evolution of Public Opinion, The Meat Scare and Its Results, The Railroad Investigation," *Independent* 60 (14 June 1906), pp. 1437–42. Howard Mumford Jones, in *The Age of Energy: Varieties of American Experience, 1865–1915* (New York: Viking Press, 1970), discusses the confusion of values apparent in American attitudes toward the robber barons and giant corporations like the railroads. The Roosevelt era, according to Jones, was characterized by such inconsistencies, as well as by the search for "a pragmatic sanction for American life and values." See pp. 404–13. See also Richard Hofstadter, *The Age of Reform, From Bryan to F.D.R.* (New York: Knopf, 1955), chaps. 4–6.

36. C. M. Keys, "The Overlords of Railroad Traffic," *World's Work* 13 (January 1907), pp. 8440–41.

37. See interviews conducted with classmates, in Seiberling, "George Bellows," pp. 181, 190, 202, 208.

38. In his autobiographical statement Bellows observed about his father: "He was a wonderfully fine man, and yet having been born in 1827 and being fifty five when I appeared, his point of view, his character even belonged to so remote a past that I look upon many of his ideas to this day with ammasement [*sic*] and sorrow" (Bellows Papers, box 4, folder 5).

39. See, for example, Rockwell Kent, *It's Me, O Lord*, p. 82; Helen Appleton Read, *Robert Henri* (New York: Whitney Museum of American Art, 1931), p. 10.

40. Robert Henri, *The Art Spirit* (Philadelphia: Lippincott, 1923; reprint, New York: Harper and Row, 1984), pp. 80, 83, 87.

41. Ibid., pp. 118–19.

42. "George Bellows, An Artist with 'Red Blood,'" *Current Literature* 53 (September 1912), p. 342; Estelle H. Ries, "The Relation of Art to Every-day Things: An Interview with George Bellows, on How Art Affects the General Wayfarer," *Arts and Decoration* 15 (July 1921), pp. 159, 202; "The Big Idea: George Bellows Talks about Patriotism for Beauty," *Touchstone* 1 (July 1917), p. 275.

43. Vernon Howe Bailey (1874–1953) was a professional painter as well as an illustrator. He had studied at the Pennsylvania Academy of the Fine Arts and the Philadelphia Museum School of Industrial Arts.

44. See, for example, *Below Atlantic City*, 1881, cat. no. 38, in Louis A. Wuerth, *Catalogue of the Etchings of Joseph Pennell* (Boston: Little, Brown, 1928), p. 14.

45. I have developed this argument more fully in "The Clean Machine: Technology in American Magazine Illustration," *Journal of American Culture* 11 (Winter 1988), pp. 73–92. John Kasson has noted that although professional, "fine" artists by no means expressed unanimous support for unrestrained industrial development, images by so-called popular artists, such as those published by Currier and Ives, would have been much more likely to embody the attitudes of the "great bulk of Americans." See his *Civilizing the Machine: Technology and Republican Values in America, 1776–1900* (New York: Penguin Books, 1977), p. 174. Likewise, pictures in popular magazines were both susceptible to the influence of a prevailing spirit or mood and instrumental in shaping public opinion.

46. Baudelaire's first appeal for the depiction of modern life came at the end of his *Salon de 1845*, but he addressed the issue repeatedly. His most influential statement on the subject, *Peintre de la vie moderne*, was published in installments in *Le Figaro* in 1863. A translation is available in Charles Baudelaire, *The Painter of Modern Life and Other Essays*, ed. and trans. Jonathan Mayne (New York: De Capo Press, 1964), pp. 1–40. Charles Buchanan noted the connection between Bellows's art and journal illustrations in "George Bellows, Painter of Democracy," *Arts and Decoration* 4 (August 1914), pp. 370–73: "He suggests to me the alertness of American journalism turned painter, the reportorial spirit armed with palette and brush" (p. 371).

47. Rockwell Kent commented on Henri's predilection for dark tonalities in *It's Me, O Lord:* "It was consistent with Henri's rather somber view of life that both in his own work of the period and in the work of his students, he should favor colors of a low intensity and somber hue; and that to ensure our work this character he stressed that we should banish all bright colors from our palettes. Bright red, bright yellows, all the blues, were, if not outlawed, strongly in disfavor; and the resulting assortment, consisting of Yellow Ochre, the Siennas, a dull red, and of course, black and white, was termed the "Simple Palette" (p. 86). It should be noted here that since the majority of Henri's students had not traveled to Europe, they learned about the style and technique of the Dutch and Spanish masters primarily through Henri's example and through what they could glean from photoreproductions.

48. Bellows's painting technique of this period is described by his roommate, Edward Keefe, in Seiberling, "George Bellows," p. 207.

49. See Wanda Corn, *The Color of Mood: American Tonalism, 1880–1910*, exh. cat. (San Francisco: California Palace of the Legion of Honor, 1972).

50. Wanda Corn has discussed the imagery of Manhattan developed by writers and artists of this decade and has pointed out that it was typically cast in terms of earlier artistic conventions: "The New New York," *Art in America* 61 (July–August 1973), pp. 59–65. See also Alan Trachtenberg's discussion of photography as part of an ideological program of finding order in urban life: "Image and Ideology: New York in the Photographer's Eye," *Journal of Urban History* 10 (August 1984), pp. 453–64. Other sources on portrayal and perception of the city include Sam Bass Warner, Jr., "Slums and Skyscrapers: Urban Images, Symbols, and Ideology," in *Cities of the Mind: Images and Themes of the City in the Social Sciences*, ed. Lloyd Rodwin and Robert M. Hollister (New York: Plenum Press, 1984), pp. 181–95; Peter B. Hales, *Silver Cities: The Photography of American Urbanization, 1839–1915* (Philadelphia: Temple University Press, 1984); Merrill Schleier, *The Skyscraper in American Art, 1890–1931* (Ann Arbor, Mich.: UMI Research Press, 1986); William Sharpe, "New York, Night, and Cultural Mythmaking: The Nocturne in Photography, 1900–1925," *Smithsonian Studies in American Art* 2 (Fall 1988), pp. 2–21.

51. Henry Adams, *The Education of Henry Adams* (1907; Boston: Houghton, Mifflin, 1973), pp. 499–500.

52. George W. Steevens, *The Land of the Dollar* (Edinburgh and London: William Blackwood and Sons, 1897), p. 10.

53. John C. Van Dyke, *The New New York* (New York: Macmillan, 1909), p. 6–7.

54. John Corbin, "The Twentieth Century City," *Scribner's* 33 (March 1903), pp. 259–72.

55. Sidney Allan [Sadakichi Hartmann], "A Plea for the Picturesqueness of New York," *Camera Notes* 4 (October 1900), pp. 92, 97.

56. T. P. O'Connor, "Impressions of New York," *Munsey's* 37 (June 1907), p. 387.

57. Moore owned several Lawsons, and he may have displayed them either at the Café or at his home on West Twenty-third Street. Both locations were gathering places. Sadakichi Hartmann describes Henri as "the patriarch of the Café Francis crowd" in "Studio-Talk," *International Studio* 30 (December 1906), pp. 182–83. John Sloan mentions the sale of Moore's collection and Crane's purchase of "an 'Excavation' by Lawson" in *John Sloan's New York Scene: From the Diaries, Notes and Correspondence, 1906–1913*, ed. Bruce St. John (New York: Harper and Row, 1965), 27 April 1908, p. 216. The early provenance of *Excavation—Penn Station* has not been established; but since no other painting of the subject by Lawson is known, the work in the collection of the University Art Museum, University of Minnesota, Minneapolis, must be the one mentioned by Sloan.

58. Bayard Boyesen, "The National Note in American Art," *Putnam's Monthly* 4 (May 1908), pp. 133–34.

59. *Excavation—Penn Station* was probably painted sometime during 1905, since the area depicted has been completely cleared of existing buildings and the actual digging appears to have only just begun. The often-cited description of Lawson's characteristic choice of high-key colors as a "palette of crushed jewels" is by James G. Huneker, in F. Newlin Price, "Lawson of the 'Crushed Jewels,'" *International Studio* 48 (February 1924), p. 367. The date of Huneker's original statement is unknown.

60. Henri, *The Art Spirit*, p. 16.

61. Florence Barlow Ruthrauff interviewed Bellows in 1911 and reported that he did pencil sketches but seldom used them when actually painting a particular scene, "so graphically is it photographed on his memory." See *New York Telegraph*, 2 April 1911, magazine section, p. 2. Ed Keefe also recalled that Bellows's memory was so exceptional that he could render a detailed landscape without relying on sketches or notations of any kind. He specifically mentioned that *Up the Hudson* was one of those "memory pictures," and Eugene Speicher said the same of *Rain on the River*. See Seiberling, "George Bellows," pp. 207, 219.

62. See William Innes Homer, *Robert Henri and His Circle* (Ithaca, N.Y.: Cornell University Press, 1969; reprint, New York: Hacker Art Books, 1988), p. 161. Emma Bellows also referred to her husband's memory in a 1959 letter, noting that he had "learned much in the Henri composition class where you had to compose a picture from memory—it was wonderful training" (Emma Bellows to Marian King, 6 February 1959. Curators' files, Corcoran Gallery of Art).

63. Henri, *The Art Spirit*, p. 27.

64. Charles Grant, "Stag at Sharkey's," p. 9.

65. Such "veils" might serve either to dilute or to intensify the original perceptual experience. It is the contention of the present study that, although Bellows felt personal involvement with his subjects, he also maintained a certain distance between himself and whatever it was that he was painting. This interaction between psychic involvement and distancing will recur at various points in subsequent chapters.

66. Henri, *The Art Spirit*, p. 118–19.

67. Ibid., p. 26.

68. See interview with Edward R. Keefe in Seiberling, "George Bellows," p. 207.

69. "Began Art Career as Illustrator on Makio," *Lantern*, undated clipping in Bellows's scrapbook, Bellows Papers.

70. "The Deserted Village in the Tenderloin," *New York Herald*, 10 May 1903, literary section, p. 6. The Tenderloin in New York City was the area from Madison Square to Forty-eighth Street, between Fifth and Ninth avenues. See Lloyd R. Morris, *Incredible New York: High Life and Low Life of the Last Hundred Years* (New York: Random House, 1951), pp. 220–24.

71. Henri, *The Art Spirit*, p. 118.

72. "National Academy Pictures," *Nation* 89 (16 December 1909), p. 608.

73. See Morgan, *George Bellows*, p. 93.

74. Bellows listed his paintings in chronological order, by month, in his record book, often including small sketches of each work. It represented one aspect of his effort to organize the materials of his life, both professional and personal, in preparation for his move from the studio–living space in the Lincoln Arcade, which he shared with three other colleagues, to the house he would share with his future wife, Emma Story.

75. Quoted in Morgan, *George Bellows*, p. 124.

76. Bellows repeated the theme of a building isolated by the process of demolition and construction in December 1909: *Lone Tenement* (National Gallery of Art).

77. Record of restoration, April 1975, curators' file, the Brooklyn Museum, Brooklyn, N.Y.

78. *Blue Morning* was folded over at the top at one time, so that approximately 2¾ inches of the canvas was hidden. As a result, since Chester Dale purchased the painting in 1956 and until it was "unfolded" by conservators at the National Gallery of Art in 1988, the canvas was commonly thought to measure 31¼ by 44 inches. Although the date of the alteration is not positively known, the painting was probably folded to accommodate reframing for an exhibition at the H. V. Allison Gallery, the sole outlet for work from Bellows's estate after 1940. *Blue Morning* was shown twice, in 1949 and in 1956. Mr. Allison's son, Gordon Allison, recalled that the painting was reframed just before one of those exhibitions, and he felt "quite certain that the upper part was purposely covered by the rabbet so as to diminish the dark effect at the top" (Gordon K. Allison to William Campbell, 15 October 1970, curatorial records, National Gallery of Art). In Bellows's record book the reduced dimensions were recorded in Emma's handwriting, adjacent to the original dimensions. The fold was tacked down by staples, which seems to support the contention that the canvas was altered either in 1949 or 1956, long after Bellows's death. It was Bellows's usual practice to stretch, and restretch, his canvases with straight tacks.

79. On Henri's impressionist phase, see Judith K. Zilczer, "Anti-realism in the Ashcan School," *Artforum* 17 (March 1979), pp. 44–49; Bennard B. Perlman, *Robert Henri, Painter*, exh. cat. (Wilmington: Delaware Art Museum, 1984).

80. On the impressionists and their relationship to modern Paris, see Sylvie Gache-Patin, "The Urban Landscape," *A Day in the Country: Impressionism and the French Landscape*, exh. cat. (Los Angeles County Museum of Art, 1984); Timothy J. Clark, *The Painting of Modern Life: Paris in the Art of Manet and His Followers* (New York: Knopf, 1985); Robert L. Herbert, *Impressionism: Art, Leisure, and Parisian Society* (New Haven, Conn.: Yale University Press, 1988), chap. 1.

81. See especially Theodore Reff, *Manet and Modern Paris*, exh. cat. (Washington, D.C.: National Gallery of Art, 1982); Harry Rand, *Manet's Contemplation at the Gare Saint Lazare* (Berkeley and Los Angeles: University of California Press, 1987).

82. *Le Pont de l'Europe* was catalog no. 6 in the *Exposition rétrospective d'oeuvres de Gustave Caillebotte* at the Galeries Durand-Ruel in Paris, June 1894.

83. Robert Henri, "Progress in Our National Art Must Spring from the Development of Individuality of Ideas and Freedom of Expression: A Suggestion for a New Art School," *Craftsman* 15 (January 1909), p. 388.

84. Condit, *Port of New York*, p. 241. Contemporary accounts of the urbanization and modernization of New York include Randall Blackshaw, "The New New York," *Century* 64 (August 1902), pp. 492–513; John Brisben Walker, "The Wonders of New York," *Cosmopolitan* 36 (December 1903), pp. 143–60; Sylvester Baxter, "The New New York," *Outlook* 83 (23 June 1906), pp. 409–24; J. M. Bowles, "A New New York," *World's Work* 13 (December 1906), pp. 8301–6; Walter Prichard Eaton, "Manhattan: An Island Outgrown," *American Magazine* 64 (July 1907), pp. 245–56; Herbert N. Casson, "New York, the City Beautiful," *Munsey's* 38 (November 1907), pp. 178–86; "The New New York," *Outlook* 93 (9 October 1909), pp. 290–92.

85. Quotation from "The Greatest Railroad Station in the World," *Harper's Weekly* 52 (9 May 1908), p. 28. Drawings of the proposed station began appearing in 1903. See, for example, Ralph D. Paine, "Plans for the New Pennsylvania Railroad Station," *Collier's* 31 (13 June 1903), pp. 10–11. An architectural model was displayed at the Saint Louis World's Fair in 1904.

86. W. Symmes Richardson, "The Architectural Motif of the Pennsylvania Station," in *History of the Engineering, Construction, and Equipment of the Pennsylvania Railroad*, p. 77.

87. Herbert Croly, "New York as the American Metropolis," *Architectural Record* 13 (March 1903), p. 193. On architecture as a cultural statement, see Richard Guy Wilson et al., *The American Renaissance, 1876–1917*, exh. cat. (Brooklyn, N.Y.: The Brooklyn Museum, 1979). Alan Trachtenberg discusses the alliance of business, politics, industry, and culture as he sees them expressed in various social systems ranging from a figure of speech, to a building, a city, etcetera, in *The Incorporation of America: Culture and Society in the Gilded Age* (New York: Hill and Wang, 1982). On the railroad station, see Carroll L. V. Meeks, *The Railroad Station: An Architectural History* (New Haven, Conn.: Yale University Press, 1956); Jeffry Richards and John M. MacKenzie, *The Railway Station: A Social History* (Oxford and New York: Oxford University Press, 1986).

88. James G. Huneker, "The Spring Academy," *New York Sun*, 20 March 1908, p. 6.

89. Frank Jewett Mather, "The Independent Artists," *Nation* 90 (7 April 1910), p. 360.

90. Lawson captured the First Hallgarten Prize that year for his painting *Ice on the Hudson*. Again Lawson and Bellows had painted closely related subjects, and by bestowing related prizes, the Academy's jury pointed up the similarities between the two paintings. The present location of the Lawson is unknown.

91. Giles Edgerton [Mary Fanton Roberts], "What Does the National Academy Stand For?" *Craftsman* 15 (February 1909), pp. 520, 529. Arthur Hoeber, "The Winter Exhibition at the National Academy of Design," *International Studio* 36 (February 1909), p. cxxxvi.

92. See, for example, "Sargent's Portraits at Academy Show . . . Many Landscapes of Merit," *New York Times*, 14 December 1908, p. 8; "Academy Landscapes," *New York Evening Post*, 16 December 1908, p. 9.

93. Arnold Friedman reported one "trick" that aspiring artists employed to win acceptance by the Academy jury: "to paint a head the best way one could and then with the paint still wet make quick, extra strokes with a large, dry brush over it, thus accomplishing the 'Sargent stroke,' the 'vigorous brush work,' 'broad handling' school of criticism then being in the ascending." See Friedman, "The Original Independent Show." Indeed, the popularity of bravura brushwork was evident in contemporary criticism. An *Evening Post* review of the 1910 annual exhibition at the Pennsylvania Academy provides an apt example: "Except for a few individualists or reactionaries, there is now only one way of applying pigment to canvas—the so-called direct method. There is no underpainting in monochrome. The tendency is to make the original stroke a constructive plane as well, and to leave it untouched. The virgin surfaces are reworked very sparsely, usually only by way of accentuation. Glazings are practically abolished, and with them a peculiar velvety loveliness of paint; scumbles are rare. Everything is *premier coup*" (*New York Evening Post*, 28 January 1910, p. 9).

94. At the symposium *Sargent in Paris and London*, 11 October 1986, at the Whitney Museum of American Art, Albert Boime made provocative suggestions about associations, in the later nineteenth and early twentieth centuries, between the bravura technique, considered the more modern, and a new class of patrons, specifically the nouveaux riches as opposed to families of older wealth.

95. Roberts, "What Does the National Academy Stand For?" p. 522. She also complained that Bellows's painting was hung "on the line" while Ettore Jacovelli's *East Side* was hung "where it is a direct intervention of Providence if any human being catches a glimpse of it."

96. Lucy Belloli, conservator of the Metropolitan Museum of Art, pointed out to me the extensive changes made at all four edges of *Up the Hudson*. The bottom margin was actually reduced twice and then expanded. The canvas was also expanded at the left: the addition amounts to 2½ inches at the top, decreasing to 1¼ inches at the bottom. The painting was reproduced with Hoeber's review for *International Studio* (p. cxxxviii) and in *American Art News* (12 December 1908, p. 3). Presumably these photographs represent what the painting looked like when it was on exhibition at the Academy. Bellows's roommate, Edward Keefe, remembered helping the artist "cut down" the painting in 1909. See Charles Morgan's notes on a 1963 interview with Keefe, in the Morgan on Bellows Papers, Amherst College Archives, Amherst College Library, Amherst, Mass. Then in 1911 Mr. Hugo Reisinger purchased the painting in order to donate it to the Metropolitan Museum. By the time it was reproduced in the museum's bulletin, the canvas had been expanded again. See *Bulletin of the Metropolitan Museum of Art*, March 1911, p. 67. The 1911 reproduction clearly shows an addition along the left margin, as well as a diagonal fold at the lower left edge, another result of the expanding and shifting of the canvas. A comparison of the reproductions suggests that Bellows changed the axis of the composition after the Academy's 1908 Winter Exhibition and before it was acquired by the Metropolitan.

97. See, for example, Leo Marx, "Introduction: The Railroad in the American Landscape," *The Railroad in the American Landscape: 1850–1950*, exh. cat. (Wellesley, Mass.: Wellesley College Museum, 1981), pp. 12–16; "The Railroad-in-the-Landscape: An Iconological Reading of a Theme in American Art," *Prospects* 10 (1987), pp. 77–117. This second essay has been reprinted in Leo Marx and Susan Danly Walther, eds. *The Railroad in American Art: Representations of Technological Change* (Cambridge, Mass.: MIT Press, 1988).

98. Marx, "The Railroad-in-the-Landscape," p. 80.

99. Hildegarde Hawthorne, *New York: Metropolis of America* (London: Adam and Charles Black, 1911), p. 35.

100. Hartmann, "A Plea for the Picturesqueness of New York," pp. 93, 92, 94.

101. News stories and feature articles related to the extension of the parkway dealt with such subjects as taxpayer protests against new assessments and the enjoyable drive from double-deck buses. In the *New York Times,* for example, see 21 May 1908, p. 5; 6 June 1908, p. 5; 7 June 1908, pt. 2, p. 14; 9 February 1909, p. 6; 10 March 1909, p. 3; 11 March 1909, p. 12; 12 March 1909, p. 1; 13 March 1909, p. 14; 14 March 1909, pt. 5, p. 5; 18 March 1909, p. 5; 10 April 1909, p. 5; 18 April 1909, pt. 2, p. 10; 23 May 1909, pt. 6, p. 7; 26 September 1909, pt, 7B, p. 1. Most of the coverage was naturally local, but Riverside Park occasionally appeared in the national press. See, for example, "New York's New $3,000,000 Parkway," *Harper's Weekly* 51 (9 November 1907), p. 1668.

102. There is no specific archival record of Bellows's presence at the Hudson-Fulton Celebration Parade. His attendance is presumed on the basis of the painting *The Warships* and its documented date, September 1901. Bellows's record book entry for *The Warships* indicates that he repainted the work in 1918. The Hirshhorn Museum and Sculpture Garden is planning technical examination to determine the nature of any alterations to the painting's composition or color scheme. Bellows's other paintings from the site include *A Cloudy Day* (1908; Hirshhorn Museum and Sculpture Garden); *Winter Afternoon* (1909; Norton Gallery of Art, West Palm Beach, Fla.); *A Morning Snow* (1910; Brooklyn Museum); *Floating Ice* (1910; Whitney Museum of American Art, New York); *Snow Capped River* (1911; Telfair Academy of the Fine Arts, Savannah, Ga.).

103. J. Nilsen Laurvik, "The Annual Exhibition of the Pennsylvania Academy of the Fine Arts," *International Studio* 38 (August 1909), p. xlvi.

104. Arthur Hoeber, "Art and Artists," *Globe and Commercial Advertiser,* 7 February 1910, p. 8.

105. Forbes Watson, "George Bellows," *New York Evening Post Saturday Magazine,* 15 November 1913, p. 9.

Chapter 2, *At Sharkey's: Boxing*

1. "Academy Exhibition—Second Notice," *New York Sun,* 23 December 1907, p. 4.

2. "In Defense of Pugilism," *American Magazine* 68 (August 1909), p. 414, 415.

3. Julian Hawthorne, "The Noble Art of Self-Defense," *Cosmopolitan* 4 (November 1887), p. 173.

4. Ibid.

5. Duffield Osborne, "A Defense of Pugilism," *North American Review* 146 (April 1888), p. 435.

6. See, especially, T. J. Jackson Lears on the impulse toward class revitalization, either perceived as such or as a private concern, in *No Place of Grace: Antimodernism and the Transformation of American Culture, 1880–1920* (New York: Pantheon Books, 1981).

7. The following discussion draws on Joe L. Dubbert, *A Man's Place: Masculinity in Transition* (Englewood Cliffs, N.J.: Prentice-Hall, 1979), especially for references to contemporary sources.

8. "The Uncultured Sex," *Independent* 67 (11 November 1909), p. 1100. For the impact of feminism on preexisting anxieties about the meaning of manliness, see Peter Gabriel Filene, *Him/Her/Self: Sex Roles in Modern America* (New York: Harcourt Brace Jovanovich, 1974).

9. See Charles E. Rosenberg, "Sexuality, Class and Role in 19th-Century America," *American Quarterly* 25 (May 1973), pp. 131–53; Filene, *Him/Her/Self,* p. 83.

10. The increasingly strident tone of discussions of gender roles and the self-consciousness about defining masculine and feminine identities in this period cannot be understood solely in relation to the women's movement. David G. Pugh has found the beginnings of a cult of masculinity in America following closely on the heels of the Revolution. See his *Sons of Liberty: The Masculine Mind in Nineteenth-Century America* (Westport, Conn.: Greenwood Press, 1983), pp. 45–91. For an overview of the scholarly literature, since the mid-1960s, that has dealt with the metaphorical and literal meaning of the "sphere," see Linda K. Kerber, "Separate Spheres, Female Worlds, Woman's Place: The Rhetoric of Women's History," *Journal of American History* 75 (June 1988), pp. 9–39.

11. See, for example, Carroll Smith-Rosenberg and Charles Rosenberg, "The Female Animal: Medical and Biological Views of Woman and Her Role in Nineteenth-Century America," *Journal of American History* 60

(September 1973), pp. 332–56; Patricia Searles and Janet Mickish, "'A Thoroughbred Girl': Images of Female Gender Role in Turn-of-the-Century Mass Media," *Women's Studies* 10, no. 3, (1984), pp. 261–81. Bram Dijkstra has catalogued some of the evidence from anthropologists, sociologists, and craniologists that was marshaled at the turn of the century to substantiate scientifically the mental and physical inferiority of the female sex, in *Idols of Perversity* (New York: Oxford University Press, 1986), chap. 6.

12. M. S. Steiner, *Pitfalls and Safeguards* (Elkhart, Ind.: Mennonite Publishing Co., 1899), p. 169.

13. G. Stanley Hall, "Feminization in School and Home: The Undue Influence of Women Teachers—The Need of Different Training for the Sexes," *World's Work* 16 (May 1908), pp. 10237–44. Silas Weir Mitchell is quoted in Lears, *No Place of Grace*, p. 104.

14. E. Anthony Rotundo, "Manhood in America: The Northern Middle Class, 1770–1920," (Ph.D. diss., Brandeis University, 1982). Rotundo's study is based on letters and diaries rather than on prescriptive literature, which, in his words, cannot "show how men dealt with conflicting ideals or how those ideals matched up with man's actual behavior" (p. 12). See also his "Body and Soul: Changing Ideals of American Middle-Class Manhood, 1770–1920," *Journal of Social History* 16 (Summer 1983), pp. 23–38. Theodore P. Greene, studying popular magazine biographies of male heroes from 1894 to 1913, reveals similar patterns: *America's Heroes: The Changing Models of Success in American Magazines* (New York: Oxford University Press, 1970).

15. James Lane Allen, "Two Principles in Recent American Fiction," *Atlantic Monthly* 80 (October 1897), p. 438; quoted in Gerald F. Roberts, "The Strenuous Life: The Cult of Manliness in the Era of Theodore Roosevelt" (Ph. D. diss., Michigan State University, 1970), p. 176. Grant C. Knight describes this article as an apologia for Allen's own self-conscious shift toward realism. See Knight, *James Lane Allen and the Genteel Tradition* (Port Washington, N.Y.: Kennikat Press, 1935), pp. 114–16.

16. On the martial ideal and masculine escape novels, see Lears, *No Place of Grace*, pp. 98–139; Roberts, "The Strenuous Life"; Larzer Ziff, *The American 1890s: The Life and Times of a Lost Generation* (New York: Viking Press, 1966),

pp. 225–28; James D. Hart, *The Popular Book: A History of America's Literary Taste* (New York: Oxford University Press, 1950). Karol L. Kelley has conducted a statistical analysis of best-selling novels of the period, with special reference to rhetoric about gender roles, in *Models for the Multitudes: Social Values in the American Popular Novel, 1850–1920* (Westport, Conn.: Greenwood Press, 1987).

17. Frank Norris, *A Man's Woman* (Garden City, N.Y.: Doubleday, 1928), p. 71. For Jackson Lears's discussion of the literary shift toward high adventure, see his *No Place of Grace*, pp. 103–8.

18. Stuart P. Sherman, "Roosevelt and the National Psychology," *Nation* 109 (8 November 1919), p. 601.

19. Reported by Mark Sullivan, *Our Times, 1900–1925*, 6 vols. (New York: Scribner's, 1940), vol. 2, pp. 217, 227.

20. On Theodore Roosevelt and the strenuous life, see Gerald F. Roberts, "The Strenuous Life"; Edwin H. Cady, "'The Strenuous Life' as a Theme in American Culture," in *New Voices in American Studies*, ed. Ray B. Browne, Donald M. Winkelman, and Allen Hayman (West Lafayette, Ind.: Purdue University Studies, 1966); John Higham, "The Reorientation of American Culture in the 1890s," in *Writing American History: Essays on Modern Scholarship* (Bloomington, Ind.: Indiana University Press, 1970), pp. 74–102; Henry F. May, *The End of American Innocence: A Study of the First Years of Our Own Time, 1912–1917* (New York: Oxford University Press, 1959), pp. 107–9; John A. Lucas and Ronald A. Smith, *Saga of American Sport*, (Philadelphia: Lea and Febiger, 1978), pp. 287–302.

21. Lawrence Abbott, *Impressions of Theodore Roosevelt* (Garden City, N.Y.: Doubleday, 1920), pp. 3–4.

22. William Allen White, "Theodore Roosevelt," in *Theodore Roosevelt: A Profile*, ed. Morton Keller (New York: Hill and Wang, 1967), p. 32; essay reprinted from White, *Masks in a Pageant* (New York: Macmillan, 1928), pp. 283–326.

23. For a contemporary account of the disdain felt for a "sissy," see Rafford Pyke, "What Men Like in Men," *Cosmopolitan* 33 (August 1902), pp. 402–6.

24. Dubbert, *A Man's Place*, pp. 129. Dubbert draws his evidence from William Allen White's *Autobiography* (New York; Macmillan, 1946) as well as a collection of short stories for boys, *The Court of Boyville* (New York: Doubleday, 1899) and a collection of political essays, *The Old Order Changeth* (New York: Macmillan, 1910). He also refers to

James R. McGovern's "David Graham Phillips and the Virility Impulse of Progressives," *New England Quarterly* 39 (September 1966), pp. 334–55.

25. White, *The Old Order Changeth*, pp. 165–68.

26. Bellows to "Maw and Paw," 9 October 1901, George Bellows Papers, box 1, folder 6.

27. See Charles Grant, "Stag at Sharkey's," manuscript, Library, National Gallery of Art, Washington, D.C.

28. From interview with Howard B. Monett, son of Bellows's half sister, recorded in Seiberling, "George Bellows," p. 176.

29. John Corbin, "The Modern Chivalry," *Atlantic Monthly* 89 (May 1902), p. 604; Lloyd S. Bryce, "A Plea for Sport," *North American Review* 128 (May 1879), p. 522.

30. See, for example, Jeffrey P. Hantover, "The Boy Scouts and the Validation of Masculinity," in *The American Man*, ed. Elizabeth H. Pleck and Joseph H. Pleck (Englewood Cliffs, N.J.: Prentice-Hall, 1980), pp. 285–302.

31. See chap. 1, n. 12.

32. See Robert G. Paterson, "'Ho' Bellows on the Campus and the Teams," *Ohio State University Monthly* 16 (February 1925), pp. 7–8; Charles Grant, "Stag at Sharkey's."

33. See interviews with a number of Bellows's classmates and professors, in Seiberling, "George Bellows"; quotations are from pp. 181, 188, 191, 194, 196.

34. James Thurber, *The Thurber Album: A New Collection of Pieces about People* (New York: Simon and Schuster, 1952), pp. 207–8.

35. As has been pointed out, the expectations in terms of gender roles for Victorian men, as well as Victorian women, were exceedingly problematic. See Jackson Lears, *No Place of Grace*, pp. 220–25. See also Walter E. Houghton, *The Victorian Frame of Mind, 1830–1870* (New Haven, Conn.: Yale University Press, for Wellesley College, 1957) and Ann Douglas, *The Feminization of American Culture* (New York: Knopf, 1977).

36. Charles W. Rishell, "The Sanctification of the Passions," *Methodist Review* 75 (May–June 1893), p. 383.

37. Quoted in McGovern, "David Graham Philips," p. 344.

38. William Dean Howells, *Criticism and Fiction* (New York: Harper and Brothers, 1891), p. 43.

39. Michael Davitt Bell, "The Sin of Art and the Problem of American Realism: William Dean Howells," *Prospects* 9 (1984), p. 121. Davitt supports his case with additional passages by Howells, of fiction as well as nonfiction, that are suggestive of anxiety about his ambiguous social and sexual identity. It would appear, moreover, that Howell's critics may have fanned the flames of his uneasiness. In 1913 John Macy called him "a feminine, delicate, slightly romantic genius" (Macy, *The Spirit of American Literature*, quoted in Edwin H. Cady, *The Realist at War: The Mature Years of William Dean Howells* (Syracuse, N.Y.: Syracuse University Press, 1958). Howells's biographer, Alexander Harvey, devoted a chapter to describing him as the head of the "sissy school," in *William Dean Howells: A Study of the Achievement of a Literary Artist* (New York: B. W. Huebsch, 1917), pp. 178–99.

Alfred Habegger offers a related though different interpretation of Howells's struggle to define himself as a man and as a writer, in *Gender, Fantasy, and Realism in American Literature* (New York: Columbia University Press, 1982).

40. In fact, leading the "strenuous life" on campus was certainly preferable to excessive bookishness. A friend of President Roosevelt, for example, wrote, "The men of the Roosevelt stamp are usually found at the bottom of the class, at least in institutions run on the old-fashioned plan . . . and no one knows better than he the mischief that is done among students by having all the honors carried away by the anaemic, dyspeptic, flat-chested, pie-crusty individuals. This is unjust to the live men of the class, the strong, self-reliant, honest men who are cut out for leadership. These are condemned to academic insignificance merely because they refuse to cram and prefer to lead a healthy, manly life" (Poultney Bigelow, "Theodore Roosevelt: President and Sportsman," *Collier's Weekly* 29 [31 May 1902], p. 10). And an *Independent* editor observed that boys were being "driven from the classroom to the football field" because it was "the only place where masculine supremacy is incontestable" ("The Uncultured Sex," *Independent* 67 [11 November 1909], p. 1100).

41. Morgan, *George Bellows*, p. 27.

42. James Thurber was in Taylor's English class at Ohio State University in 1914. His impressions of Taylor are recorded in *The Thurber Album*, pp. 165–84; quotation from p. 167.

43. Fred A. Cornell, "The Tribute of a Friend from Boyhood," *Ohio State University Monthly* 16 (February 1925), p. 9.

44. Charles Grant provided a similar account of Bellows in high school and college: "Like all people with extraordinary talent he was lopsided and peculiar. His eccentricities were apparent to his class- and team-mates and he was a natural target for a campaign of kidding that extended over the years" (Grant to Charles Morgan, 7 March 1963, Morgan on Bellows Papers, box 6, folder 13.)

45. Van Wyck Brooks, *John Sloan: A Painter's Life* (London: J. M. Dent, 1955), p. 42. Bellows occupied another residence between the YMCA and the Lincoln Arcade. He and Ed Keefe rented a room in a house owned by a doctor, at 352 West Fifty-eighth Street. They were joined by Fred Cornell, a friend from Columbus. All three moved to 1947 Broadway in the summer of 1906.

46. Grant, "Stag at Sharkey's."

47. From a conversation with Guy Pène du Bois, 5 September 1952, quoted in Bennard B. Perlman, *Painters of the Ashcan School: The Immortal Eight* (New York: Dover, 1988), a "slightly corrected republication" of *The Immortal Eight: American Painting From the Ashcan School to the Armory Show* (Cincinnati: North Light, 1979). It is possible that some of Henri's students have enhanced the "masculinity" of his rhetoric and in so doing have exaggerated sexist implications. When Henri himself was quoted in contemporary newspapers and journals, he usually avoided referring only to the men in his classes. To one writer, for example, he said, "Every individual should study his own personality to the end of knowing his tastes." See Barrell, "Robert Henri—'Revolutionary,'" p. 1432.

48. See Hartmann, "Studio-Talk," pp. 182–83.

49. Walter Pach said about Henri, "He could make convincing allusions to the men with revolvers he had known in the Far West of his youth. Jesse James was pretty nearly a hero to him. Something of the fascination, of the sense of danger and adventure of the old West hung about his talk and flashed from under his dark brows," in *Queer Thing, Painting*, p. 45. On the appeal of the frontier tradition to various factions of Greenwich Village culture and society, see Martin Green, *New York 1913: The Armory Show and the Paterson Strike Pageant* (New York: Scribner's, 1988).

50. From the account provided by Vernon Ellis, one of Bellows's fellows students in Henri's class, and paraphrased in Seiberling, "George Bellows," p. 202.

51. The words were not Bellows's own but those of Forbes Watson, from a lecture presented in 1945 at the National Gallery. His observations were based on his twenty-year personal acquaintance with the artist. Forbes Watson Papers, Archives of American Art, Smithsonian Institution, Washington, D.C.

52. There are numerous accounts of Bellows's reading, characterizing him as "an omnivorous reader." His daughter Anne remembered that he spoke highly of *Moby-Dick* (Seiberling, "George Bellows," p. 232). His daughter Jean, who now keeps what remains of Bellows's library, wrote to the author (6 September 1986) that his favorite reading included *Moby-Dick*, *The Red Badge of Courage*, and O. Henry stories. According to Thomas Beer, Bellows complained that American literature had no epics other than *Moby-Dick*, *Huckleberry Finn*, and *The Red Badge of Courage*. See Beer's introduction to *George W. Bellows: His Lithographs* (New York: Knopf, 1927), p. 22.

53. William Baurecht refers to life on the *Pequod* as "an ideal of all-male comradeship in a non-bourgeois microcosm." See his "To Reign is Worth Ambition: The Masculine Mystique in *Moby-Dick*," *Journal of American Culture* 9 (Winter 1986), p. 55. The following discussion draws on Alan Lebowitz, *Progress into Silence: A Study of Melville's Heroes* (Bloomington, Ind.: Indiana University Press, 1970); Edwin Haviland Miller, *Melville* (New York: Braziller, 1975); Charles J. Haberstroh, Jr., *Melville and Male Identity* (Madison, N.J.: Fairleigh Dickinson University Press, 1980).

54. Beer, *Bellows*, p. 22. Bellows's maternal grandmother, it might be noted, was "A sea captain who did whaling." See George Bellows, autobiographical statement, Bellows Papers, box 4, folder 5.

55. Herman Melville, *Moby-Dick, or The Whale* (Evanston and Chicago: Northwestern University Press and The Newberry Library, 1988), p. 264.

56. Melville, *Moby-Dick*, p. 134.

57. Noted by Eugene Speicher, in "A Personal Reminiscence," *George Bellows: Paintings, Drawings, and Prints*, exh. cat. (Chicago: Art Institute of Chicago, 1946), p. 5.

58. Shortly after the Cleveland Museum acquired *Stag at Sharkey's*, Bellows wrote to the director, "Before I married and became semi-respectable, I lived on Broadway opposite the Sharkey Athletic Club where it was possible under law to become a 'Member' and see the fights for a price" (Bellows to William Milliken, 10 June 1922, Curators' file, Cleveland Museum of Art).

Accounts of Bellows's first visit to Sharkey's Club are all secondhand. According to Morgan's biography, which was based on contacts with several of the artist's contemporaries, Bellows's roommate, Ed Keefe, got him interested in boxing. Keefe knew the lightweight champion of Connecticut, Moses King, from school days and brought Bellows to one of King's fights at Sharkey's (Morgan, *Bellows*, p. 69). Charles Grant, in his rather egocentric account, suggests that he was somehow involved in Bellows's exposure to boxing: he thought that Bellows should do a portrait of the famous ex-champion, Jim Jeffries, and that the plan to visit Sharkey's grew out of that idea. He did not, however, accompany Bellows on his first visit to Sharkey's. Grant cannot be correct in saying that Bellows painted *Stag at Sharkey's* the afternoon following that initial experience, as the drawing predates the painting by one month (Grant, "Stag at Sharkey's").

59. The literature on the rise of sports in the United States is extensive. See John Rickards Betts, *America's Sporting History* (Reading, Mass.: Addison-Wesley, 1974), specifically pp. 222–26 for the common contemporary view of boxing; Betts, "The Technological Revolution and the Rise of Sport, 1850–1900," *Mississippi Valley Historical Review* 40 (September 1953), pp. 231–56; Benjamin G. Rader, "The Quest for Subcommunities and the Rise of American Sport," *American Quarterly* 29 (Fall 1977), pp. 355–69; Dubbert, *A Man's Place*, pp. 163–90; Donald J. Mrozek, *Sport and the American Mentality, 1880–1910* (Knoxville: University of Tennessee Press, 1983). Melvin L. Adelman argues that the rise of sport began earlier than the later decades of the nineteenth century, in *A Sporting Time: New York City and the Rise of Modern Athletics, 1820–70* (Urbana and Chicago: University of Illinois Press, 1986).

60. See Michael T. Isenberg, *John L. Sullivan and His America* (Urbana and Chicago: University of Illinois Press, 1988).

61. Elliott J. Gorn, *The Manly Art: Bare-Knuckle Prize Fighting in America* (Ithaca, N.Y.: Cornell University Press, 1986), pp. 65–75.

62. Urban reformers were well aware that the saloon functioned as a poor man's club and expressed concern that the "demand for social expression" accounted for "the real hold of the saloon" upon the lives of its patrons. See Raymond Calkins, *Substitutes for the Saloon* (Boston: Houghton, Mifflin, 1901), pp. 2, 4. See also Jon M. Kingsdale, "The 'Poor Man's Club': Social Functions of the Urban Working Class Saloon," *American Quarterly* 25 (October 1973), pp. 472–89; Gorn, *The Manly Art*, pp. 131–45; Isenberg, *Sullivan and His America;* Roy Rosenzweig, *Eight Hours for What We Will: Workers and Leisure in an Industrial City, 1870–1920* (Cambridge: Cambridge University Press, 1983), chap. 2. Professional boxing was also seen as an opportunity to escape poverty and discrimination. See Dale A. Somers, *The Rise of Sport in New Orleans, 1850–1900* (Baton Rouge: Louisiana State University, 1972), p. 159.

63. G. Stanley Hall, *Life and Confessions of a Psychologist* (New York: Appleton, 1923), pp. 578–79, quoted in Gorn, *The Manly Art*, p. 197.

64. John Boyle O'Reilly, *The Ethics of Boxing and Manly Sport* (Boston: Ticknor, 1888), p. 69, quoted in Gorn, *The Manly Art*, p. 202.

65. In 1890 Theodore Roosevelt wrote, "A prize fight is simply brutal and degrading. The people who attend it and make a hero of the prize fighter, are , . . . to a very great extent, men who hover on the borderlines of criminality" ("Professionalism in Sports," *North American Review* 151 [August 1890], p. 187). But in his autobiography Roosevelt maintained, "I have never been able to sympathize with the outcry against prize-fighters. The only objection I have to the prize ring is the crookedness that has attended its commercial development. Outside of this I regard boxing, whether professional or amateur, as a first-class sport, and I do not regard it as brutalizing" (*An Autobiography* [New York: Macmillan, 1919], p. 48).

66. The Coney Island Athletic Club, for example, could accommodate as many as ten thousand spectators, approximately four times the seating capacity of even the larger

clubs in Manhattan. See Oliver Pilat and Jo Ranson, *Sodom by the Sea: An Affectionate History of Coney Island* (Garden City, N.Y.: Doubleday, Doran, 1941), pp. 80–92; Edo McCullough, *Good Old Coney Island: A Sentimental Journey into the Past* (New York: Scribner's, 1957), pp. 154–82. Before the Lewis bill took effect on 1 September 1900, the Horton law had permitted ten-round contests. For an account of what was legal or illegal and when, see Steven A. Reiss, "In the Ring and Out: Professional Boxing in New York, 1896–1920," *Sport in America: New Historical Perspectives*, ed. Donald Spivey (Westport, Conn.: Greenwood Press, 1985), pp. 95–128.

67. "Stop the Prizefights," *New York Times*, 1 June 1906, p. 8.

68. Quotation from "Bout Stopped; Police Cause Large Losses," *New York Globe and Commercial Advertiser*, 28 July 1908, p. 8. See also Sam C. Austin, "Trouble for New York Boxing Clubs," *Police Gazette* 91 (13 July 1907), p. 10.

69. See, for example, Larry May, *Screening Out the Past: The Birth of Mass Culture and the Motion Picture Industry* (New York and Oxford: Oxford University Press, 1980).

70. On the organization and rationalization of modern sports, see Lucas and Smith, *The Saga of American Sport;* Adelman, *A Sporting Time;* Allen Guttman, *From Ritual to Record: The Nature of Modern Sports* (New York: Columbia University Press, 1978); Benjamin G. Rader, *American Sports: From the Age of Folk Games to the Age of Spectators* (Englewood Cliffs, N.J.: Prentice-Hall, 1983). The institution of the Queensbury rules marked one step in the direction of legitimacy for boxing. The new code disallowed all wrestling and grappling holds, established three-minute rounds with one-minute rests between, and allowed ten seconds for a downed fighter to regain his feet. Boxers now donned gloves, which certainly inspired superficial changes in the style, strategies, and appearance of the game. But a gloved punch can inflict considerable damage, and the increased stress on hitting it out, rather than using wrestling maneuvers, may have actually increased the rate of serious injury. The Queensberry rules also permitted indoor bouts, emphasizing the growing ties of pugilism to the urban scene.

71. See S. Kirson Weinberg and Henry Arond, "The Occupational Culture of the Boxer," *American Journal of Sociology* 57 (March 1952), pp. 460–69.

72. On the relationship between the Irish-Catholic communities and the "bachelor" sporting fraternity, see Somers, *The Rise of Sport in New Orleans*, pp. 53, 160; Rader, *American Sports*, p. 97–104.

73. H. R. Durant, "A Sucker," *Cosmopolitan* 34 (May 1905), p. 85. Other contemporary stories centered on the boxing theme include Richard Harding Davis, "Gallegher: A Newspaper Story," *Gallegher and Other Stories* (New York: Scribner's, 1891); Jack London, *The Game* (New York: Macmillan, 1905); H. R. Durant, "When Campbell Cried," *Metropolitan Magazine* 26 (July 1907), pp. 429–38; Jack London, "A Piece of Steak," *Saturday Evening Post* 182 (20 November 1909), pp. 6–8, 42–43; O. Henry, "The Higher Pragmatism," *Munsey's* 40 (March 1909), pp. 789–94. It is frequently observed that boxing has long held a mysterious appeal for writers, from Homer and Virgil to Hemingway. On more recent authors who have written about boxing, such as Joyce Carol Oates and Norman Mailer, see Arthur Krystal, "Ifs, Ands, Butts: The Literary Sensibility at Ringside," *Harper's* 274 (June 1987), pp. 63–67.

74. E. A. Carmean, Jr., has pointed out the anecdotal character and illustrational style of the drawing in "Bellows: The Boxing Paintings," pp. 28–29. Linda Ayres describes *The Knock Out* as an academic work and presents a detailed visual analysis, in "Bellows: The Boxing Drawings," pp. 51–52. Both of these essays appear in *Bellows: The Boxing Pictures*, exh. cat. (Washington, D.C.: National Gallery of Art, 1892).

75. See Dianne H. Pilgrim, "The Revival of Pastels in Nineteenth-Century America: The Society of Painters in Pastel," *American Art Journal* 10 (November 1978), pp. 43–62; Patricia Hills, *Turn-of-the-Century America*, exh. cat. (New York: Whitney Museum of American Art, 1977), pp. 46–57.

76. The "stage" of the ring floor spans the entire composition. The triangular arrangement of the fighters and referee occupies only the right half. On the left, the ardent group of onlookers, who hang on the ropes and push themselves into the ring, form a second, inverted triangle. Seen as a spatial unit, these figures exist in the same shallow plane of the stage, adjacent to the boxers, and act as a chorus, responding to the primary action.

77. See Edith Deshazo, *Everett Shinn, 1876–1953: A Figure in His Time* (New York: Potter, 1974), pp. 40–58, 213–14.

78. Shinn's painting has been known as *Stage Scene*. See Linda Ayres's catalog entry in *American Paintings, Watercolors, and Drawings from the Collection of Rita and Daniel Fraad*, exh. cat. (Fort Worth, Tex.: Amon Carter Museum, 1985), pp. 82–83. Linda Ferber has noted that the work was originally titled *A French Music Hall*, in "Stagestruck: The Theater Subjects of Everett Shinn," *American Art around 1900*, ed. Doreen Bolger and Nicolai Cikovsky, Jr., Studies in the History of Art, no. 37 (Washington, D.C.: National Gallery of Art, 1990), pp. 59–60.

79. Discussion of possible sources for Bellows's early boxing pictures could be endless. Eleanor M. Tufts, for example, has found compositional sources as well as a source for Bellows's treatment of the grotesque in Goya. See her articles, "Bellows and Goya," *Art Journal* 30, no. 4 (1971), pp. 362–68; "Realism Revisited: Goya's Impact on George Bellows and Other American Responses to the Spanish Presence in Art," *Arts* 57 (February 1983), pp. 105–13.

80. Bellows also adjusted the size of the canvas at some point, adding approximately one inch to each edge of the portrait, now the top and bottom of the boxing scene. Tack marks appear near the edges. See Painting Conservation Department Examination Report, dated 4 March 1983, on file in the Office of Curatorial Records and Files, National Gallery of Art.

81. From letter to Miss Katherine Hiller, quoted in Thomas Beer, "George Bellows," *George W. Bellows: His Lithographs* (New York: Knopf, 1927), p. 15. Beer dates the letter from 1910.

82. "Examination Report," written 3 April 1983 by Sarah L. Fisher of the National Gallery's Conservation Department, details the effect of the underlying paint. The report also notes that a thin varnish applied over the surface does darken the colors slightly. The report is available in the Painting Conservation Department files, National Gallery of Art.

83. Robert Haywood discusses the homoerotic aspects of boxing in "George Bellows's *Stag at Sharkey's*: Boxing, Violence, and Male Identity," *Smithsonian Studies in American Art* 2 (Spring 1988), pp. 3–15.

84. The opportunity to depict the nude was definitely an issue for Bellows. In 1910 he wrote to Katherine Hiller, "Prize fighters and swimmers are the only types whose muscular action can be painted in the nude legitimately" (letter to Hiller, quoted in Beer, *Bellows: Lithographs*, p. 16). On another occasion, however, he said about his fight pictures, "I didn't paint anatomy; I painted action" (interview with W. F. Burdell, in Seiberling, "George Bellows," p. 180). Interestingly, prizefighting and swimming had also been treated by Thomas Eakins. On Eakins's interest in the nude, particularly in terms of these two subjects, and his preference for the male over the female nude, see Carl S. Smith, "The Boxing Paintings of Thomas Eakins," *Prospects* 4 (1979), pp. 403–19. See also Lloyd Goodrich, *Thomas Eakins*, 2 vols. (Cambridge, Mass.: Harvard University Press, for the National Gallery of Art, 1982), vol. 1, pp. 28–29, 147–57, 239–43; vol. 2, pp. 109–10, 144–59.

85. Bellows to Milliken, 10 June 1922, Curators' files, Cleveland Museum of Art.

86. "National Academy's Exhibition Opened," *New York Herald*, 14 December 1907, p. 3. The Deming to which the critic referred was a historical genre scene depicting Indians before the body of a slain bear.

87. J. Nilsen Laurvik, "The Winter Exhibition of the National Academy of Design," *International Studio* 33 (February 1908), pp. cxxxix–cxlii.

88. Lois Fink discusses the tendency among some critics, beginning in the latter 1890s, to reject the idea of French art training for American artists. Accompanying this tendency was an increasing veneration for such qualities as virility and wholesomeness. See Fink, *American Art at the Nineteenth-Century Paris Salons* (Cambridge: Cambridge University Press, 1990), pp. 286–88.

89. In this brief discussion of academic idealism and the genteel tradition, the variety of stylistic strains and tendencies are radically simplified. For greater specificity, see Hills, *Turn-of-the-Century America*. Other sources include Lois Fink, "The Innovation of Tradition in Late Nineteenth-Century American Art," *American Art Journal* 10 (November 1978), pp. 63–71; Lois Fink and Joshua C. Taylor, *Academy: The Academic Tradition in American Art*, exh. cat. (Washington, D.C.: Published for the National Collection of Fine Arts by the Smithsonian Institution Press, 1975); Richard Guy Wilson et al., *The American Renaissance, 1876–1917*, exh. cat. (New York: The Brooklyn Museum, 1979); David C. Huntington, *The Quest for Unity:*

American Art between the Fairs, 1876–1893, exh. cat. (Detroit: Detroit Art Institute, 1983); Trevor J. Fairbrother, *The Bostonians: Painters of an Elegant Age, 1870–1930*, exh. cat. (Boston: Museum of Fine Arts, 1986).

90. Laurvik, "The Winter Exhibition," p. cxlii.

91. J. Nilsen Laurvik, "Art at Home and Abroad: Significance of the Exhibition of the Pennsylvania Academy," *New York Times*, 26 January 1908, sec. 10, p. 8. The review was reprinted in *International Studio* 34 (March 1908), pp. xxxi–xxxvi.

92. Ibid.

93. See "National Academy Holding Its Show," *New York Herald*, 17 March 1907, literary and art section, p. 4; Frank Fowler, "Impressions of the Spring Academy," *Nation* 84 (28 March 1907), pp. 297–98. In addition to critical reviews, many newspapers and magazines printed photographs of popular paintings in major exhibitions. Virtually every season, for example, *Harper's Weekly* devoted two full pages to illustrations of paintings from the annual shows at the National and the Pennsylvania academies. The taste of *Harper's* editors, and probably of their public as well, dictated that women of noble virtue and mild-mannered children usually dominated the subjects selected for reproduction in this popular magazine.

94. Paxton's treatment of the nude in *Glow of Gold* reflects the influence of his teacher, the academician Jean Léon Gérôme. The oriental armband helps identify the nude as a slave girl in the tradition of such paintings as Gérôme's *Phryne before the Tribunal* and *Slave Market*. See Anthony F. Janson's catalog entry on *Glow of Gold, Gleam of Pearl* in *One Hundred Masterpieces of Painting: Indianapolis Museum of Art* (Indianapolis: Indianapolis Museum of Art, 1980), pp. 248–51.

95. It should go without saying that these three canvases cannot be taken to represent the entire range of conservative themes and styles. They do, however, illustrate various versions of a prevalent theme of the period: woman as an object of beauty portrayed in a passive state, removed from significant economic activity. Bernice Kramer Leader has interpreted paintings of women by Hale and Paxton and other Boston artists in terms of antifeminist sentiments and a nostalgic longing for traditional feminine ideals of passivity and domesticity, in "The Boston Lady as a Work of Art: Paintings by the Boston School at the Turn of the Century," (Ph.D. diss.: Columbia University, 1980). Leader was not referring to paintings by Paxton such as his *Glow of Gold, Gleam of Pearl*, which stresses exoticism and sensuality rather than innocence. Others have suggested more positive meanings for feminine subjects. On women as repositories of spiritual values and the aesthetic sensibility, see Julie Anne Springer, "Art and the Feminine Muse: Women in Interiors by John White Alexander," *Women's Art Journal* 6 (Fall 1985–Winter 1986), pp. 1–8. See also Ross Anderson, *Abbott Handerson Thayer*, exh. cat. (Syracuse, N.Y.: Everson Museum, 1982). For a provocative discussion of "woman as image of a type," see Martha Banta, *Imaging American Women: Idea and Ideals in Cultural History* (New York: Columbia University Press, 1897).

96. On the patronage of Boston School artists by Boston Brahmins, see Leader, "The Boston Lady."

97. Alan Trachtenberg has presented a provocative view of the connections between corporate structures and cultural institutions during the Gilded Age and their allied attempts to embrace or even legitimize industrial capitalism while preserving traditional values, in *The Incorporation of America*. Stow Persons has discussed relations between the gentry and the social-economic elite during this period, in *The Decline of Gentility* (New York: Columbia University Press, 1973).

98. Henry Childs Merwin, "On Being Civilized Too Much," *Atlantic Monthly* 79 (June 1897), p. 839.

99. See Theodore Roosevelt, *The Strenuous Life and Other Essays* (New York: The Century Co., 1905).

100. John Ward Stimson, "On the Stoa of the Twentieth Century: Ethical and Utilitarian Value of Vital Art," *Arena* 26 (July 1901), p. 82.

101. Charles Caffin, "The Story of American Painting: French Influence," *American Magazine* 61 (March 1906), p. 597. Innumerable citations could be made of proclamations about the relative virility and hardiness of American art. The Saint Louis World's Fair, for example, occasioned ruminations on the state of American art in contrast to that of European countries. One writer said that while the display of American art was cosmopolitan, "back of all influence was a vigor and energy differing from any expression of continental art" (Lena M. McCauley, "An Epoch in National Art," *Brush and Pencil* 14 [December 1904], p. 299).

The tendency to connect signs of virility with the expunging of foreign influences persisted. A reviewer of the 1909 Spring annual at the National Academy suggested that the exhibition seemed "younger than usual. Its canvases have a fresher complexion, a look of great virility. It is . . . as though it were more Americanized" ("More of the American Spirit in the Spring Exhibition of the National Academy of Design," *Craftsman* 16 [May 1909], p. 176).

102. See "Paintings Worth Seeing and Some Others," *New York Telegram*, 21 January 1904; James Huneker called Henri "the Manet of Manhattan," in "That Tragic Wall," *New York Sun*, 16 March 1907, p. 8.

103. Quoted in "The Henri Hurrah," *American Art News* 5 (23 March 1907), p. 4. The article provides a detailed contemporary account of the entire episode.

104. Samuel Swift, "Revolutionary Figures in American Art," *Harper's Weekly* 51 (13 April 1907), pp. 534–36.

105. Guy Pène du Bois, "Wm. M. Chase Forced Out of New York Art School; Triumph for the 'New Movement' Led by Robert Henri," *New York American*, 28 November 1907, p. 3. John Sloan provides additional commentary on the incident in his diary: "This is the truth. Henri has been the 'drawing card' in the school for three years and Chase's nose is out of joint" (St. John, ed., *Sloan's New York Scene*, 21 November 1907, p. 167).

106. Quoted in "What Is Art Anyhow?" *New York American*, 1 December 1907, p. 8.

107. There was no work in the 1907 Winter Exhibition by Sloan, Glackens, Luks, Myers, Coleman, or even Shinn. Lawson's *Snow Bound Boats* was exhibited, as was Henri's *Girl in Yellow Dress*.

108. See May, *The End of American Innocence*. May focuses on the pre–World War I era, but his book is central to any consideration of the revolt against the genteel tradition.

109. See Abraham Flexner, *Medical Education in the United States and Canada: A Report to the Carnegie Foundation for the Advancement of Teaching* (New York: Carnegie Foundation, 1910), cited in Cecelia Tichi, *Shifting Gears: Technology, Literature, Culture in Modernist America* (Chapel Hill: University of North Carolina Press, 1987), pp. 252–55.

110. "Art and Artists: Pennsylvania Academy—Second Article," *New York Globe and Commercial Advertiser*, 27 January 1910, p. 6.

111. Charles Grant, "Stag at Sharkey's." On another occasion, Grant gave a slightly different account of Bellows's reply: "I don't know anything about the technic of boxing. I was painting two men trying to kill each other" (Grant to Charles Morgan, 11 April 1963, Morgan on Bellows Papers, box 6, folder 13).

112. Finding fault with Bellows's realism, however, continued to come from art cognoscenti as well. When *Stag at Sharkey's* was shown at the Madison Gallery in 1911, a critic for the *New York World* noted that if the larger fighter were ever to stand up straight, he would be eight feet tall.

113. The balding figure at ringside certainly looks like Bellows, except that he still had some hair on the crown of his head in 1909. Bellows was quite conscious of his receding hairline, however, and was capable of joking about his rapidly changing appearance. On returning to Columbus, Ohio, for the Christmas holiday four months after painting *Stag at Sharkey's*, he greeted his mother wearing a bald wig. See Morgan, *Bellows*, p. 103. Bellows's daughter, Jean Bellows Booth, has confirmed the presence of her father's portrait—"the bald man peeking over the canvas"—in many of the boxing pictures (Conversation with Linda Ayres, notes dated 10 September 1982, Curatorial Records and Files, National Gallery of Art). The example of self-portraiture most often noted is that of the figure at the far left in *Dempsey and Firpo* (1924; Whitney Museum of American Art, New York). The contour of the head, the eyes, and the eyebrows of the figure peeking over the floor of the ring in *Stag at Sharkey's* all bear a strong resemblance to that balding figure in *Dempsey and Firpo*. Charles Grant reported that Bellows also included himself in the front row on the left in *Introducing John L. Sullivan* (1923; collection of Mrs. John Hay Whitney). Grant to Charles Morgan, 10 March 1963, Morgan on Bellows Papers, box 6, folder 13.

114. "Art and Artists: Pennsylvania Academy—Second Notice," *New York Globe and Commercial Advertiser*, 27 January 1910, p. 6.

115. Bellows had been called "the infant terrible [*sic*] of painting" by J. Nilsen Laurvik in his August 1909 review of the Pennsylvania Academy's Annual Exhibition, published in *International Studio*. See chap. 1, n. 103.

116. Accounts of the entire episode are available in Randy Roberts, *Papa Jack: Jack Johnson and the Era of White Hopes* (New York: The Free Press, 1983); Al-Tony Gilmore, *Bad Nigger!: The National Impact of Jack Johnson* (Port Washington, N.Y.: Kennikat Press, 1975); Jeffrey T. Sammons, *Beyond the Ring: The Role of Boxing in American Society* (Urbana: University of Illinois Press, 1988), pp. 31–40.

117. Ex-champion John L. Sullivan scolded Burns publicly for taking on the black opponent simply for money. Sullivan's statement, published in the *Indianapolis Freeman*, 19 December 1908, is quoted in Gilmore, *Bad Nigger!*, p. 27.

118. Jack London, "Jack London Says Johnson Made a Noise Like a Lullaby with His Fists As He Tucked Burns in His Little Crib in Sleepy Hollow, with a Laugh," *New York Herald*, 27 December 1908, sec. 2, p. 3.

119. *Chicago Tribune*, 4 April 1909, sec. 3, p. 4; cited in Roberts, *Papa Jack*, pp. 85–86.

120. "The Big Idea," p. 275; see chap. 1, n. 42.

121. Since meetings between black and white fighters were rare, reporters usually took special note. When Stanley Ketchel was scheduled for a bout with Sam Langford in New York City, in September 1909, the press referred to the latter as "Tar Baby Langford" and "Sambo." The fight was cancelled only two days before the scheduled meet. John Lardner makes the point that racial superiority was a less volatile issue when fighters weighed under 175 pounds. See his *White Hopes and Other Tigers* (Philadelphia: Lippincott, 1951), pp. 20–39.

122. The phrase *both members of this club* enjoyed some currency during this period. For example, a *New York Evening Journal* cartoon of 8 September 1908 (p. 1), depicting Cook and Peary racing each other to the North Pole, used the phrase as its satirical caption.

123. "Gans, Greatest of Fighters, a Negro?" *New York American*, 22 December 1907, sports section, p. 1.

124. "Topics of the Times: And May the Best Man Win!" *New York Times*, 1 November 1909, p. 10.

125. Walter St. Denis, "Mormons Are Behind Rickard," *New York Globe and Commercial Advertiser*, 24 January 1910, p. 10.

126. "Why All Mankind Is Interested in a Great Prize Fight," *New York American*, 3 April 1910, magazine section, p. 6.

127. It has never been noted, in addition, that one of Bellows's most spectacular, later boxing drawings, *The Savior of His Race*, also addressed the topical subject of Jack Johnson and the white hopes. The near-symmetrical composition of this drawing focuses on a white fighter, seated between rounds, with arms outstretched and against the corner post—an obvious allusion to crucifixion imagery. Johnson lost his title to Jess Willard on 5 April 1915 in Havana, Cuba, and Bellows's *The Savior of His Race* appeared in the *Masses* the following month. See *Masses* 6 (May 1915), p. 11.

128. Helen Appleton Read, *Robert Henri* (New York: Whitney Museum of American Art, 1931), p. 11. In a later, expanded version of the 1931 essay, Read specifically named *Both Members of This Club* as the painting that "called forth excoriations from the press." See *Robert Henri and Five of His Pupils* (New York: Century Association, 1946). Read studied with Henri when his school was located in the Lincoln Arcade Building. She later became art critic for the *Brooklyn Eagle*.

129. *Furor sexualis* was likened by physicians to the kind of sexual attacks observed in such animals as the bull and the elephant. See Hunter McGuire and G. Frank Lydston, "Sexual Crimes among the Southern Negroes: Scientifically Considered," *Virginia Medical Monthly* 20 (May 1893), p. 118, cited in John S. Haller, Jr., *Outcasts from Evolution: Scientific Attitudes of Racial Inferiority, 1859–1900* (Urbana: University of Illinois Press, 1971), p. 53. Another pseudo-scientific analysis of the "strong sex instincts" and lack of morality in blacks was provided by Joseph A. Tillinghast, *The Negro in Africa and America* (New York: Macmillan, 1902), pp. 60–65, 160–61. On Johnson's own exploitation of the myth of black sexuality, see Roberts, *Johnson and the Era of White Hopes*, p. 74. See also William H. Wiggins, Jr., "Jack Johnson as Bad Nigger: The Folklore of His Life," *Black Scholar* 2 (January 1971), pp. 35–46.

130. It seems that Bellows himself played a part in exaggerating the negative reactions to his boxing pictures. Although there is no evidence that the paintings were ever rejected by the Academy, Bellows suggests as much in a letter to Professor Taylor about the Exhibition of Independent Artists and the grievances of the participating artists

against the Academy: "There is a large class of things done which are tabooed for reasons quite outside the sphere of art, one very pri[n]ciple reason being morality, and morality of a very dinky distinctiveness. It is immoral to paint prize fighters with blood on them. No matter how beautiful their bodies in action. But perfectly moral to paint pirates gracefully frozen in gently ferocious attitudes. If you make them nice stage pirates. It is immoral to blurt out a witty idea in half an hour of expressing one[']s self with a paint brush, but quite moral to labor six months, and say nothing but 'see how well I can model nipple pink' " (Bellows to Taylor, 21 April 1910, Bellows Papers, box 1, folder 11).

131. On the Exhibition of Independent Artists, see Bennard B. Perlman, *Painters of the Ashcan School: The Immortal Eight* (New York: Dover, 1988), pp. 191–95; Constance H. Schwartz, *The Shock of Modernism in America: The Eight and Artists of the Armory Show*, exh. cat. (Roslyn Harbor, N.Y.: Nassau County Museum of Fine Art, 1984), p. 52; *The Fiftieth Anniversary of the Exhibition of Independent Artists in 1910*, exh. cat. (Wilmington: Delaware Art Center, 1960). See also St. John, ed. *Sloan's New York Scene*, pp. 395–413.

132. Guy Pène du Bois, "Exhibition by Independent Artists Attracts Immense Throngs," *New York American*, 4 April 1910, p. 6.

133. The landscape with nudes was *Golden Days*, by Lillian Genth, and the remaining four reproductions were Rockwell Kent's *Road Breaking*, William Glackens's *Russian Girl*, Walt Kuhn's *Tow Team*, and John Sloan's *Clown Making Up*. See "Art of the Insurgents," *New York Sun*, 10 April 1910, sec. 3, p. 5.

134. Henry Tyrrell, "The Battle of the Artists," *New York World*, 5 June 1910, magazine section, p. 6. Also illustrated were Robert Henri's *A Dancer*, John Sloan's *Portrait of Robert Henri*, George Bellows's *I Do So Want You Girls to Meet*, Dorothy Rice's *The Bread Line*, Gutzon Borglum's *Lincoln*, George Luks's *The Guitar*, James Preston's *Landscape, Winter*, Gus Mager's *Off the Road*, and Walt Kuhn's *Tow Team*.

135. Robert Henri, "The New York Exhibition of Independent Artists," *Craftsman* 18 (May 1910), p. 160. The Independent Artists' Exhibition was organized without a jury, and the hanging committee was responsible merely for preparing the walls and hanging the paintings on them, in alphabetical order. No prizes were awarded.

136. "Art and Artists," *New York Globe and Commercial Advertiser*, 5 April 1910, p. 10.

137. Quoted from *Outlook* 57 (22 May 1909), p. 145, in George E. Mowry, *Theodore Roosevelt and the Progressive Movement* (New York: Hill and Wang, 1960), p. 55. According to an editorial comment in *Collier's* (45 [7 June 1910], p. 91), the term *insurgent* was first applied to a group acting and voting as a unit, in that magazine and others, in the spring of 1908. It was used with most frequency during the Taft administration. In addition to Mowry's account, see Kenneth W. Hechler, *Insurgency: Personalities and Politics of the Taft Era* (New York: Columbia University Press, 1940); James Holt, *Congressional Insurgents and the Party System* (Cambridge, Mass.: Harvard University Press, 1967); David P. Thelen, *Robert M. La Follette and the Insurgent Spirit* (New York: Little, Brown, 1976).

138. See Louis R. Glavis, "Whitewashing of Ballinger," *Collier's* 14 (13 November 1909), pp. 13–17, cited in Mowry, *Roosevelt and the Progressive Movement*, p. 68.

139. Albert J. Beveridge to Joseph L. Bristow and Jonathan Bourne, July 1910, quoted in Thelen, *La Follette and the Insurgent Spirit*, p. 76.

140. "Insurgents We Are Watching," *Independent* 68 (31 March 1910), p. 693. Other prominent articles on insurgency include Henry Beach Needham, "In the Supreme Court— The People of the United States: The Insurgents vs Aldrich, Hale, Cannon, Payne, et al," *Everybody's* 21 (December 1909), pp. 797–804; Robert L. Owen, "The True Meaning of Insurgency," *Independent* 68 (30 June 1910), pp. 1420–23; William Allen White, "The Insurgence of Insurgency," *American Magazine* 71 (December 1910), pp. 170–74.

141. Tyrrell, "The Battle of the Artists," *World*, p. 6.

142. "Insurgency in Art," *Literary Digest* 40 (23 April 1910), pp. 814–16.

143. James G. Huneker, "Around the Galleries," *New York Sun*, 7 April 1910, p. 6; Courtenay Lemon, "Independent Art in New York," *Call*, 29 May 1910, p. 16.

144. For this characterization of the Progressive Era I am indebted to David B. Danbom, *"The World of Hope": Progressives and the Struggle for an Ethical Public Life* (Philadelphia: Temple University Press, 1987). Danbom bases his analysis on the premise "that the progressives were the products of the Victorian age in which they grew up. They reflected the Victorian faith in the individual and confidence in the inevitability of human progress." In Danbom's view, the progressives were looking "backward

rather than forward" in their attempt to impose a system of traditional values associated with private life onto a reluctant society and its public life. There is a considerable body of literature on the conservative nature of progressivism. For overviews of the "conflicting interpretations" of the movement, see Daniel T. Rodgers, "In Search of Progressivism," *Reviews in American History* 10 (December 1983), pp. 113–32; introduction to chapter 6, "The Progressive Movement: Liberal or Conservative," in Gerald N. Grob and George Athan Billias, eds., *Interpretations of American History: Patterns and Perspectives*, 5th ed. (New York: Free Press, 1987), vol. 2, pp. 229–47.

145. See May, *The End of American Innocence*, p. ix.

146. See Peter Conn, *The Divided Mind: Ideology and Imagination in America, 1898–1917* (Cambridge: Cambridge University Press, 1983). The quotation is from p. 1.

147. James G. Huneker, "Around the Galleries," *New York Sun*, 7 April 1910, p. 6.

148. Royal Cortissoz, "Independent Art: Some Reflections on Its Claims and Obligations," *New York Daily Tribune*, 10 April 1910, sec. 2, p. 2.

149. See Guy Pène du Bois, "Great Modern Art Display Here April 1," *New York American*, 22 March 1910, p. 8.

150. *The Fiftieth Anniversary of the Exhibition of Independent Artists in 1910* includes a reproduction of the original catalog.

151. Joseph Edgar Chamberlin, "With the Independent Artists," *New York Evening Mail*, 4 April 1910, p. 6.

152. Chamberlin, "With the Independent Artists," p. 6; Huneker, "Around the Galleries," *New York Sun*, 7 April 1910, p. 6.

153. "Young Artists' Work Shown," *New York Times*, 2 April 1910, p. 9.

154. Joseph Edgar Chamberlin, in his review, referred to the provocative nature of Salome's costume. Henri's painting, in fact, headed his list of "striking pictures" in the Independent Artists' Exhibition: "Perhaps the most remarkable is Robert Henri's 'Salome Dancer,' which was rejected at the academy this year. This is a remarkably strong work—a half-nude, sensuous-looking woman, painted with astonishing lifelikeness and vigor." See "With the Independent Artists," *New York Evening Mail*, 4 April 1910, p. 6. See also the catalog entry on *Salome* in *Robert Henri, Painter*, exh. cat. (Wilmington: Delaware Art Museum, 1984), p. 101.

Chapter 3, *The Other Half*

1. Everett Shinn, "Recollections of the Eight," *The Eight*, exh. cat. (New York: Brooklyn Museum and the Brooklyn Institute of Arts and Sciences, 1944), pp. 12, 13.

2. Helen Appleton Read, *Robert Henri and Five of His Pupils.*

3. Sam Hunter, with contributions by John Jacobus, *American Art of the Twentieth Century* (New York: Harry N. Abrams, 1973), pp. 49, 52.

4. John Baur, *Revolution and Tradition in American Art* (Cambridge, Mass.: Harvard University Press, 1951), pp. 13–18; Amy Goldin, "The Eight's Laissez Faire Revolution," *Art in America* 61 (July–August 1973), p. 45. Several others have also reevaluated the idea of radicalism in the Ashcan School. Matthew Baigell, for example, has suggested, "The 'radicalism' of the realist painters probably lies in the fact that they did explore the life of Eastern European immigrants whose presence in the country and as subject matter in art might have been feared by xenophobic business and art interests, but not in understanding the difficulties of that life." See his "Notes on Realist Painting and Photography, c. 1900–10," *Arts Magazine* 54 (November 1979), pp. 141–43. Harvey Dinnerstein and Burt Silverman described the vision of the Eight as "detached" and motivated by a "general interest in the spectacle of contemporary life," in "New Look at Protest: The Eight since 1908," *Art News* 56 (February 1958), pp. 36–39. See also M. Victor Alper, "American Mythologies in Painting, Part 2: City Life and Social Idealism," *Arts* 46 (December 1971–January 1972), pp. 31–34; Mara Liasson, "The Eight and 291: Radical Art in the First Two Decades of the Twentieth Century," *American Art Review* 2 (July–August 1975), pp. 91–102.

5. Goldin, "The Eight's Laissez Faire Revolution," p. 45.

6. The Society of American Artists' Twenty-eighth Annual Exhibition was held 17 March–22 April 1906. Bellows did have an entry, *Basketball*, in the Third Annual Water Color Exhibition at the Pennsylvania Academy at virtually the same time, although it opened a few days later, 26 March, and ran through 21 April.

7. William Dean Howells's frequently quoted phrase, describing the work of American writers, was first published in *Criticism and Fiction* (New York: Harper and Brothers, 1891), p. 128.

8. The term *Middle West Side* referred to a tenement district bounded by Thirty-fourth and Fifty-fourth streets, and by the Hudson River and Ninth Avenue. Pauline Goldmark described the area in her introduction to a two-volume survey conducted by the Bureau of Social Research, at the New York School of Philanthropy, with funding from the Russell Sage Foundation: "These 80 blocks . . . contrast sharply with almost all other tenement neighborhoods of the city. They have as nearly homogeneous and stable a population as can be found in any part of New York. The original stock was Irish and German. In each generation the bolder spirits moved away to more prosperous parts of the city. This left behind the less ambitious and in many cases the wrecks of the population. Hence in this 'backset' from the main current of the city's life may be seen some of the most acute social problems of modern urban life—not the readjustment and amalgamation of sturdy immigrant groups, but the discouragement and deterioration of the indigenous American community." See Goldman's "Preface to West Side Studies," *West Side Studies* (New York: Survey Associates, 1914). See also Elsa G. Herzfeld, *Family Monographs: The History of Twenty-four Families Living in the Middle West of New York City* (New York: Kempster Printing Co., 1905).

9. Izola Forrester, "New York's Art Anarchists: Here Is the Revolutionary Creed of Robert Henri and His Followers," *New York World*, 10 June 1906, magazine section, p. 6. Forrester highlighted the subjects students chose to depict but gave Henri ample opportunity to stress the novelty of their technique and its origins in his unacademic approach to teaching. Henri was quoted as follows: "It is the hardest thing in the world to take an art student and make him understand that you do not want academic knowledge. You want him to know life, every-day life, he sees right around him. Students think that they must copy to learn. I teach them to copy human nature, not the old masters or the latest successful magazine cover design. I want my class to be artists, not mechanics. It is not enough to be able to draw correctly, to know the rules of composition and color. One may have all of that, years perhaps, of training and study in the schools of Europe, and yet not be able to produce a single picture of real life, intimate, truthful, carrying its own message with it, distinct from the mere technical skill of the painter."

10. "Art and Artists: Pictures at the Gallery of the New York School of Art," *New York Globe and Commercial Advertiser*, 24 April 1907, p. 8.

11. Read, *Robert Henri and Five of his Pupils*.

12. James G. Huneker, "Robert Henri and Others," *New York Sun*, 21 January 1907, p. 6.

13. James G. Huneker, "George Luks," *New York Sun*, 21 March 1907, p. 8.

14. James G. Huneker, "Eight Painters: First Article," *New York Sun*, 9 February 1908, p. 8.

15. On Spargo's efforts to develop a Marxism that could be viable in America, see Gerald Friedberg, "Marxism in the United States: John Spargo and the Socialist Party of America" (Ph.D. diss.: Harvard University Press, 1964).

16. The magazine was *L'Assiette au beurre* which was famous for social satire by such artists as T.-A. Steinlen and J.-L. Forain. The entire issue for 9 January 1904 was devoted to Eugene Higgins. Higgins was never closely associated with the Henri group. Many in that circle probably would have agreed with Sloan's opinion of his work as "absolutely vacant: a bowed figure, a piece of archway, a chunk of shadow, a dingy, colored, brownish gravy art—rot." Sloan resented Mary Fanton Roberts for making "the mistake of thinking that E. Higgins is of our kind" (St. John, *Sloan's New York Scene*, p. 187). Milton Brown describes Higgins as an "independent realist," in *American Painting from the Armory Show to the Depression* (Princeton, N.J.: Princeton University Press, 1955; paperback ed., 1970), p. 28.

17. John Spargo, "Eugene Higgins: An American Artist Whose Work upon Canvas Depicts the Derelicts of Civilization As Do the Tales of Maxim Gorky in Literature," *Craftsman* 12 (May 1907), pp. 135, 136.

18. John Spargo, "George Luks: An American Painter of Great Originality and Force, Whose Art Relates to All the Experiences and Interests of Life," *Craftsman* 12 (September 1907), pp. 599, 607, 601. Spargo was a relatively regular contributor to *Craftsman*, writing on such topics as "the menace of riches" (September 1906), the cities' milk supply (June 1907), and the art of another of Henri's associates, Van Dearing Perrine (August 1907).

19. Gustav Stickley, editor's statement, *Craftsman* 1 (October 1901), title page; quoted in Barry Sanders, introduction to *The Craftsman: An Anthology* (Santa Barbara, Calif.: Petegrine Smith, 1978), p. vii.

20. A. M. Simons, "The Economic Foundation of Art," *Craftsman* 1 (October 1901), reprinted in *The Craftsman: An Anthology*, pp. 18–19, 23–24. On Gustav Stickley and the *Craftsman*, see also Eileen Boris, *Art and Labor: Ruskin, Morris, and the Craftsman Ideal in America* (Philadelphia: Temple University Press, 1986); Mary Ann Smith, *Gustav Stickley: The Craftsman* (Syracuse, N.Y.: Syracuse University Press, 1983).

21. Giles Edgerton [Mary Fanton Roberts], "The Younger American Painters: Are They Creating a National Art?" *Craftsman* 13 (February 1908), pp. 512–32.

22. Henri is usually described as a philosophical anarchist. See William Innes Homer's brief discussion of Henri's interest in anarchism and socialism, in *Robert Henri and His Circle*, pp. 179–82. His decision to teach at the Ferrer School, on the invitation of Emma Goldman, did constitute a public expression of his sympathy with anarchist ideas. He also painted Goldman's portrait in 1915 and wrote a tribute to her, "An Appreciation by an Artist," for *Mother Earth* 10 (March 1915), p. 415. In that tribute, he cited Whitman along with Ibsen, Tolstoy, and Kropotkin as founders of a tradition of strong thinking. He also expressed reluctance to adhere "to any *ism*" but suggested instead that Goldman inspired each individual "to become a free and constructive thinker."

23. St. John, *Sloan's New York Scene*, 1 June 1909, p. 316.

24. Ibid., 12 October 1907, p. 160.

25. Charles Wisner Barrell, "The Real Drama of the Slums, As Told in John Sloan's Etchings," *Craftsman* 15 (February 1909), pp. 559, 563.

26. For an analysis of the relationship between Sloan's politics and his art, his efforts "to reconcile the demands of the working class and socialism, on the one hand, with the demands of tradition, the academy, and a thoroughly bourgeois (at times even bohemian) art establishment, on the other," see Patricia Hills, "John Sloan's Images of Working-Class Women: A Case Study of the Roles and Interrelationships of Politics, Personality, and Patrons in the Development of Sloan's Art, 1905–16," *Prospects* 5 (1980), pp. 157–96.

27. Spargo, "George Luks," p. 607.

28. "Much Individuality Seen This Year in the Central Gallery at the Watercolor Exhibition," *New York Times*, 9 May 1909, sec. 10, p. 6.

29. Charles Caffin, *The Story of American Painting* (New York: Frederick A. Stokes, 1907), p. 373.

30. See, for example, Frank Jewett Mather, "The Independent Artists," *Nation* 90 (7 April 1910), p. 61; review reprinted from the *New York Evening Post*, 2 April 1910.

31. Edward Crapsey, *The Nether Side of New York; or, the Vice, Crime and Poverty of the Great Metropolis* (New York: Sheldon and Co., 1872).

32. James D. McCabe, *Lights and Shadows of New York Life* (Philadelphia: National Publishing Co., 1872), p. 590, quoted in Laura Hapke, "Down There on a Visit: Late-Nineteenth Century Guidebooks to the City," *Journal of Popular Culture* 20 (Fall 1986), p. 42. See also Stuart M. Blumin, "Explaining the New Metropolis: Perception, Depiction, and Analysis in Mid-Nineteenth-Century New York City," *Journal of Urban History* 11 (November 1984), pp. 9–38. McCabe and other writers directed their lurid accounts of the freakish aspects of the slums to curious middle-class and upper middle-class readers, who presumably disapproved not only of the degradation exhibited by society beneath their station but also of the ostentation displayed by social elites. This implied readership, however, went largely unacknowledged in the texts of this sensationalist literary genre. McCabe, in fact, stressed the strange absence in New York City of any groups between the poor and the rich. See also Blumin, "The Hypothesis of Middle-Class Formation in Nineteenth-Century America: A Critique and Some Proposals," *American Historical Review* 90 (April 1985), pp. 299–38, esp. pp. 309–10. Immigrants also moved into the ranks of the middle class. See David C. Hammack, *Power and Society: Greater New York at the Turn of the Century* (New York: Columbia University Press, 1987), pp. 64–80; Thomas Kessner, *The Golden Door: Italian and Jewish Immigrant Mobility in New York City, 1880–1915* (New York: Oxford University Press, 1977).

33. Matthew Hale Smith, *Sunshine and Shadow in New York* (Hartford, Conn.: J. B. Burr, 1869), pp. 365–66.

34. See Robert H. Bremner, *From the Depths: The Discovery of Poverty in the United States* (New York: New York University Press, 1956), pp. 68–85; Paul Boyer, *Urban Masses and Moral Order in America, 1820–1920* (Cambridge, Mass.: Harvard University Press, 1978), pp. 97,

127, 181; Ferenc M. Szasz and Ralph F. Bogardus, "The Camera and the American Social Conscience: The Documentary Photography of Jacob A. Riis," *New York History* 55 (October 1974), pp. 409–36. The following discussion also draws on Hales, *Silver Cities*, chap. 4; Maren Stange, *Symbols of Ideal Life: Social Documentary Photography in America, 1890–1950* (Cambridge: Cambridge University Press, 1989), chap. 1.

35. Smith, *Sunshine and Shadow*, p. 204.

36. *The Social Evil, with Special Reference to Conditions Existing in the City of New York. A Report Prepared under the Direction of the Committee of Fifteen*, ed. Edwin R. A. Seligman, 2d ed. (New York: Putnam's, 1912), pp. 148–49; quoted in Boyer, *Urban Masses and Moral Order*, p. 235. The following discussion also draws on Don S. Kirschner, "The Ambiguous Legacy: Social Justice and Social Control in the Progressive Era," *Historical Reflections* 2 (Summer 1975), pp 69–88; Timothy J. Gilfoyle, "The Moral Origins of Political Surveillance: The Preventive Society in New York City, 1867–1918," *American Quarterly* 38 (Fall 1986), pp. 637–52.

37. Frederick A. King, "Influences in Street Life," *Yearbook of the University Settlement Society of New York, 1900* (New York: Winthrop Press, 1900), p. 29.

38. Charles Loring Brace, *The Dangerous Classes of New York and Twenty Years' Work among Them* (New York: Wynkoop and Hallenbeck, 1872), p. 317; quoted in Boyer, *Urban Masses and Moral Order*, pp. 96–97.

39. King, "Influences in Street Life," p. 32.

40. In comparison with the older literary periodicals, the new magazines had much larger circulations, from four hundred thousand to one million. See Richard Hofstadter, *The Age of Reform* (New York: Knopf, 1955), pp. 192–212; Michael Schudson, *Discovering the News: A Social History of Newspapers* (New York: Basic Books, 1978), pp. 71–87.

41. *Philadelphia North American*, 14 August 1905; quoted in Schudson, *Discovering the News*, p. 87. On the "moralistic, evangelical, millennial" stance of McClure and his writers, see Justin Kaplan, *Lincoln Steffens: A Biography* (New York: Simon and Schuster, 1974), pp. 112–22.

42. See Hales, *Silver Cities*, pp. 192–213, 254–60; Trachtenberg, *The Incorporation of America*, p. 127. On the authorship of "Riis" photographs, see Stange, *Symbols of Ideal Life*, pp. 8–10; Sarah Greenough, "The Curious Contagion of the Camera, 1880–1918," in *On the Art of Fixing a*

Shadow: One Hundred and Fifty Years of Photography, exh. cat. (Washington, D.C.: National Gallery of Art, 1988), pp. 138–39.

43. Burton J. Hendrick, "The Great Jewish Invasion," *McClure's* 28 (January 1907), pp. 307–21; "The Menacing Mass," *Independent* 64 (11 June 1908), pp. 1355–56; A. B. Lewiston, "The Alien Peril," *Metropolitan* 32 (June 1910), pp. 279–92.

44. Mariana G. Van Rensselaer, "People in New York," *Century* 27 (February 1895), p. 546.

45. Helen Campbell, Thomas W. Knox, and Thomas Byrnes, *Darkness and Daylight; or, Lights and Shadows of New York Life* (Hartford, Conn.: Hartford Publishing Co., 1899). On the contributions of the three authors in relation to the urban horror-book formula and on the photograph-based illustrations in *Darkness and Daylight*, see Hales, *Silver Cities*, pp. 233–37.

46. Hales points out that all three authors for *Darkness and Daylight* knew Riis and that Lyman Abbott, who wrote the introduction, called the book Riis's "noble" successor. See Hales, *Silver Cities*, p. 234.

47. Thomas Knox, chap. 25 of Campbell, Knox, and Byrnes, *Darkness and Daylight*, p. 480.

48. See Boyer, *Urban Masses and Moral Order*, pp. 242–51; David Nasaw, *Children of the City: At Work and at Play* (Garden City, N.Y.: Doubleday Anchor Books, 1985); Dominick Cavallo, *Muscles and Morals: Organized Playgrounds and Urban Reform, 1880–1920* (Philadelphia: University of Pennsylvania Press, 1981); Cary Goodman, *Choosing Sides: Playground and Street Life on the Lower East Side* (New York: Shocken Books, 1979).

49. "Annual Report 1899," University Settlement, New York, p. 23; quoted in Goodman, *Choosing Sides*, p. 7.

50. Ruth A. True, *Boyhood and Lawlessness*, vol. 1 of *West Side Studies* (New York: Survey Associates, 1914), p. 23.

51. Frank Marshall White, "The 'Child Problem' of New York," *Harper's Weekly* 52 (8 August 1908), p. 27.

52. John Chase, "Street Games of New York City," *Pedagogical Seminary* 12 (1905), p. 504; cited in Goodman, *Choosing Sides*, p. 16.

53. Lilian Brandt, "In Behalf of the Overcrowded," *Charities* 12 (4 June 1904), pp. 584–85.

54. E. Idell Zeisloft, ed., *The New Metropolis: Memorable Events of Three Centuries from the Island of Mana-hat-ta to Greater New York at the Close of the Nineteenth Century* (New York: Appleton, 1899), p. 565.

55. Ibid., p. 566. Zeisloft went on to report that "the women engaged in this work—chaperons, they call themselves—have no easy task in bringing the little girls to the [settlement] house. . . . Parents must be seen, who can not understand where there is any hardship in the Little Mother's life." Elizabeth Stern recalled, in an autobiographical account of her childhood in a working-class family in New York, that she and her friends cared for infant siblings as a matter of course and did not consider it a chore. See "A New York Childhood," *American Mercury* 14 (1928), p. 57; cited in David Nasaw, *Children of the City*, p. 106.

56. Samuel Hopkins Adams, "A Matter of Principle," *McClure's* 26 (March 1906), p. 485.

57. The fact that nether New York could inspire curiosity as well as fear, of course, had been key to the success of exposé literature for decades. The *McClure's* story—predicated on Heiny's easy access to the forbidden world of tawdry barrooms and suggestively friendly women—simply borrowed from the familiar titillation-repulsion formula, modified for popular consumption.

58. Linda Ayres has pointed out that although Bellows dated *Kids* April 1906 in his record book, the painting was exhibited at the Society of American Artists the previous month. See her entry on the painting in *American Paintings, Watercolors, and Drawings from the Collection of Rita and Daniel Fraad*, p. 91. Therefore, Bellows must have completed *Kids* in early March, shortly before the opening of the exhibition.

59. Rebecca Zurier, in a provocative article on Bellows's painting *Forty-two Kids*, has pointed up the prevalence of the Yellow Kid character in popular culture. The Yellow Kid appeared in the *Hogan's Alley* comics, published in the Sunday supplement to the *New York World*, beginning in 1895, and later in the *New York Journal*. Although the cartoons were discontinued in both papers in 1898, a variety of Yellow Kid products—toys, chewing gum, cigars—"kept the character alive into Bellows' day." See "Hey Kids: Children in the Comics and the Art of George Bellows," *Print Collector's Newsletter* 18 (January–February 1988), pp.

196–203. Also see Zurier's "Picturing the City: New York in the Press and the Art of the Ashcan School, 1890–1917" (Ph.D. diss., Yale University, 1988), chap. 4.

60. The two photographs appeared as a single-page feature, "New York City's Rivers As First Aid in Keeping Cool." Each photograph carried a caption: (top) "A Public Swimming Station on the North River, where numerous Bathers Amuse Themselves from Dawn till Dusk throughout the Summer Months"; (bottom) "A Bathing-place on the East River opposite Blackwells Island which is largely patronized by Dwellers on the crowded Upper East Side."

61. Campbell, *Darkness and Daylight*, p. 153.

62. Frank Fowler, "Impressions of the Spring Academy," *Nation* 84 (28 March 1907), p. 298.

63. The jury for the Pennsylvania Academy's Annual Exhibition voted 8 to 2 in favor of awarding the Lippincott Prize to Bellows for *Forty-two Kids*. That decision was changed to avoid the possibility of offending the donor. Robert Henri indicated in his diary account (23 January 1908) that the title as well as the subject aroused concern (Henri Papers, Archives of American Art, Smithsonian Institution; cited in Zurier, "Hey Kids," p. 199). Bellows mentioned the incident in a letter to the director of the Museum of Art, Carnegie Institute, at the time that *Forty-two Kids* was purchased by Robert C. Hall out of the Thirteenth Annual International in May 1909. He wanted Dr. Hall to be informed of the Pennsylvania Academy jury's vote, and of the reversal. See Bellows to John W. Beatty, 24(?) May 1909, Carnegie Institute Records, Archives of American Art, Smithsonian Institution.

64. Bellows clipped the cartoon and included it in his scrapbook, which is now among the Bellows Papers. The location and date of its original publication is unknown. The cartoon, like the painting, lends itself to various interpretations. Certainly, the cartoonist intended to lampoon the common or crude nature of the subject of *Forty-two Kids* as well as the contorted, elongated, and quite unidealized bodies of the boys. At the same time, the artist was probably also making fun of the hostile, reactionary response to the painting. In addition, the chubby little policeman frantically waving his nightstick at a group of boys engaged in a fairly innocent activity might be a humorous jibe at law enforcement. Thousands of children were arrested in New York for violating "street laws." The 1909 annual report of the New York City Children's Court reported that nearly half of the 11,494 children brought be-

fore the court had committed offenses no more serious than playing ball on the street, building bonfires, or playing shinny. See Goodman, *Choosing Sides*, p. 15.

65. See "George Bellows, An Artist with 'Red Blood,'" *Current Literature* 53 (September 1912), p. 345; Joseph Edgar Chamberlin, "An Excellent Academy Show," *New York Evening Mail*, 14 March 1908, p. 8.

66. "The New Leaders in American Illustration: The Humorous Men: Newell, Kemble, Sullivant, Zimmerman and Hamilton," *Bookman* 11 (June 1900), pp. 336–37.

67. See "A Note on the Text," in the facsimile edition of Mark Twain, *The Adventures of Huckleberry Finn* (New York: Chandler, 1962), p. xviii.

68. See, for example, J. Stanley Lemons, "Black Stereotypes as Reflected in Popular Culture, 1880–1920," *American Quarterly* 29 (Spring 1977), pp. 102–16. For a discussion of the "coon song" craze (which coincided with the popularity of Kemble's "coons") as a "sociopsychological mechanism for justifying segregation and subordination," see James H. Dormon, "Shaping the Popular Image of Post-Reconstruction American Blacks: The 'Coon Song' Phenomenon of the Gilded Age," *American Quarterly* 40 (December 1988), pp. 450–71.

69. Robert G. McIntyre, "George Bellows—an Appreciation," *Art and Progress* 3 (August 1912), p. 679.

70. Jackson Lears discusses the exaltation of "authentic" experience during the period from 1880 to 1920 as a means of accommodating to a new, secular social order, in *No Place of Grace*.

71. Hutchins Hapgood, *Types from City Streets* (New York: Funk and Wagnalls, 1910), pp. 9, 23, 24.

72. "The Fabulous East Side," *New York Sun*, 8 May 1910, p. 16.

73. Christopher Lasch sees points of connection between what he calls the religion of experience and involvement with urban reform. See his *New Radicalism in America, 1889–1963: The Intellectual as a Social Type* (New York: Knopf, 1965).

74. "Independents' Victory," *Brooklyn Standard-Union*, 14 July 1910.

75. Izola Forrester, "New York's Art Anarchists," p. 6.

76. "Miss Rice to Show Her Art," *New York American*, 22 March 1910, p. 8. At the time of this article, occasioned by an exhibition of her paintings in her parents' apartments in the Ansonia Hotel in New York, Rice said she had never studied art. Bennard Perlman, however, reports that Rice was a Henri pupil. See *Painters of the Ashcan School*, p. 192.

77. Quoted in Louis Baury, "The Message of the Proletaire," *Bookman* 34 (December 1911), p. 400.

78. Frank Jewett Mather, "The Independent Artists," *New York Evening Post*, 2 April 1910; review reprinted in *Nation* 90 (7 April 1910), pp. 360–61.

79. Noted in Morgan, *George Bellows*, p. 67.

80. Edward Keefe reported that Ibsen was the only one of these writers that held any attraction for Bellows, but that he continued to read secondhand volumes of nineteenth-century fiction during this period. See Frank A. Seiberling's interview with Keefe, summarized in "George Bellows," p. 208.

81. Noted in Grant, "Stag at Sharkey's."

82. Pach, *Queer Thing, Painting*, p. 48. See also chapter 2 above, the section entitled "Bellows and Victorian America."

83. Margaret Byington, "Fifty Annual Reports," *Survey* 23 (26 March 1910), pp. 970–77. This review of annual reports from settlement houses and reform organizations is cited in Hales, *Silver Cities*, pp. 253–54.

84. Bellows was asked by a reporter for the *New York Herald* whether, in his opinion, museum administrators had feared that Mr. Lippincott, sponsor of the prize, might object to the naked children. "'No,' said the artist, 'it was the naked painting that they feared'" ("Those Who Paint What They See," *New York Herald*, 23 February 1908, literary and art section, p. 4).

85. Arthur Hoeber, "Art and Artists: Academy of Design—Second Notice," *Globe and Commercial Advertiser*, 21 March 1908, p. 6; James G. Huneker, "The Spring Academy: Second Notice," *New York Sun*, 21 March 1908, p. 6.

86. Rice's entries in the Independent Artists' Exhibition included three paintings, *The Bread Line, An Anarchist*, and *Nuns;* four drawings, *The German Comedian, A Politician, My Neighbor*, and *A Sport;* and three pieces of sculpture, *Longings, Mother and Child*, and *Labor. Bread Line* was reproduced in the *New York World*, 5 June 1910, magazine section, p. 6.

87. James G. Huneker, "Around the Galleries," *New York Sun*, 7 April 1910, p. 6.

88. Joseph Edgar Chamberlin, "With the Independent Artists," *New York Evening Mail*, 4 April 1910, p. 6.

89. St. John, *Sloan's New York Scene*, 21 April 1907, p. 123.

90. Huneker called *Pennsylvania Excavation* "a slice of New York keenly observed, keenly transcribed." The entire description—from "Around the Galleries," *New York Sun*, 25 April 1907, p. 8—is quoted in chapter 1 above.

91. St. John, *Sloan's New York Scene*, 16 December 1907, p. 172.

92. Ibid., 7 March 1908, p. 203; 13 March 1908, pp. 204–5.

93. James G. Huneker, "The Spring Academy: Second Notice," *New York Sun*, 21 March 1908, p. 6.

94. St. John, *Sloan's New York Scene*, 27 March 1908, p. 209.

95. See Hills, "John Sloan's Images of Working-Class Women," pp. 161–62.

96. Barrell, "The Real Drama of the Slums," p. 559.

97. St. John, *Sloan's New York Scene*, 6 July 1911, p. 549; cited in Hills, "John Sloan's Images of Working-Class Women," p. 178. For a psychoanalytic interpretation of Sloan's people watching in relation to his art, see John Baker, "Voyeurism in the Art of John Sloan: The Psychodynamics of a 'Naturalistic' Motif," *Art Quarterly*, n. s., 1 (Autumn 1978), pp. 379–95.

98. St. John, *Sloan's New York Scene*, 29 May 1909, p. 315.

99. Barrell, "The Real Drama of the Slums," p. 563.

100. Ibid. The scene that inspired *The Picnic Grounds* was not observed in New York City, as Barrell suggested, but in the woods near Bayonne, New Jersey. Sloan recorded his visit to the place and his start on the painting in his diary, 30 May and 2 June 1906 (St. John, *Sloan's New York Scene*, pp. 38, 39).

101. See Suzanne L. Kinser, "Prostitutes in the Art of John Sloan," *Prospects* 9 (1984), pp. 231–54.

102. In the case of the 1910 Spring Annual, Sloan noted his submissions (24 February 1910) and rejections (9 March 1910), thereby identifying his entries for the record as *Pigeons* and *Three A.M.* Bellows's record book indicates that the artist reworked *Beach at Coney Island* in December 1910, several months after he exhibited the painting at the National Academy's spring exhibition. Close visual examination reveals minor changes to some of the figures in the composition, but the extent of these changes cannot be determined conclusively without further technical investigations.

103. Frank Jewett Mather, "National Academy Pictures," *New York Evening Post*, 17 March 1910, p. 9.

104. James G. Huneker, "Around the Galleries," *New York Sun*, 30 January 1911, p. 6. Huneker expressed similar sentiments when he described Ernest Lawson's *Umbrellas, Coney Island:* "The transcription of an essentially ugly theme, a patch of beach at Coney Island on a glaring summer's day, a common episode at best" ("The Winter Academy," *New York Sun*, 14 December 1909, p. 8).

105. Coney Island was a popular amusement resort by the 1880s. Exclusive hotels were constructed at the east end of the island, but the west end continued to be known as a refuge for criminals and underworld types. Norton's Pier hosted prizefights and horse races, which attracted a male subculture not unlike the clientele of Sharkey's Athletic Club. The opening of three amusement parks—Steeplechase Park (1897), Luna Park (1903), and Dreamland (1903)—began to attract more middle-class excursioners. On these parks and the emergence of a new mass culture, see John F. Kasson, *Amusing the Million: Coney Island at the Turn of the Century* (New York: Hill and Wang, 1978). See also Michele H. Bogart, "Barking Architecture: The Sculpture of Coney Island," *Smithsonian Studies in American Art* 2 (Winter 1988), pp. 2–17; Robert A. M. Stern, Gregory Gilmartin, and John Montague Massengale, *New York 1900: Metropolitan Architecture and Urbanism, 1890–1915* (New York: Rizzoli, 1983); Robert E. Snow and David E. Wright, "Coney Island: A Case Study in Popular Culture and Technical Change," *Journal of Popular Culture* 9 (Spring 1976), pp. 960–75.

106. [Alfred Trumble,] *Coney Island Frolics: How New York's Gay Girls and Jolly Boys Enjoy Themselves by the Sea!* (New York: Richard K. Fox, 1883), p. 9.

107. Belle Lindner Israels, "The Way of the Girl," *Survey* 22 (3 July 1909), p. 486.

108. King, "Influences in Street Life," p. 30; cited in Kathy Peiss, "'Charity Girls' and City Pleasures: Historical Notes on Working-Class Sexuality, 1880–1920," in *Powers of Desire: The Politics of Sexuality*, ed. Ann Snitow, Christine Stansell, and Sharon Thompson (New York: Monthly Review Press, 1983), p. 75. The following discussion also draws on Peiss's informative study *Cheap Amusements:*

Working Women and Leisure in Turn-of-the-Century New York (Philadelphia: Temple University Press, 1986).

109. Ruth S. True, *The Neglected Girl*, vol. 1, pt. 2, of *West Side Studies* (New York: Survey Associates, 1914), pp. 57–58.

110. For the sake of argument, in this discussion I have emphasized Sloan's "objectivity"—his straightforward, uncondescending approach to the working class—at the expense of other significant aspects of his work. It goes without saying, for example, that his vision was laced with romanticism.

111. Neil Harris discusses the new consciousness of class and ethnic differences in his introduction to *The Land of Contrasts, 1880–1901* (New York: Braziller, 1970).

112. James G. Huneker, *New Cosmopolis: A Book of Images* (New York: Scribner's, 1915), pp. 153, 157.

113. Agnes M., "The True Life Story of a Nurse Girl," in *Workers Speak: Self Portraits*, ed. Leon Stein and Philip Taft (New York: Arno, 1971), pp. 104–5; cited in Peiss, *Cheap Amusements*, pp. 115–16.

114. Lindsay Denison, "The Biggest Playground in the World," *Munsey's* 33 (August 1905), p. 562; "To Remake Coney Island into a Model Resort," *New York Sun*, 29 October 1912, sec. 4, p. 4.

115. Edwin E. Slosson, "The Amusement Business," *Independent* 57 (21 July 1904), p. 134; Huneker, *New Cosmopolis*, p. 153.

116. King, "Influences of Street Life," p. 30.

117. Quoted in Brooks, *John Sloan*, p. 95.

118. Bellows to Miss Beaux, 9 January 1909, Cecilia Beaux Papers, Archives of American Art, Smithsonian Institution, Washington, D.C. I am grateful to Tara Tappert for bringing this letter to my attention.

119. Quotations and reminiscences from "George Bellows as Seen by Ethel A. Clarke," an account written for Bellows's daughters in March 1961, Morgan on Bellows Papers, box 4, folder 4.

120. St. John, *Sloan's New York Scene*, 7 February 1911, p. 506. Sloan's account indicates that he favored the boycott idea and was puzzled at first by Henri's objections. He listed in his diary the names of artists they had hoped would participate: "Kent, Sloan, Henri, Davies, Luks, Boss, McPherson, DuBois, Coleman, Prendergast, Shinn, Golz, Myers, Stafford, Mrs. Preston, J. Preston, *Redfield!!* [Sloan's enemy on the Pennsylvania Academy's jury], Glackens, and Lawson (5 February 1911, p. 505). Also see Henri's diary account of his 5 February 1911 conversation with Kent and his reasons for opposing Kent's scheme: "I said I would have nothing to do with any movement that limited independence. . . . Ten men might well get together and decide not to send to the academy but the idea of coercion which he voiced would never meet with my approval" (Henri Papers, Archives of American Art).

121. Rockwell Kent, *It's Me, O Lord* p. 228.

122. Henri heard Goldman lecture for the first time on 29 January 1911. He was very impressed and read her *Anarchism and Other Essays* the next day. See Homer, *Robert Henri and His Circle*, p. 180. He took the Sloans to hear her speak on 22 October 1911. See St. John, *Sloan's New York Scene*, p. 570. There is no indication of the first time Bellows accompanied him to a Goldman lecture.

123. See Brooks, *John Sloan*, pp. 194–95.

124. The Ferrer School was dedicated to the Spanish educator and anticlerical freethinker Francisco Ferrer y Guardia, who was executed on 13 October 1909. Ferrer had promoted an education based on the scientific development of reason rather than piety and obedience. His debt to Bakunin and his emphasis on practical experience and the development of personal dignity would have held a strong appeal for Henri. On the impact of these ideas in America, see Paul Avrich, *The Modern School: Anarchism and Education in the United States* (Princeton, N.J.: Princeton University Press, 1980), especially the section on Henri, pp. 145–53.

125. "Sees Artists' Hope in Anarchic Ideas," *New York Times*, 18 March 1912, p. 8. For Henri's interest in philosophical anarchism, see note 22.

126. "Editorial Notice," *Masses* 4 (December 1912), p. 3. For an informed history of the magazine and the interaction between art and politics that it represented during the years before World War I, see Rebecca Zurier, *Art for "The Masses": A Radical Magazine and Its Graphics* (Philadelphia: Temple University Press, 1988). See also Leslie Fishbein, *Rebels in Bohemia: The Radicals of the Masses, 1911–1917* (Chapel Hill: University of North Carolina Press, 1982); Richard A. Fitzgerald, *Art and Politics: Cartoonists of the Masses and Liberator* (Westport, Conn.: Greenwood Press, 1973); William L. O'Neill, introduction to *Echoes of Revolt: The Masses, 1911–1917* (Chicago: Quadrangle, 1966).

127. Bellows produced his first work for *The Masses* in April. His name began to appear on the list of contributing art editors in June.

128. Typescript of letter to *The Masses*, ca. 1917, Bellows Papers, box 4, folder 4.

129. For accounts of the dispute, see Eastman, *Enjoyment of Living*, pp. 549–56; Hills, "Sloan's Images of Working-Class Women," pp. 169–71; Zurier, *Art for "The Masses*," pp. 52–57.

130. Bellows to Max Eastman, March 1917; quoted in Max Eastman, *The Enjoyment of Living* (New York: Harper and Brothers, 1948), pp. 557–58.

131. "Honor George Bellows, Artist Who Blasts Traditions," *New York Herald*, 29 September 1912, magazine section, p. 9. Forbes Watson, who knew Bellows personally, supported the contention that politics was never a primary concern. In notes for a 1945 lecture, Watson wrote, "If we talked of Emma Goldman, Alexander Berkman or Isadora Duncan or the Ferrer School, the distraction from painting was comparatively short-lived. Emma Goldman was a great friend of Henri's and Bellows's and talk of her made us feel pleasantly liberal if not radically advanced" ("George Bellows—the Boy Wonder of American Painting," Forbes Watson Papers, Archives of American Art, Smithsonian Institution, Washington, D.C.).

132. From an editorial statement that appeared in each issue of the magazine, beginning February 1913.

133. The controversy is discussed in Morgan, *George Bellows*, pp. 165–66.

134. The media are discussed in Zurier, *Art for "The Masses*," pp. 130, 134; Myers, *George Bellows: The Artist and His Lithographs*, pp. 20–27. Bellows's illustration work is also discussed in Charlene Stant Engel, "George W. Bellows' Illustrations for 'The *Masses*' and Other Magazines and the Sources of His Lithographs of 1916–17" (Ph.D. diss., University of Wisconsin, Madison, 1976).

135. As Zurier admits in *Art for "The Masses*," the absence of surviving subscription lists makes it impossible to know who read the magazine. There is little evidence, however, that it was widely circulated within the working class. Certainly, radical attitudes toward the established church and the traditional family expressed in *The Masses* would have narrowed its range of appeal. Elsewhere, Martin Green makes a related observation about points of commonality shared by two events of 1913, the Armory Show and the Paterson strike pageant: "The spirit of 1913 was an aspiration to transcend what most people accepted as ordinary and so inevitable. It was the ordinariness of capitalism and liberalism and class hierarchy, in the case of the IWW strike; and in the case of the Armory Show, it was old forms of art, appreciation, and beauty" (*New York 1913, p. 7). The Masses* might have combined aspects of both events and thus also shared "the same significance, of being 'radical,'" as well as the same "primary audience," which Green associates with Greenwich Village (p. 11).

136. See Rosenzweig, *Eight Hours for What We Will*, p. 63; Peiss, *Cheap Amusements*, p. 28.

137. Arnold Bennett, *Your United States: Impressions of a First Visit* (New York and London: Harper and Brothers, 1912), p. 187.

138. Brandt, "In Behalf of the Overcrowded," p. 585.

139. Guy Pène du Bois, "Fifteen Young Americans at the Montross Gallery," *Art and Decoration* 4 (December 1913), p. 71.

140. Charles L. Buchanan, "George Bellows: Painter of Democracy," *Arts and Decoration* 4 (August 1914), p. 373.

141. Rollo Walter Brown, "George Bellows—American," *Scribner's* 83 (May 1928), p. 586.

142. John Canaday, "George Bellows and the End of a World Picasso Never Knew," *New York Times*, 13 March 1966, sec. 10, p. 27.

143. Watson, "George Bellows—Boy Wonder," p. 1.

144. James G. Huneker, "Around the Galleries," *New York Sun*, 12 March 1908, p. 6.

145. Florence Barlow Ruthraff, "His Art Shows 'The Big Intention,'" *New York Telegraph*, 2 April 1911, magazine section, p. 2.

Select Bibliography

Archives

Archives of American Art. Smithsonian Institution, Washington, D.C.

George Bellows Papers. Special Collections Department, Amherst College Library, Amherst, Massachusetts.

Morgan on Bellows Papers. Amherst College Archives, Amherst, Massachusetts.

University Archives. Ohio State University, Columbus, Ohio.

Newspapers

New York American, 1907–1913
New York Call, 1908–1913
New York Daily Tribune, 1904–1913
New York Evening Mail, 1908–1913
New York Evening Post, 1904–1913
New York Globe and Commercial Advertiser, 1904–1913
New York Herald, 1904–1913
New York Sun, 1906–1913
New York Times, 1902–1913
New York World, 1904–1913

Journals

Exhibition reviews (1904–1914) in *American Art News, Arts and Decoration, Craftsman, International Studio, Literary Digest, Nation*

Contemporary Sources

Addams, Jane. "Some Reflections on the Failure of the Modern City to Provide Recreation for Young Girls." *Charities and the Commons* 21 (5 December 1908), pp. 365–68.

———. *The Spirit of Youth and the City Streets.* New York: Macmillan, 1909. Reprint. Urbana: University of Illinois Press, 1972.

"The Americanism of George Bellows." *Literary Digest* 84 (31 January 1925), pp. 26–27.

Barrell, Charles Wisner. "The Real Drama of the Slums, As Told in John Sloan's Etchings." *Craftsman* 15 (February 1909), pp. 559–64.

———. "Robert Henri—'Revolutionary.'" *Independent* 64 (25 June 1908), pp. 1427–32.

Baury, Louis. "The Message of Bohemia." *Bookman* 34 (November 1911), pp. 256–66.

———. "The Message of the Proletaire." *Bookman* 34 (December 1911), pp. 399–413.

Baxter, Sylvester. "The New New York." *Outlook* 83 (23 June 1906), pp. 409–24.

Bellows, Emma, comp. *George W. Bellows: His Lithographs.* Introduction by Thomas Beer. New York: Knopf, 1927.

———. *The Paintings of George Bellows.* New York: Knopf, 1929.

Bellows, George. "What Dynamic Symmetry Means to Me." *American Art Student* 3 (June 1921), pp. 4–7.

Betts, Lillian W. "Open Letters: Some Tenement-House Evils." *Century* 45 (December 1892), pp. 314–16.

Beuf, Carlo. "The Art of George Bellows: The Lyric Expression of the American Soul." *Century* 112 (October 1926), pp. 724–29.

Beveridge, Albert J. *The Young Man and the World.* New York: Appleton, 1905.

Bigelow, Poultney. "Theodore Roosevelt: President and Sportsman." *Collier's Weekly* 29 (31 May 1902), p. 10.

"The Big Idea: George Bellows Talks about Patriotism for Beauty." *Touchstone* 1 (July 1917), pp. 269–75.

Blackshaw, Randall. "The New New York." *Century* 64 (August 1902), pp. 492–513.

Boyesen, Bayard. "The National Note in American Art." *Putnam's Monthly* 4 (May 1908), pp. 131–40.

Boyesen, Hjalmar H. "The Most Athletic Nation in the World." *Cosmopolitan* 37 (May 1904), pp. 83–86.

Brace, Charles Loring. *The Dangerous Classes of New York and Twenty Years' Work among Them.* New York: Wynkoop and Hallenbeck, 1872.

Brandt, Lilian. "In Behalf of the Overcrowded." *Charities* 12 (4 June 1904), pp. 583–86.

Brown, Rollo Walter. "George Bellows—American." *Scribner's* 83 (May 1928), pp. 575–87. Reprint. "An Adventurer Out of the West." In *Lonely Americans*, pp. 127–62. New York: Coward-McCann, 1929.

Buchanan, Charles L. "George Bellows: Painter of Democracy." *Arts and Decoration* 4 (August 1914), pp. 370–73.

Caffin, Charles, *The Story of American Painting.* New York: Frederick A. Stokes, 1907.

Calkins, Raymond. *Substitutes for the Saloon.* Boston: Houghton, Mifflin, 1901.

Camp, Walter. "American Sports." *Century* 79 (November 1909), pp. 60–73.

Campbell, Helen, Thomas W. Knox, and Thomas Byrnes. *Darkness and Daylight; or, Lights and Shadows of New York Life.* Hartford, Conn.: Hartford Publishing Co., 1899.

Carrington, James B. "New York at Night." *Scribner's* 27 (March 1900), pp. 326–36.

Casson, Herbert N. "New York, the City Beautiful." *Munsey's* 38 (November 1907), pp. 178–86.

Cochrane, Charles H. "The Future Terminal Facilities of New York; II. The Pennsylvania's $120,000,000 Station." *Broadway Magazine* 17 (October 1906), pp. 3–16.

Cole, Robert J. "The Young Progressive Who Became an Elder Statesman." *Outlook* 136 (2 January 1924), pp. 18–19.

Collier, Price. "Sport's Place in the Nation's Well-Being." *Outing* 32 (July 1898). pp. 382–88.

Cope, E. D. "The Effeminization of Man." *Open Court* 7 (26 October 1893), p. 3847.

Corbin, John. "The Modern Chivalry." *Atlantic Monthly* 89 (May 1902), pp. 601–11.

———. "The Twentieth Century City." *Scribner's* 33 (March 1903), pp. 259–72.

Cortissoz, Royal. "The Field of Art." *Scribner's* 78 (October 1925), pp. 440–48.

Couper, William, ed. *History of the Engineering, Construction, and Equipment of the Pennsylvania Railroad Company's New York Terminal and Approaches.* (New York: Isaac H. Blanchard, 1912.

Cournos, John. "Three Painters of the New York School." *International Studio* 56 (October 1915), pp. 242–46.

Craven, Thomas. "George Bellows." *Dial* 80 (February 1926), pp. 133–36.

Croly, Herbert. "New York as the American Metropolis." *Architectural Record* 13 (March 1903), pp. 193–206.

DeForest, Robert W., and Lawrence Veiller, eds. *The Tenement House Problem.* 2 vols. New York: Macmillan, 1903.

Denison, Lindsay. "The Biggest Playground in the World." *Munsey's* 33 (August 1905), pp. 556–66.

Deutsch, Babette. "A Superb Ironist." *New Republic* 23 (21 July 1920), pp. 220–21.

"A Discussion of Canvas: An Interview with George Bellows." *Touchstone* 4 (February 1920), p. 345.

Donovan, Mike. *The Roosevelt That I Know.* New York: B. W. Dodge, 1909.

Dreiser, Theodore. "The Cliff Dwellers—A Painting by George Bellows." *Vanity Fair* 25 (December 1925), pp. 55, 118.

Dwight, H. G. "An Impressionist's New York." *Scribner's* 38 (November 1905), pp. 555–54.

Eaton, Walter Prichard. "Manhattan: An Island Outgrown." *American Magazine* 64 (July 1907), pp. 245–56.

Edgren, Robert. "Fighters by Nature." *Outing* 43 (December 1903), pp. 343–46.

———. "Fighters in Real Life." *Outing* 51 (March 1908), pp. 745–49.

———. "The Modern Gladiator: Why the American Succeeds—Brute Strength Superseded by Scientific Cleverness." *Outing* 41 (March 1903), pp. 735–47.

Ely, Catherine Beach. "The Modern Tendency in Henri, Sloan and Bellows." *Art in America* 10 (April 1922), pp. 132–43.

"The Excavation for the Pennsylvania Railroad Station, New York." *Scientific American* 94 (2 June 1906), pp. 453–54.

Flint, Ralph. "Bellows and His Art." *International Studio* 81 (May 1925), pp. 79–88.

Frohman, Louis H. "Bellows as an Illustrator." *International Studio* 78 (February 1924), pp. 421–25.

"George Bellows, an Artist with 'Red Blood.'" *Current Literature* 53 (September 1912), pp. 342–45.

Gladden, Washington. "The Problem of Poverty." *Century* 45 (December 1892), pp. 235–56.

Godkin, E. L. "The Athletic Craze." *Nation* 19 (7 December 1893), pp. 422–23.

——. "Athletics and Health." *Nation* 59 (20 December 1894), pp. 457–58.

Grant, Percy Stickney. "Children's Street Games." *Survey* 23 (13 November 1909), pp. 232–36.

"The Greatest Railroad Station in the World." *Harper's Weekly* 52 (9 May 1908), pp. 20, 28.

Gutman, Walter. "George Bellows." *Art in America* 17 (February 1929), pp. 103–12.

Hall, G. Stanley. "Feminization in School and Home: The Undue Influence of Women Teachers—the Need of Different Training for the Sexes." *World's Work* 16 (May 1908), pp. 10237–44.

——. "Some Relations between Physical and Mental Training." *Proceedings of the American Association for the Advancement of Physical Education*, 1894, no. 2, pp. 30–37.

Hapgood, Hutchins. "Emma Goldman's Radicalism." *Bookman* 32 (February 1911), pp. 639–40.

——. *The Spirit of the Ghetto.* New York: Funk and Wagnalls, 1902. Reprint. New York: Schocken Books, 1966.

——. *Types from City Streets.* New York: Funk and Wagnalls, 1910.

Hartmann, Sadakichi. "Studio-Talk." *International Studio* 30 (December 1906), pp. 182–83.

——. [Sidney Allan, pseud.]. "A Plea for the Picturesqueness of New York." *Camera Notes* 4 (October 1900), pp. 91–97.

Hawthorne, Julian. "The Noble Art of Self-Defense." *Cosmopolitan* 4 (November 1887), pp. 173–81.

Hendrick, Burton J. "The Great Jewish Invasion." *McClure's* 28 (January 1907), pp. 307–21.

Henri, Robert. "An Appreciation by an Artist." *Mother Earth* 10 (March 1915), p. 415.

——. *The Art Spirit.* Philadelphia: Lippincott, 1923. Reprint. New York: Harper and Row, 1984.

——. "Progress in Our National Art Must Spring from the Development of Individuality of Ideas and Freedom of Expression: A Suggestion for a New Art School." *Craftsman* 15 (January 1909), pp. 386–401.

"The Henri Hurrah." *American Art News* 5 (23 March 1907), p. 4.

Herzfeld, Elsa G. *Family Monographs: The History of Twenty-four Families Living in the Middle West of New York City.* New York: James Kempster, 1905.

Howells, William Dean. *Criticism and Fiction.* New York: Harper and Brothers, 1891.

——. "The Worst of Being Poor." *Harper's Weekly* 46 (1 March 1902), p. 261.

Hughes, Rupert. *The Real New York.* New York: Smart Set, 1904.

Huneker, James G. *New Cosmopolis: A Book of Images.* New York: Scribner's, 1915.

——. "What Is the Matter with Our National Academy?" *Harper's Weekly* 56 (6 April 1912), pp. 8–9.

"In Defense of Pugilism." *American Magazine* 68 (August 1909), pp. 414–16.

Inglis, William. "Trinity and Its Critics." *Harper's Weekly* 53 (20 February 1909), p. 15.

"Insurgency in Art." *Literary Digest* 40 (23 April 1910), pp. 814–16.

Israels, Belle Lindner. "The Way of the Girl." *Survey* 22 (3 July 1909), pp. 486–97.

Jenkins, Stephen. *The Greatest Show in the World: The Story of Broadway, Old and New, from the Bowling Green to Albany.* New York: Putnam's, 1911.

Jones, Thomas Jesse. *The Sociology of a New York City Block.* New York: Columbia University Press and Macmillan, 1904.

King, Frederick A. "Influences in Street Life." In *Yearbook of the University Settlement Society of New York, 1900*, pp. 29–32. New York: Winthrop Press, 1900.

Latson, W. R. C. "The Moral Effects of Athletics." *Outing* 49 (December 1906), pp. 389–92.

Lee, Joseph. *Constructive and Preventive Philanthropy.* New York: Macmillan, 1906.

"Legislation against Prize-Fighting." *Outlook* 64 (10 March 1900), pp. 562–63.

Lewiston, A. B. "The Alien Peril." *Metropolitan Magazine* 32 (June 1910), pp. 279–92.

McBride, Henry. "Bellows and His Critics." *Arts* 8 (November 1925), pp. 291–95.

McIntyre, Robert G. "George Bellows—an Appreciation." *Art and Progress* 3 (August 1912), pp. 679–82.

Mather, Frank Jewett. "Some American Realists." *Arts and Decoration* 7 (November 1916), pp. 15–17.

Mallon, George Barry. "The Hunt for Bohemia." *Everybody's Magazine* 12 (February 1905), pp. 187–97.

The Masses. New York City, 1911–17. Reissued with introduction by Alex Baskin. Millwood, N.Y.: Kraus Reprints, 1980.

Mechlin, Leila. "The Bellows Memorial Exhibition." *American Magazine of Art* 16 (December 1925), pp. 652–57.

Memorial Exhibition of the Work of George Bellows. Introduction by Frank Crowninshield. Exhibition catalog. New York: Metropolitan Museum of Art, 1925.

"The Menacing Mass." *Independent* 64 (11 June 1908), pp. 1355–56.

Merwin, Henry Childs, "On Being Civilized Too Much." *Atlantic Monthly* 79 (June 1897), pp. 838–46.

Milliken, William M. "Stag at Sharkey's, by George W. Bellows." *Cleveland Museum of Art Bulletin* 9 (December 1922), pp. 172–75.

"The New York School of Art." *Sketch Book* 3 (April 1904), pp. 219–20.

O'Connor. T. P. "Impressions of New York." *Munsey's* 37 (June 1907), pp. 387–91.

Osborne, Duffield. "A Defense of Pugilism." *North American Review* 146 (April 1888), pp. 430–35.

Owen, Robert L. "The True Meaning of Insurgency." *Independent* 68 (39 June 1910), pp. 1420–23.

Paine, Albert Bigelow. "The New Coney Island." *Century* 68 (August 1904), pp. 528–38.

Paine, Ralph D. "Plans for the New Pennsylvania Railroad Station." *Collier's Weekly* 31 (13 June 1903), pp. 10–11.

"Pennsylvania Railroad's New Terminal Station, New York City." *Scientific American* 94 (26 May 1906), pp. 438–39.

"The Pennsylvania's New York Station." *Architectural Record* 27 (June 1910), pp. 518–21.

Phillips, Duncan. "The Allied War Salon." *American Magazine of Art* 10 (February 1919), p. 123.

Poole, Ernest. "Newsboy Wanderers Are Tramps in the Making." *Charities* 10 (14 February 1903), pp. 160–62.

———. "Waifs of the Street." *McClure's* 21 (May 1903), pp. 40–48.

"Prize-Fighting Suppressed." *Outlook* 83 (16 June 1906), pp. 349–50.

Pyke, Rafford. "What Men Like in Men." *Cosmopolitan* 53 (August 1902), pp. 402–6.

"The Relation of Painting to Architecture: An Interview with George Bellows." *American Architect* 118 (29 December 1920), pp. 847–51.

Ries, Estelle H. "The Relation of Art to Every-day Things: An Interview with George Bellows, on How Art Affects the General Wayfarer." *Arts and Decoration* 15 (July 1921), pp. 158–59, 202.

Rihani, Ameen. "Luks and Bellows: American Painting, Part III." *International Studio* 71 (August 1920), pp. xxi–xxvi.

Riis, Jacob A. *The Children of the Poor.* New York: Scribner's, 1892.

———. *How the Other Half Lives.* New York: Scribner's, 1890.

Roberts, A. R. "Bellows, Patron Saint of Art Students." *American Art Student* 3 (June 1921), pp. 14–15.

Roberts, Mary Fanton. "George Bellows—An Appreciation." *Arts and Decoration* 23 (October 1925), pp. 38–40, 79.

——— [Giles Edgerton, pseud.]. "What Does the National Academy Stand For?" *Craftsman* 15 (February 1909), pp. 520–32.

———. "The Younger American Painters: Are They Creating a National Art?" *Craftsman* 13 (February 1908), pp. 512–32.

Roosevelt, Theodore. *An Autobiography.* New York: Macmillan, 1919.

———. "Degeneration and Evolution." *North American Review* 161 (July 1895), pp. 96–109.

———. "'Professionalism' in Sports." *North American Review* 151 (August 1890), pp. 187–91.

———. "The Recent Prize Fight." *Outlook* 95 (16 July 1910), pp. 550–51.

———. *The Strenuous Life and Other Essays.* New York: Century, 1905.

———. "Value of an Athletic Training." *Harper's Weekly* 37 (23 December 1893), p. 1236.

Russell, Charles Edward. "The Tenements of Trinity Church." *Everybody's Magazine* 19 (July 1908), pp. 47–57.

Russell, Charles Edward, and Lewis W. Hine. "Unto the Least of These." *Everybody's Magazine* 21 (July 1909), pp. 75–87.

Scenes of Modern New York. Portland, Me.: L. H. Nelson, 1907.

Scott, Miriam Finn. "At the Bottom." *Everybody's Magazine* 27 (October 1912), pp. 536–45.

Select New York. Brooklyn: Albertype, n.d.

Seligman, Edwin R. A., ed. *The Social Evil, with Special Reference to Conditions Existing in the City of New York. A Report Prepared under the Direction of the Committee of Fifteen.* 2d ed. New York: Putnam's, 1912.

Simonds, Frank. "The Relation of Children to Immoral Conditions." In *Yearbook of the University Settlement Society of New York, 1900*, pp. 33–35. New York: Winthrop Press, 1900.

Sloan, John. *John Sloan's New York Scene: From the Diaries, Notes and Correspondence, 1906–1913.* Edited by Bruce St. John. New York: Harper and Row, 1965.

Souvenir Guide to Coney Island: Where to Go, What to See, and How to Find It. Brooklyn: Megaphone Press, 1905.

Spargo, John. *The Bitter Cry of the Children.* New York: Macmillan, 1907.

———. "Eugene Higgins: An American Artist Whose Work upon Canvas Depicts the Derelicts of Civilization As Do the Tales of Maxim Gorky in Literature." *Craftsman* 12 (May 1907), pp. 135–46.

———. "George Luks, An American Painter of Great Originality and Force, Whose Art Relates to All the Experiences and Interests of Life." *Craftsman* 12 (September 1907), pp. 599–607.

Staley's Views of Coney Island. New York: Charles Frances Press, 1908.

Stimson, John Ward. "On the Stoa of the Twentieth Century: Ethical and Utilitarian Value of Vital Art." *Arena* 26 (July 1901), pp. 78–90.

Swift, Samuel. "Down with the Art Jury!" *Harper's Weekly* 56 (10 February 1912), pp. 13–14.

———. "Revolutionary Figures in American Art." *Harper's Weekly* 51 (13 April 1907), pp. 534–36.

Teters, Luellen. "The Waifs of a Great City." *Metropolitan Magazine* 24 (July 1906), pp. 425–33.

Thompson, Maurice. "Vigorous Men, A Vigorous Nation." *Independent* 50 (1 September 1898), pp. 609–11.

True, Ruth S. *West Side Studies.* Vol. 1, *Boyhood and Lawlessness; The Neglected Girl.* Preface by Pauline Goldmark. New York: Survey Associates, 1914.

[Trumble, Alfred.] *Coney Island Frolics: How New York's Gay Girls and Jolly Boys Enjoy Themselves by the Sea!* New York: Richard K. Fox, 1883.

Turner, George Kibbe. "The Daughters of the Poor." *McClure's* 34 (November 1909), pp. 45–61.

"Undercurrents of New York Life Sympathetically Depicted in the Drawings of Glenn O. Coleman." *Craftsman* 17 (November 1909), pp. 142–49.

Van Dyke, John C. *The New New York.* New York: Macmillan, 1909.

Veiller, Lawrence. "The Social Value of Playgrounds in Crowded Districts." *Charities and the Commons* 18 (3 August 1907), pp. 507–10.

Views of Coney Island. Portland, Me.: L. H. Nelson, 1909.

Wald, Lillian D. *The House on Henry Street.* New York: Henry Holt, 1915.

Walker, John Brisben. "The Wonders of New York, 1903 and 1909." *Cosmopolitan* 36 (December 1903), pp. 143–60.

White, Frank Marshall. "The 'Child Problem' in New York." *Harper's Weekly* 52 (8 August 1908), p. 27.

———. "To Eliminate the Tramp." *Harper's Weekly* 53 (6 February 1909), pp. 16–17.

White, William Allen. "The Insurgence of Insurgency." *American Magazine* 71 (December 1910), pp. 170–74.

———. *The Old Order Changeth.* New York: Macmillan, 1910.

———. "Roosevelt: A Force for Righteousness." *McClure's* 28 (February 1907), pp. 386–94.

———. "Theodore Roosevelt." In *Masks in a Pageant*, pp. 283–326. New York: Macmillan, 1926.

"Who's Who in American Art." *Arts and Decoration* 5 (July 1915), p. 366.

Willets, Gilson. "Digging a $60,000,000 Hole in New York." *Leslie's Weekly* 100 (30 March 1905), pp. 294–95.

Wilson, Edmund. "George Bellows." *New Republic* 44 (28 October 1925), pp. 254–55.

Wister, Owen. "Theodore Roosevelt: The Sportsman and the Man." *Outing* 38 (June 1901), pp. 242–48.

Woolston, Florence. "Our Untrained Citizens." *Survey* 23 (2 October 1909), pp. 21–35.

Zeisloft, E. Idell, ed. *The New Metropolis: Memorable Events of Three Centuries From the Island of Mana-hatta to Greater New York at the Close of the Nineteenth Century.* New York: Appleton, 1899.

Secondary Sources

Adelman, Melvin L. *A Sporting Time: New York City and the Rise of Modern Athletics, 1820–70.* Urbana: University of Illinois Press, 1986.

Alper, M. Victor. "American Mythologies in Painting, Part 2: City Life and Social Idealism." *Arts* 46 (December 1971–January 1972), pp. 31–34.

Andrews, Wayne, and Garnett McCoy. "The Artist Speaks, Part IV: Reaction and Revolution." *Art in America* 53 (August–September 1965), pp. 68–87.

Baigell, Matthew. "Notes on Realistic Painting and Photography, c. 1900–10." *Arts Magazine* 54 (November 1979), pp. 141–43.

Baker, John Howard. "Erotic Spectacle in the Art of John Sloan: A Study of the Iconography, Sources, and Influences of a Subject Matter Pattern." Ph.D. diss., Brown University, 1972.

———. "Voyeurism in the Art of John Sloan: The Psychodynamics of a 'Naturalistic' Motif." *Art Quarterly*, n. s., 1 (Autumn 1978), pp. 379–95.

Banta, Martha. *Imaging American Women: Idea and Ideals in Cultural History.* New York: Columbia University Press, 1987.

Baur, John I. H. *Revolution and Tradition in Modern American Art.* Cambridge, Mass.: Harvard University Press, 1951.

Betts, John Rickards. *America's Sporting History.* Reading, Mass.: Addison-Wesley, 1974.

Bledstein, Burton J. *The Culture of Professionalism: The Middle Class and the Development of Higher Education in America.* New York: Norton, 1976.

Blumin, Stuart M. "Explaining the New Metropolis: Perception, Depiction, and Analysis in Mid-Nineteenth-Century New York City." *Journal of Urban History* 11 (November 1984), pp. 9–38.

———. "The Hypothesis of Middle-Class Formation in Nineteenth-Century America: A Critique and Some Proposals." *American Historical Review* 90 (April 1985), pp. 299–338.

Boswell, Peyton, Jr. *George Bellows.* New York: Crown, 1942.

Boyer, Paul. *Urban Masses and Moral Order in America, 1820–1920.* Cambridge, Mass.: Harvard University Press, 1978.

Braider, Donald. *George Bellows and the Ashcan School of Painting.* Garden City, N.Y.: Doubleday, 1971.

Bremner, Robert H. *From the Depths: The Discovery of Poverty in the United States.* New York: New York University Press, 1956.

Brooks, Van Wyck. *John Sloan: A Painter's Life.* London: J. M. Dent, 1955.

Brown, Milton. *American Painting from the Armory Show to the Depression.* Princeton, N.J.: Princeton University Press, 1955.

Brown, Richard D. "Modernization: A Victorian Climax." *American Quarterly* 27 (December 1975), pp. 533–44.

Cady, Edwin H. "'The Strenuous Life' as a Theme in American Culture." In *New Voices in American Studies*, edited by Ray B. Browne et al. West Lafayette, Ind.: Purdue University Studies, 1966.

Carmean, E. A., Jr., John Wilmerding, Linda Ayres, and Deborah Chotner. *Bellows: The Boxing Pictures.* Exhibition catalog. Washington, D.C.: National Gallery of Art, 1982.

Cashman, Sean Dennis. *America in the Gilded Age: From the Death of Lincoln to the Rise of Theodore Roosevelt.* New York: New York University Press, 1984.

Cavallo, Dominick. *Muscles and Morals: Organized Playgrounds and Urban Reform, 1880–1920.* Philadelphia: University of Pennsylvania Press, 1981.

Chambers, John Whiteclay, III. *The Tyranny of Change: America in the Progressive Era, 1900–1917.* New York: St. Martin's, 1980.

Christman, Margaret C. S. *Portraits by George Bellows.* Exhibition catalog. Washington, D.C.: National Portrait Gallery, 1981.

Condit, Carl W. *The Port of New York: A History of the Railroad and Terminal System from the Beginnings to Pennsylvania Station.* Chicago: University of Chicago Press, 1980.

Conn, Peter. *The Divided Mind: Ideology and Imagination in America, 1898–1917.* Cambridge: Cambridge University Press, 1983.

Corn, Wanda. "The New New York." *Art in America* 61 (July–August 1973), pp. 59–65.

Crunden, Robert M. *Ministers of Reform: The Progressives' Achievement in American Civilization, 1889–1920.* New York: Basic Books, 1982.

Danbom, David B. *"The World of Hope": Progressives and the Struggle for an Ethical Public Life.* Philadelphia: Temple University Press, 1987.

Deshazo, Edith. *Everett Shinn, 1876–1953: A Figure in His time.* New York: Potter, 1974.

Diggins, John P. *The American Left in the Twentieth Century.* New York: Harcourt Brace Jovanovich, 1973.

Dinnerstein, Harvey, and Burt Silverman. "New Look at Protest: the Eight since 1908." *Art News* 56 (February 1958), pp. 36–39.

Douglas, Ann. *The Feminization of American Culture.* New York: Knopf, 1977.

The Drawings of George Bellows. Introduction by Charles H. Morgan. Alhambra, Calif.: Borden, 1973.

Dubbert, Joe L. *A Man's Place: Masculinity in Transition.* Englewood Cliffs, N.J.: Prentice-Hall, 1979.

du Bois, Guy Pène. *Artists Say the Silliest Things.* New York: American Artists Group, 1940.

Eastman, Max. *Enjoyment of Living.* New York: Harper and Brothers, 1948.

Eggers, George W. *George Bellows.* New York: Whitney Museum of American Art, 1931.

Ekirch, Arthur A., Jr. *Progressivism in America: A Study of the Era from Theodore Roosevelt to Woodrow Wilson.* New York: New Viewpoints, 1974.

Elzea, Rowland, and Elizabeth Hawkes. *John Sloan: Spectator of Life.* Exhibition catalog. Wilmington: Delaware Art Museum, 1988.

Emery, Edwin. *The Press and America.* 3d rev. ed. Englewood Cliffs, N.J.: Prentice-Hall, 1972.

Engel, Charlene Stant. "George W. Bellows' Illustrations for the *Masses* and Other Magazines and the Sources of His Lithographs of 1916–17." Ph.D. diss., University of Wisconsin, Madison, 1976.

——. "The Realist's Eye: The Illustrations and Lithographs of George Bellows." *Print Review* 10 (1979), pp. 70–86.

Erenberg, Lewis A. *Steppin' Out: New York Nightlife and the Transformation of American Culture, 1890–1930.* Westport, Conn.: Greenwood Press, 1981.

The Fiftieth Anniversary of the Exhibition of Independent Artists in 1910. Exhibition catalog. Wilmington: Delaware Art Center, 1960.

Filene, Peter Gabriel. "Between a Rock and a Soft Place: A Century of American Manhood." *South Atlantic Quarterly* 84 (Autumn 1985), pp. 339–55.

——. *Him/Her/Self: Sex Roles in Modern America.* New York: Harcourt Brace Jovanovich, 1974.

Fink, Lois Marie, and Joshua C. Taylor. *Academy: The Academic Tradition in American Art.* Exhibition catalog. Washington, D.C.: Published for the National Collection of Fine Arts by the Smithsonian Institution Press, 1975.

Fink, Lois Marie. "The Innovation of Tradition in Late Nineteenth-Century American Art." *American Art Journal* 10 (November 1978), pp. 63–71.

Fishbein, Leslie. *Rebels in Bohemia: The Radicals of "The Masses," 1911–1917.* Chapel Hill: University of North Carolina Press, 1973.

Fitzgerald, Richard A. *Art and Politics: Cartoonists of "The Masses" and "Liberator."* Westport, Conn.: Greenwood Press, 1973.

George Bellows: Paintings, Drawings, and Prints. Exhibition catalog. Chicago: Art Institute of Chicago, 1946.

George Bellows: Paintings, Drawings, Lithographs. Exhibition catalog. New York: Gallery of Modern Art, 1966.

George Bellows: A Retrospective Exhibition. Introduction by Henry McBride. Exhibition catalog. Washington, D.C.: National Gallery of Art, 1957.

George Wesley Bellows: Paintings, Drawings, and Prints. Exhibition catalog. Columbus, Ohio: Columbus Museum of Art, 1979.

Gilfoyle, Timothy J. "The Moral Origins of Political Surveillance: The Preventive Society in New York City, 1867–1918." *American Quarterly* 38 (Fall 1986), pp. 637–52.

Gillette, Howard, Jr. "The City in American Culture." In *American Urbanism: A Historiographical Review,* edited by Howard Gillette, Jr., and Jane L. Miller. New York: Greenwood Press, 1987.

Gilmore, Al-Tony. *Bad Nigger!: The National Impact of Jack Johnson.* Port Washington, N.Y.: Kennikat Press, 1975.

Glackens, Ira. *William Glackens and the Eight.* New York: Horizon Press. 1957.

Goldin, Amy. "The Eight's Laissez Faire Revolution." *Art in America* 61 (July–August 1973), pp. 42–49.

Goldman, Emma. *Living My Life.* Garden City, N.Y.: Garden City Publishing Co., 1934.

Goodman, Cary. *Choosing Sides: Playground and Street Life on the Lower East Side.* New York: Schocken Books, 1979.

Goodrich, Lloyd. *Thomas Eakins.* 2 vols. Cambridge, Mass.: Harvard University Press, for the National Gallery of Art, 1982.

Gorn, Elliott J. *The Manly Art: Bare-Knuckle Prize Fighting in America.* Ithaca, N.Y.: Cornell University Press, 1986.

Grant, Charles. "Stag at Sharkey's." *Beta Theta Pi Magazine* (May 1947), pp. 647–79.

Green, Catherine. "George Bellows: His Vision of America and the Response of the American People to His Vision." In *George Bellows: Works from the Permanent Collection of the Albright-Knox Art Gallery.* Exhibition catalog. Buffalo, N.Y.: Albright-Knox Art Gallery, 1981.

Green, Martin. *New York 1913: The Armory Show and the Paterson Strike Pageant.* New York: Charles Scriber's Sons, 1988.

Habegger, Alfred. *Gender, Fantasy, and Realism in American Literature.* New York: Columbia University Press, 1982.

Hales, Peter B. *Silver Cities: The Photography of American Urbanization, 1839–1915.* Philadelphia: Temple University Press, 1984.

Hammack, David C. *Power and Society: Greater New York at the Turn of the Century.* New York: Columbia University Press, 1987.

Hapgood, Hutchins. *A Victorian in the Modern World.* New York: Harcourt Brace, 1939.

Harris, Neil. Introduction to *The Land of Contrasts, 1880–1901.* New York: George Braziller, 1970.

Hawkes, Elizabeth H. *City Life Illustrated 1890–1940: Sloan, Glackens, Luks, Shinn—Their Friends and Followers.* Exhibition catalog. Wilmington: Delaware Art Museum, 1980.

Haywood, Robert. "George Bellows's *Stag at Sharkey's:* Boxing, Violence, and Male Identity." *Smithsonian Studies in American Art* 2 (Spring 1988), pp. 3–15.

Higham, John. "The Reorientation of American Culture in the 1890s." In *The Origins of Modern Consciousness.* Detroit: Wayne State University, 1965.

Hills, Patricia. "John Sloan's Images of Working-Class Women: A Case Study of the Roles and Interrelationships of Politics, Personality, and Patrons in the Development of Sloan's Art, 1905–16." *Prospects* 5 (1980), pp. 157–96.

_____. *The Painter's America: Rural and Urban Life, 1810–1910.* Exhibition catalog. New York: Praeger, in association with the Whitney Museum of American Art, 1974.

_____. *Turn-of-the-Century America: Paintings, Graphics, Photographs, 1890–1910.* Exhibition catalog. New York: Whitney Museum of American Art, 1977.

Hirschfeld, Charles. "'Ash Can' versus 'Modern' Art in America." *Western Humanities Review* 10 (Autumn 1956), pp. 353–73.

Hobbs, Susan. "John La Farge and the Genteel Tradition in American Art, 1875–1910." Ph.D. diss., Cornell University, 1974.

Hofstadter, Richard. *The Age of Reform, From Bryan to F. D. R.* New York: Knopf, 1955.

Holcomb, Grant. "The Forgotten Legacy of Jerome Myers, (1867–1940): Painter of New York's Lower East Side." *American Art Journal* 9 (May 1977), pp. 78–91.

Homer, William Innes. *Robert Henri and His Circle.* Ithaca, N.Y.: Cornell University Press, 1969. Reprint. New York: Hacker Art Books, 1988.

Howe, Daniel Walker, ed. *Victorian America.* Philadelphia: University of Pennsylvania Press, 1976.

Huber, Richard M. *The American Idea of Success.* New York: McGraw-Hill, 1971.

Isenberg, Michael T. *John L. Sullivan and His America.* Urbana: University of Illinois Press, 1988.

Johns, Elizabeth. *Thomas Eakins: The Heroism of Modern Life.* Princeton, N.J.: Princeton University Press, 1983.

Kaplan, Amy. *The Social Construction of American Realism.* Chicago: University of Chicago Press, 1988.

Kaplan, Justin. *Lincoln Steffens: A Biography.* New York: Simon and Schuster, 1974.

Kasson, John F. *Amusing the Million: Coney Island at the Turn of the Century.* New York: Hill and Wang, 1978.

_____. *Civilizing the Machine: Technology and Republican Values in America, 1776–1900.* New York: Penguin Books, 1977.

Kelly, Franklin. "George Bellows' *Shore House.*" In *American Art Around 1900,* edited by Doreen Bolger and Nicolai Cikovsky, Jr. Studies in the History of Art, no. 37. Washington, D.C.: National Gallery of Art, 1990.

Kelly, Karol L. *Models for the Multitudes: Social Values in the American Popular Novel, 1850–1920.* Westport, Conn.: Greenwood Press, 1987.

Kent, Rockwell. *It's Me, O Lord: The Autobiography of Rockwell Kent.* New York: Dodd, Mead, 1955.

Kerber, Linda K. "Separate Spheres, Female Worlds, Woman's Place: The Rhetoric of Women's History." *Journal of American History* 75 (June 1988), pp. 9–39.

Kingsdale, Jon M. "The 'Poor Man's Club': Social Functions of the Urban Working-Class Saloon." *American Quarterly* 25 (October 1973), pp. 472–89.

Kinser, Suzanne L. "Prostitutes in the Art of John Sloan." *Prospects* 8 (1984), pp. 231–54.

Kirschner, Don S. "The Ambiguous Legacy: Social Justice and Social Control in the Progressive Era." *Historical Reflections* 2 (Summer 1975), pp. 69–88.

Kuspit, Donald B. "Individual and Mass Identity in Urban Art: The New York Case." *Art in America* 65 (September–October 1977), pp. 67–77.

Kwait, Joseph J. "John Sloan: An American Artist as Social Critic, 1900–1917." *Arizona Quarterly* 10 (Spring 1954), pp. 52–64.

_____. "Robert Henri and the Emerson-Whitman Tradition." *Publications of the Modern Language Association* 71 (September 1956), pp. 617–36.

Lasch, Christopher. *The New Radicalism in America: The Intellectual as a Social Type.* New York: Knopf, 1965.

Lears, T. J. Jackson. "From Salvation to Self-Realization: Advertising and the Therapeutic Roots of the Consumer Culture, 1880–1930." In *The Culture of Consumption: Critical Essays in American History, 1880–1980,* edited by Richard Wightman Fox and T. J. Jackson Lears. New York: Pantheon Books, 1983.

_____. *No Place of Grace: Antimodernism and the Transformation of American Culture, 1880–1920.* New York: Pantheon Books, 1981.

Lees, Andrew. *Cities Perceived: Urban Society in European and American Thought, 1820–1940.* New York: Columbia University Press, 1985.

McGovern, James R. "David Graham Phillips and the Virility Impulse of the Progressives." *New England Quarterly* 39 (September 1966), pp. 334–55.

Marcaccio, Michael D. *The Hapgoods: Three Earnest Brothers.* Charlottesville: University Press of Virginia, 1977.

Mason, Lauris, assisted by Joan Ludman. *The Lithographs of George Bellows: A Catalogue Raisonné.* Millwood, N.Y.: KTO Press, 1977.

May, Henry F. *The End of American Innocence: A Study of the First Years of Our Own Time, 1912–1917.* New York: Oxford University Press, 1959.

May, Larry. *Screening Out the Past: The Birth of Mass Culture and the Motion Picture Industry.* New York: Oxford University Press, 1980.

Morgan, Charles H. *George Bellows: Painter of America.* New York: Reynal, 1965. Reprint. Millwood, N.Y.: Kraus Reprint, 1979.

Mowry, George E. *Theodore Roosevelt and the Progressive Movement.* New York: Hill and Wang, 1960.

Mrozek, Donald J. *Sport and the American Mentality, 1880–1910.* Knoxville: University of Tennessee Press, 1983.

Myers, Jane, and Linda Ayres. *George Bellows: The Artist and His Lithographs, 1916–1924.* Exhibition catalog. Fort Worth, Tex.: Amon Carter Museum, 1988.

Myers, Jerome. *Artist in Manhattan.* New York: American Artists Group, 1940.

Nasaw, David. *Children of the City: At Work and at Play.* Garden City, N.Y.: Anchor Press, 1985.

O'Neill, William L., ed. *Echoes of Revolt: "The Masses," 1911–1917.* Chicago: Quadrangle, 1966.

_____. "Reconsideration: Hutchins Hapgood." *New Republic* 166 (19 February 1972), pp. 31–32.

Pach, Walter. *Queer Thing, Painting: Forty Years in the World of Art.* New York: Harper and Brothers, 1938.

Peiss, Kathy. "'Charity Girls' and City Pleasures: Historical Notes on Working-Class Sexuality, 1880–1920." In *Powers of Desire: The Politics of Sexuality,* edited by Ann Snitow, Christine Stansell, and Sharon Thompson. New York: Monthly Review Press, 1983.

_____. *Cheap Amusements: Working Women and Leisure in Turn-of-the-Century New York.* Philadelphia: Temple University Press, 1986.

Perlman, Bennard B. *Painters of the Ashcan School: The Immortal Eight.* New York: Dover, 1988. Reprint. Originally published as *The Immortal Eight: American Painting from Eakins to the Armory Show, 1870–1913.* Cincinnati: North Light, 1979.

_____. *Robert Henri, Painter.* Exhibition catalog. Wilmington: Delaware Art Museum, 1984.

Porter, Fairfield. "George Bellows: Journalists' Artist." *Art News* 55 (February 1957), pp. 32–35.

Read, Helen Appleton. *New York Realists, 1900–1914.* New York: Whitney Museum of American Art, 1937.

_____. *Robert Henri.* New York: Whitney Museum of American Art, 1931.

_____. *Robert Henri and Five of His Pupils.* New York: Century Association, 1946.

Reiss, Steven A. "In the Ring and Out: Professional Boxing in New York, 1896–1920." In *Sport in America: New Historical Perspectives*, edited by Donald Spivey. Westport, Conn.: Greenwood Press, 1985.

———. "The New Sport History." *Reviews in American History* 18 (September 1990), pp. 311–25.

Rich, Daniel Catton. "Bellows Revalued." *Magazine of Art* 39 (April 1949), pp. 139–42.

Roberts, Gerald F. "The Strenuous Life: The Cult of Manliness in the Era of Theodore Roosevelt." Ph.D. diss., Michigan State University, 1970.

Roberts, Randy. *Papa Jack: Jack Johnson and the Era of White Hopes*. New York: Free Press, 1983.

Rodgers, Daniel T. "In Search of Progressivism." *Reviews in American History* 10 (December 1983), pp. 113–32.

Rosenberg, Charles E. "Sexuality, Class and Role in Nineteenth-Century America." *American Quarterly* 25 (May 1973), pp. 131–53.

Rosenzweig, Roy. *Eight Hours for What We Will: Workers and Leisure in an Industrial City, 1870–1920*. Cambridge: Cambridge University Press, 1983.

Rotundo, E. Anthony. "Body and Soul: Changing Ideals of American Middle-Class Manhood, 1770–1920." *Journal of Social History* 16 (Summer 1983), pp. 23–38.

———. "Manhood in America: The Northern Middle Class, 1770–1920." Ph.D. diss., Brandeis University, 1982.

Sammons, Jeffrey T. *Beyond the Ring: The Role of Boxing in American Society*. Urbana: University of Illinois Press, 1988.

Schudson, Michael. *Discovering the News: A Social History of Newspapers*. New York: Basic Books, 1978.

Schwab, Arnold T. *James Gibbons Huneker: Critic of the Seven Arts*. Stanford, Calif.: Stanford University Press, 1963.

Schwartz, Constance H. *The Shock of Modernism in America: The Eight and Artists of the Armory Show*. Exhibition catalog. Roslyn Harbor, N.Y.: Nassau County Museum of Fine Art, 1984.

Scott, David W., and Edgar John Bullard III. *John Sloan, 1871–1951*. Exhibition catalog. Washington, D.C.: National Gallery of Art, 1971.

Sedgwick, Ellery, III. "The American Genteel Tradition in the Early Twentieth Century." *American Studies* 25 (Spring 1984), pp. 49–67.

Seiberling, Frank, Jr. "George Bellows, 1882–1925: His Life and Development as an Artist." Ph.D. diss., University of Chicago, 1948.

Shinn, Everett. "Recollections of the Eight." In *The Eight*. Exhibition catalog. Brooklyn Museum and the Brooklyn Institute of Arts and Sciences, 1944.

Simkhovitch, Mary Kingsbury. *Neighborhood: My Story of Greenwich House*. New York: Norton, 1938.

Smith, Carl S. "The Boxing Paintings of Thomas Eakins." *Prospects* 4 (1979), pp. 403–19.

Smith-Rosenberg, Carroll. *Disorderly Conduct: Visions of Gender in Victorian America*. New York: Knopf, 1985.

Stange, Maren. *Symbols of Ideal Life: Social Documentary Photography in America, 1890–1950*. Cambridge: Cambridge University Press, 1989.

Stein, Sally. "Making Connections with the Camera: Photography and Social Mobility in the Career of Jacob Riis." *Afterimage* 10 (May 1983), pp. 9–15.

Sullivan, Mark. *Our Times, 1900–1925*. 6 vols. New York: Scribner's, 1940.

Susman, Warren I. "'Personality' and the Making of Twentieth-Century Culture." In *Culture As History: The Transformation of American Society in the Twentieth Century*. New York: Pantheon Books, 1984.

Sweet, Frederick A. "Bellows Twenty-Three Years after Dempsey-Firpo." *Art News* 44 (15 January 1946), pp. 12–13, 27–28.

Szasz, Ferenc M., and Ralph F. Bogardus. "The Camera and the American Social Conscience: The Documentary Photography of Jacob A. Riis." *New York History* 55 (October 1974), pp. 409–36.

Thelen, David P. *Robert M. La Follette and the Insurgent Spirit*. New York: Little, Brown, 1976.

———. "Social Tensions and the Origins of Progressivism." *Journal of American History* 56 (September 1969), pp. 323–41.

Tichi, Cecelia. *Shifting Gears: Technology, Literature, Culture in Modernist America*. Chapel Hill: University of North Carolina Press, 1987.

Trachtenberg, Alan. "Image and Ideology: New York in the Photographer's Eye." *Journal of Urban History* 10 (August 1984), pp. 453–64.

————. *The Incorporation of America: Culture and Society in the Gilded Age.* New York: Hill and Wang, 1982.

Tufts, Eleanor M. "Bellows and Goya." *Art Journal* 30, no. 4 (1971), pp. 362–68.

————. "Realism Revisited: Goya's Impact on George Bellows and Other American Responses to the Spanish Presence in Art." *Arts* 57 (February 1983), pp. 105–13.

Wagenknecht, Edward. *American Profile, 1900–1909.* Amherst, Mass.: University of Massachusetts Press, 1982.

Walker, Don D. "American Art on the Left, 1911–1950." *Western Humanities Review* 8 (Autumn 1954), pp. 323–46.

Warner, Sam Bass, Jr. "Slums and Skyscrapers: Urban Images, Symbols, and Ideology." In *Cities of the Mind: Images and Themes of the City in the Social Sciences,* edited by Lloyd Rodwin and Robert M. Hollister. New York: Plenum Press, 1984.

Watson, Forbes. "Realism Undefeated." *Parnassus* 9 (March 1937), pp. 11–14, 37–38.

Wertheim, Arthur Frank. *The New York Little Renaissance: Iconoclasm, Modernism, and Nationalism in American Culture, 1908–1917.* New York: New York University Press, 1976.

Wiebe, Robert H. *The Search for Order, 1877–1920.* Westport, Conn.: Greenwood Press, 1967.

Wiggins, William H., Jr. "Jack Johnson as Bad Nigger: The Folklore of His Life." *Black Scholar* 2 (January 1971), pp. 35–46.

Wilson, Christopher P. *The Labor of Words: Literary Professionalism in the Progressive Era.* Athens: University of Georgia Press, 1985.

Wilson, Richard Guy, Dianne H. Pilgrim, and Richard N. Murray. *The American Renaissance, 1876–1917.* Brooklyn: Brooklyn Museum, 1979.

Young, Mahonri Sharp. *The Paintings of George Bellows.* New York: Watson-Guptill, 1973.

Zilczer, Judith K. "Anti-realism in the Ashcan School." *Artforum* 17 (March 1979), pp. 44–49.

Zurier, Rebecca. *Art for "The Masses": A Radical Magazine and Its Graphics, 1911–1917.* Introduction by Leslie Fishbein. Philadelphia: Temple University Press, 1988.

————. "Hey Kids: Children in the Comics and the Art of George Bellows." *Print Collector's Newsletter* 18 (January–February 1988), pp. 196–203.

————. "Picturing the City: New York in the Press and the Art of the Ashcan School." Ph.D. diss., Yale University, 1988.

Index